SPLENDORS *of* PUNJAB HERITAGE

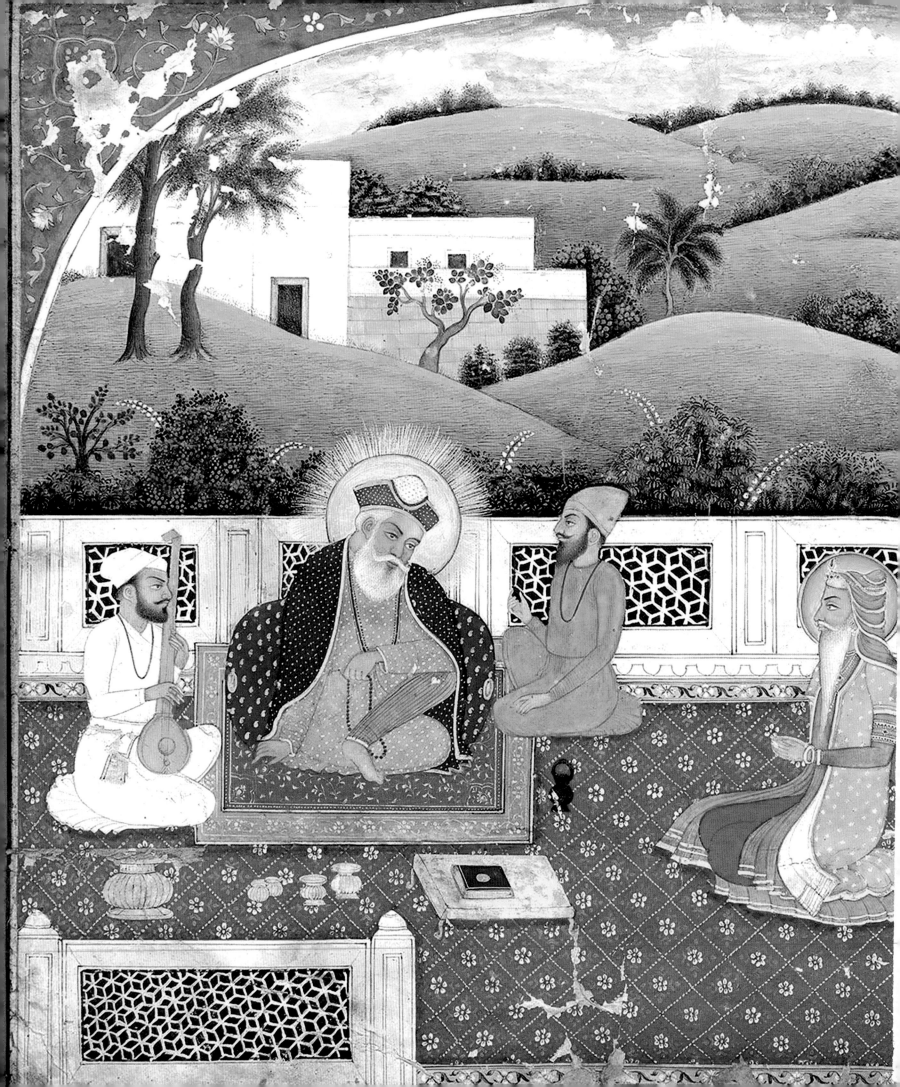

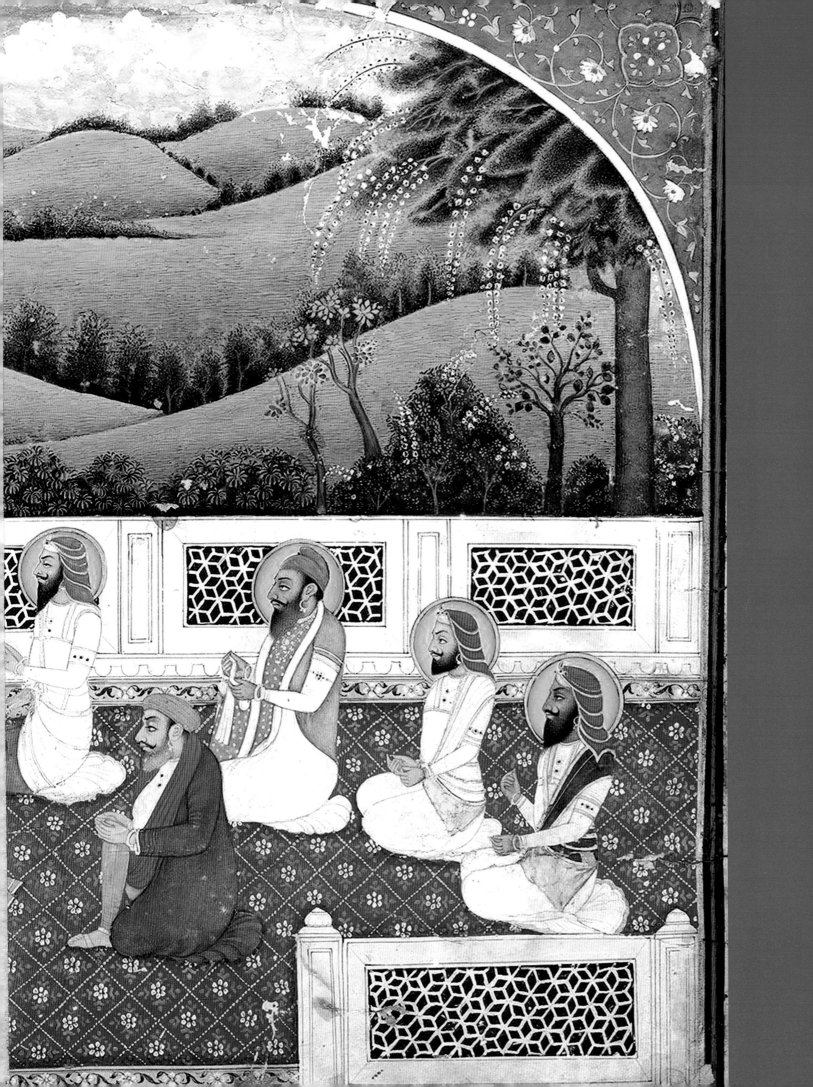

SPLENDORS *of* PUNJAB HERITAGE
ART FROM THE KHANUJA FAMILY COLLECTION

With Essays by
DR. PARVINDERJIT SINGH KHANUJA

Edited with an Introduction by
DR. PAUL MICHAEL TAYLOR

Sikhmuseum.org

in association with
Asian Cultural History Program,
Smithsonian Institution

Lustre Press
Roli Books

Published by Roli Books (New Delhi, India) in association with Sikhmuseum.org and with the Asian Cultural History Program, Department of Anthropology, Smithsonian Institution, Washington, D.C. 20560 USA

Unless otherwise noted in the caption, all photographs here are © Sikhmuseum.org, LLC. which reserves all rights to the photographs. Object measurements are given in inches, in the order: height X width, or width X height X depth, unless otherwise noted.

First published by Roli Books, 2022
M-75, Greater Kailash II Market
New Delhi-110 048, India
Phone: ++91-11-4068 2000
E-mail: info@rolibooks.com
Website: www.rolibooks.com

Cataloging-in-Publication Data:
Khanuja, Dr. Parvinderjit Singh 1959-(author of essays) and
Taylor, Dr. Paul Michael, 1953- (editor)
Splendors of Punjab Heritage: Art from the Khanuja Family Collection /
With essays by Dr. Parvinderjit Singh Khanuja. Edited with an introduction by
Dr. Paul Michael Taylor.

ISBN-13: 978-93-92130-16-8

1. Art – India – Punjab. 2. Art – Pakistan – Punjab. 3. Art – Sikh.
4. Sikhism — Art 5. Art, Sikh – Private Collections –Arizona.
I. Khanuja, Parvinder Singh, 1959- II. Taylor, Paul Michael, 1953- III.
Sikhmuseum.org (Paradise Valley, Arizona) IV. National Museum of Natural History
(U.S.). Asian Cultural History Program.

In celebration of the 400th anniversary of Guru Tegh Bahadur's birth, this book is produced and distributed by Sikhmuseum.org in association with the Asian Cultural History Program, Smithsonian Institution.

The opinions and ideas expressed within the essays in this book are those of the essay author, and not necessarily those of Sikhmuseum.org, nor of the Smithsonian Institution.

Design: Sneha Pamneja
Project editor: Neelam Narula
Pre-press: Jyoti Dey
Production: Lavinia Rao

Printed at Samrat Offset,
New Delhi, India

First edition. First printing 2022

Front cover: "Dukh Bhanjani Beri (dispeller of suffering), Golden Temple" by The Singh Twins, 2020. See image 1, page 76.
Back cover: Detail of: "Maharaja Ranjit Singh" by anonymous artist, 1800-1820. See image 51, page 180.

Page 1: *Chand tika*
See image 62, page 222

Frontispiece: Mool Mantra, composed by Guru Nanak
Hardeep Singh | 2019 | 18 x 15 in | Deckle edged hand-made
paper, lamp black ink, golden foiled leaves and coloring

Pages 2-3: Guru Nanak and Maharaja Ranjit Singh
Artist unknown | 19th century | 12.6 x 17.9 in | Gouache and gold on paper

Pages 5 and 7: Illustration from motif used in "Mool Mantra, composed by Guru Nanak"

CONTENTS

PREFACE AND ACKNOWLEDGMENTS 9

INTRODUCTION by Dr. Paul Michael Taylor 20

1. ONE AND THE SAME LIGHT:
 GURUS IN SIKHISM 24

2. GURDWARAS: SPIRITUAL AND
 TEMPORAL ABODES OF
 AUTHORITY 76

3. THE FIGHT FOR *DEGH*, *TEGH*, AND
 FATEH: BANDA SINGH BAHADUR
 AND THE *MISLS* 132

4. BUILDING A SIKH EMPIRE:
 THE LIFE AND TIMES OF
 RANJIT SINGH 144

5. ENCOUNTERS WITH THE COLONIAL:
 THE POST-RANJIT SINGH YEARS 184

6. THE MAKING OF A MARTIAL RACE:
 MILITARY TRADITIONS IN SIKHISM 228

7. PRINCELY STATES OF PUNJAB:
 ARTS AND ARTIFACTS 274

8. EMBROIDERED AND WOVEN
 MASTERPIECES: TEXTILE
 TRADITIONS OF GREATER PUNJAB 304

9. SYMBOLS OF SOVEREIGNTY:
 SIKH COINAGE 354

10. MISCELLANEOUS ILLUSTRATIONS
 IN THE KHANUJA FAMILY
 COLLECTION 370

11. THE SPIRIT OF *PUNJABIYAT* AND
 CHARDI KALA 406

BIBLIOGRAPHY 430

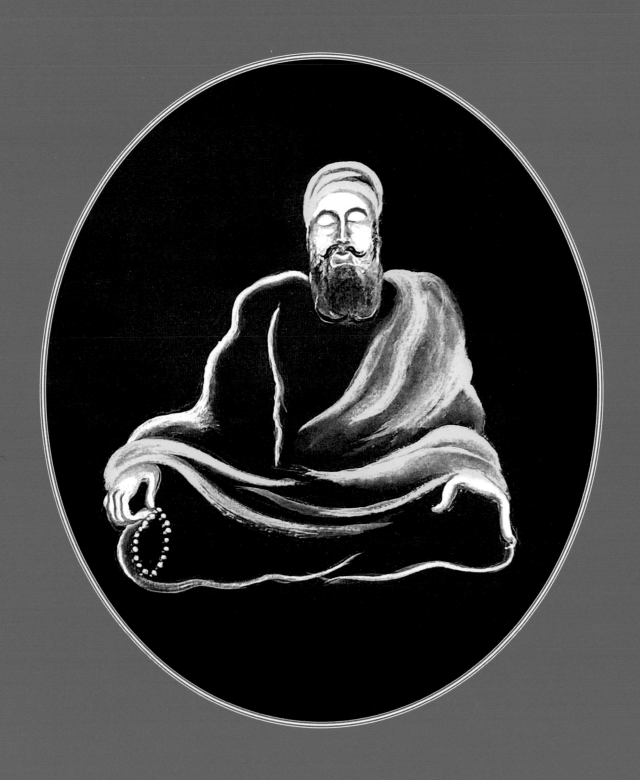

DEDICATION

IN HONOR OF GURU TEGH BAHADUR SAHIB, NINTH SIKH GURU

This book is published in association with the worldwide celebration (2021–2022)
of the 400th birth anniversary of Guru Tegh Bahadur.

PREFACE AND ACKNOWLEDGMENTS

Located in the northwest of the Indian subcontinent, Punjab derives its name from the five rivers that flow through its fertile lands. The birthplace of the Indus Valley, one of the oldest civilizations in the world (3300–1300 BC), the region's wealth and strategic location made it the target of several historic invasions. Alexander led his army here in 327 BC via the Khyber Pass. The Aryans, Persians, Mongols, Arabs, Turks, Afghans and Mughals came in subsequent waves and Punjab continued to bear the brunt of incessant attacks till the might of Sikh ruler Maharaja Ranjit Singh's army closed the Khyber Pass at the end of the eighteenth century.

The early invaders who eventually settled in this land assimilated over time with the locals, giving rise to a unique and culturally diverse population. There are approximately 130 million Punjabi speakers around the globe, making it the ninth most spoken language. In India and elsewhere, Punjabis are well-known for their resilience, hard work, and ability to adapt, characteristics that have helped them survive and thrive over the centuries.

This book focuses on two famous sons of the soil: Guru Nanak (1469–1539), who founded Sikhism, and Maharaja Ranjit Singh (1780–1839), who succeeded in unifying the region and establishing one of the finest empires (Khalsa Raj) bringing stability, peace, and prosperity. The famous Muslim poet Muhammad Iqbal (1877–1938) wrote about Guru Nanak: "Again from the Punjab the call of monotheism arose:/A perfect man roused India from slumber."[1] Discussing Ranjit Singh's reign, the Austrian nobleman and army officer, Charles von Hugel (1795–1870) adeptly commented: "Never was so large an empire founded by one man with so little criminality."[2]

Punjab, and especially Sikh art, has taken multiple forms ranging from scriptural manuscripts and floral adornments to illustrations and illuminations. We see among them various types of jewelry, textiles, arms, coinage, religious architecture, monuments, murals and frescoes, paintings in Mughal, Punjab, and Pahari styles, as well as calligraphy. All these artistic expressions enhance the region's culture and add to its beauty. Foreign artists such as Emily Eden, August Shoefft, Alexis Soltykoff have also left their imprint on the region's art. The selection of works from our collection that we present in this book strives to reflect the incredible richness of Punjab's artistic production.

This book also includes three gatefolds depicting artifacts that I cherish very much and that have great artistic and cultural significance. The first one presents swords. These weapons are symbols of military preparedness, an important concept in the Sikh faith. The second gatefold depicts the Golden Temple, a special spiritual abode for Sikh people. The third gatefold shows Kashmir shawls, superb examples of craftsmanship which are truly unique in their own way.

Our work is still in progress. We continue to discover, analyze, and research different works, and this book is just the start of a process that will give us further understanding of our collection. Our fervent hope is that efforts like this will encourage scholars to produce more research in the future on the topics of Punjab art, history, and culture. We also hope that projects like this will bring greater attention to Sikh art, which is still severely underrepresented in museums around the globe. It is our strong belief that art can play an essential role not only in enriching cultural heritage and uplifting human spirit, but also in achieving mutual understanding, promoting tolerance, and building connections.

Our collection, which we partially present in this book, is a labor of love that started with an interest in the history of Punjab, discovered by listening to the stories our elders shared as well

Detail of "Guru Tegh Bahadur's Martyrdom" by Arpana Caur, 2021. See image 72, page 67.

9

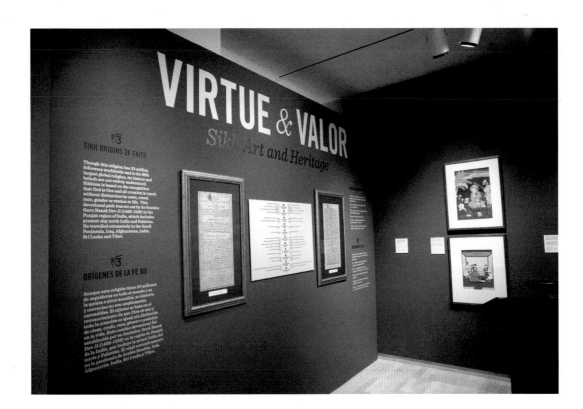

10 as by reading books about it. With the help of my daughter Jasleen, this interest evolved into the expensive passion of collecting artifacts and paintings, which I have pursued over the last fifteen years. Along this journey, I came across many gracious people to whom I am profoundly thankful. They include Gurprit Singh, who introduced me to numismatics; Dr. Gurpal Bhuller, a pioneer collector of Sikh art who kindly entrusted me with some of his acquisitions so that they can be preserved for future generations. I received wisdom and encouragement from Dr. Narinder Kapany (unfortunately not with us anymore), a legend in the field of Sikh art, as well as from Sonia Dhami, the Executive Director of the Sikh Foundation. I am indebted to Davinder Toor, a trailblazer in the U.K., who has shown me what an extraordinary collection should look like. Peter Bance has been generous with his advice, and Sunmit Singh has been invaluable with his research. Runjeet Singh has generously parted with his personal collection of Sikh arms, painstakingly collected over the last twenty years, and has educated me on the subject. Frank Ames has also been liberal with his advice and with some of his collection of Kashmir shawls. Finally, I extend my gratitude to young enthusiasts like Sumeet Aurora, Gurmanas Singh, and Gurinder Johal for the optimistic nudges they provided along the way.

The Phoenix Art Museum has been gracious enough to provide a location for a permanent Sikh art gallery (only the second one at a major museum in the West). Dr. Janet Baker, the museum's Curator of Asian Art, has done a wonderful job in creating multiple exhibits around our collection, such as *Virtue and Valor* (2017), *Warriors of World War I* (2017–18), and *Saintly Soldiers of the Sikh Faith* (2018). In 2019 she curated an exhibition celebrating the 550th anniversary of Guru Nanak's birth. More recently she has worked on an exhibition entitled *The Golden Temple: Center of Sikh Faith*, which will run through April 2022, as well as on multiple associated publications. I would be remiss if I did not mention Dr. Paul Michael Taylor from the Smithsonian Institution, a gentleman scholar who has created several exhibits and publications pertaining to Sikh art and

culture. In January 2019, Dr. Taylor was kind enough to publish an article on our collection in the magazine *Arts of Asia.*[3]

In April 2020 I made a courtesy call to Dr. Taylor to enquire about his health during the Covid-19 pandemic. As we spoke, he suggested I consider publishing a book on my collection, reminding me this was also his opinion when we had first met as he began examining images of my artworks. I was taken aback, but upon further encouragement from my friends, I decided to embark on this ambitious journey. As a practicing medical oncologist in Phoenix, Arizona, I am neither a professional writer, nor have I had any formal training in the fields of art and history. Therefore, I expect that this work will be different from other books on the same topic and that it will have some deficiencies. Although there are people who have been kind with their suggestions, some of which I have incorporated, I am solely responsible for all the mistakes. In this regard amongst others, I thank Ajeet Caur, Anjum Dara, Gurprit Singh, Inni Kaur, Madanjit Kaur, Peter Bance, Runjeet Singh, and Sonia Dhami for their insights.

After studying multiple books on Sikh art and wondering how my work could be different while still providing value, I decided to write less and let the visuals do more talking. As for the selected works presented in this volume, I have tried to emphasize their connections with Sikhism, while also placing them in the broader context of the arts of Punjab. I have also chosen to discuss topics that usually are not covered in mainstream art publications, such as numismatics, textiles, arms, and social aspects. I have also included the work of contemporary artists. Some of them are well known such as Arpana Caur (a gentle soul who has always been extremely kind in giving her works and producing paintings whenever I needed her help), Devinder Singh, Jarnail Singh, Singh Twins, and Sukhpreet Singh. In addition, I have included the works of Bholla Javed, Datti Kaur, Fyza Fayyaz, Gurpreet Singh, Jaspal Singh, Keerat Kaur, Rupy Tut, Saira Wasim, Sumeet Aurora, and others. I hope this decision will inspire others to acquire and publish the work of these artists.

This book would not have been possible without the encouragement and help of the team at Roli Books, a renowned publishing house that took a chance with a novice writer like me. For this I am indebted to Pramod and Kapil Kapoor, along with their outstanding Art Director Sneha Pamneja for her patience and brilliance. I also thank Neelam Narula, Managing Editor at Roli Books, for overseeing this project. Dr. Taylor accepted the duties of Editor; Jaspreet Kaur and Dr. Daniele Lauro were kind enough to help with the editing, while Gabby Washburn provided technical assistance. For the photography we are grateful to Michael Lundgren, the Phoenix Art Museum, and many others.

Finally, I thank my elders Sardar Hazoora Singh, Mula Singh, Rawel Singh, Darshan Singh, Ajit Kaur, Jaswant Singh, Mohinder Kaur, Harbhajan Singh, Sarvjit Kaur, Anit Kaur, Arvinderjeet, Manmohan Kaur, and my immediate family – Parveen, Jasleen, and Neel-Preet, who have all contributed in their own way, helping and encouraging me along this path.

I dedicate this book to Guru Tegh Bahadur Sahib, the ninth guru, whose 400th birth anniversary we celebrate this year. He sacrificed his life in his fight to protect Kashmiri Pandits and their rights to practice their religion freely. Reverentially called "Hind Ki Chadar" ("Shield of India"), Guru Tegh Bahadur epitomizes the fight for freedom and human rights. In the final chapter of this book, we present a painting depicting Indian farmers' recent protests for their rights. Their fight would be an appropriate tribute to the legacy of Guru Tegh Bahadur, who we believe should be more aptly called "Srisht-di-Chadar" ("Protector of Humanity").

May the spirit of *chardi kala* (eternal optimism) guide us.

PARVINDERJIT SINGH KHANUJA

Sikhmuseum.org LLC

A rare Sikh *tulwar*

c. 18th century | Total length: 35 in | Blade length 30 in | Steel, silver

An extremely rare Sikh sword related to a group of well-known Sikh swords marked "Akaal Sahai…" this one looks different due to its earlier date, and the inscription on the inside of the knuckle guard in Gurmukhi, which reads: "Gu(ru) Nanak Sahai Sarbati Singh Ghanali." This sword was most probably made for an important Sikh warrior, and so far unique because of the Guru Nanak Sahai inscription.

REFERENCES & NOTES

1. M. Iqbal, *Tulip in the Desert. A Selection of the Poetry of Muhammad Iqbal*, trans. Mustansir Mir (Kuala Lumpur: Islamic Book Trust, 2011), 88.

2. A. Hugel, *Travels in Kashmir and the Panjab, containing a particular account of the government and character of the Sikhs* (London: J. Petheram, 1845), 154.

3. P.M. Taylor, "Sikh Art and Devotion in the Collection of Parvinder S. Khanuja." *Arts of Asia* 49, no. 1 (January–February 2019): 107–16.

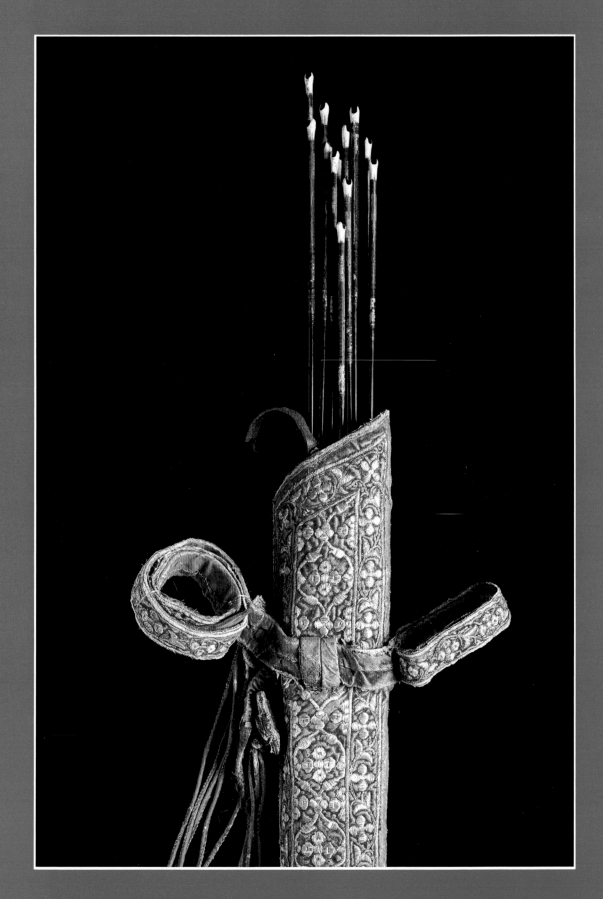

Quiver

See image 37, page 253

INTRODUCTION

This volume compiles in a succinct and visually compelling way a lasting record of the remarkable collection of Punjabi artworks and historical memorabilia representing the cultural history of the Punjab, assembled by Dr. Parvinderjit Singh Khanuja and his family. Dr. Khanuja has added here his personal perspectives on the historical importance and the meaningfulness of these objects, through essays accompanying the images and captions compiled in each of the chapters. The range of the collection is vast, reflecting the depth and variety of Punjabi artistic achievements – collectively forming a catalog of value to many fields, presenting well-described objects arranged not in chronological order, but rather in the form of pictorial essays on selected highly iconic themes in the tangible and intangible cultural history of the Punjab. Four of the chapters are on highly prized artistic media or types of material (textiles, coins, weapons and related elements of the Sikh martial tradition, illustrations and photography), while one chapter compiles images of Sikh Gurdwaras (temples). Others compile a range of artistic expressions from the Khanuja Family Collection about key aspects of (or personages in) the history and philosophy of Sikhism and the Sikh polity in the Punjab through time (the Gurus, Banda Singh Bahadur and the Misl Period; Maharaja Ranjit Singh and the later Sikh Empire; and the Princely States of the Punjab). A concluding chapter brings together examples from this collection that, according to the collector Dr. Khanuja, express the concept of "Panjabiyat" which he explores in another essay expressing his personal sense of this very indigenous concept about the characteristics of Punjabi people. In every thematic group, the wide-ranging and well-selected collection cataloged here is thus accompanied by an essay expressing the collector's perspective.

The resulting catalog or sourcebook of Punjabi history and art that we present here, drawn from the Khanuja Family Collection, is a unique and significant compilation that will be useful to scholars in many fields. It is beautifully illustrated, systematic, and replete with detailed information about each of the objects – yet not at all like a typical museum catalog of a public or private collection. It is "systematic" in its careful illustration and identification of the objects, primarily giving voice to the honest and inspiring views of the collector, allowing readers to join the Khanuja family in their enthusiastic retracing of Punjabi cultural history and the Sikh ethos through the tour they provide of objects in their collection.

As curator of the Smithsonian's Sikh Heritage Project, I have been honored to work with Dr. Khanuja on the preparation of this volume. The Smithsonian's Sikh Heritage Project was founded in the year 2000 within the Smithsonian's Asian Cultural History Program (Department of Anthropology, National Museum of Natural History). That Project has produced or contributed to many lectures, performances, and publications, in addition to the long-term traveling exhibition *Sikhs: Legacy of the Punjab*, which opened in 2004. I first met Dr. Khanuja in January 2017, and at that meeting suggested the idea of a future book about his collection, since by then we were associated with several publications bringing to light various public and private collections of Sikh art.[1] When we published a new translation and commentary on the Japji of Guru Nanak, as part of celebrations for the 550th birth anniversary of Guru Nanak Dev Ji, the First Sikh Guru, Dr. Khanuja kindly allowed us to use many images from his collection to illustrate our publication.[2] The idea of publishing a book on the Khanuja family collection was revived during the recent pandemic

Exterior view of the Phoenix
Art Museum, Phoenix, Arizona.

lockdowns and now achieved through the production of this volume, which the Khanuja family has dedicated to the 400th birth anniversary of Guru Tegh Bahadur, the ninth Sikh guru (whose year-long anniversary celebration began in late April 2021). The design and layout of the book have been ably done by Roli Books. Within the Smithsonian's Asian Cultural History Program, I gratefully acknowledge the editorial assistance of Dr. Daniele Lauro, who has quite professionally handled much of the editorial work on this publication.

As a sourcebook of images and detailed information on such a large and important collection, this book will surely be useful to scholars of South Asian arts and history, and hopefully also an inspiration for many audiences. This book reflects the importance of collecting artworks as an element of diasporic Sikh identity and also makes a major contribution to the growing recent corpus of other published Sikh art collections and exhibitions.[3] The Khanuja family collection serves to encourage Sikh understanding and appreciation for the culture and values of the Sikhs, and to introduce non-Sikhs to their cultural heritage. In that respect, it parallels the Khanuja family's recent establishment, at the Phoenix Art Museum (Phoenix, Arizona) of a permanent "Sikh Art Gallery." (see illustration, above). That space is named for Dr. Khanuja's and his wife's parents, the "Dr. Darshan Singh and Ajit Kaur Khanuja and Mr. Jaswant Singh and Mohinder Kaur Sikh Art Gallery." The Gallery was inaugurated with the Museum's first-ever Sikh exhibition, entitled *Virtue and Valor: Sikh Art and Heritage* (see illustration, p. 22), which opened on April 22, 2017 and was curated by the Museum's Asian curator Dr. Janet Baker. All works displayed there were loaned from the Khanuja Family Collection.[4]

As an immigrant medical doctor from India, Dr. Parvinderjit S. Khanuja, the primary assembler of this collection and the author of the essays presented with the pictorial chapters, built up his medical practice and offices in Phoenix, Arizona, as managing and founding partner of cancer and research centers, always maintaining his strong interest in the history of his family's homeland in the Punjab. His family shares with many other Punjabis the memories of the upheavals of India's partition from Pakistan in 1947. In that year Pakistan separated from India, and the new border bifurcated the Sikh homeland in the Punjab, causing Sikhs great heartache and loss of life and property. About 10 million people relocated—Sikhs left Pakistan for India and Muslims moved from India to Pakistan.[5] Khanuja's ophthalmologist father, Darshan Singh Khanuja, had been born in 1917 in Jhelum, Pakistan, and fled eastward in 1947 with his wife, Ajit Kaur Khanuja, who had

21

22

been born in Nairobi before her own family had moved back to South Asia. Their son Parvinderjit, born in 1959, completed his medical doctorate in India before immigrating to the United States in 1983, continuing his medical training and practice in Detroit until he decided to move to Phoenix in 1993. He says he was drawn to Phoenix by the same things that draw so many people there, "the weather and the opportunity."

Dr. Khanuja once described to me how he considers art collecting a form of religious practice. "At the end of the day," he says, "collecting is for the community, and also to safeguard this art." He finds inspiration in several verses of the Sikh sacred book, the Guru Granth Sahib, about *seva* or service. "One who performs selfless service, without thought of reward, shall attain his Lord and Master" (SGGS p. 286); and more simply, "You shall find peace, doing *seva*." (SGGS p. 25). He also strongly feels that collectors help preserve Sikh heritage of which much has already been lost in Pakistan as well as India. We are grateful to Dr. Khanuja for sharing with us this journey through the art and history of the Punjab since the time of the earliest Sikh gurus. The outstanding array of objects in this richly illustrated sourcebook are allowed to speak for themselves, yet presented alongside Dr. Khanuja's very appealing and personable essays providing a believer's insight, with truly devoted connoisseurship and dedication to Sikh and Punjabi heritage.

A view of the exhibition "Virtue and Valor: Sikh Art and Heritage" (April – November 2017), the first of a series of exhibitions in the Phoenix Art Museum's new permanent gallery of Sikh art, funded through a donation by Parvinderjit Singh Khanuja.

PAUL MICHAEL TAYLOR

REFERENCES & NOTES

1. See e.g. P.M. Taylor, "Sikh Heritage at the Smithsonian," *Journal of Punjab Studies* 11, no. 2 (2004): 221–36; P.M. Taylor, "Introduction: Perspectives on the Punjab's Most Meaningful Heirlooms," in S. Singh and R. Singh, *Sikh Heritage: Ethos and Relics* (New Delhi: Rupa, 2012), viii-ix; P.M. Taylor, "Sikh Material Heritage and Sikh Social Practice in a Museum-Community Partnership: The Smithsonian's Sikh Heritage Project," Sikh Research Journal 1, no. 1 (Spring/Summer 2016); P.M. Taylor, "Exhibiting the Kapany Collection: Observations on the Transformation of Sikh Art and Material Culture in Museums," in P.M. Taylor and S. Dhami, eds., *Sikh Art from the Kapany Collection* (Palo Alto, Calif.: The Sikh Foundation, in association with the Asian Cultural History Program, Smithsonian Institution, 2017), 286–309; P.M. Taylor, and R. Pontsioen, *Sikhs: Legacy of the Punjab* (Washington D.C.: Asian Cultural History Program, Smithsonian Institution, 2014). P.M. Taylor and S. Dhami, eds., *Sikh Art from the Kapany Collection* (Palo Alto, Calif.: The Sikh Foundation, in association with the Asian Cultural History Program, Smithsonian Institution, 2017); R. Brar, *The Japji of Guru Nanak: A New Translation with Commentary* (Washington, D.C.: Asian Cultural History Program, Smithsonian Institution, 2019); P.M. Taylor, "Sikh Art and Devotion in the Collection of Parvinder S. Khanuja," *Arts of Asia* 49, no. 1 (January–February 2019): 107–116; P.M. Taylor, and S. Dhami, "Collecting the Arts of the Punjab: Art and Identity for the Sikh Diaspora in Singapore and Beyond." In press. To be published in: Tan Tai Yong, ed., *Sikhs in Singapore – A Story Untold* (Singapore: Indian Heritage Centre).

2. R. Brar, *The Japji of Guru Nanak: A New Translation with Commentary* (Washington, D.C.: Asian Cultural History Program, Smithsonian Institution, 2019).

3. On the topic of collecting artwork as an element of diasporic Sikh identity, see P.M. Taylor and S. Dhami, eds., *Sikh Art from the Kapany Collection* (Palo Alto, Calif.: The Sikh Foundation, in association with the Asian Cultural History Program, Smithsonian Institution, 2017); D. Toor, *In Pursuit of Empire: Treasures from the Toor Collection of Sikh Art* (London: KashiHouse, 2018); R. Singh, *The goddess: arms & armour of the Rajputs* (Coventry, England: Runjeet Singh, 2018); R. Singh, *Arms, Armour & Works of Art* (Coventry, England: Runjeet Singh, 2019); R. Singh, *Treasures from Asian armories* (Coventry, England: Runjeet Singh, 2019); P.M. Taylor and S. Dhami, "Collecting the Arts of the Punjab: Art and Identity for the Sikh Diaspora in Singapore and Beyond." In press. To be published in: Tan Tai Yong, ed., *Sikhs in Singapore – A Story Untold* (Singapore: Indian Heritage Centre). For example of recently published Sikh art collections and exhibitions, see B.N. Goswamy, *I See No Stranger: Early Sikh Art and Devotion* (Ocean Township, NJ: Rubin Museum of Art, 2006); S. Singh and R. Singh, *Sikh Heritage: Ethos and Relics* (New Delhi: Rupa, 2012); Susan Stronge, *The Arts of the Sikh Kingdoms* (New York: Weatherhill, 1999); P.M. Taylor and R. Pontsioen, *Sikhs: Legacy of the Punjab* (Washington D.C.: Asian Cultural History Program, Smithsonian Institution, 2014), C.M. Sethi, *Phulkari: The Embroidered Textiles of Punjab* (Philadelphia: Philadelphia Museum of Art, 2016).

4. This description of the Phoenix Art Museum's gallery and of Dr. Khanuja's background is taken from my earlier introduction to the Khanuja collection published in *Arts of Asia* (Taylor 2019).

5. P.M. Taylor, and R. Pontsioen, *Sikhs: Legacy of the Punjab* (Washington D.C.: Asian Cultural History Program, Smithsonian Institution, 2014), 56.

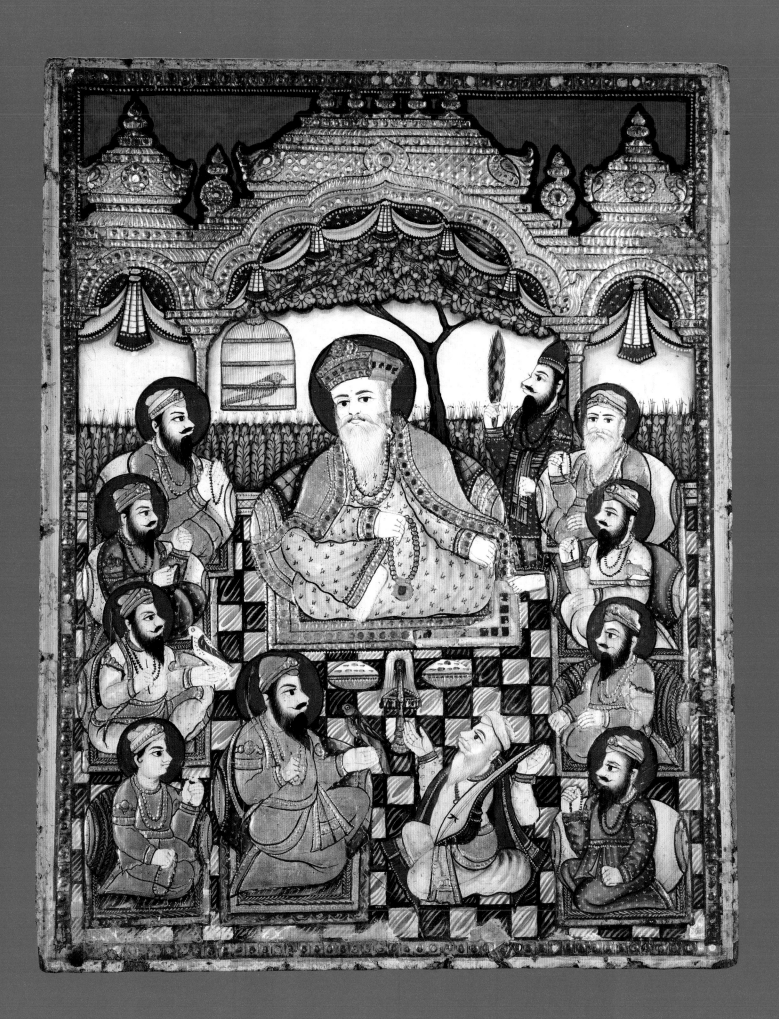

1

ONE AND THE SAME LIGHT: GURUS IN SIKHISM

"THE BENEFACTOR GIVER HEARD THE CRIES (OF HUMANITY) AND GURU NANAK WAS SENT TO THIS WORLD."[1]

Bhai Gurdas (Sikh Theologian)

Currently the fifth largest religion in the world with over 25 million followers, Sikhism's birth, history, and tenets are closely tied to the lives of its early spiritual leaders. The gurus were important institution builders who founded religious centers which expanded into townships and became experiments in egalitarian community life.

Sikhism's much-celebrated founder is GURU NANAK (1469–1539), born at Rai Talwandi, now known as Nankana Sahib, and situated in the Punjab province of Pakistan. An insight into the life and teachings of Guru Nanak can be acquired by delving into his writings and his *janamsakhis* (biographies). The compilers of these biographies strove to lend authenticity and historical credibility to the anecdotes pertaining to the life of the first guru by inserting quotations from the hymns of Guru Nanak and of his successors as found in the Sri Guru Granth Sahib, the holy scripture of Sikhism (henceforth SGGS). Many of these anecdotes attest to Guru Nanak's wise words along with miraculous happenings. A notable instance of the latter is an event that took place at Sultanpur Lodhi, where the first guru went for a morning bath in the Bein river. Guru Nanak reappeared three days later, after having an experience with the Divine, which has been aptly described by William Cole. He writes, "Guru Nanak's experience is regarded as one of commissioning rather than enlightenment; Sikhs consider him to have been born in a state of spiritual liberation."[2]

During his lifetime, Guru Nanak covered an extraordinary 20,000 miles, mostly on foot. He traveled to many parts of Asia and the Middle East. In the words of Janet Baker, "Guru Nanak Ji's life can be viewed as a testament to interfaith tolerance and spiritual oneness. His principles were revolutionary in the world of Hindu and Muslim India 500 years ago. In defiance of the caste system and social practices of his day, he declared that all people are equal; Hindu and Muslim, man and woman, rich or poor."[3]

Wherever Guru Nanak went, he established a community of devotees of the Divine. Believers gathered in communal hubs traditionally known as *dharamsals*, where they sang divine hymns and where food was prepared in the communal kitchens (*langar*). Guru Nanak created the ideal community of Kartarpur (in present-day Pakistan), where he spent the last eighteen years of his life. As Nikky G.K. Singh has noted, Guru Nanak also "set up the institutions of *sangat* (congregation), *seva* (selfless labor) and *langar* (community meal, kitchen) to foster the spirit of communitas."[4] He upheld the principle of equality of all persons, regardless of their background and caste. He instilled the ethics of sharing and inclusiveness. Guru Nanak also established the important tradition of *Gurmat Kirtan* (Sikh devotional hymns). His singing of revelations in certain melodies was based on classical musical traditions that enhanced the message and the feelings therein.

Guru Nanak's respect for the glory of the natural world and the beauty of the cosmos reflected his reverence for the all-pervasive spirit of the Divine and nature. This is well expressed in the verse, "Air is the Guru, Water is the Father, and Earth is the Great Mother of all…." (SGGS p. 1021).

On the aspect of equality, "the idealistic approach to Sikhism is to recognize the *existence* of the same heavenly Light in every human being."[5] As an activist, Guru Nanak spread the message of equality, especially when it came to women:

1. The ten gurus

Artist unknown | *c.* Late 19th century | 26 x 21 in | Panel painting on wooden plank

The ten gurus are portrayed in a typical Thanjavur style painting, a popular art form from southern India made up of rich and vibrant colors with glittering gold overlaid on delicate but extensive gesso work. The paintings are also embedded with glass beads and pieces or precious gemstones.

We are born of woman, we are conceived in the womb of woman, we are engaged and married to woman…Why should we talk ill of her, who gives birth to kings? The woman is born from woman; there is none without her (SGGS p. 473).

Guru Nanak is fondly remembered as Baba Nanak Shah Fakir, Hindu ka Guru, Musalman ka Pir, suggesting that he belonged equally to Muslims and Hindus and was revered by both.

Nine other human gurus succeeded Guru Nanak. The gurus were institution builders. They founded townships that became centers for congregations of followers of the Divine and for ideal citizens.

The second guru, GURU ANGAD (1504–52), opened schools in Khadur Sahib, a city he graced with his presence, and he formalized the Gurmukhi script, which was used to write the hymns through these institutions. At the same time his wife, Mata Khivi, strengthened the institution of *langar*.

The third guru, GURU AMARDAS (1479–1574), developed the city of Goindval and, as Sikhs grew in numbers, he organized distant congregations into administrative units known as *manjis*. Preachers were appointed for the *manjis* and amongst them there were women as well. He also formalized the concept of *langar*, which propagated equality and a feeling of community as everyone sat together to have their meals. Guru Amardas emphasized the importance of equal rights for women, encouraged widows to re-marry, spoke against *sati* (the burning to death of a widow), and discouraged *purdah* (the covering of women's face with a veil).

The fourth guru, GURU RAM DAS (1534–81), is especially known for his humility. He founded the town of Ramdaspur, which later became the holy city of Amritsar and further strengthened the *manji* system.

The fifth guru, GURU ARJAN (1563–1606), epitomized service and self-sacrifice. He had Mian Mir, a Muslim saint, lay the foundation of the Golden Temple (Harmandir Sahib or Abode of the Divine). The Golden Temple was built in the middle of a *sarovar* (a body of sacred water). The city of Amritsar grew rapidly during this time and became a major congregation center and a commercial hub. Guru Arjan is also known for laying the foundation of the city of Taran Taran and for developing another town, Kartarpur, in the Jalandhar Doab. He redeveloped the ruins of Ruhela village, which was renamed Gobindpur and subsequently Hargobindpur.

Guru Arjan was responsible for the initial compilation in 1604 of the Adi Granth, the principal holy scripture of Sikhism. This sacred book included a selection of devotional hymns composed by the first five gurus, along with verses by other Hindu and Muslim saints. These saints were from different regions and belonged to different castes, but their teachings were in concordance with the praise of the Divine. This further propagated the idea of Sikhism as a universal religion devoid of idol worship and superstitions. It put forward the ideology of believing in equality and of maintaining a balance between renunciation and worldliness. Guru Arjan promoted the message that "truth is the highest virtue, but higher still is truthful living" (SGGS p. 62).

During this period, the Sikh population increased dramatically and Sikhs could be seen in all the major towns. But the Mughal Emperor Jehangir did not take to this too kindly. He arrested and tortured Guru Arjan, who became the first martyr-guru. According to Max Arthur Macauliffe, Guru Arjan uttered the following words to his friend Mian Mir: "I bear all this torture to set an example to the teachers of the True Name, that they may not lose patience or rail at God in affliction."[6]

The sixth guru, GURU HARGOBIND (1595–1644), embodied sovereignty, liberty, and justice. He adorned himself with two swords representing temporal power (*miri*) and spiritual authority (*piri*). He also established a fighting force as a defensive measure in the face of increasing threats. Writing about Guru Hargobind, historian Hari Ram Gupta noted that "in front of Hari Mandar he constructed in 1606 Akal Takhat… Hari Mandar was the seat of his spiritual authority and Akal Takhat the seat of his temporal authority."[7] He also founded the cities of Kiratpur and Hargobindpur, where he built a mosque, Guru ki Maseet, for its Muslim inhabitants.

2. Guru Nanak

Artist unknown | *c.* Late 19th century | 17.5 x 12 in | Gouache on paper

Guru Nanak, the founder of the Sikh religion painted in a contemplative style. He is wearing a holy robe (*chola sahib*), *silliee topi*, and holding beads of meditation. As the first guru of Sikhism, Guru Nanak led a life that exemplified a fine balance between meditative worship and righteous living.

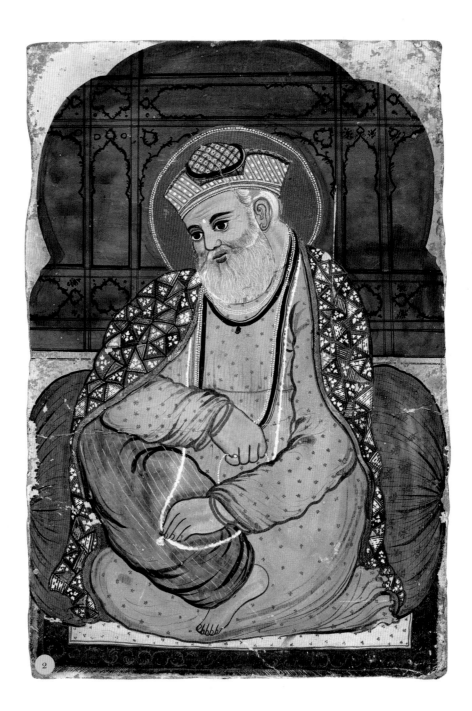

The seventh guru, GURU HAR RAI (1630–61), is acclaimed for his environmental work and for the development of indigenous medicines. He shared a rare medicine with Emperor Shah Jahan for the treatment of his son, Prince Dara Shukoh. Guru Har Rai also worked toward expanding multiple congregation centers in eastern India, Kabul, Dhaka, and Multan, while establishing important preaching missions.

The eighth guru, GURU HAR KRISHAN (1656–64), is celebrated for his clarity of purpose, love for humanity, and diplomacy. He served the smallpox-ridden population of Delhi and briefly graced the cities of Kiratpur and Delhi with his presence.

The ninth guru, GURU TEGH BAHADUR (1621–75), exemplified composure, diplomacy, and self-sacrifice. He established the city of Chak Nanki at Makhowal. The previous gurus had also established multiple cities in Punjab that continue to flourish to this day. Guru Tegh Bahadur travelled widely all over India to meet various congregations and spread the word of *naam*. As Patwant Singh noted,

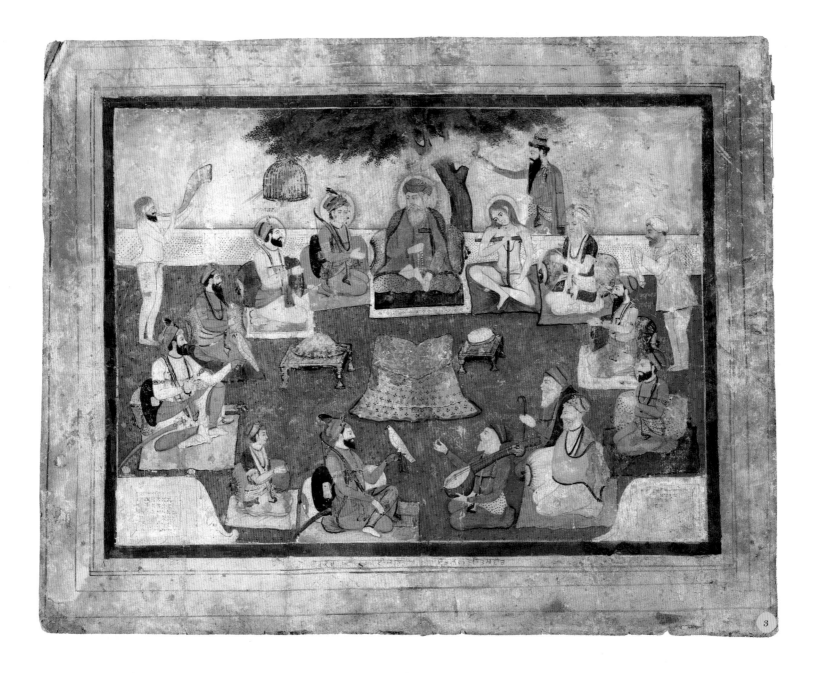

Guru Nanak Ji used three key terms to describe the nature of divine revelation in its totality from the Sikh perspective: Naam (Divine name), Shabad (Divine word), Guru (Divine preceptor). Naam refers to the divine presence that is manifest everywhere around and within us.[8]

Guru Tegh Bahadur lived through a time of extreme religious intolerance practised by the Mughal rulers. As described by Patwant Singh in his *Empire of the Sikhs*,

after the delegation from Kashmir had described in detail the forcible conversions, atrocities and other humiliations Hindus were suffering... Guru Tegh Bahadhur Ji, after long and careful thought, offered to inform the emperor that if he could make him convert to Islam, the Kashmiri Pandits too would follow suit.[9]

He was subsequently tortured along with his companions, but he held on to his faith unwaveringly.

Guru Tegh Bahadur is also known as Hind di Chadhar (The cloth covering India) to indicate the role he played in protecting the country. His compositions strove to portray fearlessness during unsettling times. For instance, one of his verses states, "He who holds none in fear, nor is afraid of anyone, is acknowledged as a man of true wisdom" (SGGS p. 1427). His martyrdom was central to the advancement of human rights as he stood for righteousness and sacrificed his life to allow people from another religion to freely practice their faith. Arguably, there is no parallel to this anywhere in the history of the world.

The tenth guru, GURU GOBIND SINGH (1666–1708), personified visionary leadership, courage, and justice. He expanded the city of Chak Nanki and renamed it Anandpur Sahib (Abode of Bliss). He was a patron of literature and had fifty-two poets in his congregation. Guru Gobind Singh also founded the city of Paonta. This was an age of holy conflict, and the tenth guru was involved in multiple battles for defensive purposes.

Guru Gobind Singh formalized the practice of baptism and created the Khalsa (literally meaning pure). This was a seminal event that, in the words of writer Khushwant Singh, allowed Guru Gobind to "train the sparrow to hunt the hawk and one man to fight the legion."[10] During the ceremony the guru mixed sugar with water and churned it with a double-edged dagger to the recitation of hymns. There were initially five persons who participated in the baptism ceremony, and each one of them was from a different Hindu caste and region of India. All five of them drank out of one bowl, signifying their initiation into the casteless fraternity of the Khalsa. In the following weeks, thousands took part in this ceremony.

The concept of Khalsa propagated the idea of egalitarianism, and in the words of Balwant Singh Dhillon, "the institution of the Khalsa reinforced the ideal of equality enunciated by Guru Nanak."[11] Additionally, as Louis E. Fenech states, "warriors who out of love for Akal Purakh and fellow beings, battle and die to destroy tyranny, protect the poor and establish social harmony."[12] The concept was not completely new. As Jaswant Singh Grewal has noted, "the Khalsa do not represent a new order; they are a continuation of the Sikh Panth instituted by Guru Nanak and nurtured by his successors."[13] The belief was for righteousness and, as observed by Hari Ram Gupta, "Guru Gobind Singh did not proclaim himself a ruler. He conquered no lands. He was a saint soldier."[14]

The creation of the Khalsa was an act of equality, brotherhood, and genuine democracy. In the words of Nikky G.K. Singh, it was the "Guru's radical enactment of the principle of equality… [and] was intended for both genders."[15] William Hewat Mcleod has also noted how "the Khalsa was resolutely to uphold justice and to oppose only that which is evil."[16] In the decision to become a member of the Khalsa by baptism, one voluntarily surrenders himself or herself to the guru, indicating a continuous effort to live according to the guru's wisdom. In many ways, the journey of life only begins with this act of humble submission. While stressing the concern for all mankind, Guru Gobind Singh said, "All human beings are the reflection of one and the same Lord. Recognize ye the whole human race as one."[17]

Guru Gobind Singh compiled the Sri Guru Granth Sahib in its final form at Damdama Sahib in 1705. He invested the holy scripture with the status of "Eternal Guru" and made it his official successor at the time of his death in 1708. The human gurus left us with a universal religion that aims at spreading the message of oneness.

Bhai Gurdas, a famous Sikh theologian and the scribe of the Adi Granth, wrote that "as a lamp lights another lamp, with the light (of Guru Nanak), the flame (of Guru Angad) has been lit."[18] This indicates that the guruship is like a flame that continues to burn as it passes from one guru to the next and that it now resides in the Sri Guru Granth Sahib. We are privileged to present some paintings of the gurus and of occurrences associated with their lives. We also want to emphatically state that the representations of the gurus are the artists' depictions and should by no means be considered as objects to be worshipped.

REFERENCES & NOTES

1. B. Gurdas, "Bhai Gurdas Vaaran (Vaar 1, Pauri 23)," Search Gurbani, accessed on August 11th, 2021. https://www.searchgurbani.com/bhai-gurdas-vaaran/vaar/1/pauri/23/line/1

2. W.O. Cole, "Sikh Interactions with Other Religions," in *The Oxford Handbook of Sikh Studies*, eds. P. Singh and L.E. Fenech (Oxford: Oxford University Press, 2014), 251.

3. J. Baker, "Guru Nanak: 550th birth anniversary of Sikhism's founder," *Sikh Formations* 15, nos. 3–4 (2019): 495–515.

4. N.G.K. Singh, *The First Sikh: The Life and Legacy of Guru Nanak* (New Delhi: Penguin Random House, 2019), 61.

5. Sikh Missionary Center, *Sikh Religion* (Ann Arbor: Braun-Brumfield, 1990), 3.

6. M.A. Macauliffe, *The Sikh Religion: Its Gurus, Sacred Writings and Authors*, vol. 3 (London: Oxford Press, 1909), 94.

7. H.R. Gupta, *History of the Sikhs*, vol. 1 (New Delhi: Munshiram Manoharlal Publishers Pvt. Ltd., 2008), 157.

8. P. Singh, "*Gurmat*: The Teachings of the Gurus", in *The Oxford Handbook of Sikh Studies*, eds. P. Singh and L.E. Fenech (Oxford: Oxford University Press, 2014), 231.

9. P. Singh and J.M. Rai, *Empire of the Sikhs: The Life and Times of Maharaja Ranjit Singh* (New Delhi: Hay House India, 2008), 58.

10. K. Singh, *A History of the Sikhs (1469–1839)*, vol. 1 (New Delhi: Oxford University Press, 1999), 89.

11. B.S. Dhillon, "From Guru Har Gobind to Guru Gobind Singh," in *Brill's Encyclopedia of Sikhism*, eds. K.A. Jacobsen et al. (Boston: Brill, 2017), 43.

12. L.E. Fenech, *Martyrdom in the Sikh Tradition* (New Delhi: Oxford University Press, 2000), 89.

13. J.S. Grewal, *Four Centuries of Sikh Tradition* (New Delhi: Oxford University Press, 2011), 185.

14. H.R. Gupta, *History of Sikhs*, vol. 1 (New Delhi: Munshiram Manoharlal Publishers Pvt. Ltd., 2008), 336.

15. N.G.K. Singh, *The Birth of the Khalsa: A Feminist Re-memory of Sikh Identity* (New York: State University of New York Press, 2005), 39.

16. W.H. McLeod, *Sikhism* (New Delhi: Penguin Books, 1997), 105.

17. "The Saint-Soldier (Guru Gobind Singh): Extracts from Guru Gobind Singh's Writings," Sikh Missionary Society, accessed on August 12th, 2021. https://www.sikhmissionarysociety.org/sms/smspublications/thesaintsoldier/chapter16/

18. B. Gurdas, "Bhai Gurdas Vaaran (Vaar 23, Pauri 8)," Search Gurbani, accessed on August 22nd, 2021. https://www.searchgurbani.com/bhai-gurdas-vaaran/vaar/24/pauri/8/line/1

4. The ten gurus

Artist unknown | *c.* 19th century | 11.25 x 9 in | Gouache on paper

This painting is unusual in its style as the gurus are painted in an odd-even sequence, left to right rather than clockwise or anti-clockwise. With Guru Nanak sitting in the center, also seen in the painting are Bhai Bala, reverently standing on the right with a peacock-feather whisk and Bhai Mardana sitting below and playing his *rabab*.

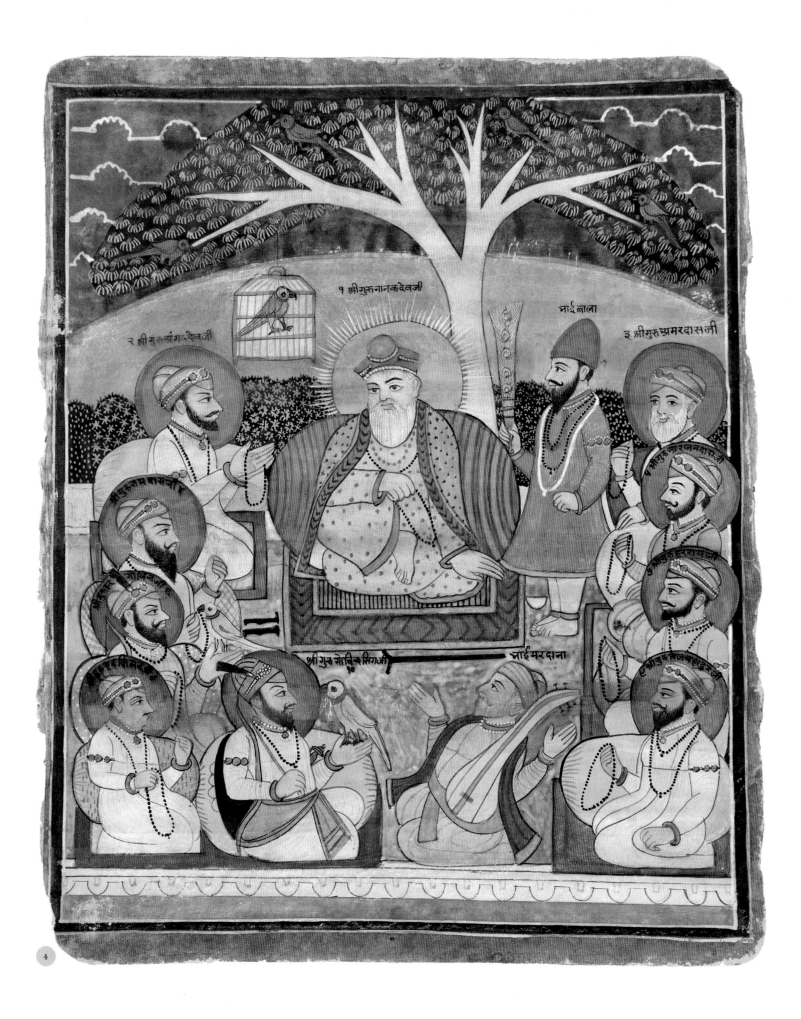

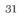

31

BABA NANAK
SHAH FAKIR

Guru Nanak is often seen with his two spiritual companions, Bhai Bala and Bhai Mardana. Together they represent the interfaith ethos of Sikhism.

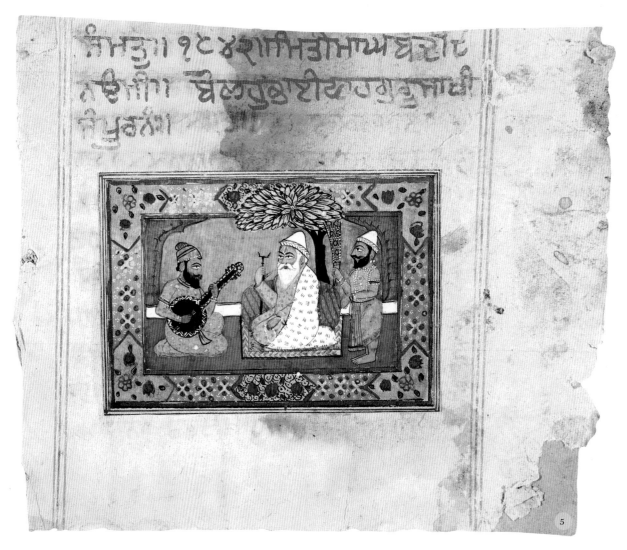

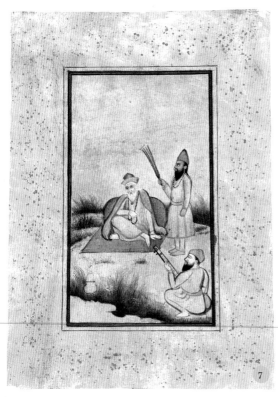

5. Guru Nanak with his
companions, Bhai Bala
and Bhai Mardana

Artist unknown | *c.* 1785 |
4.2 x 2.8 in | Ink on paper

6. Guru Nanak in a
mountainous forest

Artist unknown | 18th century |
12 x 10 in | Watercolor on paper

7. Guru Nanak with Bhai Bala and
Bhai Mardana

Artist unknown | *c.* Late 18th century |
11 x 8.5 in | Gouache and gold dust
on paper

8. Guru Nanak with Bhai Mardana
playing a *rabab*

Artist unknown | *c.* 1780–1800 |
9 x 5.5 in | Watercolor on paper

9. Guru Nanak with Bhai Bala
holding a fly whisk

Artist unknown | *c.* 1790–1820 |
6.5 x 4.8 in | Watercolor on paper

34

10. Guru Nanak in Mecca

Artist unknown | *c.* Late 18th century |
9 x 6 in | Gouache on paper

Baba Nanak is seen lying down to
rest with his feet pointed towards the
Kaaba, considered by Muslims to be
the house of God. As per stories from
Nanak's life and travels mentioned
in *janamsakhis*, when he is asked to
move his feet he suggests politely to
turn them in the direction where God
does not dwell.

11. Guru Nanak takes charge at *modikhana*, a granary store at Sultanpur

Artist unknown | *c.* Late 19th century |
9 x 7 in | Gouache on paper

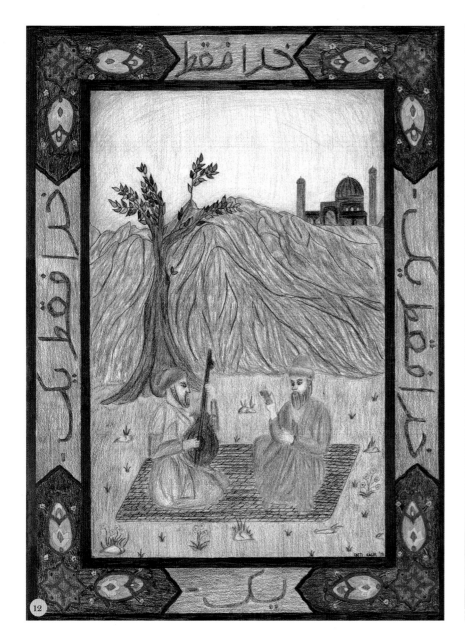

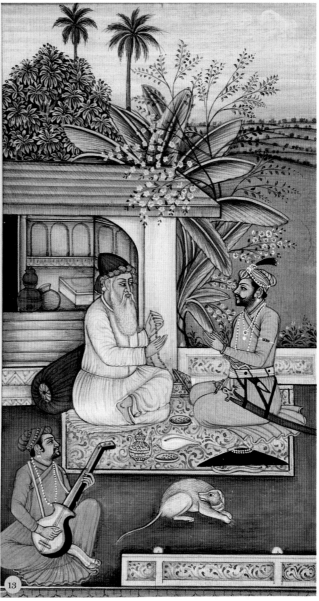

12. Guru Nanak in Tibet, in discussion with an ascetic

Datti Kaur | 2019 | 30 x 22 in | Color pencil on paper

Guru Nanak is said to have visited Tibet more than once. His visit to Mount Kailash is described in the *janamsakhis*.

13. Guru Nanak with Raja Shivnabh of Sri Lanka

Artist unknown | *c.* 1895 | 10 x 6.5 in | Gouache on paper

The raja of Sri Lanka had waited patiently to see the guru for many years. Bhai Mardana can be seen playing his *rabab*.

36

14. Guru Nanak with a Brahmin in discussion

Artist unknown | *c.* Early 19th century | 8.5 x 6.5 in | Watercolor on paper

15. Guru Nanak with a Hindu priest who is listening to him with folded hands

Artist unknown | *c.* 19th century | 8.25 x 7 in | Gouache on paper

16. Guru Nanak with Bhai Mardana playing his *rabab* and Bhai Bala with *chaur sahib* standing behind the guru

Artist unknown | *c.* Early 19th century | 9.5 x 7.5 in | Gouache on paper

Guru Nanak spread the message of universal humanism and laid the foundation for an equal and compassionate society.

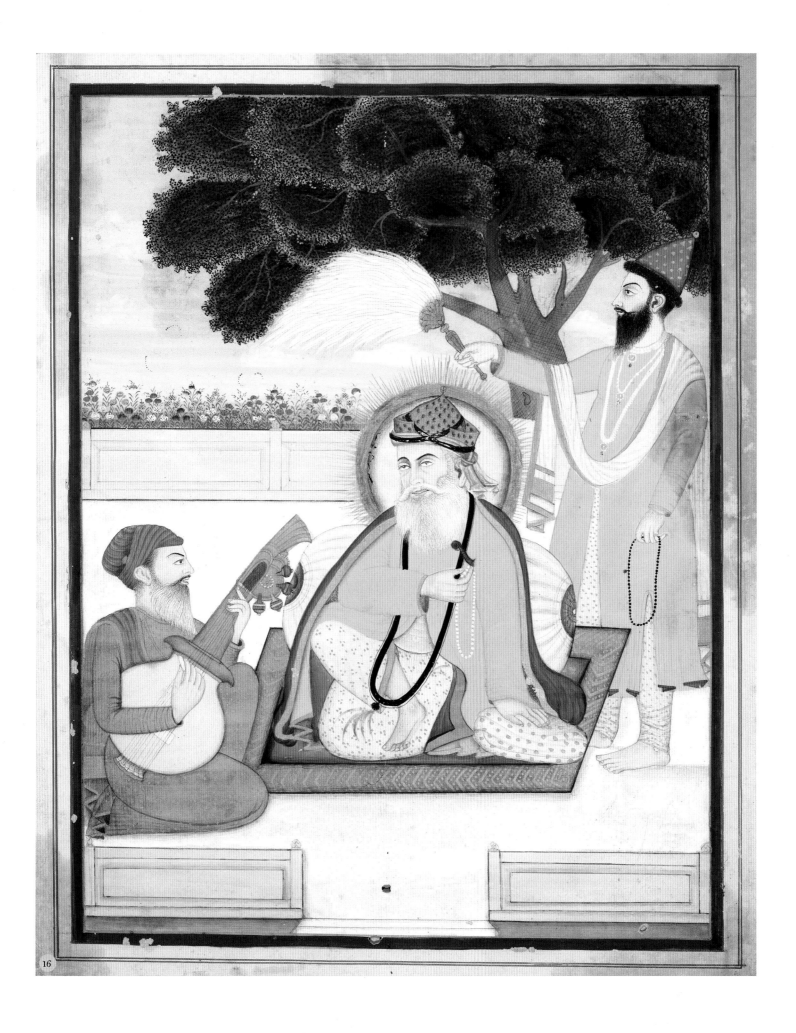

PAINTING THE GURUS

Indian artists often turned to epics and religious texts and created miniatures to transform words into a visual reality.

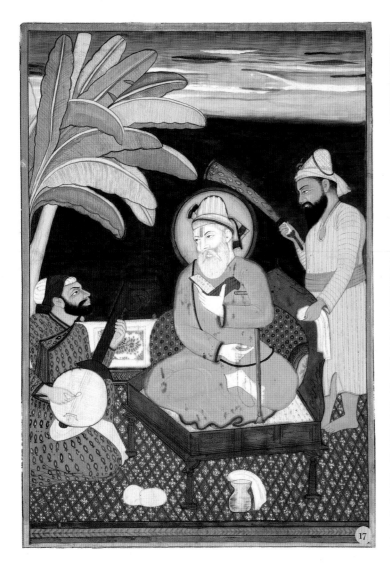

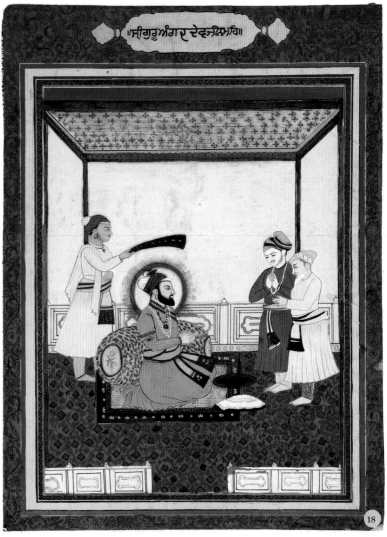

17. Guru Nanak with his
companions Bhai Bala and
Bhai Mardana

Artist unknown | 19th century |
21.5 x 15 in | Gouache on paper

18. Guru Angad Dev
(second guru)

Artist unknown | 19th century |
18 x 13.5 in | Gouache on paper

19. Guru Amardas
(third guru)

Artist unknown | 19th century |
17 x 13 in | Gouache on paper

20. Guru Ram Das
(fourth guru)

Artist unknown | 19th century |
19 x 13.75 in | Gouache on paper

21. Guru Arjan Dev
(fifth guru)

Artist unknown | 19th century |
17.5 x 13.5 in | Gouache on paper

22. Guru Hargobind
(sixth guru)

Artist unknown | 19th century |
16 x 12 in | Gouache on paper

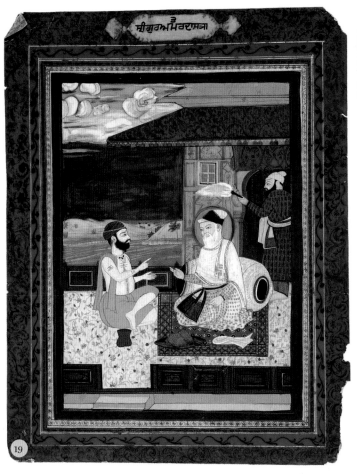

ਸ੍ਰੀਗੁਰੂਅਮਰਦਾਸਤਾ

19

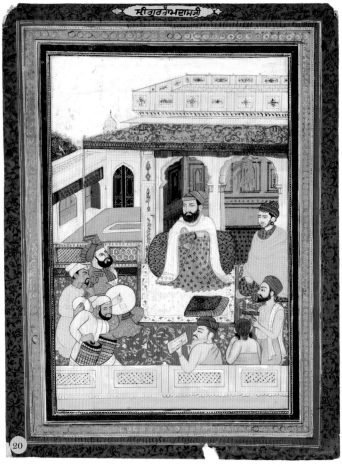

ਸ੍ਰੀਗੁਰੂਰਾਮਦਾਸਜੀ

20

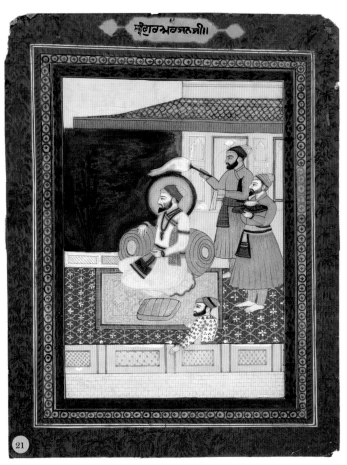

ਸ੍ਰੀਗੁਰੂਅਰਜਨਜੀ॥

21

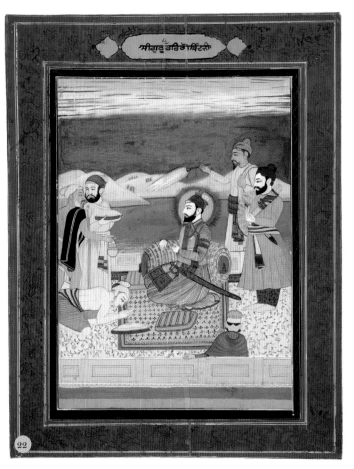

ਸ੍ਰੀਗੁਰੂ ਹਰਿਗੋਬਿੰਦਜੀ

22

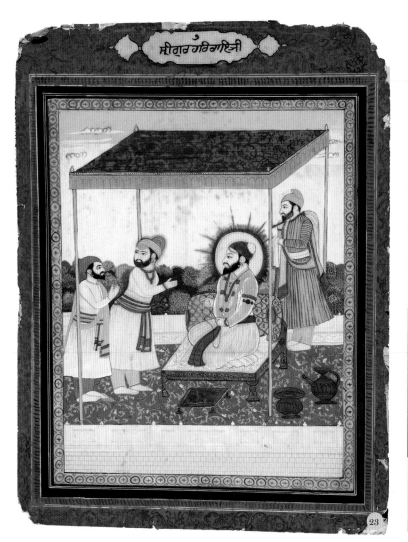

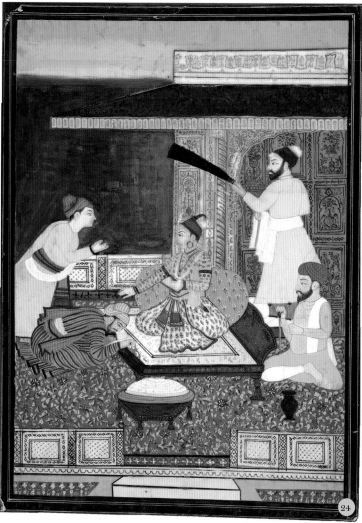

40

23. Guru Har Rai
(seventh guru)

Artist unknown | 19th century |
18.5 x 15 in | Gouache on paper

24. Guru Har Krishan
(eighth guru)

Artist unknown | 19th century |
20.5 x 15 in | Gouache on paper

25. Guru Tegh Bahadur
(ninth guru)

Artist unknown | 19th century |
16.75 x 11.75 in | Gouache on paper

26. Guru Gobind Singh
(tenth guru)

Artist unknown | 19th century |
16 x 12.5 in | Gouache on paper

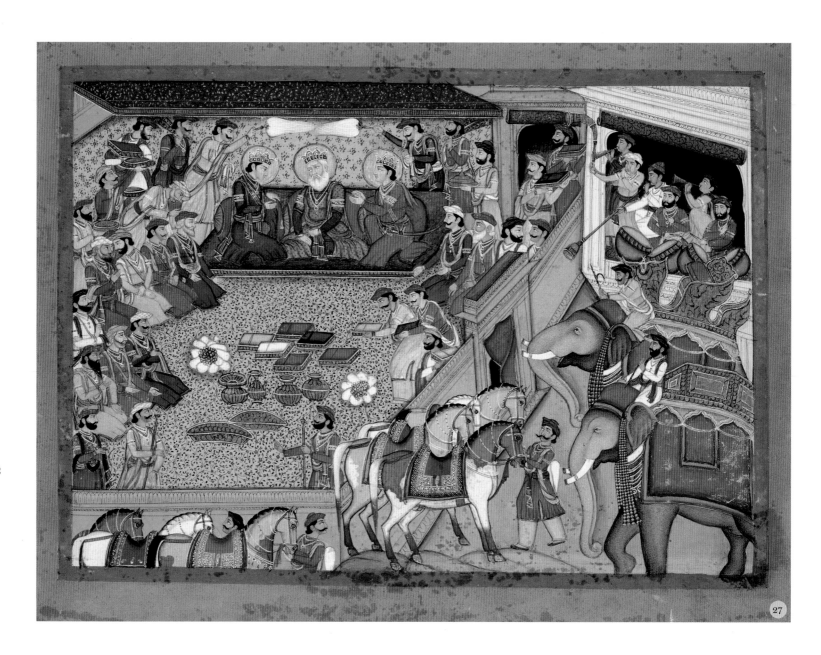

27

27. Guru Nanak with possibly his two sons or divinities

Artist unknown | 19th century |
10 x 14 in | Gouache on paper

An unusual painting of Guru Nanak
with his two sons or other divinities.
The range of persons present, the gifts
being brought and laid out, the music
being played, and the elephants
and horses in waiting are fit for
an emperor.

JANAMSAKHIS

Janamsakhis are narratives about Guru Nanak's birth and life. These were generally oral accounts which were written down and illustrated after he passed away. Various *janamsakhis* were produced in different regions and periods.

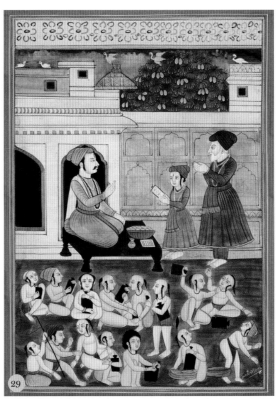

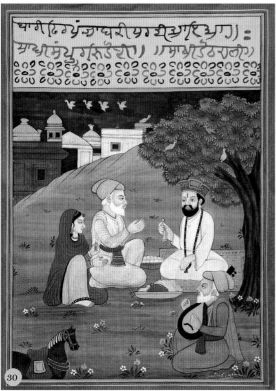

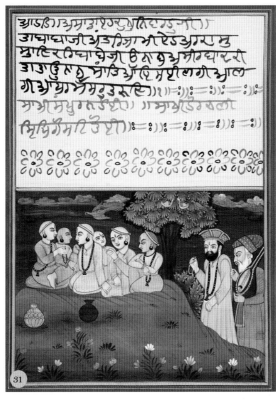

28. Guru Nanak's discourse with a physician

Artist unknown | 20th century |
11.2 x 8.2 in | Gouache on paper

29. Guru Nanak receives instructions from his teacher

Artist unknown | 20th century |
11.2 x 8 in | Gouache on paper

30. Guru Nanak with his parents, mother Tripta and father Kalu

Artist unknown | 20th century |
11.2 x 8.2 in | Gouache on paper

31. Guru Nanak at Mount Sumeru

Artist unknown | 20th century |
11.2 x 8.2 in | Gouache on paper

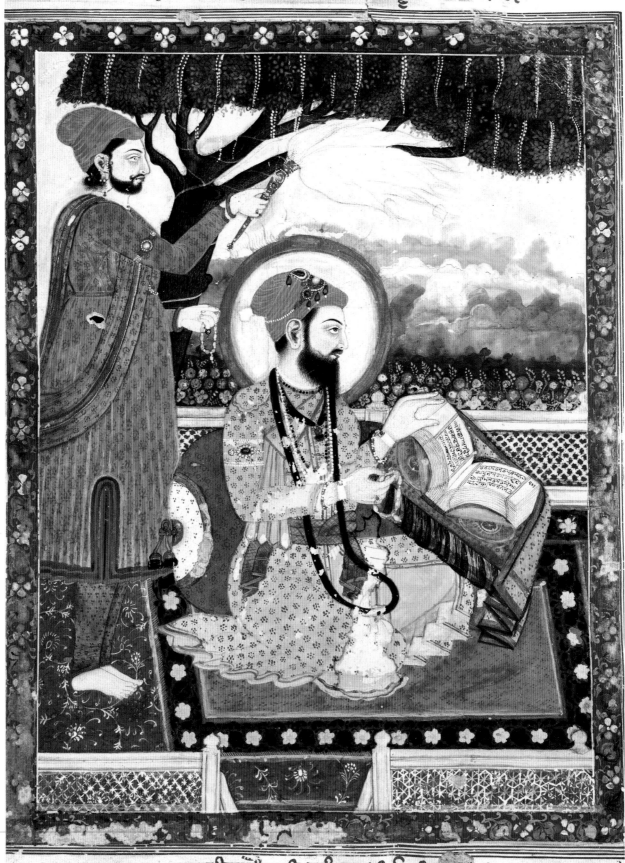

44

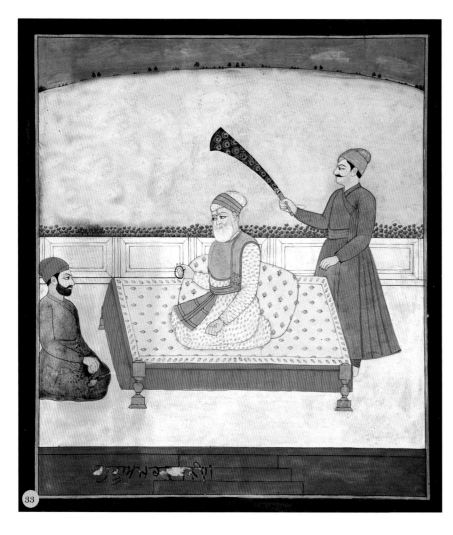

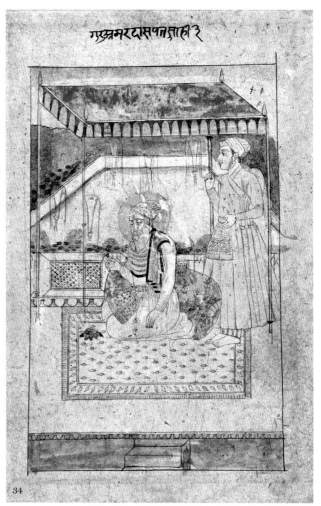

गुरूरूअमरदासपनशाही ३

33

34

32. Guru Angad Dev reading the sacred verses

Artist unknown | *c.* 1874 |
11 x 8 in | Gouache on paper

Guru Angad, the second guru was named Lehna. He served and worked with Guru Nanak, who gave him the name Angad ("my own limb/body"), and chose him as the second Sikh guru.

33. Guru Amardas with a devotee

Artist unknown | *c.* Late 1800s |
9.8 x 10.5 in | Gouache on paper

34. Guru Amardas seated beneath a canopy with an inscription on top of the painting in Nagari script which reads, "Guru Amar Das Patshahi 3"

Artist unknown | *c.* First half of
18th century | 9.5 x 6.5 in |
Watercolor on paper

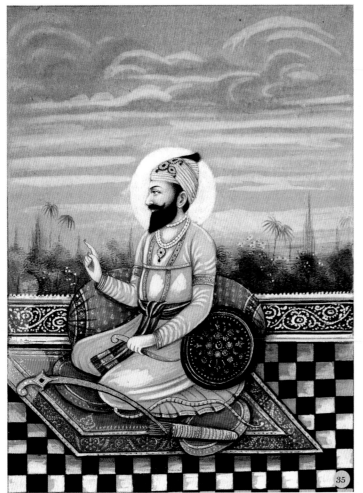

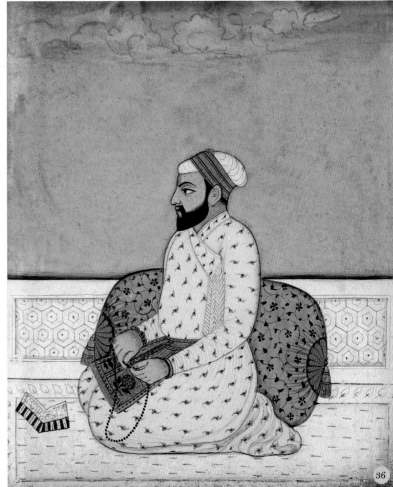

46

35. Guru Arjan Dev

Artist unknown | 19th century |
8.6 x 6.25 in | Gouache on paper

36. Guru Arjan Dev

Artist unknown | *c.* Early 19th century |
4.5 x 3.75 in | Gouache on paper

37. Guru Hargobind standing armed with sword, shield, bow and a quiver of arrows

Artist unknown | *c.* Mid-18th century |
9.25 x 6.25 in | Gouache and gold dust on paper

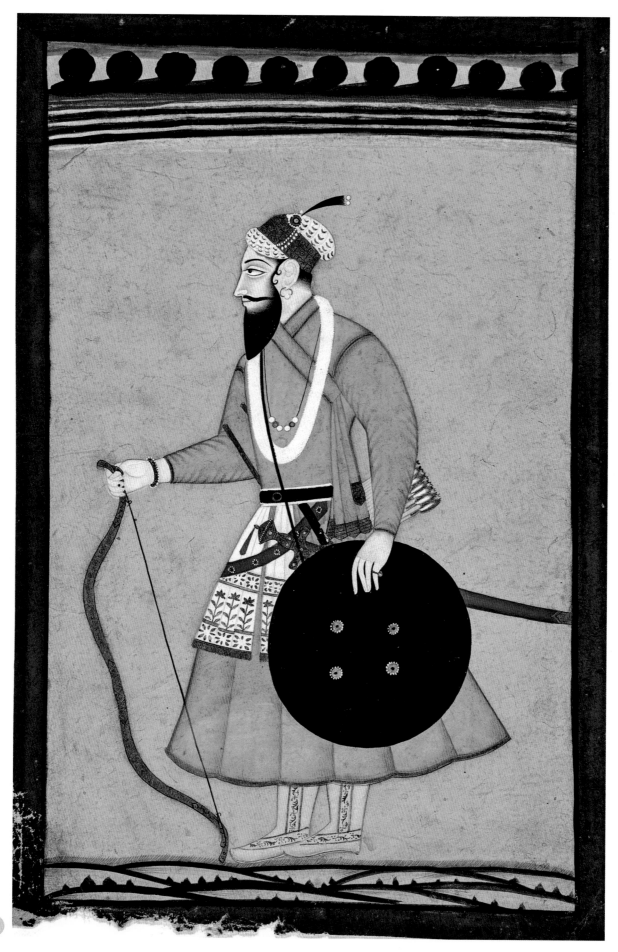

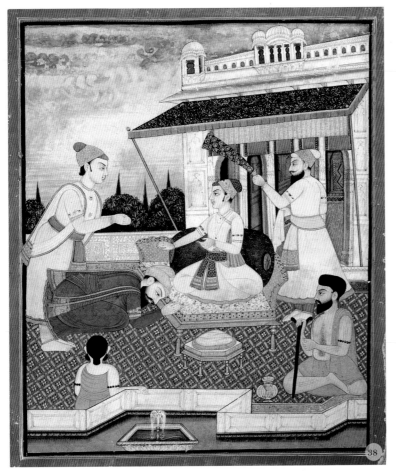

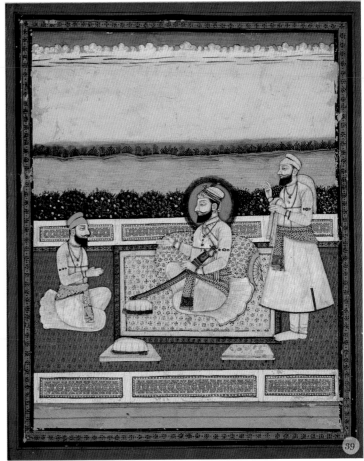

48

38. Guru Har Krishan

Artist unknown | *c.* Early 19th century | 13 x 11.5 in | Ink and color on paper

The young Guru Har Krishan blessing and receiving attendees and devotees in a serene royal surrounding.

39. Guru Gobind Singh with attendants

Artist unknown | *c.* 1830s | 10 x 8.5 in | Watercolor

A divine messenger, a warrior, a poet, and a philosopher, Guru Gobind Singh molded the Sikh religion into its present shape, with the institution of Khalsa, and the completion of the Sri Guru Granth Sahib in its final form.

40. Guru Gobind Singh with an attendant

Artist unknown | *c.* 1800–20 | 8.5 x 6.2 in | Gouache and gold dust

Also called the "emperor-prophet," Guru Gobind Singh is depicted in this Guler-Pahari style painting wearing regal clothes, riding a horse, while an attendant is holding an umbrella over his head.

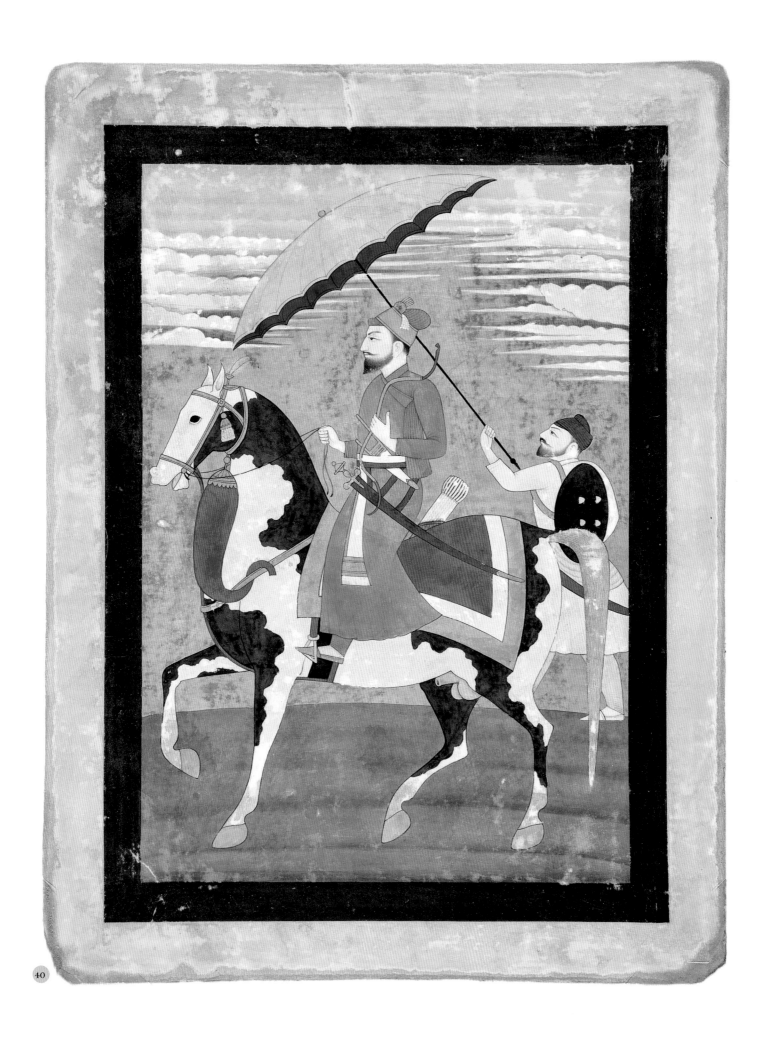

41. Guru Hargobind (preparatory sketch)

Artist unknown | Punjab, 19th century | Pencil on paper

A horse being presented to Guru Hargobind. This scene is most likely related to the story of Bidhi Chand.

42. Guru Tegh Bahadur (preparatory sketch)

Artist unknown | 18th century | 5.8 x 3.8 in | Pencil on paper

A drawing depicting Guru Tegh Bahadur seated against a bolster.

43. Guru Gobind Singh on horseback, shooting an arrow (preparatory sketch)

Artist unknown | c. 1850s | 11.5 x 8.2 in | Pencil on paper

44. Guru Gobind Singh with attendants (preparatory sketch)

Artist unknown | 19th century | 11 x 8 in | Pencil on paper

42

43

44

PAINTING EPISODES FROM THE GURUS' LIVES

Devender Singh, a contemporary artist based in India, transforms episodes from Sikh religious history into delightful compositions.

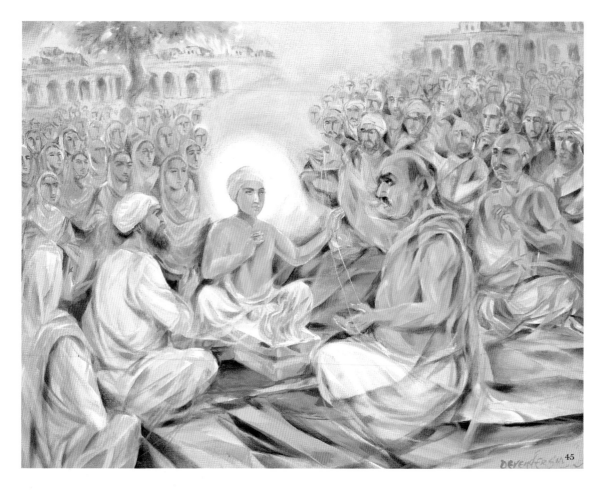

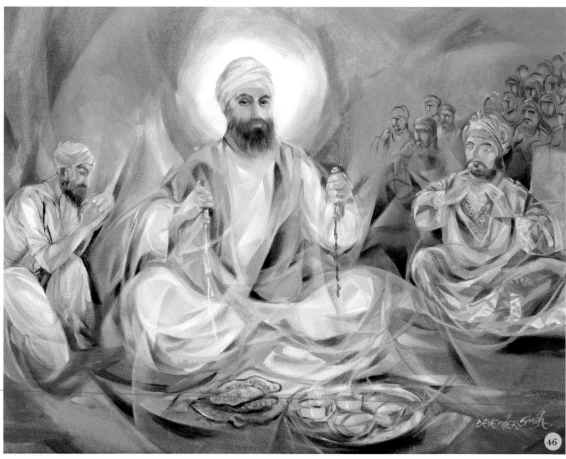

52

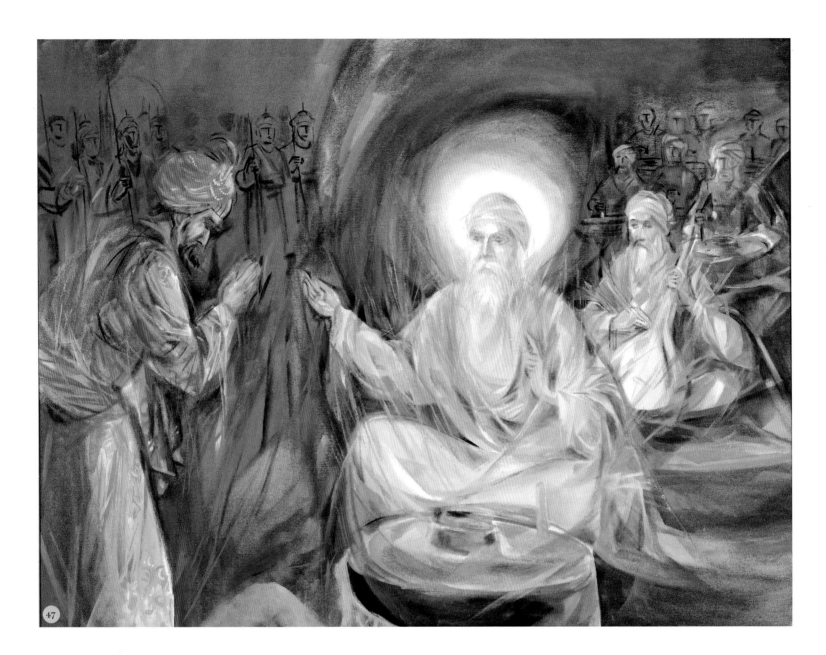

45. Guru Nanak and the sacred thread

Devender Singh | 2018 | 35.5 x 45.5 in | Oil on canvas

Guru Nanak at the age of nine refused to wear the sacred thread, or *janeu*, which according to Hindu tradition would define his high social status. As the Hindu priest presented the thread, young Nanak caught the thread with his hand in protest and reasoned that it is only by adoring and praising the Divine's name that honor and a true thread are obtained. He rejected using rituals and objects to worship the Divine.

46. Guru Nanak and Bhai Lalo the carpenter

Devender Singh | 2018 | 35.5 x 45.5 in | Oil on canvas

Guru Nanak, upon his visit to Saidpur in Punjab chose to stay at the house of a lowly and honest carpenter, Bhai Lalo, over the rich and wealthy, Malik Bhago. When the latter approached for explanations, Guru Nanak squeezed the bread he had received from both men. Milk, a symbol of honest labor, came out of Bhai Lalo's bread. Malik Bhago's bread instead oozed blood, a symbol of ill-gotten wealth.

47. Babur asking for Guru Nanak's forgiveness

Devender Singh | 2018 | 35.5 x 45.5 in | Oil on canvas

The Mughal troops under Babur sacked Saidpur in Punjab, and Guru Nanak and his companions were imprisoned. When the guru was forced to grind corn, the grinding stone moved on its own, while he meditated and sang hymns. Babur, on hearing of this miracle, asked for forgiveness. Guru Nanak's advice was to be just to all. He also urged the emperor to be merciful and forgive others.

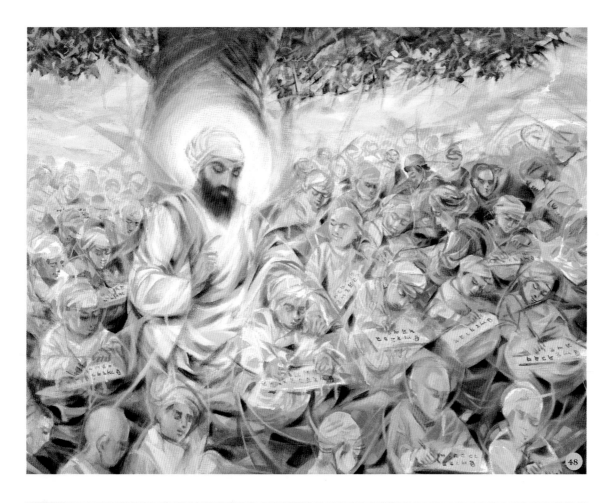

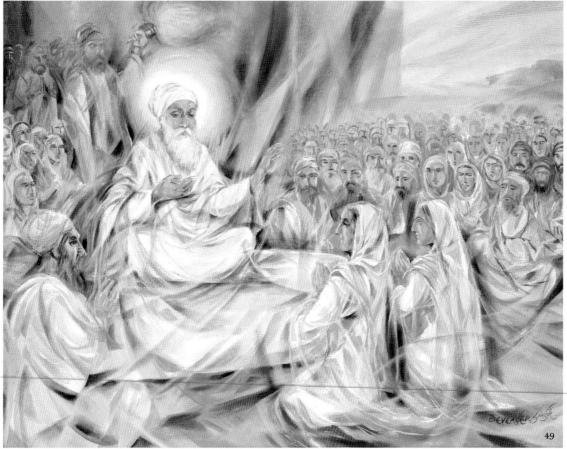

54

48. Guru Angad teaching Gurmukhi

Devender Singh | 2018 |
35.5 x 45.5 in | Oil on canvas

Guru Angad formalizing and teaching the Gurmukhi script in which the hymns of the gurus are recorded. Gurmukhi, literally meaning "from the mouth of the guru," also gave the common people a language to learn, write and read the guru's *bani*.

49. Guru Amardas with preachers

Devender Singh | 2018 |
35.5 x 45.5 in | Oil on canvas

Guru Amardas established twenty-two *manjis* or Sikh educational centers to spread the message of the guru. The word *manji* refers to the low wooden cots on which the Sikh preachers would sit and teach the guru's doctrines and principles to their *sangats* and sing hymns of divine devotion with the congregation.

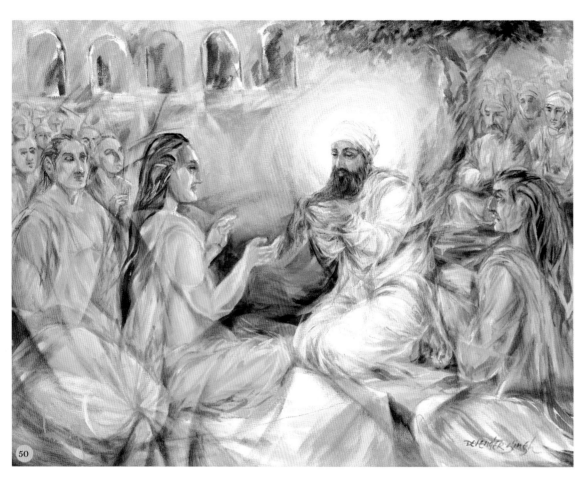

50. Guru Ram Das meets Baba Sri Chand

Devender Singh | 2018 |
35.5 x 45.5 in (with frame) |
Oil on canvas

This painting illustrates the extreme humility of Guru Ram Das. Upon his visit to Guru Ram Das, Baba Sri Chand, the elder son of Guru Nanak remarked on the extremely long beard of the guru. The guru said that he had grown it long so as to wipe the dust off the feet of holy men such as Baba Sri Chand.

51. Emperor Akbar having *langar* before his meeting with Guru Ram Das

Devender Singh | 2018 |
35.5 x 45.5 in | Oil on canvas

Emperor Akbar partakes food at the *langar* of Guru Ram Das. It was made mandatory for anyone who wished to meet the guru to have a meal with the rich and poor of different caste, class or gender to instill equality.

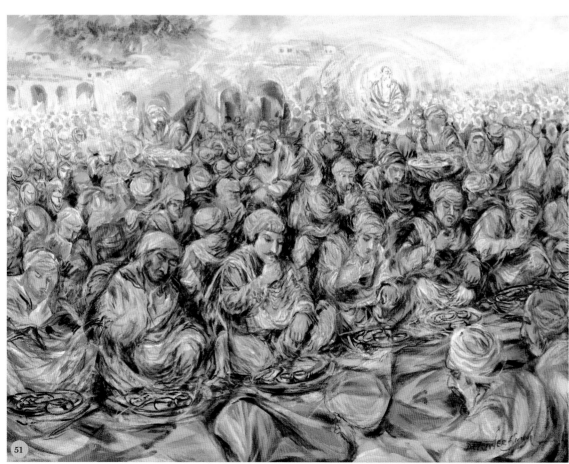

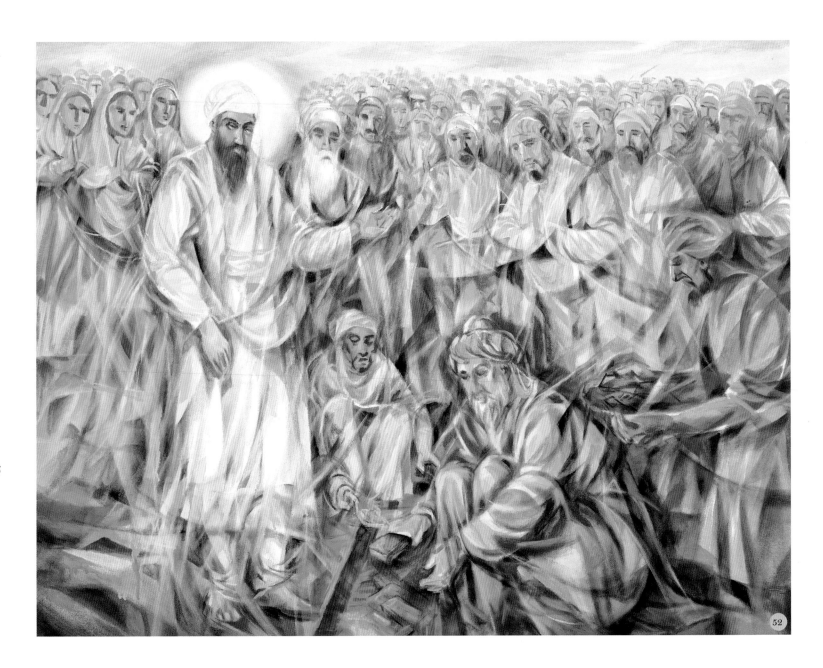

52. Guru Arjan Dev with Mian Mir laying the foundation stone of Harmandir Sahib

Devender Singh | 2018 | 35.5 x 45.5 in (with frame) | Oil on canvas

As a mark of interfaith harmony, Guru Arjan requesting the Sufi saint, Mian Mir to lay the foundation stone of Harmandir Sahib in Amritsar.

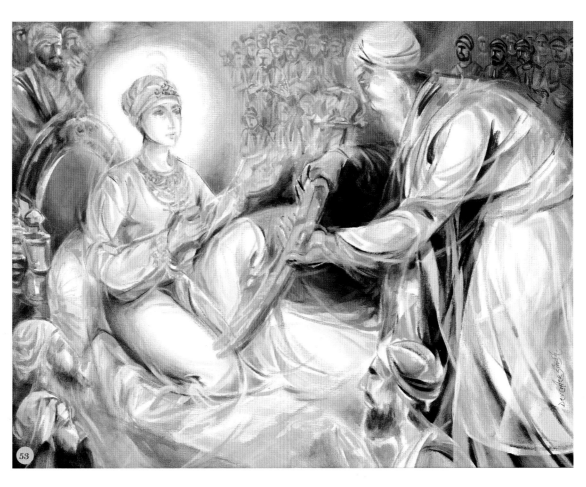

53. Guru Hargobind at guruship ceremony

Devender Singh | 2018 |
35.5 x 45.5 in | Oil on canvas

The concept of *miri* and *piri* was highlighted by Guru Hargobind at the guruship (succession) ceremony in 1606, when he asked for two *kirpans* to be donned on him – one to symbolize the concept of *miri* or temporal authority and the second to symbolize the concept of *piri* or spiritual authority.

54. Guru Har Rai giving medicinal herbs

Devender Singh | 2018 |
35.5 x 45.5 in | Oil on canvas

Guru Har Rai was acclaimed for the development of indigenous medicines. In this painting he is giving life-saving medicines to Mughal officials for the ailing Dara Shukoh, Mughal Emperor Shah Jahan's eldest son.

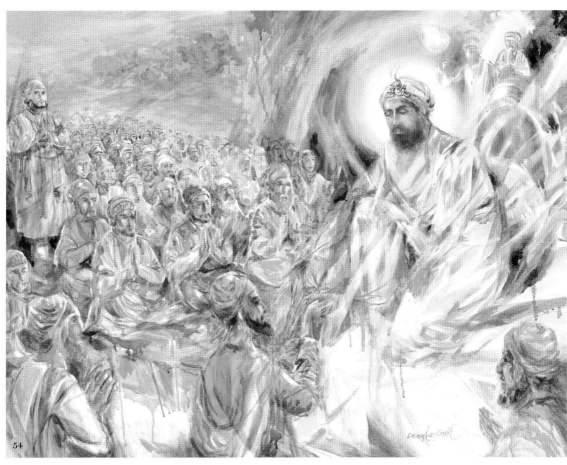

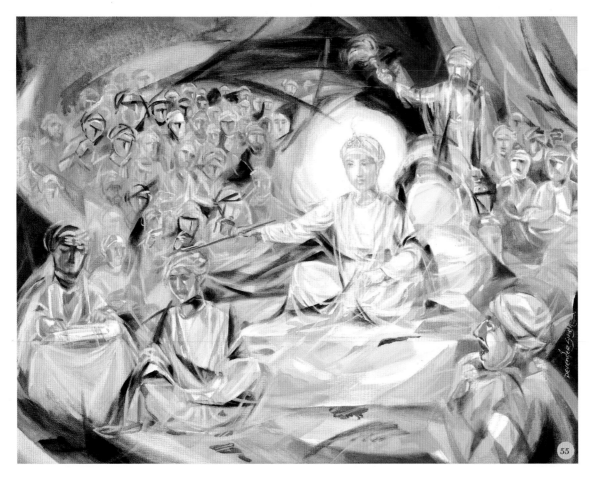

55. Guru Har Krishan

Devender Singh | 2018 | 35.5 x 45.5 in | Oil on canvas

Guru Har Krishan was once asked by a proud pandit to translate Bhagavad Gita (Hindu holy book), to justify the godly name the guru was known by. Guru Har Krishan offered that the Pandit could bring anyone for the purpose. Chajju Ram, an illiterate who was also deaf and unable to speak was presented by the pandit. As soon as the guru placed his *chhadee* or stick on his forehead, the divine power transcended into Chajju Ram and he began to translate the sacred text like a learned man.

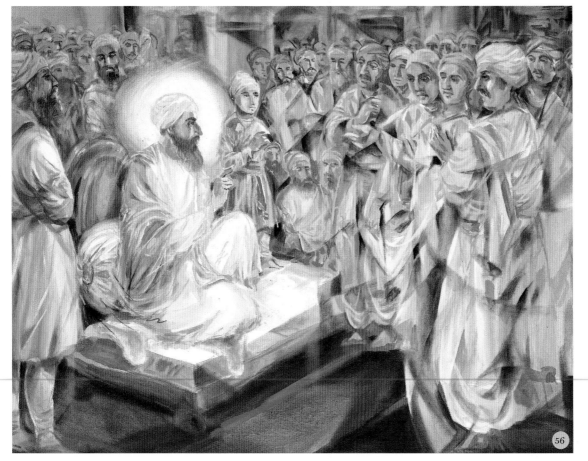

56. Guru Tegh Bahadur and his young son Gobind Rai meeting Kashmiri Pandits

Devender Singh | 2018 | 36 x 46 in | Oil on canvas

This painting reveals Guru Tegh Bahadur and his young son Gobind Rai in the presence of Kashmiri Pandits lead by Kirpa Ram who came to Anandpur in May 1675 to seek the assistance and protection against atrocities of the Mughal Emperor Aurangzeb. The guru asked them to communicate to the emperor that if he (Guru Tegh Bahadur) was converted, they would all voluntarily accept conversion to Islam. His unique act of sacrificing his life for others, so they could practice their religion without any fear, thus exemplifies the highest honor of upholding human rights.

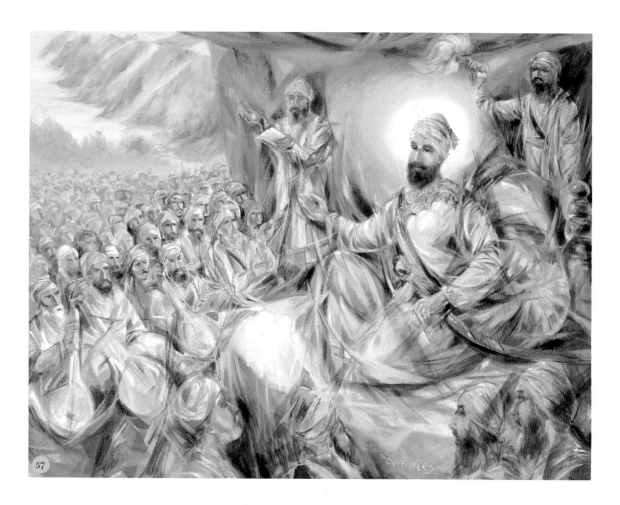

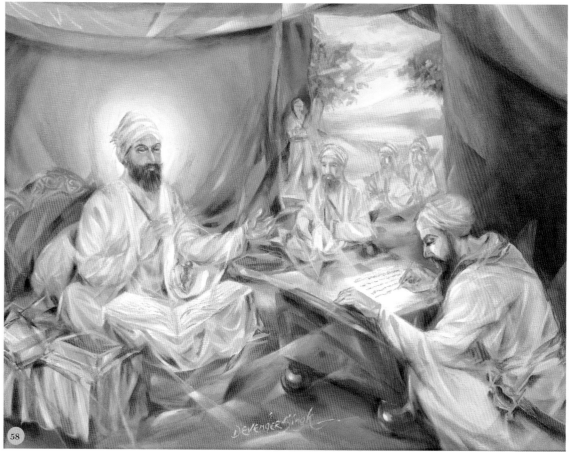

57. Guru Gobind Singh with poets in his durbar (court)

Devender Singh | 2018 | 35.5 x 45.5 in (with frame) | Oil on canvas

Guru Gobind Singh, prophet and soldier, was an accomplished poet and also a great patron of literary works. *Bavanja kavi*, literally meaning fifty-two poets, is how the galaxy of poets and scholars who attended on Guru Gobind Singh are popularly designated.

58. Guru Gobind Singh getting the final version of the Sri Guru Granth Sahib prepared

Devender Singh | 2018 | 35.5 x 45.5 in (with frame) | Oil on canvas

Guru Gobind Singh arrived at Talwandi Sabo, now called Damdama Sahib in January 1706. During his stay there of over nine months, he formalized the Sikh scripture, the Sri Guru Granth Sahib, with the celebrated scholar, Bhai Mani Singh. From the literary activity initiated here, the place came to be known as the Guru's Kashi or seat of learning.

SIKH GURUS IN CONTEMPORARY ART

These artworks by the Singh Twins draw inspiration from Sikh tradition,
Western medieval illuminated manuscripts, and contemporary Western culture.

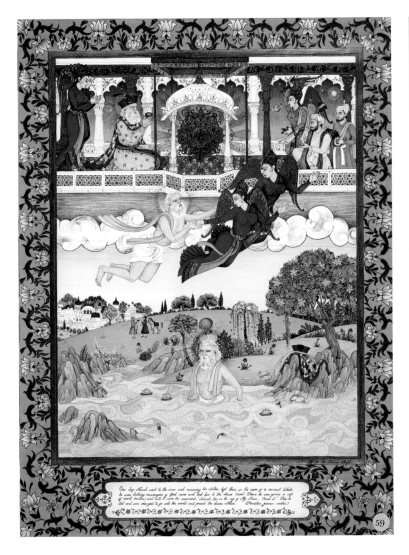

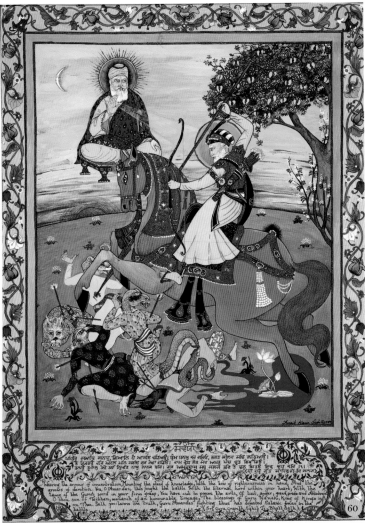

59. Enlightenment of Guru Nanak

Rabindra K.D. Kaur Singh | 1992 |
14 x 11 in | Gouache on paper |
© The Singh Twins

Guru Nanak is shown in a narrative
sequence, first bathing, then being
taken up to the Divine abode in the
upper register of the composition,
and finally receiving the *naam* or
spiritual message, thereby attaining
complete enlightenment. Following
the *janamsakhi* convention, these
paintings too integrate text and
images, but are more imaginative and
complex in their presentation and
treatment.

60. Guru Amardas destroys the five vices

The Singh Twins | 1989 |
16.4 x 11.6 in | Gouache and gold dust |
© The Singh Twins

This allegorical portrait of Guru Amardas
illustrates verses from the Sri Guru Granth
Sahib which pay tribute to him as a warrior
striking victory over his enemies - the five
vices. In Sikh symbolism, the vices (lust,
anger, greed, pride, and attachment) are
likened to five animals. Other details in
the artwork, such as the entwined trees
(symbolizing the human soul clinging on to
the Divine) represent how destruction of
the vices through Divine's grace leads to
spiritual enlightenment and union.

61. Ascension of Guru Ram Das

The Singh Twins | 1990 |
16 x 11.5 in | Gouache and gold dust |
© The Singh Twins

This painting depicts the passing of
the guruship from Guru Ram Das to
Guru Arjan. The occasion is witnessed
by the entire creation, blessed by the
previous gurus and glorified by deities
representing the Divine presence.
The artists reveal how the guruship
was ultimately vested in the Sikh
scriptures, which are given due respect
- depicted enthroned, garlanded,
and shaded by the umbrella of royal
authority. The umbrella, emblazoned
with a map of the world, symbolizes
the universality of Sikh teachings.

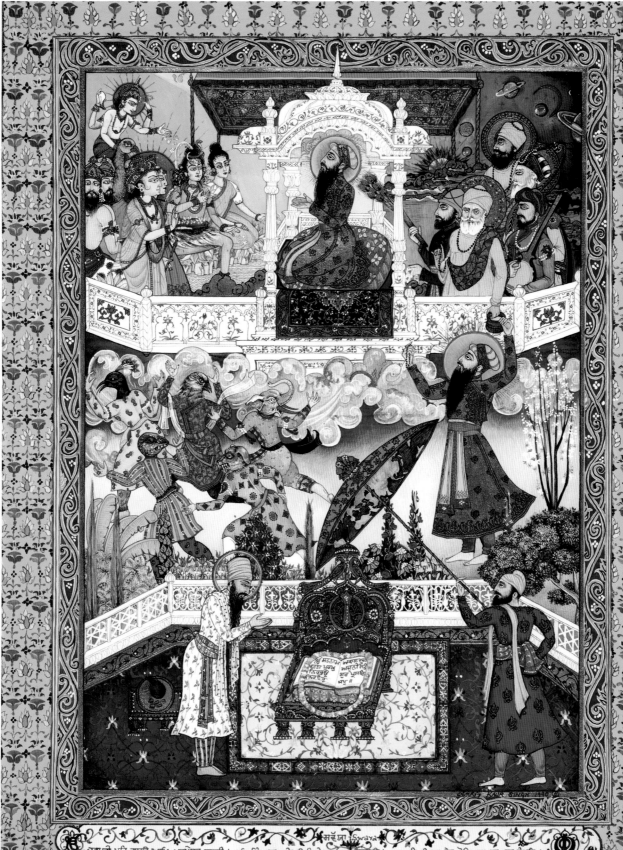

ੴ ਦਰਬਾਰੀ ਮਤਿ ਗਾਸਣੂ ਆਪਿ ਪਰਮੇਸੁਰ ਬਾਸਈ । ਗੁਰਿ ਸਿੰਘਾਸਣੁ ਦੀਅਉ ਸਿਰਗੁ ਗੁਰੁ ਤਹ ਬੈਠਾਯੲ ॥ ਰਹਸੁ ਕੀਅਉ ਸੁਰ ਦੇਵ ਤੇਹਿ ਜਸ ਜਸ ਜਾਸ ਜੈਪਹਿ ।

ਅਸੁਰ ਗਾਏ ਤੇ ਭਾਗਿ ਪਾਪ ਤਿਨ੍ ਭੀਤਰਿ ਕੰਪਹਿ । ਕਾਟੇ ਸੁ ਪਾਪ ਤਿਨ ਨਰਹ ਕੇ ਗੁਰ ਰਾਮਦਾਸੁ ਜਿਨ ਪਾਇਅਉ । ਛਤ੍ ਸਿੰਘਾਸਨੁ ਪਿਰਥਮੀ ਗੁਰ ਅਰਜੁਨ ਕਉ ਦੇ ਆਇਅਉ ॥੨॥

When such was the Lord's will, (Guru Ram Das) repaired to the Abode of God. And God offered him His Throne and seated him there Himself. And all the gods were pleased and proclaimed his Victory. And the demons hastened away, for, within them trembled their sinful deeds. Yea whosoever attained to Guru Ram Das was rid of his sins. And his Throne (of Moral law) and the Canopy (of Grace) passed on to Guru Arjan for the Redemption of the world. (Bhatt Haribans –Sri Guru Granth Sahib Ji)

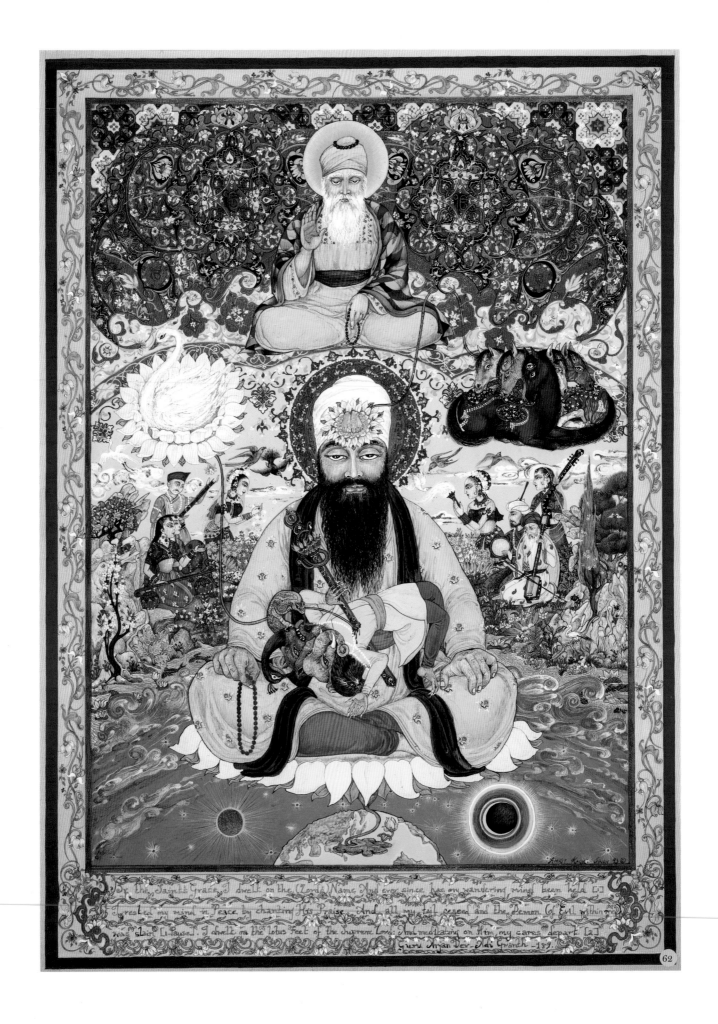

By the Saint's Grace, I dwelt on the (Lord) Name And ever since has my wandering mind been held [1] I rested my mind in Peace by chanting His Praise. And all my toil ceased and the Demon (of Evil within me) slain (i Pause) I dwell in the lotus feet of the Supreme Lord: And meditating on Him, my cares depart. [2]

Guru Arjan Dev. Adi Granth -189.

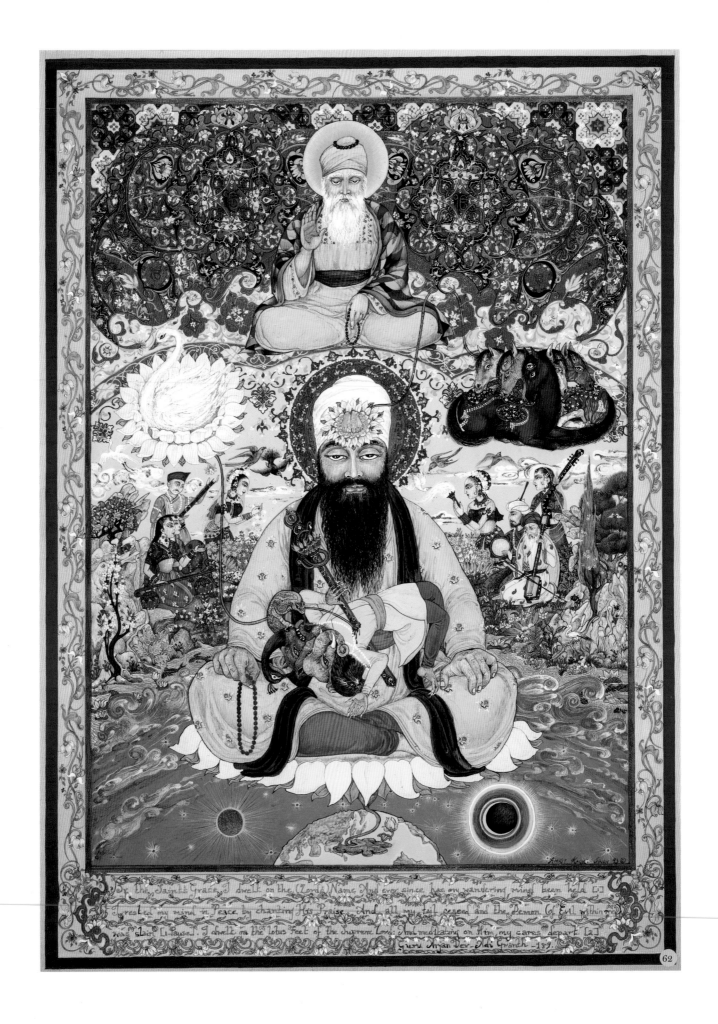

62. The spiritual enlightenment of Guru Arjan Dev

The Singh Twins | 1992 |
16 x 11.6 in | Gouache and gold dust |
© The Singh Twins

The guru is depicted as an exemplary figure of spiritual enlightenment achieved through controlling the five senses and a destruction of the vices which keep us attached to the material world in a false sense of permanence. Drawing on traditional Sikh symbolism, the guru is likened to the lotus which rises above the muddy water (material world).

63. Guru Gobind Singh with Amrit Sanchar

The Singh Twins | 2018 | 16 x 12 in |
Digital artwork on archival paperwork;
Mixed Media | © The Singh Twins

The creation of the Khalsa as an historic event is depicted in a scene that dominates the bottom half of the artwork. This shows Guru Gobind Singh and Mata Sahib (known as the mother of the Khalsa) preparing *amrit* (nectar), which was used to initiate the guru's followers into the Khalsa community of warrior saints. The date of this event (Vaisakhi 1699) and the name for this community (Khalsa Panth) are inscribed on the banners, bottom left and right of the composition. The gurdwara on the right depicts Patna Sahib, which commemorates the place where the guru was born in 1666. The one on the left represents Hazur Sahib, commemorating the place of the guru's martyrdom and cremation in 1708. The artwork combines traditional Indian miniature and Art Nouveau styles.

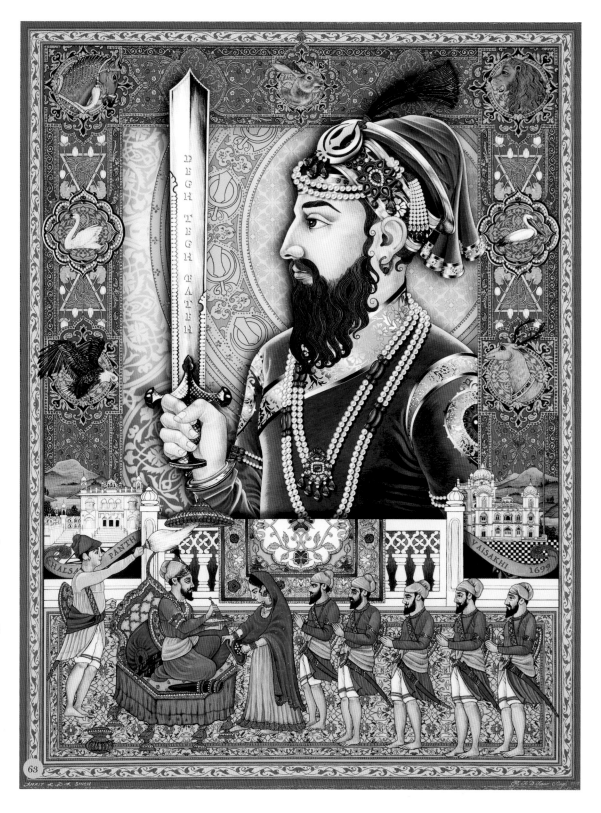

63

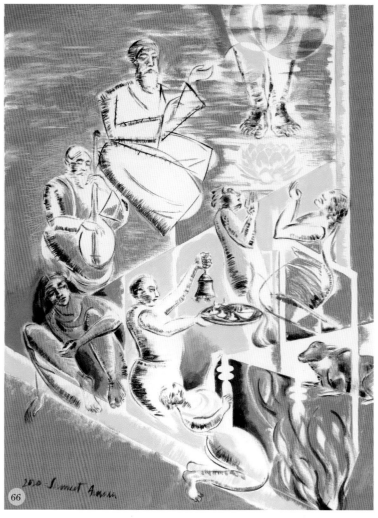

64. Guru Nanak

M.F. Hussain | 1972 | 50 x 40.25 in (with frame) | Digital, limited edition

A modern rendition of Guru Nanak's portrait by one of the most celebrated and internationally recognized Indian artists of the twentieth century. Presented on the day of Gurpurab, this is the only painting of Guru Nanak that Hussain ever made.

65. *Sodar* (a musical composition of the Divine) by Guru Nanak

Sumeet Aurora | 2020 | 53 x 40 in | Acrylic on canvas

The painting celebrates the joyous yearning of the seeker in pursuit of the exquisite throne of the Divine as disclosed in the *pauree* or stanza 27 of Guru Nanak's *Japji*.

66. *Aarti* (musical depiction in praise of the Divine), composed by Guru Nanak

Sumeet Aurora | 2020 | 54 x 40 in | Acrylic on canvas

A depiction of the sacred prayer called *Aarti* that Guru Nanak recited at Jagannath Temple in Puri.

GURU TEGH BAHADUR

These paintings were sketched by Arpana Caur to celebrate the 400th birth anniversary of Guru Tegh Bahadur.*

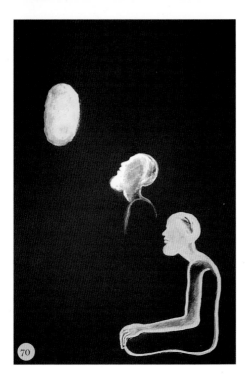

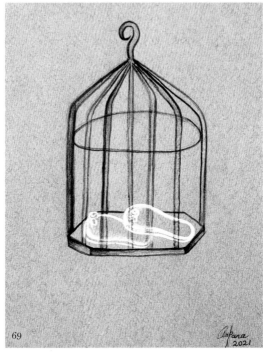

67. Guru Tegh Bahadur rescuing Makhan Shah's drowning boat

Arpana Caur | 2021 | 10.6 x 13.8 in | Gouache on paper

68. Guru Tegh Bahadur and Mata Gujri in meditation

Arpana Caur | 2021 | 13.8 x 10.6 in | Gouache on paper

69. Guru Tegh Bahadur in a cage, incarcerated by Mughal Emperor Auragzeb

Arpana Caur | 2021 | 13.8 x 10.6 in | Gouache on paper

70. Guru Tegh Bahadur (transcendence)

Arpana Caur | 2021 | 13.8 x 10.6 in | Gouache on paper

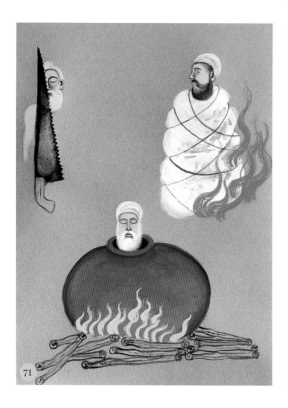

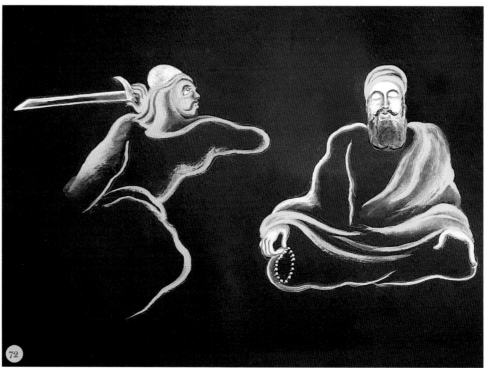

71. Martyrdom of Bhai Mati Das, Bhai Sati
Das and Bhai Dyala (companions of Guru
Tegh Bahadur) in Chandni Chowk

Arpana Caur | 2021 | 13.8 x 10.6 in |
Gouache on paper

72. Guru Tegh Bahadur's martyrdom

Arpana Caur | 2021 | 10.6 x 13.8 in |
Gouache on paper

73. Guru Tegh Bahadur
(secret cremation of the headless
body by Lakhi Shah Vanjara)

Arpana Caur | 2021 | 13.8 x 10.6 in |
Gouache on paper

74. Guru Tegh Bahadur
(journey of the sacred head,
Bhai Jaita to Guru Gobind Rai)

Arpana Caur | 2021 | 13.8 x 10.6 in |
Gouache on paper

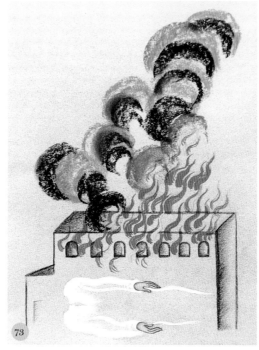

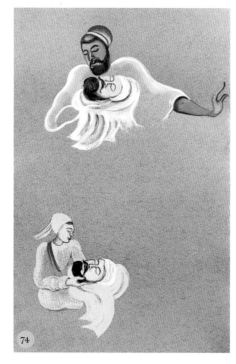

*Paintings 67 to 70 and 72 to 74 were first published in *Celebrating the Life and Spirit of Guru Tegh Bahadur* by Harminder Kaur.

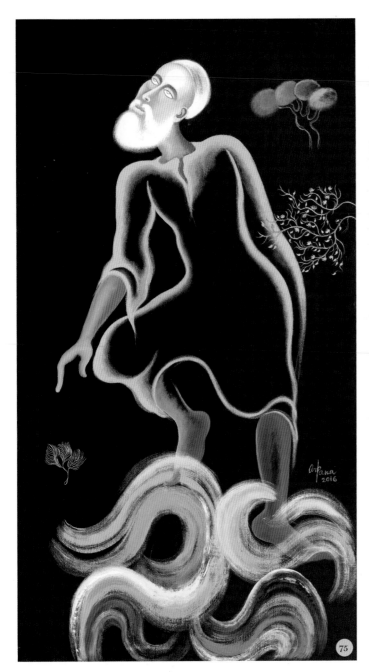

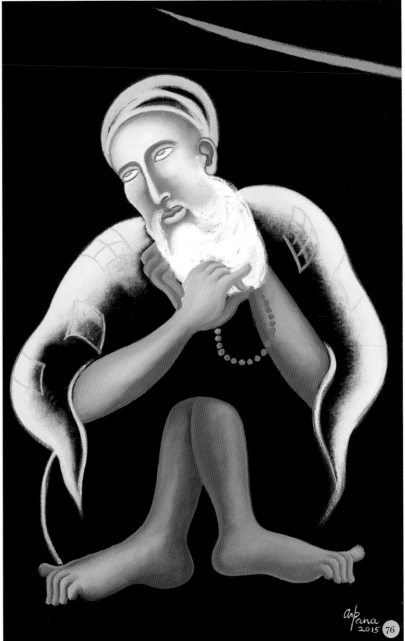

**75. Re-Emergence of Guru Nanak
from river Bein**

Arpana Caur | 2016 | 67 x 37 in (with
frame) | Oil on canvas

**76. Guru Nanak in meditation
with prayer beads**

Arpana Caur | 2015 | 37.25 x 25.25 in
(with frame) | Oil on canvas

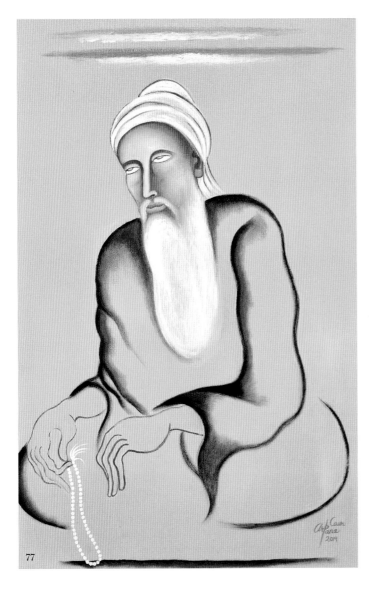

77. Baba Farid

Arpana Caur | 2019 | 36 x 26 in (with frame) | Oil on canvas

A twelfth-century revered Punjabi-Muslim preacher and mystic in North India. Some of his verses are in the Sri Guru Granth Sahib.

78. Bhai Mardana in the footsteps of Guru Nanak

Arpana Caur | 2015 | 49 x 37 in | Oil on canvas

Bhai Mardana appears to be in a celestial gaze in the footsteps of Guru Nanak.

SRI GURU GRANTH SAHIB

A compilation of hymns written by six Sikh gurus, fifteen saints – including Bhagat Kabir, Bhagat Ravidas, Sheikh Farid and Bhagat Namdev – eleven *bhatts* (balladeers) and four Sikhs. The verses are composed in thirty-one *ragas*.

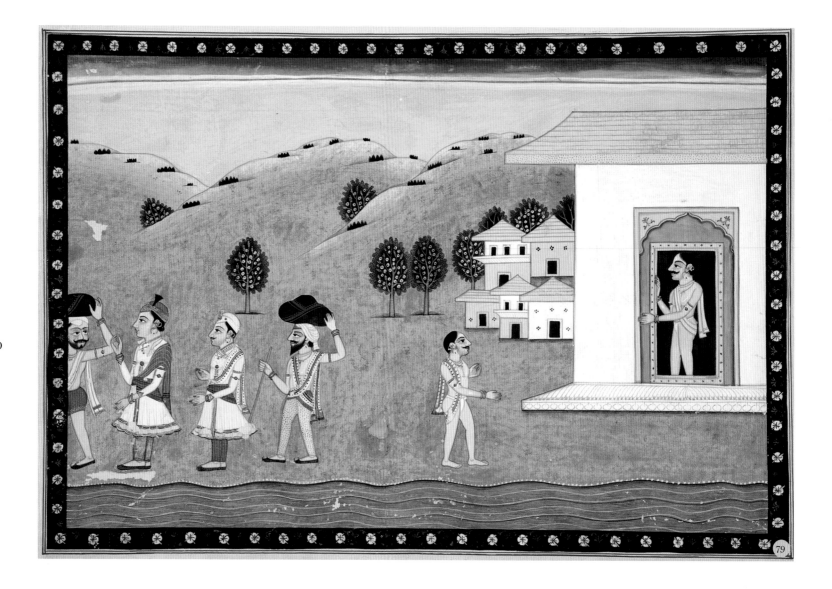

79. A Sikh prince and his entourage leaving an ashram carrying packages, perhaps a copy of the Sri Guru Granth Sahib

Artist unknown | *c.* 1830-50s | 10.25 x 15.25 in | Gouache on paper

This fine painting with pink floral borders is most probably from the Sikh-Pahari school and bears inscriptions on the reverse in the Nagari and Gurmukhi scripts.

80. Sri Guru Granth Sahib (miniature)

c. 1914 | 1.25 x 1.25 in

This miniature Sri Guru Granth Sahib contains 1,430 pages, and can be read with a magnifying glass. Printed in Germany, it was used by Sikh soldiers during the First World War. It was carried in the turbans of the Sikh soldiers, thus giving them comfort that the guru was with them.

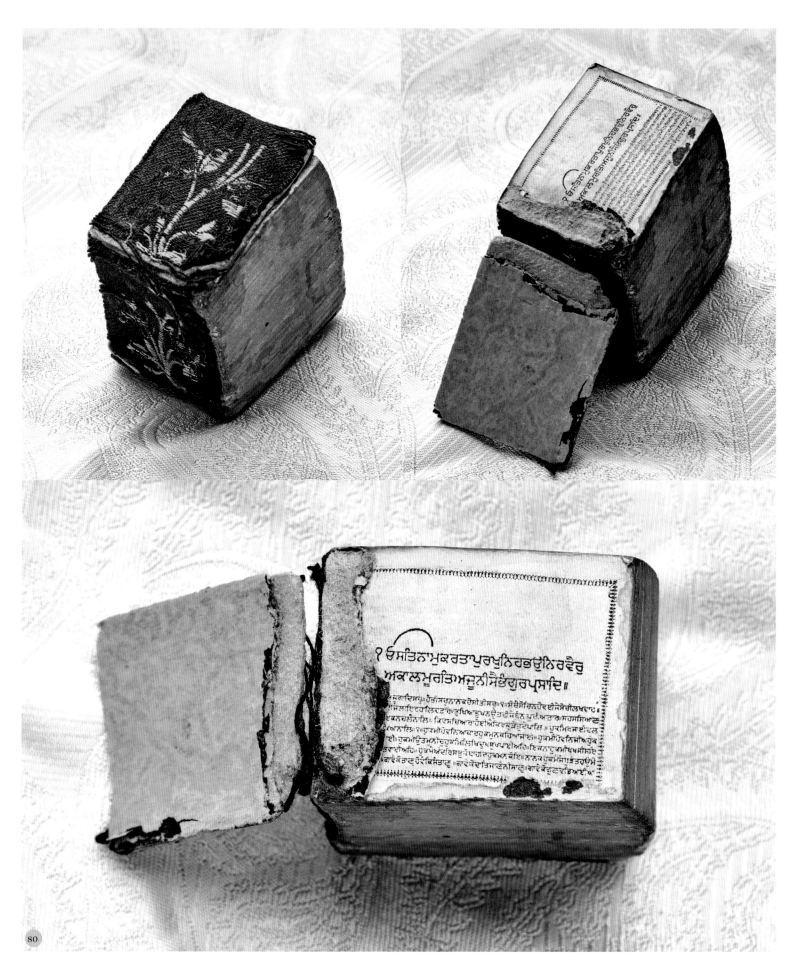

BHAGATS

The term *bhagat* refers to a holy person who leads a life of spirituality and dedication to the Divine.

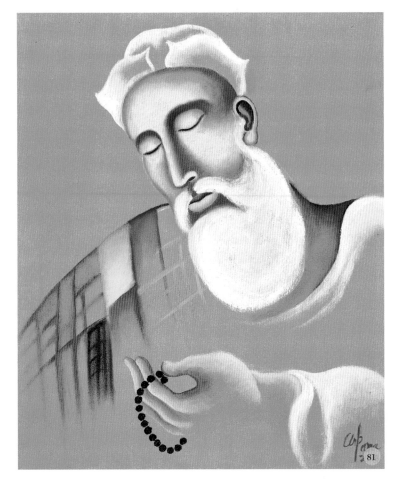

81. Guru Nanak in meditation

Arpana Caur | 2018 | 22 x 19 in | Oil on canvas

82. Bhagat Kabir

Arpana Caur | 1993 | 69 x 44 in (with frame) | Oil on canvas

83. Bhagat Kabir and Guru Nanak

Arpana Caur | 2020 | 9.75 x 12.75 in | Pencil and pastel on paper

84. Bhagat Jaidev, Bhagat Parmanand, Bhagat Sadhna, and Bhagat Ravidas

Arpana Caur | 2020 | 11.5 x 16.5 in | Pencil and pastel on paper

85. Bhagat Farid, Bhagat Sain, Bhagat Surdas, and Bhagat Namdev

Arpana Caur | 2020 | 11.5 x 16.5 in | Pencil and pastel on paper

86. Bhagat Beni, Bhagat Pipa, Bhagat Tirlochan, Bhagat Bhikhan, Bhagat Parmanand, and Bhagat Dhanna

Arpana Caur | 2020 | 11.5 x 16.5 in | Pencil and pastel on paper

87. Bhai Gurdas and Bhai Mani Singh

Arpana Caur | 2020 | 11.5 x 16.5 in | Pencil and pastel on paper

The Adi Granth was calligraphed by Bhai Gurdas and installed at Harmandir Sahib. Later, Guru Gobind Singh added the hymns of Guru Tegh Bahadur and appointed the Sri Guru Granth Sahib as his successor. The scribe, Bhai Mani Singh completed the work in 1705.

88. Sikh women associated with the gurus

Arpana Caur | 2020 | 11.5 x 16.5 in | Pencil and pastel on paper

The painting depicts three Sikh women. Bibi Nanaki (sister of Guru Nanak), giving a *rabab* to Bhai Mardana. Mata Khivi, the wife of Guru Angad took on the responsibility of organizing the arrangements of offering comfort and hospitality to the many devotees and ran the *langar*. Mata Sahib Kaur (wife of Guru Gobind Singh), is known as the "Mother of the Khalsa." She earned the distinction of preparing the first *amrit* (nectar) for the Khalsa baptism ceremony.

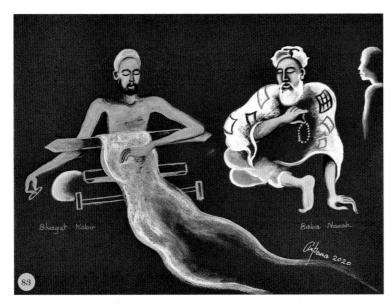

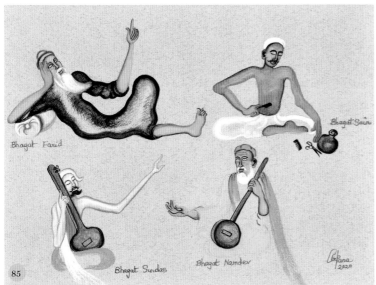

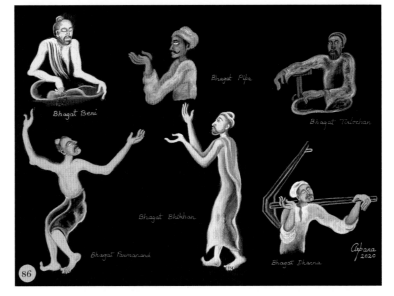

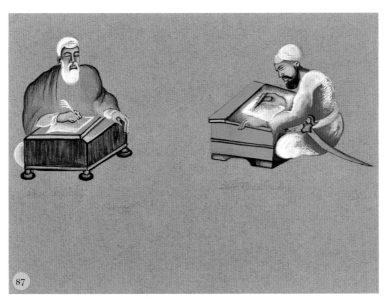

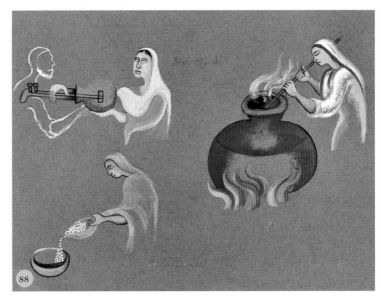

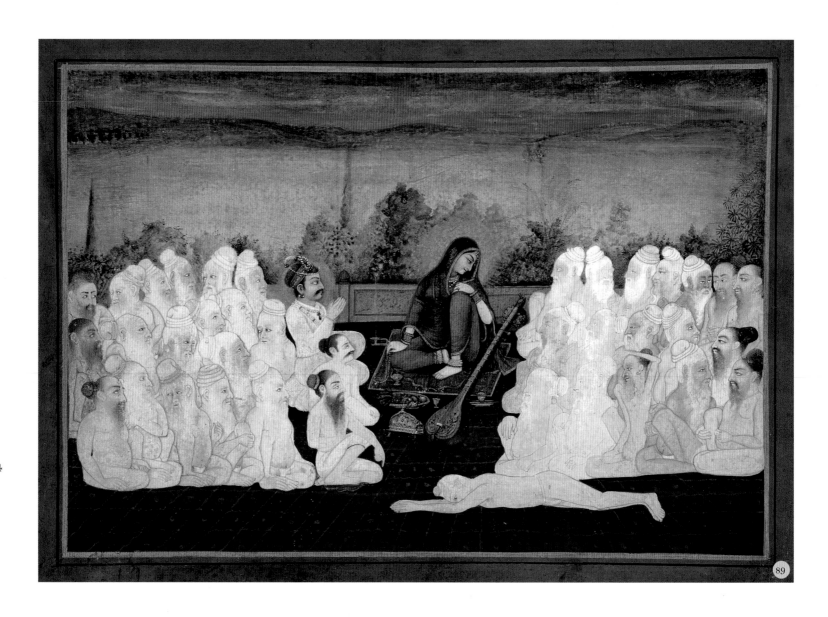

89

89. Mira Bai surrounded by devotees

Artist unknown | *c.* 17th–18th century | 7.5 x 11 in | Watercolor on paper

Mira Bai was a *bhagat* saint of the sixteenth century. Born into a Rajput royal family, she was a devotee of Krishna. Some of the earlier copies of Adi Granth do have a few of her writings. However, the final Sri Guru Granth Sahib does not have any incorporated in it. Here we see her surrounded by devotees listening to her soulful *bhajans* (songs).

90. Bhagat Kabir with attendants and devotees

Artist unknown | *c.* Late 17th/early 18th century | 8.7 x 6.7 in | Gouache and gold on paper

One of the most revered saints of the Bhakti and Sufi movement, Bhagat Kabir's compositions are also part of the Sri Guru Granth Sahib. Out of the fifteen *bhagats* whose *bani* is part of the Sikh scriptures, Kabir's contribution is the largest.

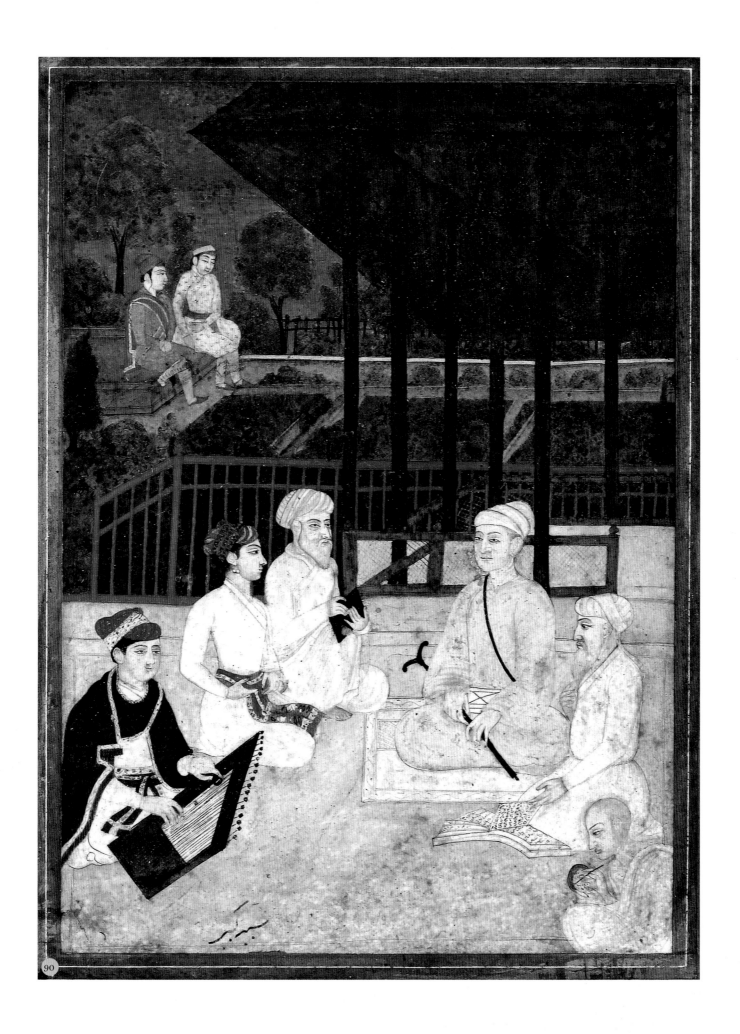

Dukh Banjan Tera Naam Ji, Dukh Banjan Tera Naam.

GURDWARAS: SPIRITUAL AND TEMPORAL ABODES OF AUTHORITY

"IT WAS BEAUTIFUL, THIS OFFERING OF THE BLUSHING FLOWERS, THE REVERENCE, THE MEEKNESS, THE ATMOSPHERE OF MYSTICISM, THE LAVISH RESPLENDENT WEALTH, THE IMPRESSIVE MUSIC, THE FASCINATING EARNESTNESS OF IT ALL. SO I CAME AWAY SPEAKING NO WORD."[1]

John Foster Fraser recounting his visit to the Harmandir Sahib in 1897

The word gurdwara means "gateway to the guru." It refers to the *dharamsals* which were set up and graced by the gurus of Sikhism as well as to the later-day centers of worship and congregation established by Sikhs in India and abroad. Besides being religious places, gurdwaras also foster a sense of community and offer room for collective reflection and activism. Here, we highlight and discuss a select few gurdwaras depicted in the Khanuja Family Collection, with a special focus on the Harmandir Sahib (Golden Temple).

Nankana Sahib in Pakistan's Punjab province is the birthplace of Guru Nanak, the founder of Sikhism. The city has multiple gurdwaras associated with events from his life. The most significant one is Janam Asthan, built on the site where he was born. Another gurdwara represented in our collection is Sacha Sauda (literally, true bargain). It is also connected to Guru Nanak, who, according to his biographies (*janamsakhis*), received twenty rupees from his father to conduct business. But the guru came across hungry *sadhus* (ascetics) and decided to feed them as a good deed. This act can be considered as the origin of the *langar* that became an important part of *seva* within Sikhism and which remains a critical element of Sikh ethos to this day.

In this chapter we also present a painting of a well at Kartarpur Sahib (Home of the Divine), a town founded by Guru Nanak, where he spent the last eighteen years of his life, laying the foundations of an ideal society based on the message of oneness. He exhorted his followers to commit to a life of spiritual enlightenment, compassion, sharing, and hard work. The well depicted in the painting symbolizes the concept of equality, since all can draw water from it and share it too. Its significance lies in the fact that it brings together people from different castes, economic backgrounds, and religions, thereby challenging prejudice. The paintings depicting the gurdwaras discussed thus far are done by Bholla Javed, an artist from Faisalabad, Pakistan. He has made every piece unique by utilizing the soil from each of these gurdwaras as the basis of his paint mixture. For Sikhs, dust is a source of deep reverence tied to the value of humility. In this connection, the Guru Granth Sahib says, "Become the dust of all men's feet, and so merge with the Divine" (SGGS p. 322).

The word *takht* literally means "throne or seat of authority" and is a spiritual and temporal center of Sikhism associated with certain gurdwaras. There are five *takht*s for the Sikhs: three are in Punjab, while two are outside the state. The Akal Takht (literally, Throne of the Immortal) is situated in the Golden Temple complex and it represents political autonomy and righteousness. The second *takht*, Sri Kesgarh Sahib is located at Anandpur Sahib. It is the birthplace of Khalsa and is famous for the Baisakhi, yearly commemorations for the formation of the Khalsa that are attended by throngs of followers. The *takht* at Sri Damdama Sahib, Bathinda, holds a very special place in Sikh history: this is where Sri Guru Granth Sahib was compiled and given the status of

77

1. Dukh Bhanjani Beri (dispeller of suffering), Golden Temple

The Singh Twins | 2020 | 36 x 28 in | Giclee artwork (archival ink on archival paper), embellished by hand | © The Singh Twins

Artwork inspired by the story of Bibi Rajni and her husband who was cured by the miraculous water of the *sarovar* at the Sri Harmandir Sahib. Bibi Rajni and her husband are shown below Harmandir Sahib and next to the Dukh Bhanjani Beri (a jujube tree), literally meaning "healer of sorrow." Also seen in the painting is an inset portrait of Guru Ram Das, the founder of Amritsar; a reference to the healing waters of the *sarovar*; a verse from Sikh scriptures relating to the story; a small inset of Guru Arjan as founder of Harmandir Sahib; a detail of Guru Hargobind who founded Akal Takht; an elderly Sikh couple in traditional Punjabi attire (including a white turban and *kirpan* for the man) with Guru Nanak touching the man's shoulder.

holy scripture of Sikhs and eternal guru. The fourth *takht* at Gurdwara Patna Sahib is the place where the tenth guru, Guru Gobind Singh was born. Maharaja Ranjit Singh built it as a mark of remembrance. The fifth *takht* at Sri Hazur Sahib in Nanded is integral to Sikh pilgrimage as this is the place where Guru Gobind Singh breathed his last in 1708.

The Golden Temple or Sri Harmandir Sahib in Amritsar is the central religious site for Sikhs. It is also known as Darbar Sahib (Court of the Sovereign). The Golden Temple is surrounded by a body of sacred water (*sarovar*) and it is built on a 67 square feet platform which is at a level lower than the surrounding land, thus embodying and imparting the message of humility and egalitarianism. The four entrances in four directions welcome people from all walks of life inside the sanctum sanctorum. Along with its surroundings it is referred to as the Golden Temple or Harmandir Sahib complex. According to Fauja Singh, "legend has it also that the site was visited by Guru Nanak during his wanderings and even by Lord Buddha."[2]

A pond already existed in the area where the Dukh Bhanjani Beri, a jujube tree, whose name literally means "healer of sorrow," stands today. Around 1573 the fourth guru, Guru Ram Das, decided to build a new settlement around the pond, which was initially called Ramdaspur. Guru Ram Das undertook the construction of a tank at a lower level than the surrounding land (*amrit sarovar*). His successor, Guru Arjan, had the tank lined with bricks and plans were made to build a temple in the middle of the holy *sarovar*. As a mark of communal harmony and interfaith tolerance, it is believed that a Muslim saint, Hazrat Mian Mir of Lahore, laid the foundation stone of the temple, which was completed in 1601. Sikhs from near and far contributed to its construction by performing voluntary labor (*seva*) and donating 10 percent of their income (*daswandh*). Such selfless practices continue to date and form the basis of Sikhism.

The main entrance leading to the pathway to the Golden Temple is an arch known as Darshani Deori. The door frame of the arch is about 10 feet in height and 8 feet and 6 inches in breadth. The wooden portals attached to it are 6 inches thick, made of sheesham wood, and covered with silver sheets. The door panels are intricately decorated with beautiful patterns. The door opens onto the causeway or bridge that leads to the main building of Sri Harmandir Sahib. The bridge is 202 feet in length and 21 feet in width, and it is connected to a 13-feet-wide *pradakshina* (circumambulatory path), which runs round the main shrine and leads to the Har ki Pauri (Steps of God).

The main structure of Sri Harmandir Sahib comprises of three stories. The front, which faces the bridge, is decorated with cusped arches and the roof of the first floor is at a height of 26 feet and 9 inches. The dome is designed in the shape of a lotus flower and is plated with copper covered in gold. Commenting on the temple's layout and architecture, Madanjit Kaur states, "The low-level ground (earth) of the setting of the Harimandir Sahib and its high dome is [*sic*] symbolic of the elevation of the lower level of human existence to its prime height – its prime height – its cosmic unity with the Supreme Reality in the space."[3] In time, many have contributed to enhance its magnificence and grace. For instance, according to Surinder Johal, "Maharaja Ranjit Singh beautified the temple with gold work, marble mosaic and fresco-paintings."[4] The process of cleaning and desilting the body of water surrounding the temple is considered an act of devotion (called *kar-seva*) performed periodically. This practice has been carried out multiple times by great number of volunteer devotees and has been documented in 1843, 1923, 1973, 1984, and 2004. At present, a filtration system maintains the cleanliness of the body of water.

Let us now turn to the other structures that are part of the Golden Temple complex. This includes the Toshakhana, a storehouse that contains precious gifts offered by various individuals at the Sri Harmandir Sahib, Akal Takht Sahib, and Baba Atal Gurdwara, mostly during the period of Sikh rule in Punjab. The Toshakhana is located on the first floor of the Darshani Deori. The items stored in it are displayed at Sri Harmandir Sahib on certain *gurpurabs* (days marking the accession to guruship, as well as the death or martyrdom of all the gurus).

Harmandir Sahib is surrounded by other gurdwaras, *bungas* (rest-houses), halls serving as communal kitchens, and other structures. *Bungas* were initially rest-houses or dwellings, but over

time began to be used for defensive, social, and religious purposes, and later also as educational centers. At one time, it was presumed that there were up to eighty-four *bungas* in existence. Most of them have now disappeared to widen the *parikrama* (walkway), which circumscribes the sacred water tank. Of all the historical *bungas* that existed in the past, Ramgarhia Bunga is one of the few *bungas* that remains. Built in 1755 during the pre-Ranjit Singh era by the chief of the Ramgarhia Misl, Jassa Singh Ramgarhia, it is a striking three-storied structure located close to the Dukh Bhanjani Beri.

The Akal Takht Sahib, originally called Akal Bunga (Sovereign Throne of the Timeless) stands opposite to the Darshani Deori. It embodies the *miri* (temporal power) and serves as a symbol of sovereignty for the Sikhs. The sixth guru, Guru Hargobind, used to sit at the Akal Takht on a platform and hold his court with people coming to pay homage and seek guidance. The *dhadis* (minstrels) sang ballads here with their voices vibrating in every corner of the holy complex. Since then, the Akal Takht has become the center of Sikhs' political activity. For instance, it has been hosting the Sarbat Khalsa, an assembly of representatives of the Sikh community who gather to deliberate and decide on pressing political issues, as well as all major social and political programs, campaigns, and agitations.

In front of the Akal Takht are two deep orange triangular flags, known as *nishan sahib*. According to Kuldeep Singh Virdi, "the two saffron colored flags stand as a testimony to the concept of Miri (temporal) and Piri (spiritual) authority in Sikhism."[5]

The Gurdwara Yaadgar Shahidan, which stands to the left of the Akal Takht Sahib, was built to honor and commemorate the martyrdom of those who died defending the Sri Harmandir Sahib after the Indian government attacked it in 1984. Not too far from this memorial is another gurdwara known as Gurdwara Thara Sahib, which commemorates the visit of the ninth guru, Guru Tegh Bahadur Sahib.

The Central Sikh Museum is situated above the main entrance of the Harmandir Sahib complex and was established in 1958. In addition to artifacts pertaining to the Sikh gurus, it displays portraits and paintings of prominent personalities in Sikh history, including *bhagats*, warriors, and many outstanding leaders who contributed to the preservation and strengthening of Sikhism and Sikh tradition. The museum also houses a rich collection of Sikh artifacts, including coins, old arms, ancient manuscripts, and paintings.

Another important repository is the Sikh Reference Library, which is situated on the northeastern side of the Harmandir Sahib. The library holds a large collection of rare manuscripts, books, edicts, and *hukamname* injunctions signed by the guru. Unfortunately, many of these extraordinary gems were destroyed or taken away by the Indian army during the attack on the Golden temple in June of 1984.

The Golden Temple complex also features three historic Ber (jujube) trees. One is called Beri Buddha Sahib and it is named after Baba Buddha Ji (one of Guru Nanak's companions and the first *granthi* or priest of Harmandir Sahib), who sat here and supervised the excavation of the Amrit Sarovar and construction of Sri Harmandir Sahib.

The Lacchi Ber is where Guru Arjan used to sit and supervise the construction of the temple. Finally, the Dukh Bhanjani Beri is where, according to tradition, the husband of Bibi Rajni (a devotee of the fourth guru) was cured of leprosy after taking a dip in the holy *sarovar*.

Another important structure in the Golden Temple complex is the Guru Ram Das Langar, a community kitchen primarily run by volunteers, which feeds up to 100,000 people a day. Men, women, and children equally contribute to or perform *langar seva*, which is another important occasion for community participation.

Other memorials in the complex include the Gurdwara Baba Atal Sahib, a nine-storied octagonal building, about 150 feet high. The memorial is dedicated to Atal Rai Ji, the younger son of Guru Hargobind, who died at age nine. There are frescoes, murals, and scenes from the *janamsakhis* of Guru Nanak on the lower floors.

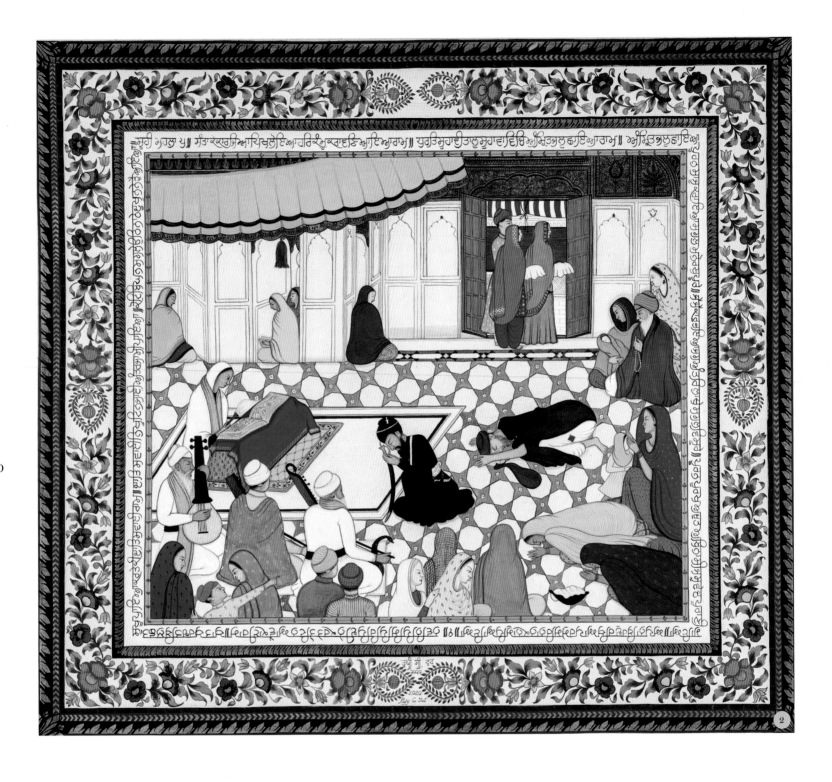

The complex also hosts a shrine dedicated to Baba Deep Singh, the legendary venerated martyr, who died here in 1757 while leading his saint soldiers to stop the desecration of Harmandir Sahib by the Afghans. Devotees stop here to sprinkle rose petals or lay fresh garlands in his honor.

Today the Golden Temple complex is one of the most visited places in the world by people of all religions. Going down the steps leading to the *parikrama*, the sight of the serene Harmandir Sahib in the middle of the *sarovar* yields a feeling of awe, quiet strength, reverence, and spirituality unparalleled elsewhere. The reflection of the golden facades and domes in the shimmering water at sunrise and sunset makes visitors feel as if they are blessed with a touch of the Divine, causing ecstasy and leaving an indelible impression.

2. *Darshan*, or the act of perceiving the guru

© Rupy C. Tut | 2020 | 16 x 18 in | Hand-made hemp paper with pigments and gold

The painting shows devotees as they receive *darshan* of the holy scripture and the *sangat* (congregation) around them. Traditional instruments (including the *taus*, the *dilruba* and the *rabab*) are highlighted in the setting of the Darbar Sahib, Amritsar.

The Sri Guru Granth Sahib is the central religious scripture of Sikhism, regarded by Sikhs as the final, sovereign, and eternal living guru following the ten human gurus of the religion. It is the scriptural canon of the Sikhs, offering words of wisdom, grace, and freedom to all people. The Adi Granth, its first rendition of the holy scripture of Sikhism, was compiled by the fifth guru, Guru Arjan in 1604 and installed inside Harmandir Sahib. Baba Buddha Ji was appointed the first *granthi* of Darbar Sahib. The final recension was completed by Guru Gobind Singh in 1705 and it became the official spiritual guru in 1708, after his demise. The text includes about 3,000 poetic compositions and in its current printed format has a standard pagination of 1430 pages.[6]

The Sri Guru Granth Sahib is unique among the world's major religious scriptures because, while compiling the holy scripture, the Sikh gurus incorporated not only their own writings but also those of other contemporary saints from Hinduism and Islam – including saints belonging to the lowest strata of untouchables in the Hindu caste system – who believed in the oneness of humanity and the Divine. The scriptures' distinctiveness lies in the fact that it was written by the founders of the faith during their lifetime and that music forms the basis of the rhythms and classification of hymns of devotion. It is a scripture for modern mankind stressing universal love and propagating oneness and equality. Moreover, the Guru Granth Sahib does not claim exclusivity, as reflected by Guru Nanak's words, "Just as there is only one sun but it provides us many seasons, so too there is but one creator who manifests himself in many Revelations" (SGGS p. 12). Its authenticity is defined by Guru Arjan who states, "By myself, I do not even know how to speak; I speak all that the Lord commands" (SGGS p. 763).

It is worth noting that it is not the body of the guru, but his word, i.e. *gurbani* (divine hymns) that is the real guru. In this regard the Guru Granth Sahib states, "Bani is the Guru and the Guru is the Bani, in the Bani rests all the ambrosial essence" (SGGS p. 982). Stressing the value of the Sri Guru Granth Sahib, W.H. McLeod stated that "the world is poorer for its ignorance of the Sikh scriptures."[7]

Harmandir Sahib with its centerpiece Guru Granth Sahib as the eternal guru became a hallowed place for the Sikhs and its sacredness is emphasized by Guru Arjan who once stated, "I have seen all places, there is not another like thee" (SGGS p. 1362).

REFERENCES & NOTES

1. J.F. Fraser, *Round the World on a Wheel* (London: Methuen & Co., 1899), 203.

2. F. Singh, *The City of Amritsar* (Patiala: Punjabi University Press, 1977), 102.

3. M. Kaur, *The Golden Temple*, 3rd edition (Amritsar: Guru Nanak Dev University, 2013), 189.

4. S. Johar, *The Heritage of Amritsar* (New Delhi: National Book Shop, 2008), 37.

5. K. Virdi, *Amritsar and Guru Nanak Dev University. The Contours of Inheritance* (Amritsar: Guru Nanak Dev University, 2019), 63.

6. G. Singh Mann, "Guru Granth: The Scripture of the Sikhs," in *Brill's Encyclopedia of Sikhism*, eds. K.A. Jacobsen, G. Singh Mann, K. Myrvold and E. Nesbitt (Boston: Brill, 2017), 130.

7. W.H. McLeod, *Sikhs and Sikhism* (Oxford: Oxford University Press, 1999), 82.

NATIVE SOIL ART

As an act of deep reverence, artist Bholla Javed utilized soil from the sites depicted in paintings 3–5. He also used bamboo shoots from these sacred sites to make a brush to paint these artworks associated with Guru Nanak's life.

3. Gurdwara Nankana Sahib

Bholla Javed | 2004 | 23 x 35.25 in | Soil/acrylic/paint on board

Gurdwara Janam Asthan, popularly known as Gurdwara Nankana Sahib, is a highly revered place of worship that was built at the site where Guru Nanak was born.

4. Gurdwara Sacha Sauda

Bholla Javed | 2020 | 36 x 48 in | Soil/acrylic/paint on board

Built by Maharaja Ranjit Singh, Gurdwara Sacha Sauda, near Lahore in present-day Pakistan, is associated with a key event in Guru Nanak's early life. According to *janamsakhis,* the young Nanak fed a group of starving ascetics gathered at this site, using the money he had received from his father to trade.

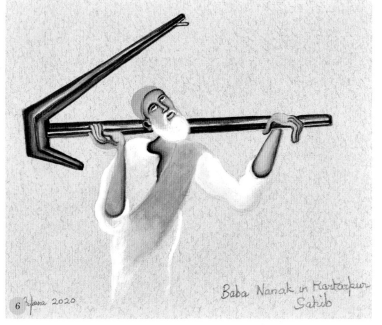

5. Kartarpur *dharamshala* well

Bholla Javed | 2018 | 17 x 11 in | Soil/acrylic/paint on board

Kartarpur (City of the Creator or Divine) was founded by Guru Nanak. This painting of a well has a deep social meaning since water from it was shared by all, thus breaking down barriers of caste, class, and religion.

6. Guru Nanak farming at Kartarpur Sahib

Arpana Caur | 2020 | 8.5 x 11.5 in | Pencil and pastel on paper

Guru Nanak settled in Kartarpur after his travels. He spent the last eighteen years of his life there teaching the principles of hard work, sharing, and remembrance of the Divine.

7. Gurdwara, Kartarpur Sahib

2019 | 4 x 6.25 in

Commemorative postal envelope issued by Pakistan in 2019, celebrating the 550th anniversary of Guru Nanak's birth and the opening of the Sri Kartarpur Sahib corridor, connecting the gurdwara in Pakistan to the border with India.

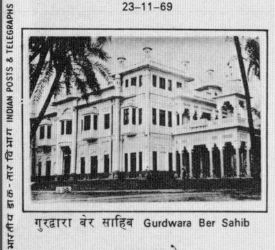

प्रथम दिवस आवरण FIRST DAY COVER

23-11-69

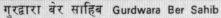

GURU NANAK DEV
23-11-69
NEW DELHI

गुरुद्वारा बेर साहिब Gurdwara Ber Sahib

गुरु नानक देव
GURU NANAK DEV

8

10

प्रथम दिवस आवरण FIRST DAY COVER

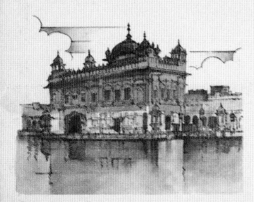

BOMBAY

श्री हरमंदर साहिब, अमृतसर
SRI HARMANDIR SAHIB, AMRITSAR

9

**8. Gurdwara Ber Sahib,
first-day cover and stamp**

1969 | 3.5 x 6 in

**9. Sri Harmandir Sahib,
Amritsar, first-day cover
and stamp**

1987 | 4 x 7 in

**10. Commemorative stamps
celebrating 300 years of the
birth of Khalsa, Gurdwara
Anandpur Sahib**

1999

11. Commemorative special-place cover and stamp of one of the five *takhts*, Gurdwara Patna Sahib, the birthplace of Guru Gobind Singh

2013 | 4.2 x 7.5 in

12. Commemorative postal envelope celebrating the 300th anniversary of Sri Guru Granth Sahib's final preparation. Guru Gobind Singh prepared the final version of the Sri Guru Granth Sahib at Takht Sri Damdama Sahib, in Bathinda, Punjab

2006 | 4 x 9 in

13. Gurdwara Sachkhand Sahib in Nanded, one of the five *takhts*, special cover and stamp commemorating the tercentenary of Guru Gobind Singh's death

2008 | 4.5 x 9 in

SRI HARMANDIR SAHIB, AMRITSAR

One of the world's holiest shrines, Sri Harmandir Sahib is regarded as the spiritual center of the Sikh faith. Originally built by Guru Arjan in the late sixteenth century, the gurdwara was renovated by Maharaja Ranjit Singh.

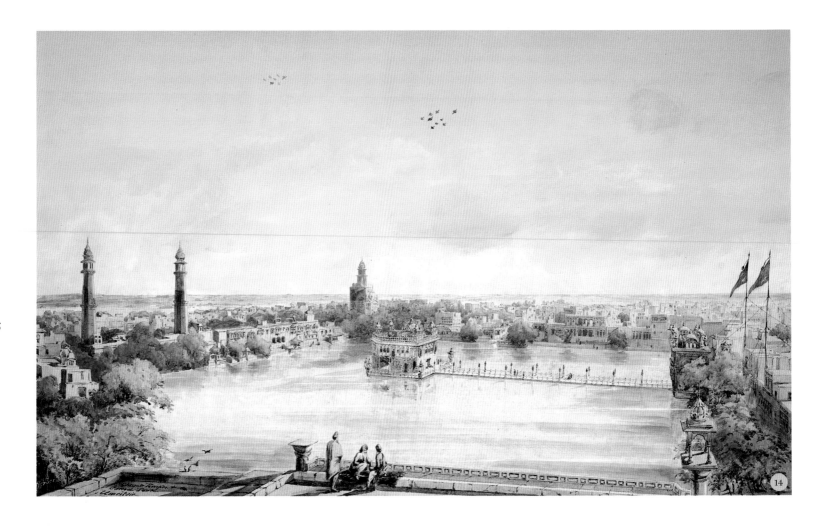

14. Golden Temple, Amritsar

Major Charles Herbert |
c. 1850s | 24 x 40 in |
Watercolor on paper

Likely one of the earliest and largest watercolors depicting a panoramic view of the Golden Temple and the city of Amritsar.

15. "The Holy Temple," from *Original Sketches in the Punjaub. By a Lady.*

c. 1854 | 7.75 x 10.5 in |
Hand-colored lithographs

Possibly privately published, this is from a collection of drawings by the wife of a British officer.

16. "Entrance to the Holy Temple at Umritsar, from the Gate of the Kutwallee," from *Original Sketches in the Punjaub. By a Lady.*

c. 1854 | 7.75 x 10 in | Hand-colored lithograph

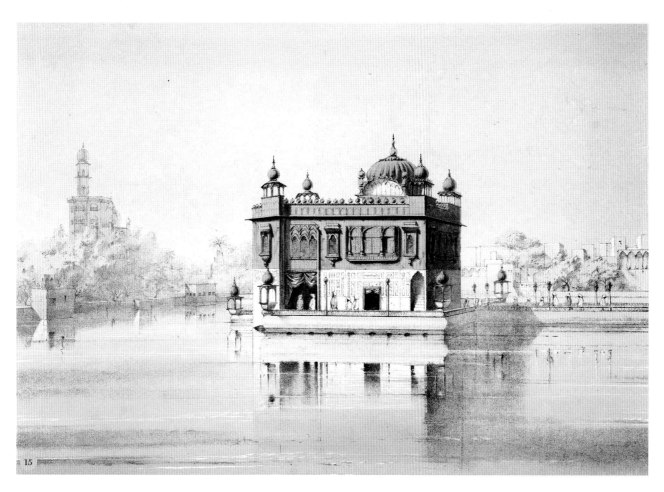

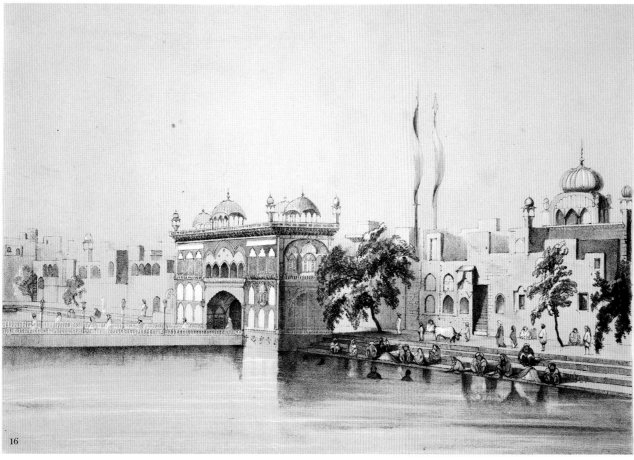

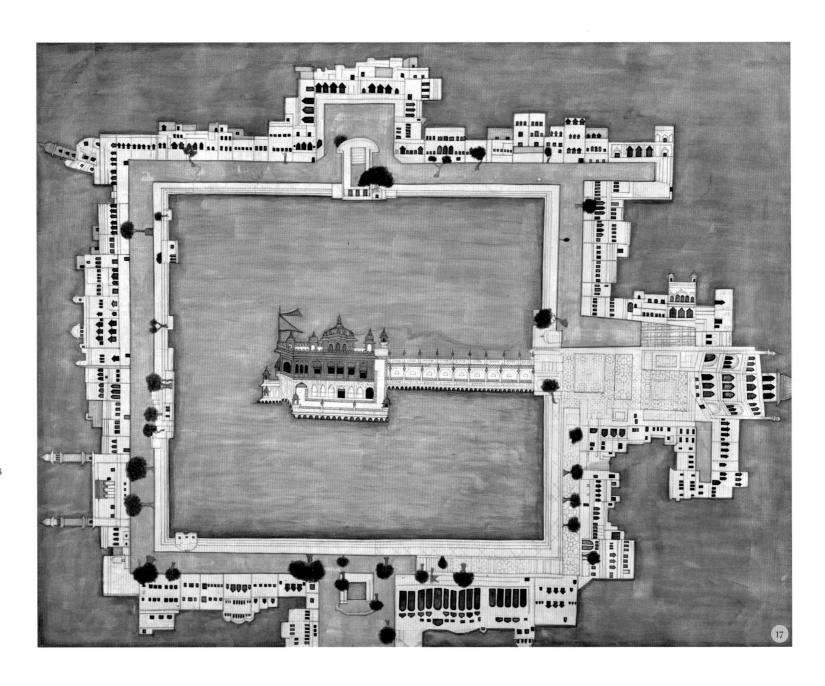

88

17. An architectural sketch of the Golden Temple, Amritsar

Artist unknown | *c.* Early 1900s | 21 x 26.5 in | Gouache on paper, mounted on linen

18. Golden Temple, Amritsar

Artist unknown | *c.* Mid- to late-19th century | 16.5 x 14 in | Pencil and wash on paper

19. Gateway to the Golden Temple at Amritsar, viewed from the causeway

Artist unknown | *c.* Mid- to late-19th century | 18.5 x 21.5 in | Pencil and wash on paper

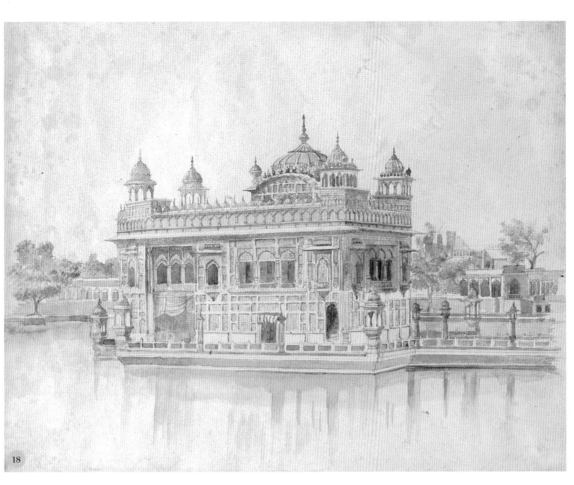

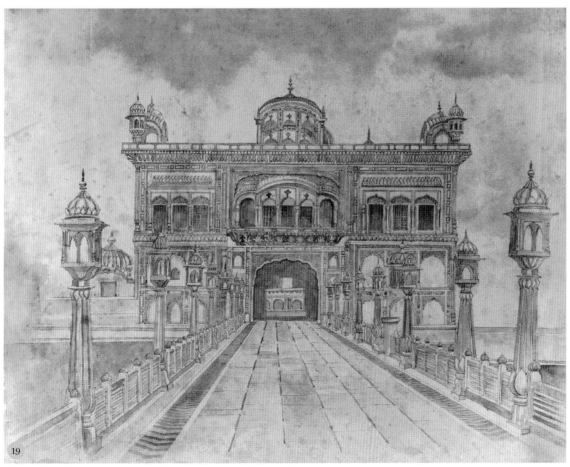

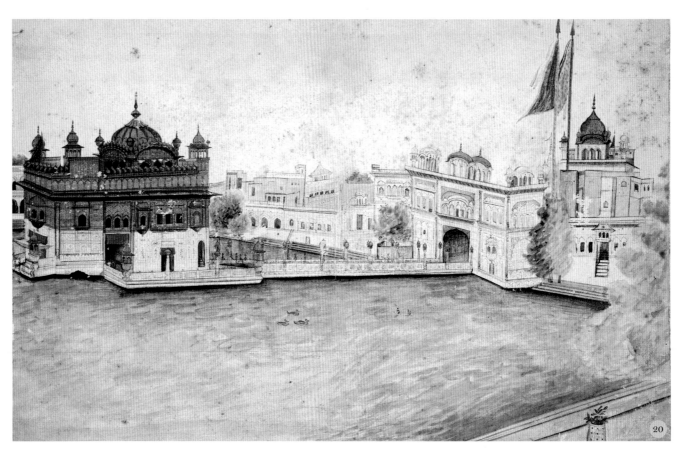

90

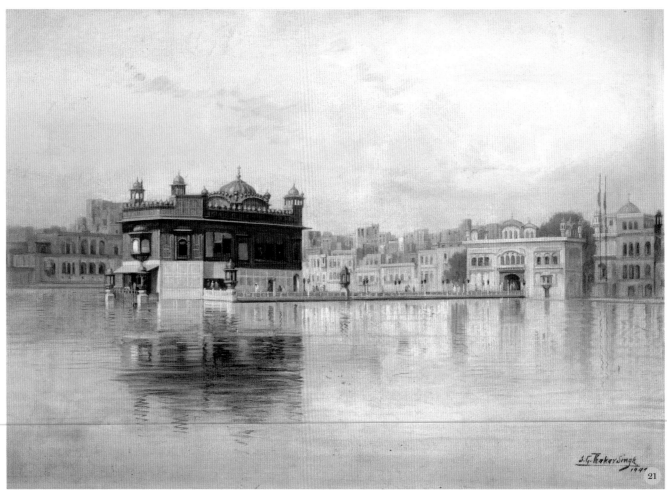

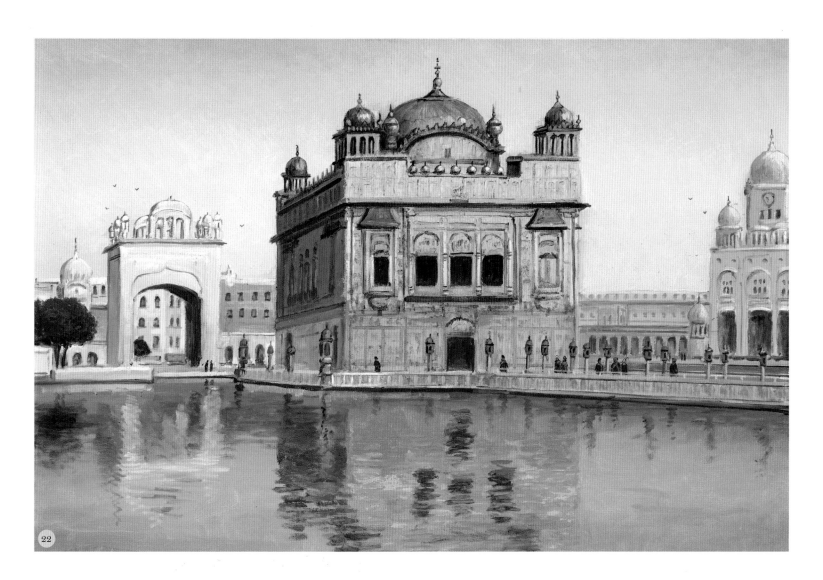

20. Golden Temple, Amritsar

Artist unknown | *c.* Early 1900s |
9 x 12 in | Watercolor on paper

21. Golden Temple, Amritsar

S.G. Thakur Singh | 1949 | 23 x 32 in
(with frame) | Oil on canvas

22. Golden Temple, Amritsar

Gregory Sievers | 1999 | 32 x 45 in |
Oil on canvas

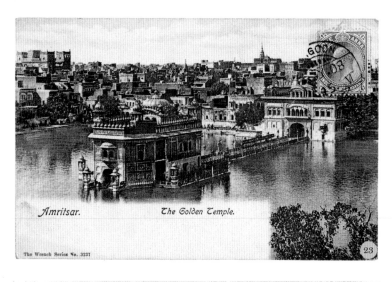

23

Amritsar. The Golden Temple.

The Wrench Series No. 3237

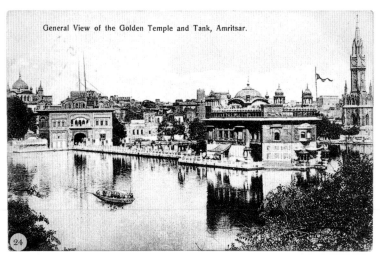

General View of the Golden Temple and Tank, Amritsar.

24

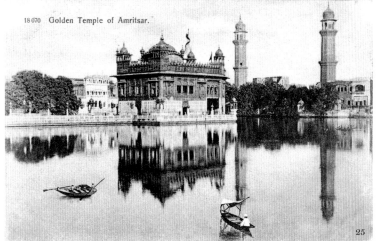

18070 Golden Temple of Amritsar.

25

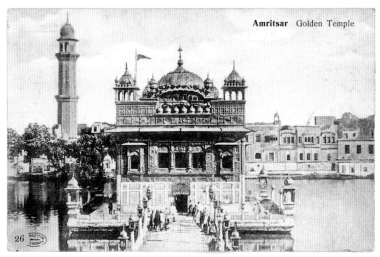

Amritsar Golden Temple

26

92

23-30. Golden Temple
complex, postcards

c. Early 1900s | 3.5 x 5.5 in (each)

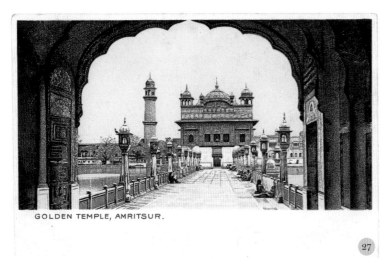

GOLDEN TEMPLE, AMRITSUR.

27

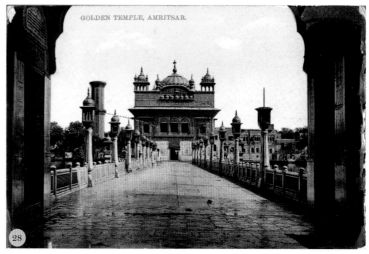

GOLDEN TEMPLE, AMRITSAR.

28

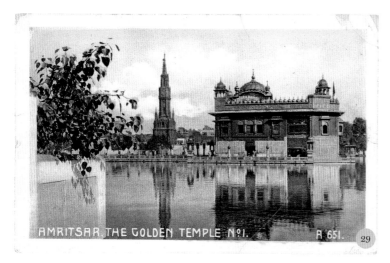

AMRITSAR. THE GOLDEN TEMPLE Nº1. A 651.

29

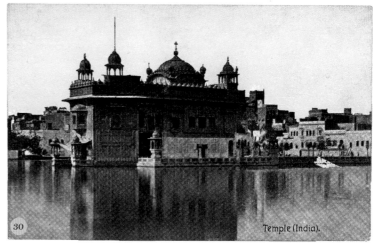

30

Temple (India).

93

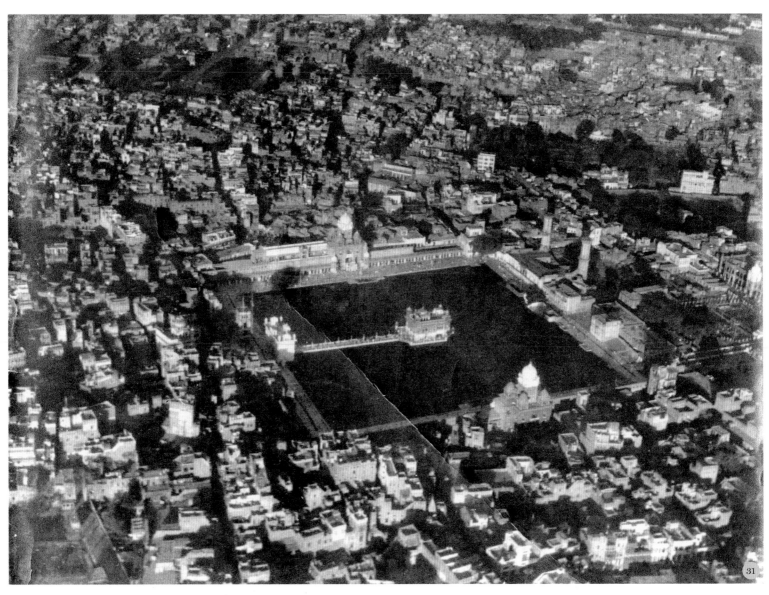

94

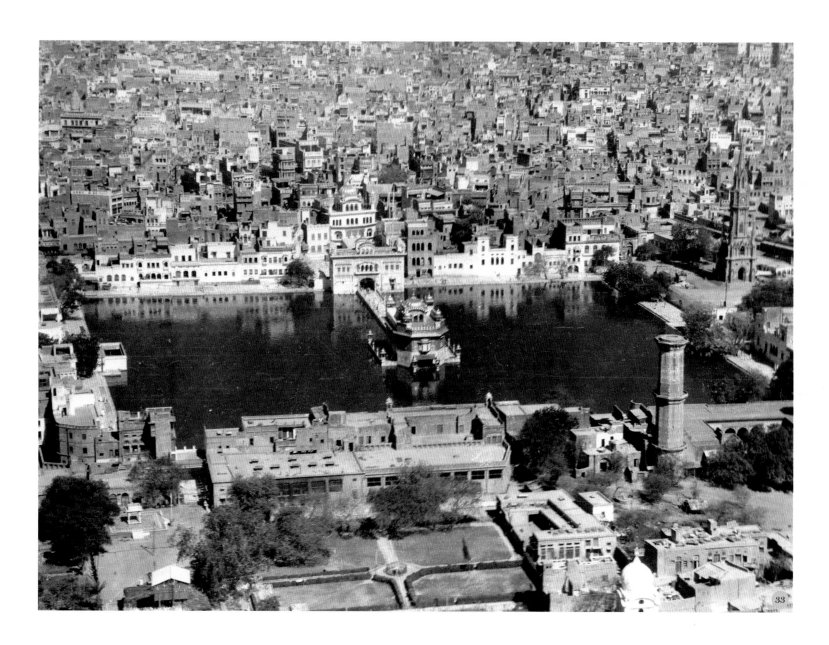

31. An aerial view of the
Golden Temple complex
and the city of Amritsar,
including Jallianwala Bagh

Photographer unknown |
c. 1950s | 15.5 x 11.6 in

32. Golden Temple with a
panoramic view of Amritsar

Photographer unknown |
c. Late 19th century | 8 x 11 in

33. An aerial photograph of
the Golden Temple complex

Photographer unknown |
c. Early 20th century | 6 x 8 in

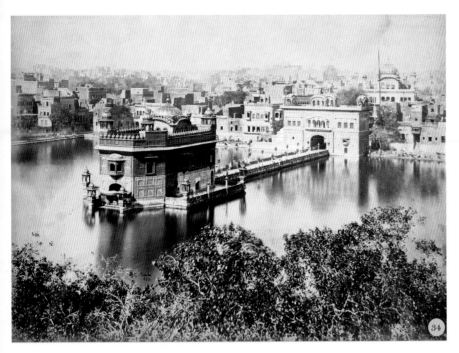

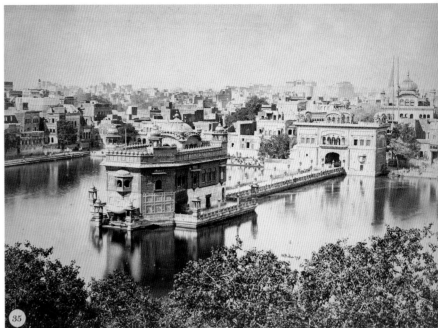

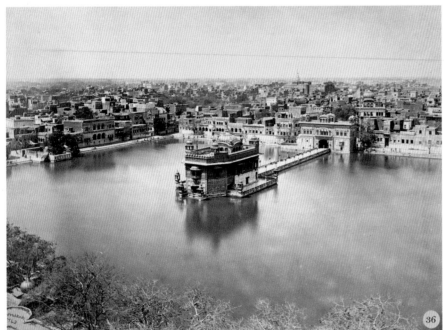

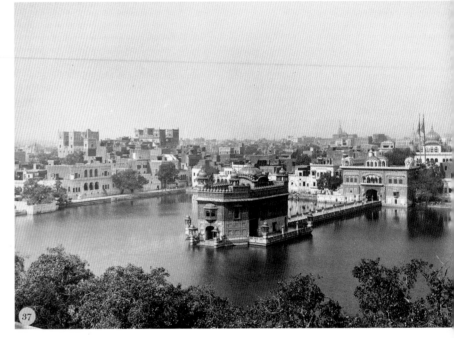

THE GOLDEN TEMPLE COMPLEX AND THE SACRED *SAROVAR*

Built on a square platform in the center of the *sarovar*, the temple symbolizes the historical and spiritual heritage of the Sikhs. The four entrances in four directions welcome people from all walks of life inside the sanctum sanctorum. Along with its surroundings this site is referred to as Golden Temple complex.

34.
John Edward Sache | *c.* 1870 | 9 x 11 in | Albumen print

35.
William Henry Baker | *c.* 1870 | 8.75 x 11.6 in | Albumen print

36.
George Craddock | *c.* 1870-80 | 8.5 x 11.5 in | Albumen print

37.
Photographer unknown | *c.* 1895 | 8.5 x 11.75 in

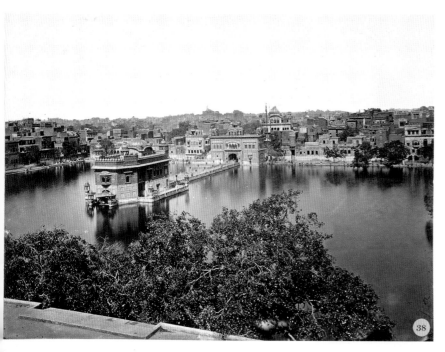

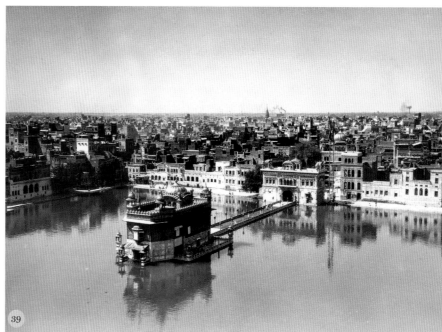

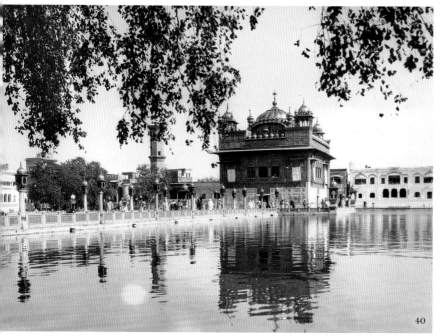

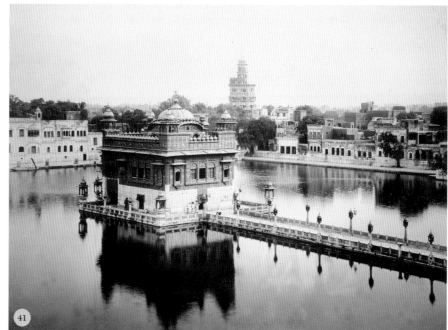

38.

Photographer unknown | *c.* Late 19th century | 9 x 9.5 in

39.

Photographer unknown | *c.* Late 19th century | 9 x 11 in

40.

Photographer unknown | *c.* Late 19th/ early 20th century | 8.5 x 11 in

41.

Photographer unknown | *c.* Late 19th/ early 20th century | 8.5 x 11.5 in

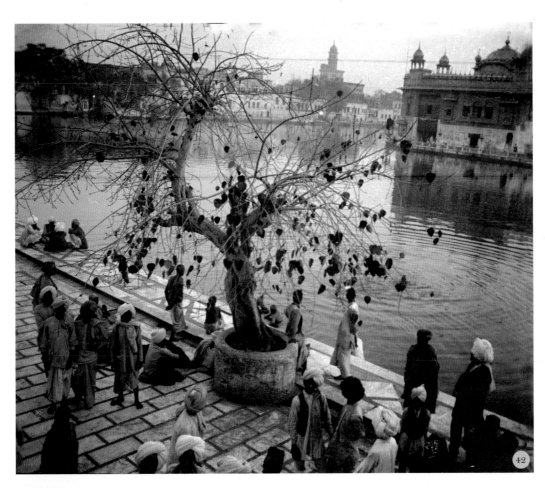

42

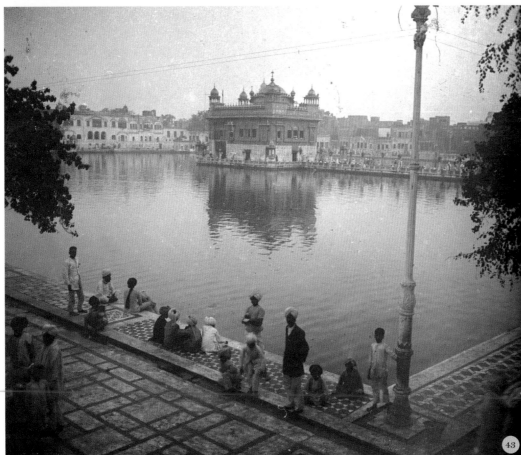

43

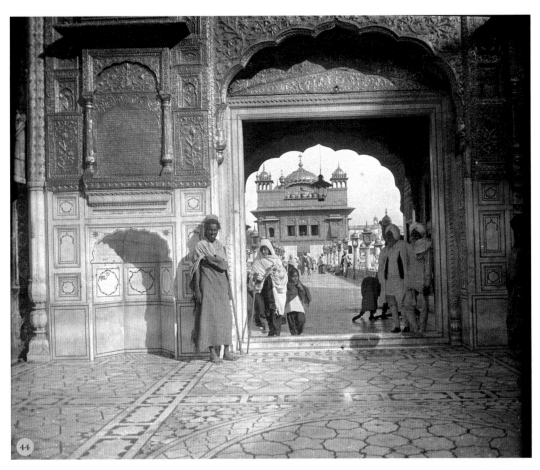

42. Devotees resting near the sacred jujube tree, Dukh Bhanjani Beri, Golden Temple

Photographer unknown |
c. 1900-1910 | 1.5 x 4 in |
Glass plate negative

43. Devotees sitting on the edge of the *sarovar*, Golden Temple

Photographer unknown |
c. 1900-1910 | 1.5 x 4 in |
Glass plate negative

44. Entrance to the Golden Temple

Photographer unknown |
c. 1900-1910 | 1.5 x 4 in |
Glass plate negative

45. Devotees sitting in the courtyard of the Golden Temple

Photographer unknown |
c. 1900-1910 | 1.5 x 4 in |
Glass plate negative

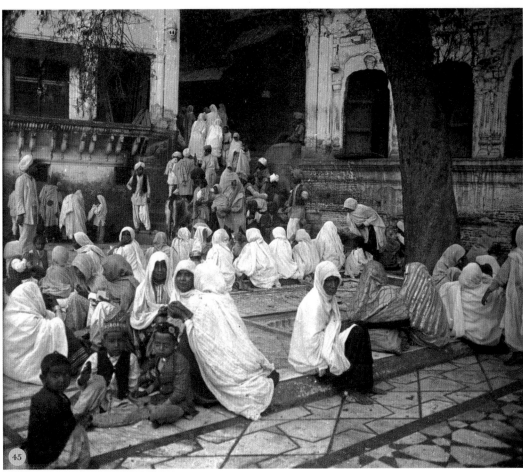

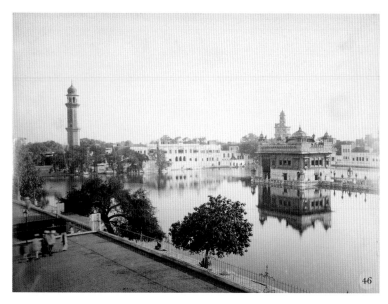

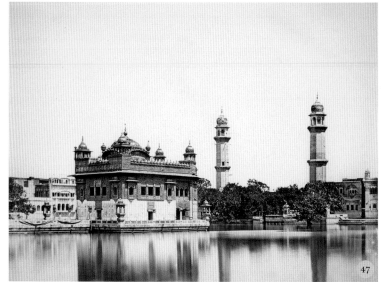

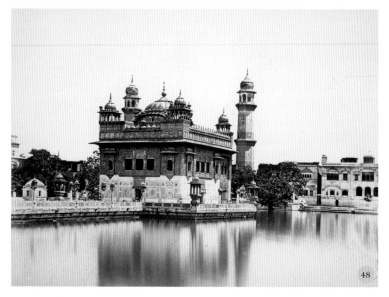

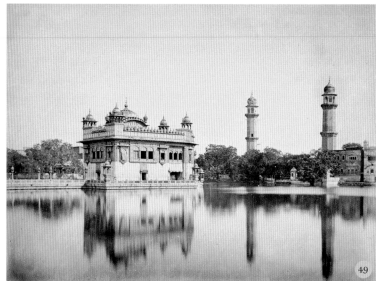

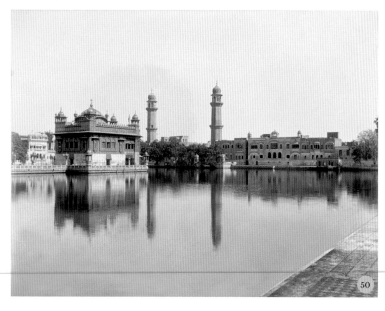

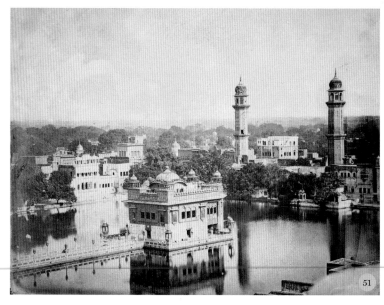

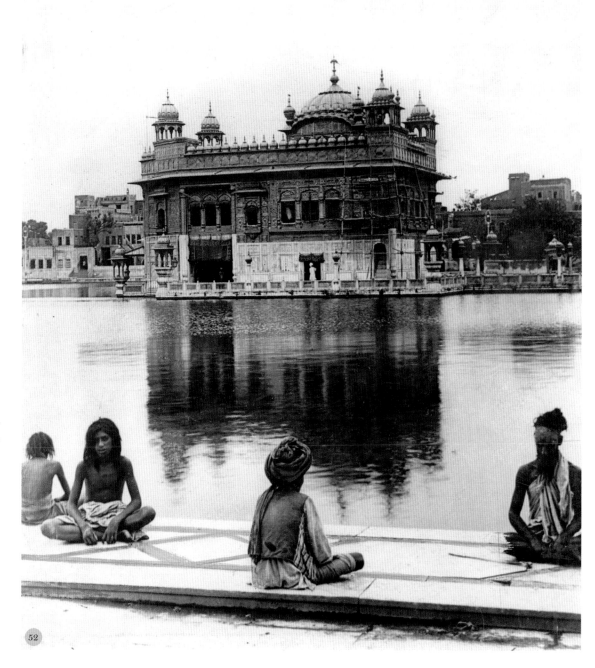

46. Golden Temple and *sarovar*

Photographer unknown |
c. Late 19th century | 9.2 x 11.5 in

47. Golden Temple and *sarovar*

Felice Beato | 1859 | 9 x 11 in |
Albumen print

This was most probably one of the earliest photographic studies of the Golden Temple complex. Felice Beato, an Italian-British photographer produced a series of nineteen images, some of which are a study of the architectural details of the complex.

48. Golden Temple, Amritsar

Felice Beato | 1859 | 9 x 11 in |
Albumen print

49. Golden Temple, Amritsar

Samuel Bourne | *c.* 1864 |
8.5 x 11.5 in | Albumen print

50. Golden Temple, Amritsar

John Burke | 1870 | 9.5 x 11.7 in |
Albumen print

51. Golden Temple, Amritsar

Photographer unknown | *c.* Late 19th century | 9.5 x 11 in | Albumen print

52. *Sadhus* (possibly *udaasis* or travelers) at the edge of the sacred pool overlooking the Golden Temple

Underwood & Underwood |
c. 1903 | 7.7 x 6.2 in |
Albumen print

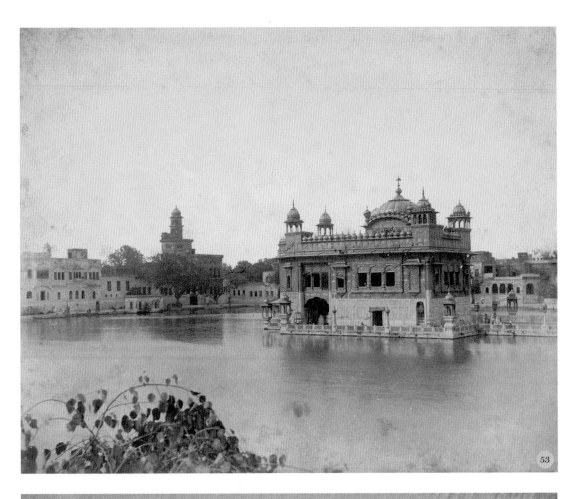

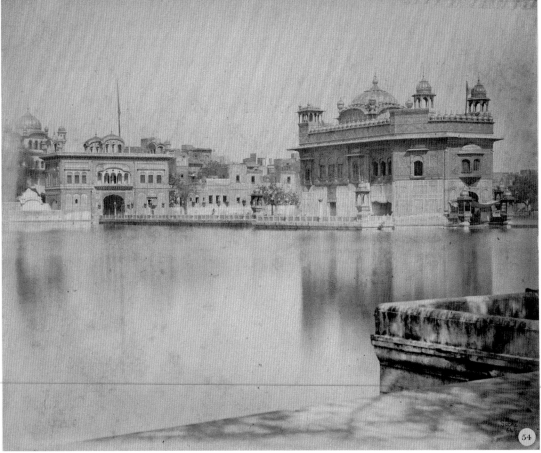

53. Golden Temple and Gurdwara Baba Atal in the background

Photographer unknown |
c. Late 19th century | 9.5 x 11 in |
Albumen print

54. Golden Temple and the sacred *sarovar* in the foreground

John Edward Sache | *c.* 1870s |
9 x 11 in | Albumen print

55. Golden Temple with entrance to the causeway to the right

Photographer unknown | *c.* Late 19th century | 10.5 x 14.5 in |
Albumen print

56. Golden Temple with children and pilgrims in the foreground

Photographer unknown |
c. Early 20th century | 4.3 x 7.5 in |
Albumen print

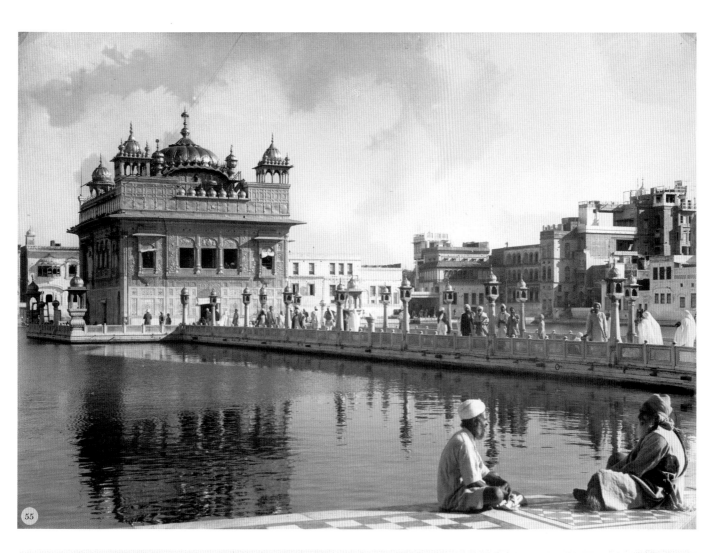

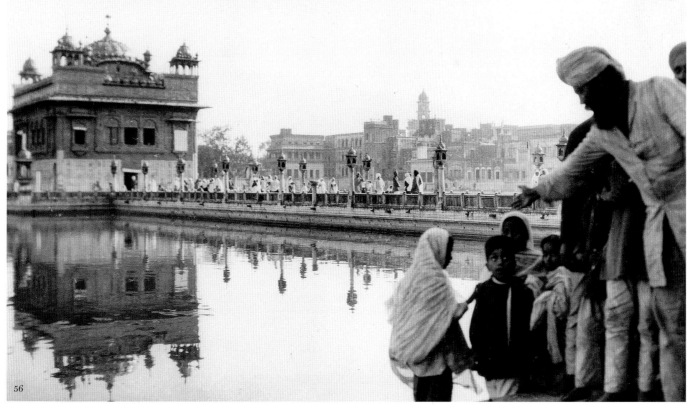

CLOCK TOWER, AMRITSAR

The construction of the gothic style clock tower started in 1862 and was finished in 1874. Built by the British Government, the tower was demolished seventy years later, in the closing months of 1945.

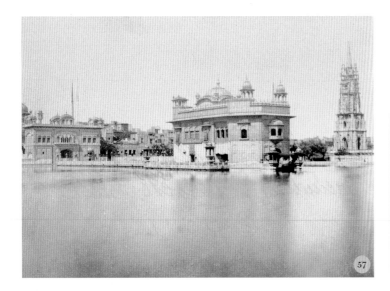

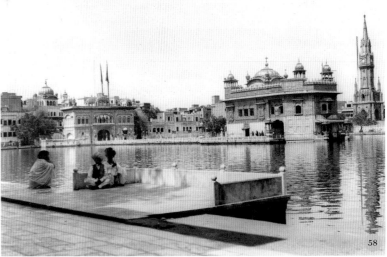

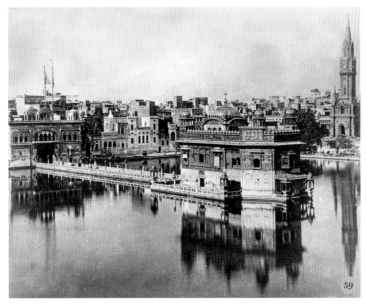

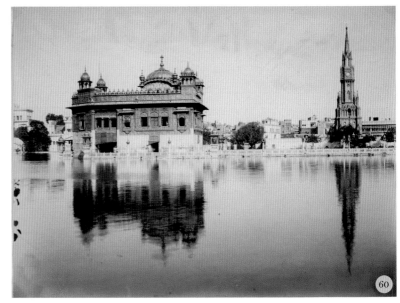

57. Golden Temple and a view of the partially constructed clock tower, Amritsar

Photographer unknown | *c.* 1870 | 3.9 x 5.5 in | Albumen print

58. Golden Temple and the clock tower with pilgrims in the foreground

Photographer unknown | *c.* Early 20th century | 6.5 x 9.5 in | Albumen print

59. Golden Temple and the clock tower

Photographer unknown | *c.* Late 19th century | 8 x 10 in | Albumen print

60. Golden Temple and the clock tower

Photographer unknown | *c.* Late 19th century | 9 x 11 in | Albumen print

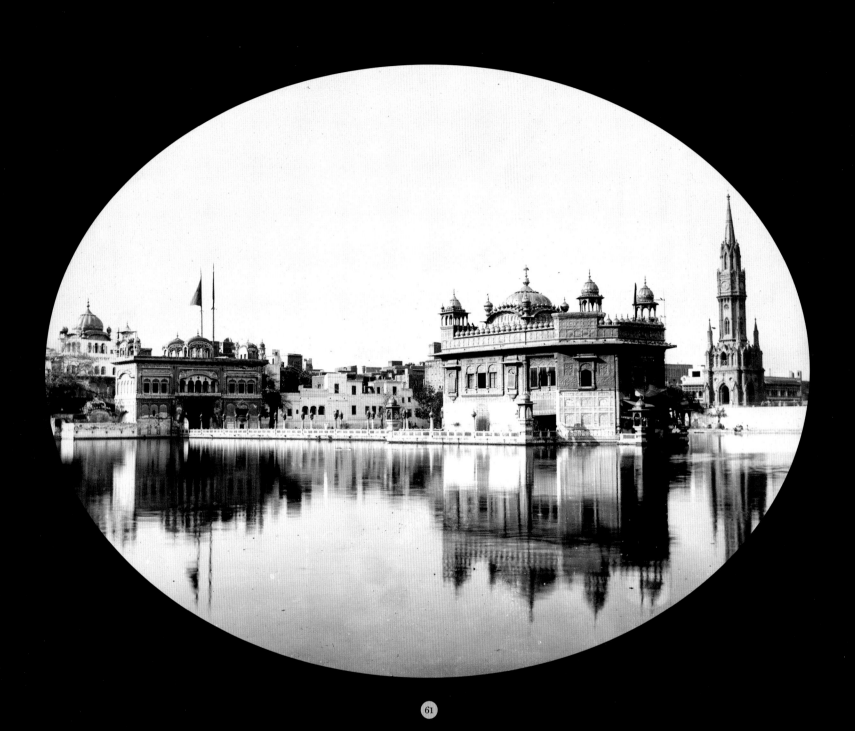

61

61. Golden Temple, Akal Takht
(left), and the clock tower

Photographer unknown |
c. Early 1900s | 7 x 9 in |
Albumen print

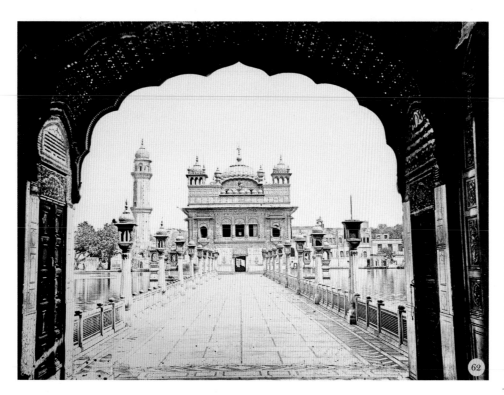

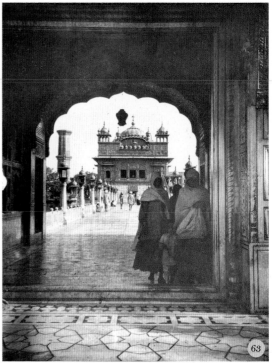

62. Golden Temple as viewed from the Darshani Deori

Photographer unknown |
c. Late 19th century | 6.5 x 8.25 in |
Albumen print

63. Golden Temple, a view from the entrance to the causeway

Photographer unknown |
c. Early 20th century | 8.5 x 6.5 in |
Albumen print

64. View from the causeway away from Sri Harmandir Sahib

John Burke | *c.* 1870 |
10.25 x 12.5 in | Albumen print

65. On the causeway looking towards the Darshani Deori, Golden Temple, Amritsar

Photographer unknown |
c. 1895 | 15.2 x 17.7 cm |
Albumen print

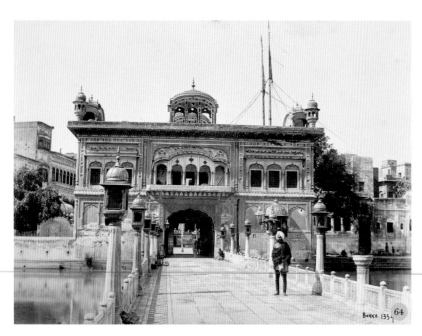

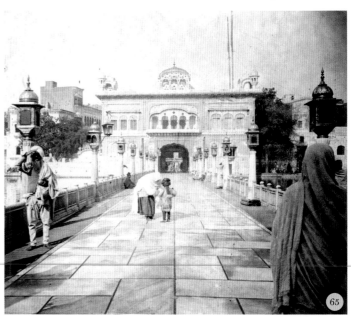

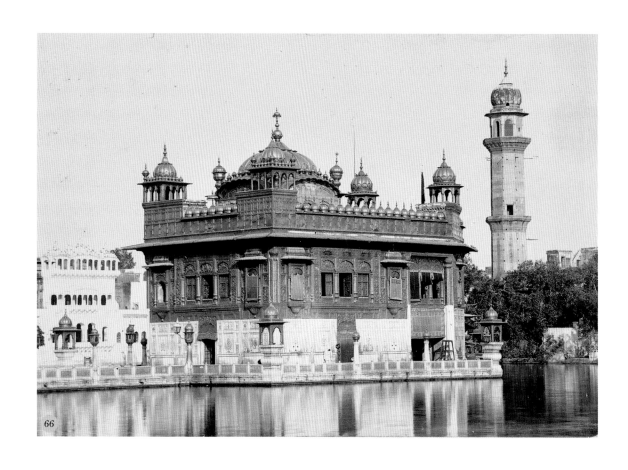

66

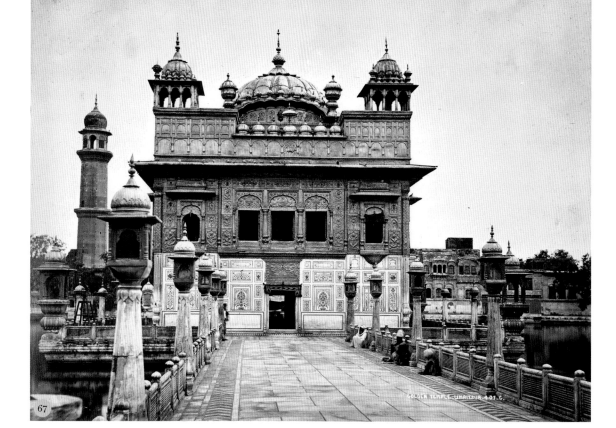

67

66. Golden Temple

Photographer unknown |
c. 1900 | 4.2 x 6.25 in |
Albumen print

**67. Entrance to the causeway
leading to Darbar Sahib, the
sanctum sanctorum of the
Golden Temple complex**

Samuel Bourne | *c.* 1863–64 |
9 x 11.2 in | Albumen print

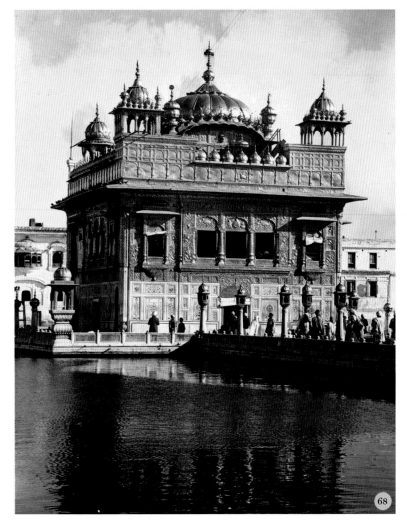

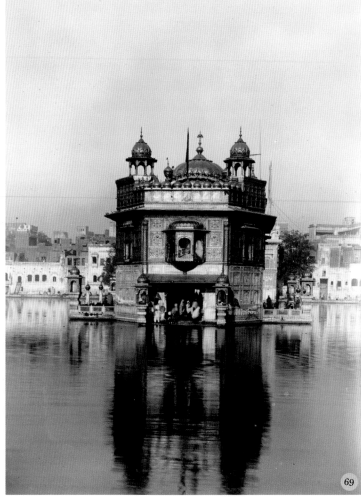

68. Golden Temple

Photographer unknown |
c. Late 19th century | 14.5 x 11.5 in |
Albumen print

**69. View of Har ki Pauri,
Golden Temple**

Photographer unknown |
c. 1910 | 8.2 x 5.9 in | Albumen print

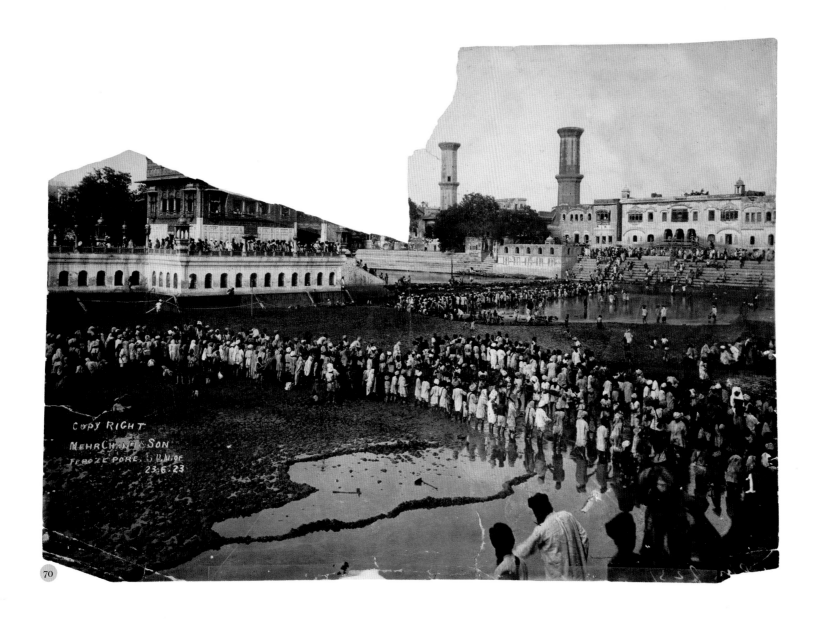

70. Cleaning of the *sarovar* by devotees, Golden Temple

Photographer unknown | 1923 |
8 x 11.25 in | Albumen print

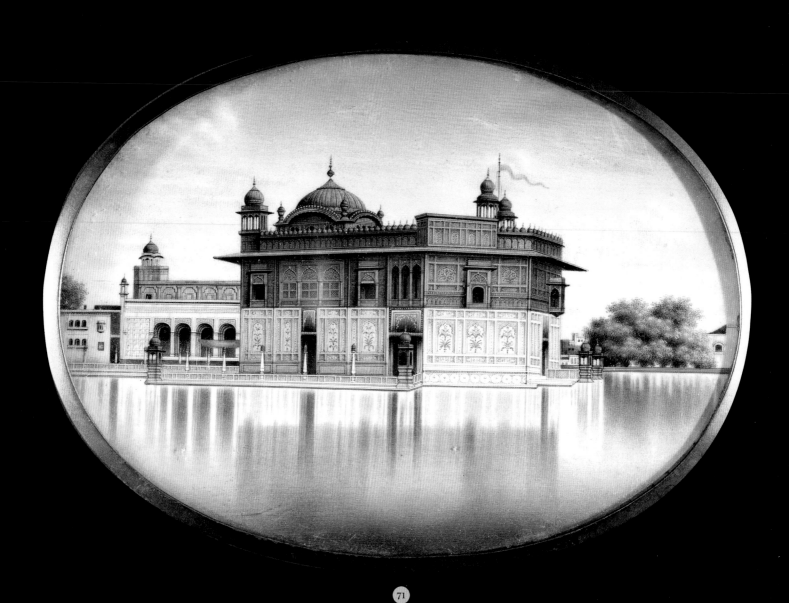

71

71. Golden Temple

Artist unknown | *c.* 1850–60s |
4.5 x 6.5 in | Painting on ivory

72–75. Interior of the Golden Temple with details of different decorations and artwork

Satpal Danish | Late 20th century | Photographs, 11.5 x 8.25 in (each)

76. Preparatory sketch for *jaratkari* (marble inlay)

Gian Singh Naqqash | Early 20th century | 14 x 12 in | Watercolor on paper

Jaratkari is an art form characterized by interesting designs obtained by inlaying stones in marble. It was used to decorate gurdwaras. Main designs include flowers, leaves, fruits, and human figures.

77. Preparatory sketch of *mohrakashi* (frescos)

Gian Singh Naqqash | Early 20th century | 16 x 12 in | Watercolor on paper

Original work on paper with pigments to finalize the design and color scheme. This sketch was used to trace and transfer the pattern to the wall at the Golden Temple. Gian Singh Naqqash was one of the last fresco painters who worked at the Golden Temple.

78. Sons of Guru Nanak, Lakhmi Chand and Sri Chand with Ani Rai, son of Guru Hargobind

Artist unknown | *c.* 1891 | Copper plate

Copper-embossed plates like this one can be seen on the upper portion of the walls in gurdwaras, usually over a doorway or window.

79. Guru Gobind Singh with attendants

Artist unknown | *c.* Late 19th century | 4 x 7.5 in | Silver plaque

The solid rectangular silver plaque shows Guru Gobind Singh on horseback with a falcon resting on his hand. He is accompanied by attendants holding a *chaur sahib* and a battle standard. This plate is similar to the gilded panels found at the Golden Temple complex.

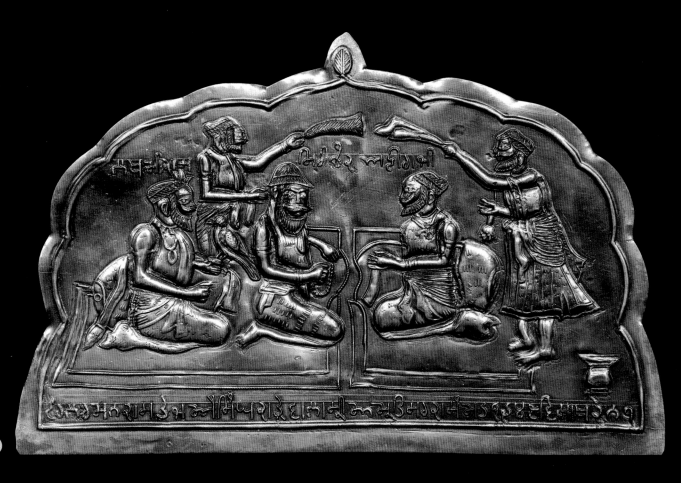

78

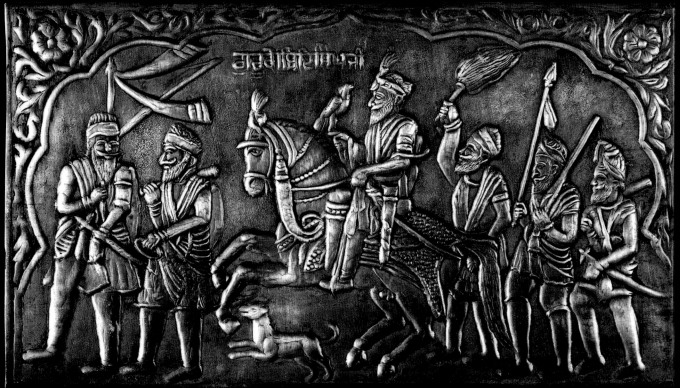

79

80. Baba Buddha carrying the Adi Granth Sahib to Harmandir Sahib

Devender Singh | 2020 | 34 x 54 in | Oil on canvas

Bhai Buddha carrying the Adi Granth Sahib on his head and Guru Arjan walking behind with the *chaur sahib*, leading the *sangat* singing hymns. The Sri Guru Granth Sahib was ceremonially installed in the center of the inner sanctuary in 1604.

81. Maharaja Ranjit Singh presenting gifts at Harmandir Sahib

Devender Singh | 2020 | 54 x 64 in | Oil on canvas

Maharaja Ranjit Singh holds an open *durbar* or court to present the precious ornaments and jewels at the Golden Temple. Among his family members and prominent courtiers, seated next to him is his son Kharak Singh and grandson Nau Nihal Singh.

82. Bhai Buddha carrying the Adi Granth Sahib

Arpana Caur | 2020 | 11.5 x 8.5 in | Pencil and pastel on paper

The first *granthi* of Sri Harmandir Sahib, Bhai Buddha occupies a unique position in Sikh history. He remained in close association with the first six Sikh gurus for over a hundred years.

FELICE BEATO IN AMRITSAR

In October 1859, while traveling in India, Felice Beato visited Amritsar, the spiritual and cultural center of Sikh religion and produced a series of nineteen images of the city. Images 90–98 are part of Beato's monumental photographic study of the Golden Temple complex and other buildings in Amritsar.

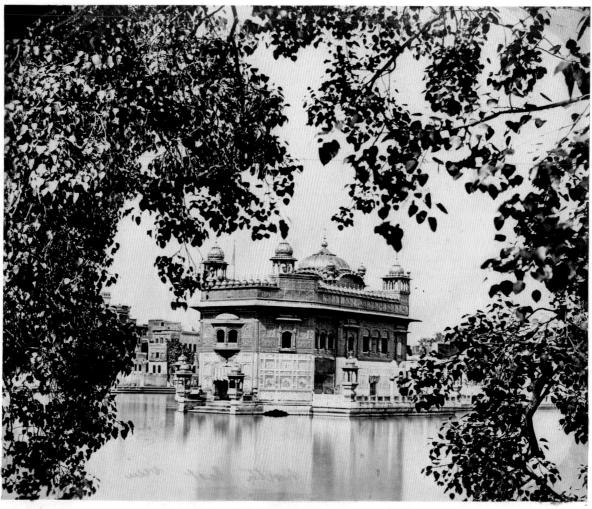

GOLDEN TEMPLE, DURBAR SAHIB

UMRITSIR.

83

83. Golden Temple, view from northeast

Felice Beato | 1859 | 11.2 x 9.2 in | Albumen print

84. Golden gate and entrance to the temple

Felice Beato | 1859 | 11.8 x 10 in | Albumen print

85. Marble mosaic, inside the Golden Temple

Felice Beato | 1859 | 11 x 9.3 in | Albumen print

86. Street inside the sacred tank area, Golden Temple

Felice Beato | 1859 | 12 x 9.2 in | Albumen print

87. View of the Akal Takht, Golden Temple

Felice Beato | 1859 | 12 x 10.1 in | Albumen print

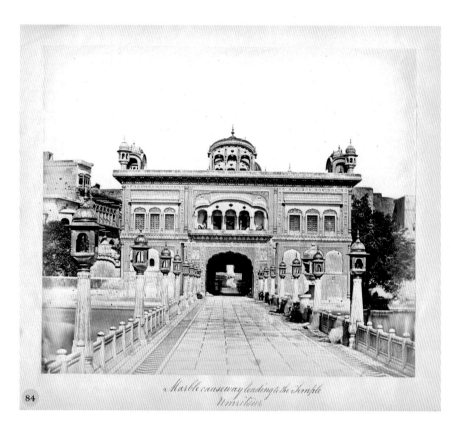

Marble causeway leading to the Temple
Umritsur

84

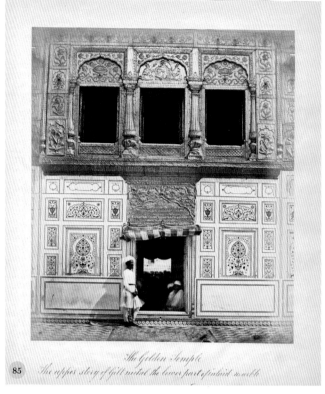

The Golden Temple
The upper story of gilt metal the lower part of inlaid marble

85

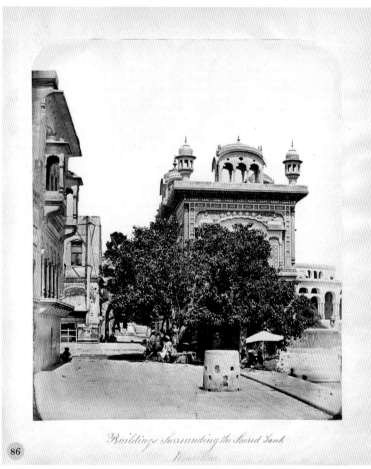

Buildings Surrounding the Sacred Tank
Umritsur

86

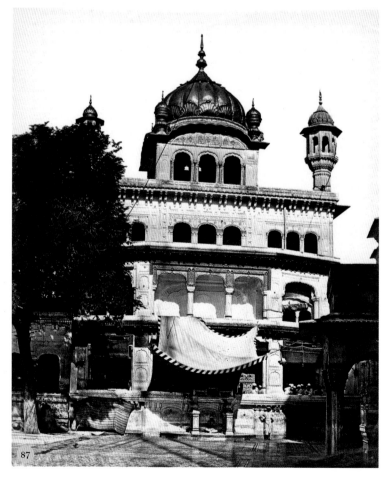

87

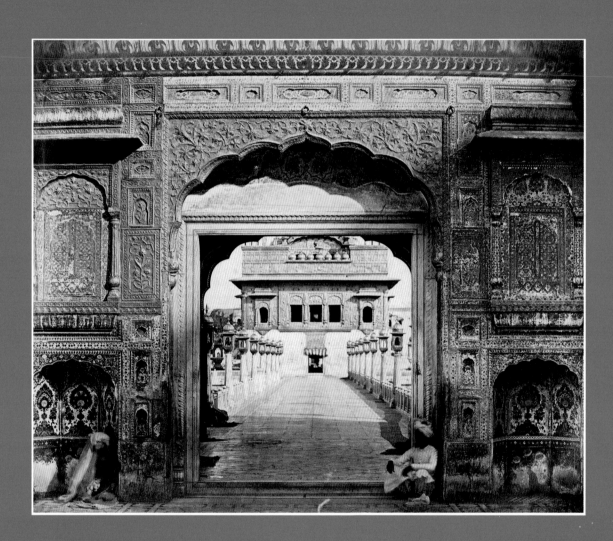

88. View through the piazza with golden lamps

Felice Beato | 1859 | 11.2 x 9.2 in | Albumen print

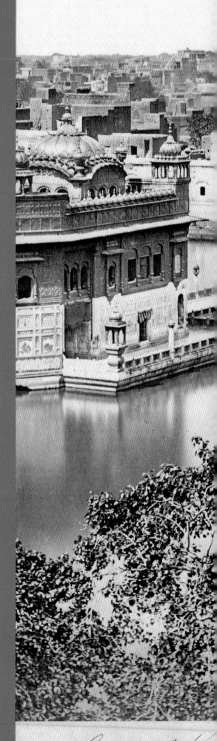

General Vie

Golden Temple

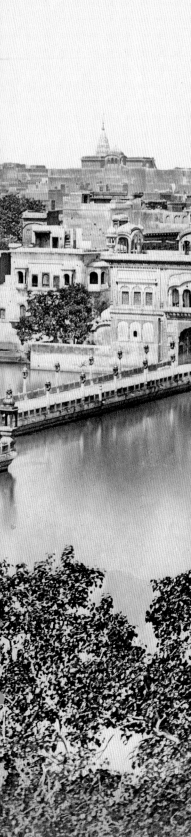

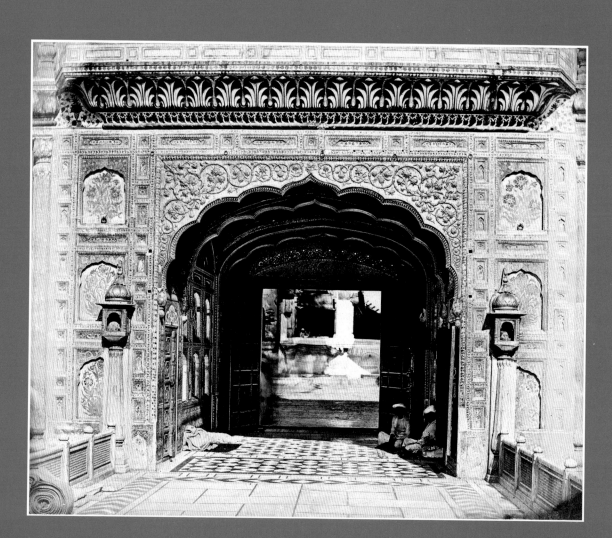

90. Goden gate to the temple (near view)

Felice Beato | 1859 | 11.8 x 10 in | Albumen print

GURDWARA BABA ATAL SAHIB

According to popular belief, Atal Rai, at the age of nine, revived his close friend Mohan after his sudden death. Guru Hargobind felt that his son's act was against Sikh tradition and rebuked him for performing a feat involving a miracle. He also warned him that one's spiritual power should not be displayed. Young Atal Rai went into a meditative trance and soon breathed his last. Gurdwara Baba Atal Sahib, made in his memory, is an octagonal tower situated to the south of the Golden Temple. Its nine stories represent Atal Rai's nine years of life before his death in 1628.

126

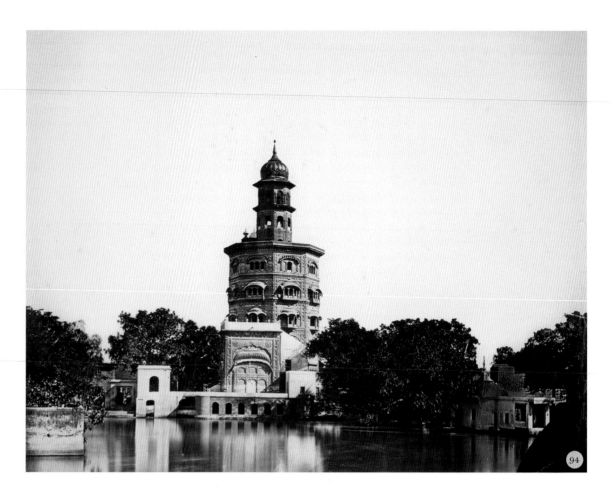

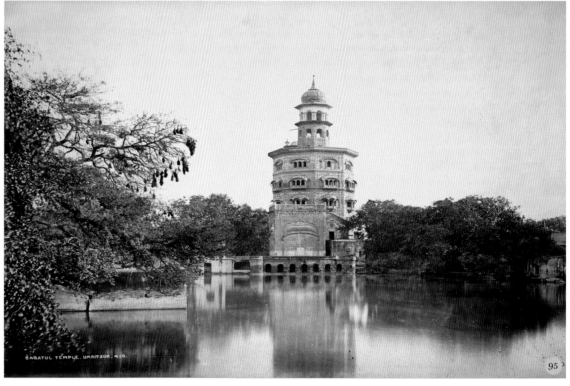

94.

Felice Beato | 1859 | 9 x 11 in | Albumen print

95.

Bourne and Shepherd | *c.* 1863–64 | 9 x 11 in | Albumen print

96.

G.S. Sohan Singh | *c.* 1940 | 17 x 11.5 in | Oil on canvas

96 G.S. CONAN SINGH

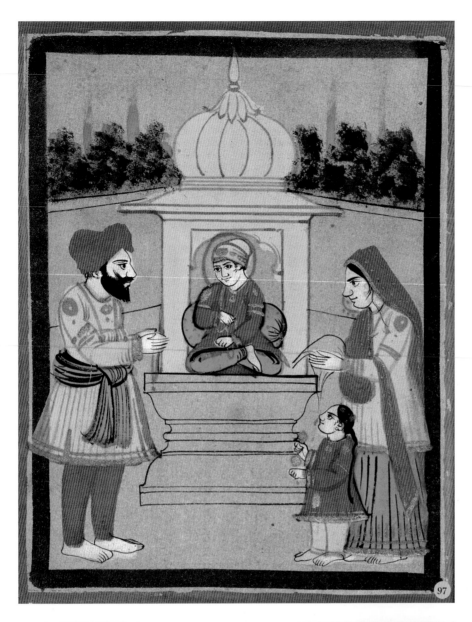

128

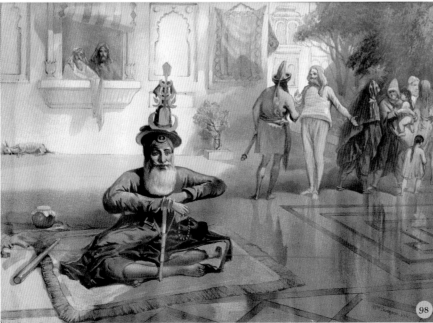

97. Baba Atal Rai being visited by his friend Mohan and his parents

Artist unknown | *c.* Late 19th century | 8 x 6.3 in | Gouache and gold dust

98. Akali Mohan Singh Nihang resting on his fakir's crutch in the forecourt between the Golden Temple and Akal Takht, Amritsar

William Simpson | *c.* 1860s | 9.6 x 13.4 in | Chromolithograph

99. Darshani Deori and Akal Takht viewed from the clock tower platform

Fred Bremner | 19th century | 5.7 x 8 in | Albumen print

100. The great square, Akal Takht, Golden Temple

Lala Deen Dayal | *c.* 1880–85 | 9.5 x 11.75 in | Albumen print

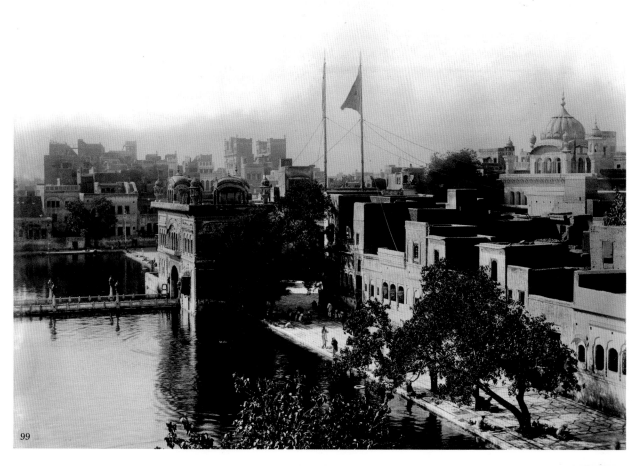

99

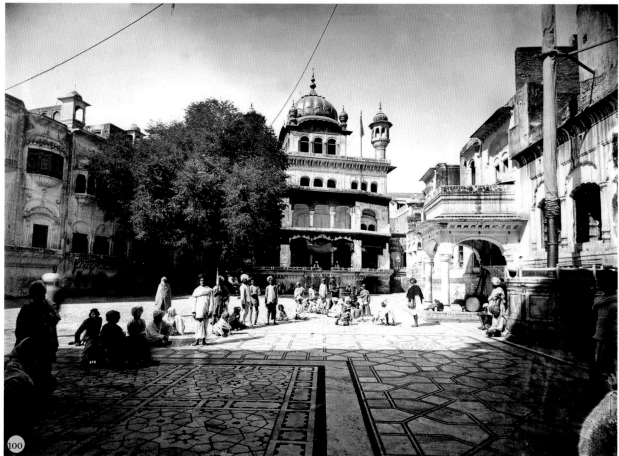

100

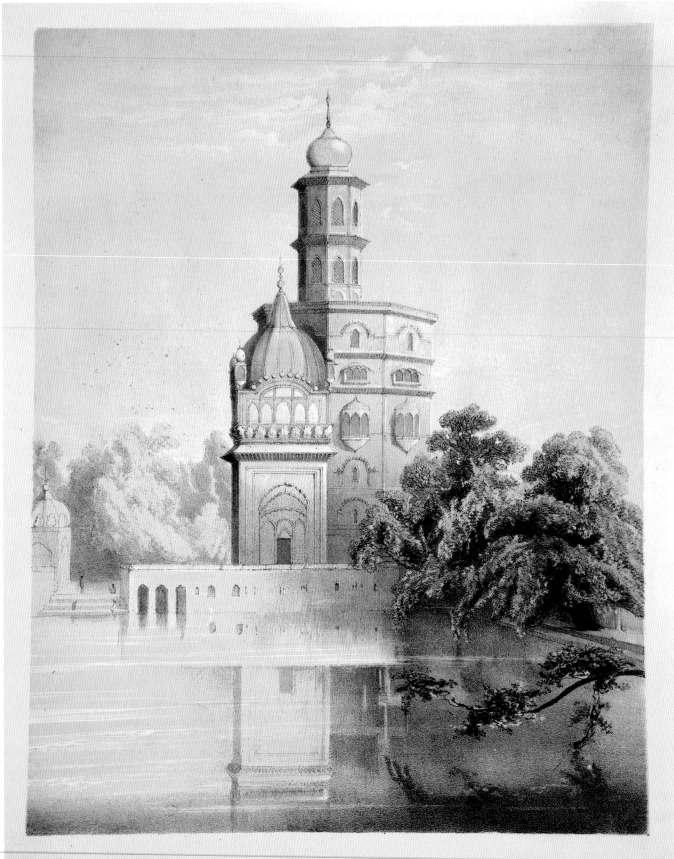

A Seikh Temple in honor of Baba Attull Raee, youngest son of Hur Govind,
6th in descent of the Seikh Gooroos.

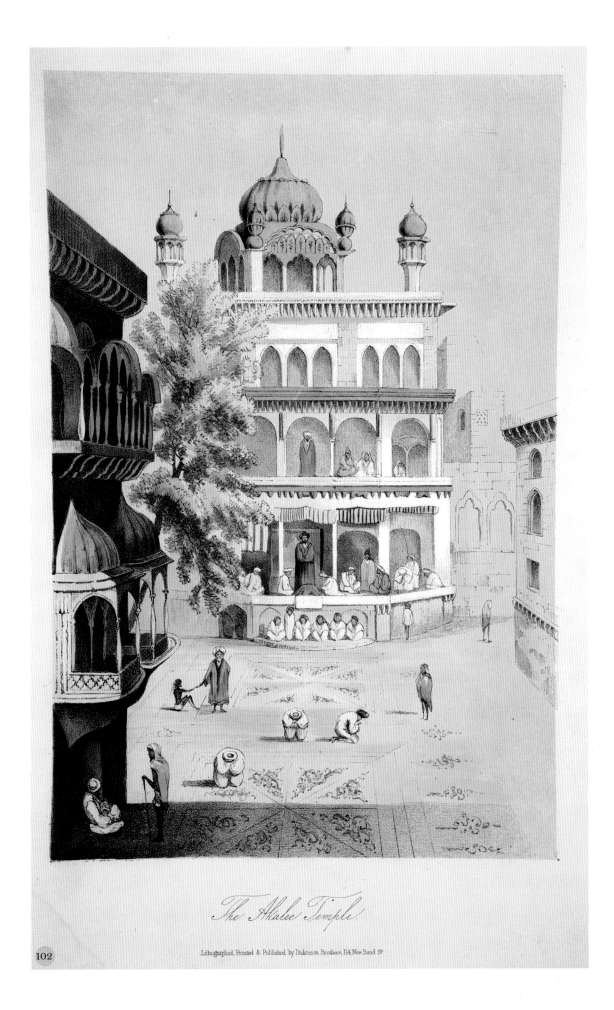

The Akalee Temple

Lithographed, Printed & Published by Dickinson Brothers, 114, New Bond St.

102

101. Gurdwara Baba Atal from *Original Sketches in the Punjaub. By a Lady.*

c. 1854 | 8.75 x 11 in | Hand-colored lithograph

102. View of Akal Takht from *Original Sketches in the Punjaub. By a Lady.*

c. 1854 | 10.5 x 7.25 in | Hand-colored lithograph

3

THE FIGHT FOR *DEGH*, *TEGH*, AND *FATEH*: BANDA SINGH BAHADUR AND THE *MISLS*

"He disdained an earthly superior and acknowledged no other master than his prophet."[1]

G. Forster on a Sikh man's reaction upon being asked his leader's name

The tenth guru of Sikhism, Guru Gobind Singh, initiated the Khalsa tradition, which, in the words of Purnima Dhawan, was "created as a casteless egalitarian community," whose members were "bound to each other by brotherly love and a sense of service."[2] Guru Gobind also empowered the Khalsa by allowing groups of five baptized Sikhs to act as representatives and make decisions for the community and on behalf of the guru. While visiting the southern part of India, the tenth guru baptized Banda Singh Bahadur and entrusted him and a group of accompanying Sikhs with the task of going back to Punjab and creating a just society. In the words of Max A. Macauliffe, "the Guru instructed Banda in the tenets of his religion, and in due time baptized him."[3]

After their arrival in Punjab, Banda Singh Bahadur and the men who had been traveling with him quickly created a fighting force comprising of mostly Sikhs, low-caste Hindus, and Muslims, who took on the Mughal imperial army and fought against oppression. The struggle against the Mughals fostered an awakening amongst the people of Punjab and laid the foundation for the political freedom of the region and Sikhs. As Michael Hawley has noted, the principle of Sikhism "were appropriated by Banda Bahadhur in the slogan '*deg, tegh, fateh*' (cooking pot, sword, victory)," an expression conveying "the message that feeding the poor (*degh*: cooking pot) and protecting the oppressed (*tegh*: sword) are mutual obligations in the Khalsa way of life."[4]

Between 1709 and 1715, Banda Singh Bahadur instituted social reforms, including granting the right of proprietorship to peasants. This decision was informed by the fact that when Guru Gobind Singh initiated the Khalsa tradition, he had advocated for the concepts of equality and sovereignty of the downtrodden. In their fight against the Mughals, the army assembled by Banda Singh Bahadur adopted a guerilla warfare known as *dhai put* (meaning, hit, run, and turn back to hit again), a strategy that proved to be highly effective against the heavily armed imperial forces. Banda Singh Bahadur soon succeeded in taking control of the area between Jamuna and Sutlej, after capturing Sirhind, the region's main city, and subjugating surrounding towns. After consolidating his power in the region, he struck coins, inscribing the names and words of the gurus, thus establishing a symbol of sovereignty.

Punjab's peasantry rose in a wave of freedom, causing Mughal authority to survive only in the capital city of Lahore and in Kasur. It required the full might of the Mughal army to defeat Banda Singh Bahadur. After numerous battles, Banda Singh Bahadur and hundreds of his companions were captured. The Mughals tortured and eventually executed them in Delhi in March 1716. As historian Ganda Singh has noted, "the Sikhs welcomed death with undaunted spirit, presented their heads to the executioners with cheerful faces, and, with the words '*Waheguru! Waheguru!*' on their lips."[5]

Between 1716 and 1733 attempts to annihilate the Sikhs continued with increasing vigor and a price being put on each of their heads. Therefore, many Sikhs disappeared into the jungles and ravines to survive. Their indomitable spirit seldom wavered in the face of the enemy's overpowering

1. "Ik Onkar" and four-weapon Sikh symbols (*khanda*) Lithophane, Lladró

2020 | 5.5 x 4 in | High porcelain

Engraved on a translucent porcelain surface, "Ik Onkar" signifies that there is only one Divine. In a broader sense, "Ik" also means we are all one with no distinction. The *khanda* is one of the most important symbols of Sikhism. This symbol is made up of depictions of four weapons commonly used by Sikhs. In the center of the symbol is the two-edged sword which symbolizes the creative power of the Divine that controls the destiny of the universe. On the outside of the two-edged sword, on the left is the sword of spiritual sovereignty (*piri*). On the right is the sword of political sovereignty (*miri*). The *chakra* or *chakkar* in the center is a symbol of the all-embracing Divine Manifestation, including everything and wanting nothing, without beginning or end, neither first nor last, and is timeless and absolute.

numbers. They held onto the noble edifice of their faith, despite the staggering losses and even as their blood soaked the land of Punjab.

In 1733 Nawab Kapur Singh (1697–1753), viewed as an embodiment of humility in Sikh tradition, emerged as the leader of the Sikhs. The Mughal government tried to make peace with him, however, these attempts were short-lived. In 1736, the Mughals slaughtered 7,000 Sikhs in a massacre remembered as Chota Ghallughara (Smaller Genocide). An additional 3,000 Sikhs were captured and later executed by the Mughal rulers. In 1739, the Persian ruler Nadir Shah attacked northern India and, after defeating the Mughals, he plundered the region, carrying with him riches and women. While crossing Punjab, on his way back to Persia, Nadir Shah and his army were hounded by bands of Sikh guerillas, who deprived him of some of his loot and released the captured women. The liberated women were respectfully escorted back to their households.

Nawab Kapur Singh divided the Sikhs into groups based on geographical territories. Ultimately twelve major groups called *misls* (an Arabic word meaning "equal") emerged. He organized warriors from the *misls* into two fighting forces, the Taruna Dal or "youthful soldiers" and the Buddha Dal or "veterans," which would collectively be known as the Dal Khalsa. Jassa Singh Ahluwalia was chosen to serve as the joint commander of the entire Dal Khalsa, while Nawab Kapur Singh continued to be acknowledged as the supreme commander. The twelfth *misl*, the Phulkian Misl under Baba Ala Singh of Patiala, was not part of the Dal Khalsa forces, but it cooperated with them for common

2. Map, northern India

c. 1780 | 9 x 13.75 in

Hand-colored map by Christopher Rigobert Bonne, French hydrograher and cartographer. It is believed to be the first map to recognize Sikh *misl* territory in the Punjab/Lahore region. The word Schiecks on the map refers to the Sikhs.

survival. The Dal Khalsa was a kind of loose confederacy without any regular constitution, and every chief maintained his independent character. Cavalry constituted the greatest part of the fighting forces from the various *misls*. Anyone who was an active horseman and proficient in the use of arms could join any of the *misls* and had the option to change membership whenever desired. All were welcome, and they could join without any restrictions based on class or caste.

The *misls* were subject to the decisions of the Sarbat Khalsa, the bi-annual assembly of the *panth* (fellowship of Sikhs) at Akal Takht (see chapter 2) on matters affecting the welfare of the community. The Akal Takht became a central forum of the *panth* for reaching consensus on various issues through the system of *gurmata* (decisions adopted in the presence of the Sri Guru Granth Sahib, suggesting the will of the guru).

Jassa Singh Ahluwalia, the head of the Dal Khalsa, along with other leaders at the Akal Takht, set out plans for strengthening the Khalsa tradition. They addressed social issues affecting the community at large and handled political matters. Additionally, they managed military affairs, including coordinating battles, recruiting forces, allotting tasks and responsibilities, protecting different areas. The Akal Takht was the symbol of the unity of the Dal Khalsa, marking the beginnings of a Sikh state in the making.

The Dal Khalsa with its total estimated strength of 70,000 consisted primarily of cavalry, while artillery and infantry elements were almost non-existent. The *misl* chief exercised full authority within his territories and worked for the common good of all classes of people. Each village operated a sort of a small republic, administering its affairs through a *panchayat,* which was generally a council of five elders led by a headman representing the collective will of the people. Members of the *panchayat* could belong to any religious faith.

Between 1748 and 1768, Ahmad Shah Abdali of Afghanistan invaded north India eight times. The skirmishes between the Sikhs and Mughal rulers as well as Abdali resulted in violent and uncertain times that caused a great destruction of lives and property. For instance, in 1762 some 30,000 people lost their lives in the massacre known as Wada Ghallughara (Great Genocide), including many women and children. Abdali launched a surprise attack, putting the Sikhs at a disadvantage. Sikh soldiers were outnumbered on an open ground and could not fall back on the usual guerilla tactics in which they excelled.

Subsequently, Abdali defiled the sacred body of water (*sarovar*) and damaged the Harmandir Sahib. Despite the attacks by Afghani invaders and Mughal rulers, Sikhs were fighting against injustice, and as Bhagat Singh has noted, they "did not entertain any enmity against Mohammadans or their religion. Their struggle was against the government."[6]

Following Nawab Kapur Singh, Jassa Singh Ahluwalia became the Sikh leader in 1753 and retained this role until his death in 1783. He is celebrated as a fearless and honorable man and he was aided by other *misl* chiefs such as Jassa Singh Ramgarhia, Charat Singh Sukerchakia, Jai Singh Kanhaiya, Baghel Singh, Ala Singh, and the Bhangi leaders amongst others. The community was blessed to have such bold and daring chiefs who had weathered constant warfare and continued to lead in high spirits. In a letter written in 1776, Colonel Antoine Polier wrote,

> As for the Seikhs, that formidable aristocratic republick... fifty of them are enough to keep at bay a whole battalion of the King's forces, such as they are. This shows the force of prejudice and the value of military reputation. Such are the immediate neighbours of the King.[7]

Sikhs occupied Lahore in 1765 and started minting coins in the names of their gurus. They subsequently extended their territories from Attock to Delhi. The Harmandir Sahib complex started to be rebuilt, and all *misl* leaders contributed to this effort, guided by their faith and reverence for it. Reconstructing and beautifying the Harmandir Sahib complex, an effort for which no expense was spared, was a momentous event in their life, since they led a simple life. The *misl* chiefs dressed modestly, carrying neither signs of social status nor any personal embellishment.

While the Harmandir Sahib was the supreme spiritual authority, all political and future decisions of the community were taken at Akal Takht and no one went against the established protocols of their faith and the collective decisions undertaken there. The *misl* chiefs built *bungas* around Harmandir Sahib for defense purposes and used these structures as their accommodation when they visited the shrine. They also started to build gurdwaras in various parts of Punjab associated with the visits of the gurus to those areas.

After submitting himself to the Sikhs in 1783, the Mughal emperor in Delhi agreed to the building of seven historic gurdwaras associated with the Sikh gurus, and Bhagel Singh, a *misl* leader, was entrusted with the direction of the construction work. Facing an external force, the *misls* cooperated to defeat the common enemy. Nevertheless, as they became more powerful, and especially after the death of their leader Jassa Singh Ahluwalia in 1783, disagreements and territorial disputes among them became more frequent.

During the eighteenth century, approximately 200,000 Sikhs were killed in their fight for justice. Nonetheless, by the end of the century they were able to close the Khyber Pass (which historically was used as the entry point to India by invaders) after 800 years of foreign aggressions. Most importantly, in keeping with the worldview of the Khalsa, the Sikh army brought together people across different faiths and beliefs, and, as Hari Ram Gupta has noted, Sikh leaders showed "no prejudice in appointments to important posts against Hindus and Muslims."[8] Notably, they also ensured that Sikh women played a major role in administration, with many of them participating in war efforts and leadership.

Despite being a minority and constituting approximately 10 percent of the total population of Punjab at their peak, Sikhs managed to survive tumultuous forces that shaped the eighteenth century. Moreover, they also succeeded in establishing a secular independent state, in which decisions (*gurmata*) were made collectively (Sarbat Khalsa) with the goal of ensuring the good of the region and of community.

REFERENCES & NOTES

1. G. Forster, *A Journey from Bengal to England*, vol. 1 (London: R. Fauldner, New Bond Street, 1798), 330.

2. P. Dhawan, "Early Sikh Darbars," in *Brill's Encyclopedia of Sikhism*, eds. K.A. Jacobsen et al. (Boston: Brill, 2017), 67.

3. M.A. Macauliffe, *The Sikh Religion*, vol. 5 (Oxford: Clarendon Press, 1909), 238.

4. M. Hawley, "Sikh Institutions," in *The Oxford Handbook of Sikh Studies* (Oxford: Oxford University Press, 2014), 323.

5. G. Singh, *Life of Banda Singh Bahadur*, 4th edition (Patiala: Punjabi University, 2016), 151. "Waheguru" is a word used in Sikhism to refer to the Divine.

6. B. Singh, *A History of the Sikh Misls* (Patiala: Punjabi University, 2019), 38.

7. G. Singh, *Early European Accounts of the Sikhs* (Calcutta: R.K. Maitra, 1962), 65–66.

8. H.R. Gupta, *History of Sikhs*, vol. 4 (New Delhi: Munshiram Manohar Publishers Pvt. Ltd., 2008), 363.

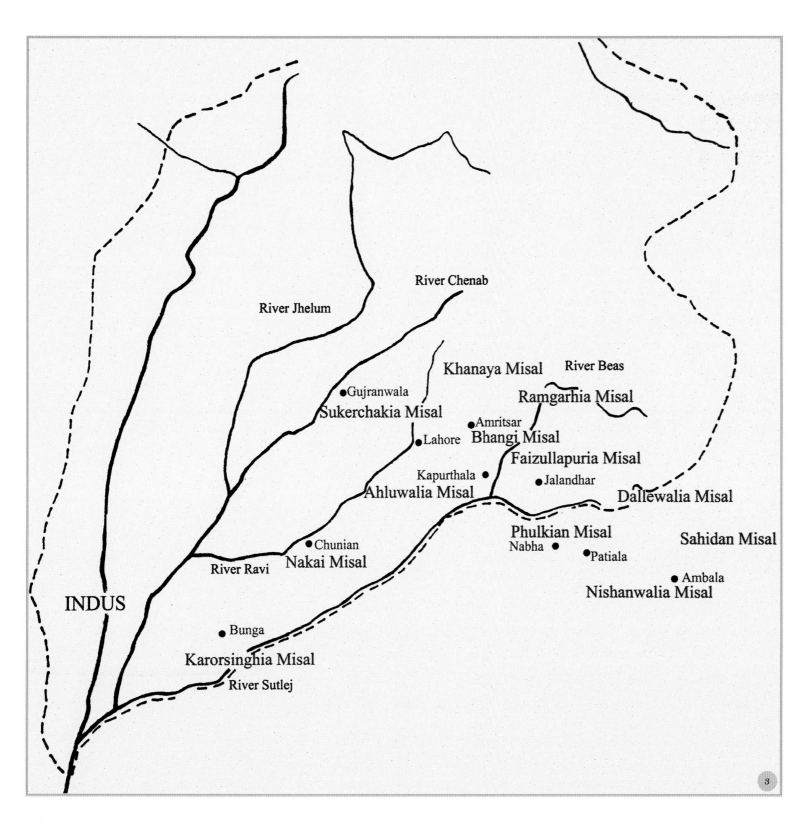

River Chenab

River Jhelum

Khanaya Misal

River Beas

●Gujranwala

Ramgarhia Misal

Sukerchakia Misal

●Amritsar

●Lahore

Bhangi Misal

Faizullapuria Misal

Kapurthala ●

●Jalandhar

Dallewalia Misal

Ahluwalia Misal

Phulkian Misal

Sahidan Misal

Nabha ●

●Patiala

●Chunian

Nakai Misal

●Ambala

River Ravi

Nishanwalia Misal

INDUS

●Bunga

Karorsinghia Misal

River Sutlej

3. A rough map showing the different Sikh *misls* and the geographical areas controlled by them

20th century

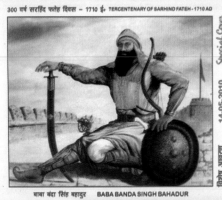

300 वर्ष सरहिंद फतेह दिवस – 1710 ई॰ TERCENTENARY OF SARHIND FATEH - 1710 AD

Special Cover

14-05-2010

विशेष आवरण

बाबा बंदा सिंह बहादुर BABA BANDA SINGH BAHADUR

4

300 वर्ष सरहिंद फतेह दिवस – 1710 ई॰ दरबार बाबा बाज़ सिंह, बाबा आली सिंह

Special Cover

12-05-2010

विशेष आवरण

TERCENTENARY OF SARHIND FATEH - 1710 AD DARBAR BABA BAAZ SINGH, BABA AALI SINGH

5

प्रथम दिवस आवरण FIRST DAY COVER

50 भारत INDIA

नई दिल्ली
NEW DELHI
4·4·85
BABA JASSA SINGH AHLUWALIA

बाबा जस्सा सिंह अहलुवालिया
BABA JASSA SINGH AHLUWALIA 1718-1783

6

प्रथम दिवस आवरण FIRST DAY COVER

भारत INDIA

300 वर्ष
YEARS
19.03.2010
16 पंजाब (सेकेंड पटियाला)
16 PUNJAB (2nd PATIALA)
नई दिल्ली 110001 NEW DELHI

300 वर्ष 16 पंजाब (सेकेंड पटियाला)
YEARS 16 PUNJAB (2nd PATIALA)

7

4. Banda Singh Bahadur depicted on a special cover commemorating the 300th anniversary of victory at Sarhind – the Mughal stronghold and place of martyrdom of the two younger sons of Guru Gobind Singh

2010 | 4 x 8.7 in

5. Baba Baaz Singh, Baba Aali Singh, special cover celebrating the 300th anniversary of victory at Sarhind in 1710

2010 | 4.2 x 8.75 in

6. First-day cover depicting Jassa Singh Ahluwalia

1985 | 4 x 7 in

7. First-day cover commemorating the 300th anniversary of Patiala and its founder Ala Singh

2010 | 4.4 x 8.6 in

8. Banda Singh Bahadur and the subsequent prominent leaders of the Sikh *misls*

Sumeet Aurora | 2020
28 x 22 in | Acrylic, watercolor and ink on paper

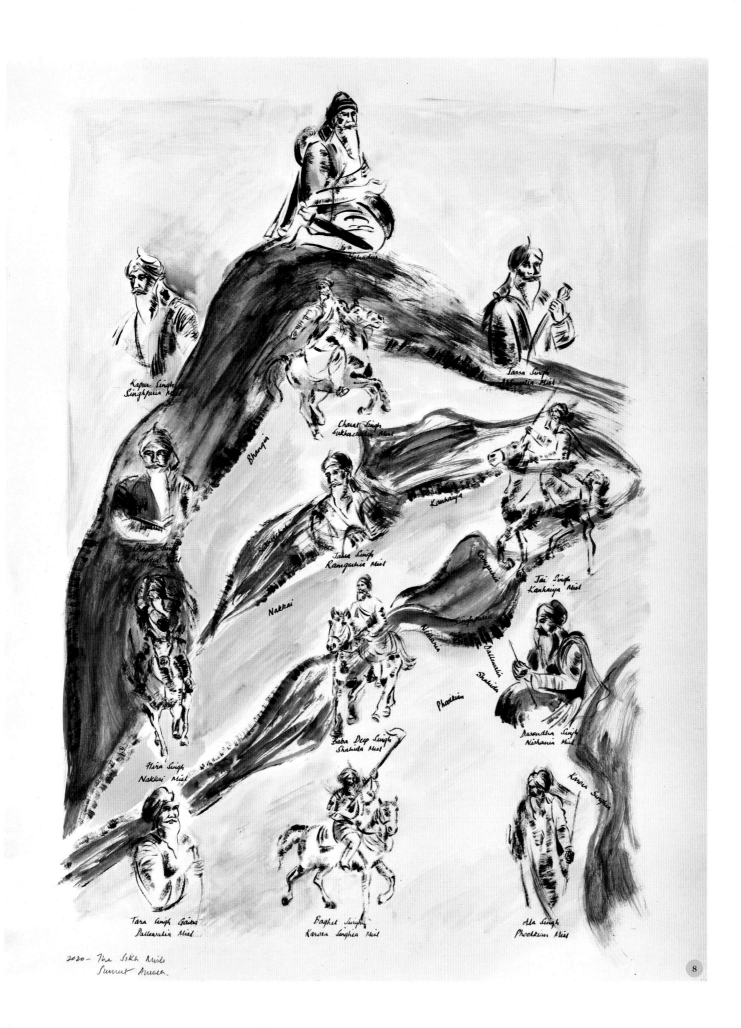

Kapur Singh
Singhpuria Misl

Jassa Singh
Ahluwalia Misl

Charat Singh
Sukkacharia Misl

Bhangia

Kanhaiya

Sukkacharia

Jassa Singh
Ramgarhia Misl

Nakkai

Jai Singh
Kanhaiya Misl

Singhpuria

Nakkai

Dallewalia

Shahida

Phoolkian

Hara Singh
Nakkai Misl

Baba Deep Singh
Shahida Misl

Dasondha Singh
Nishania Misl

Karora Singhia

Tara Singh Gaiba
Dallewalia Misl

Baghel Singh
Karora Singhia Misl

Ala Singh
Phoolkian Misl

2020 - The Sikh Misls
Sarmut Anand

9. *Katar* (punch dagger)

c. Late 18th century | 18 in | Cast steel

The *katar* was designed to penetrate armor. The blade is thickest near the point, making it extremely strong.

10. Spearhead

c. Late 18th century | 16 x 2.5 in | Cast steel

This spearhead has very sharp edges and is decorated with floral patterns at the base. It appears to have been extensively used.

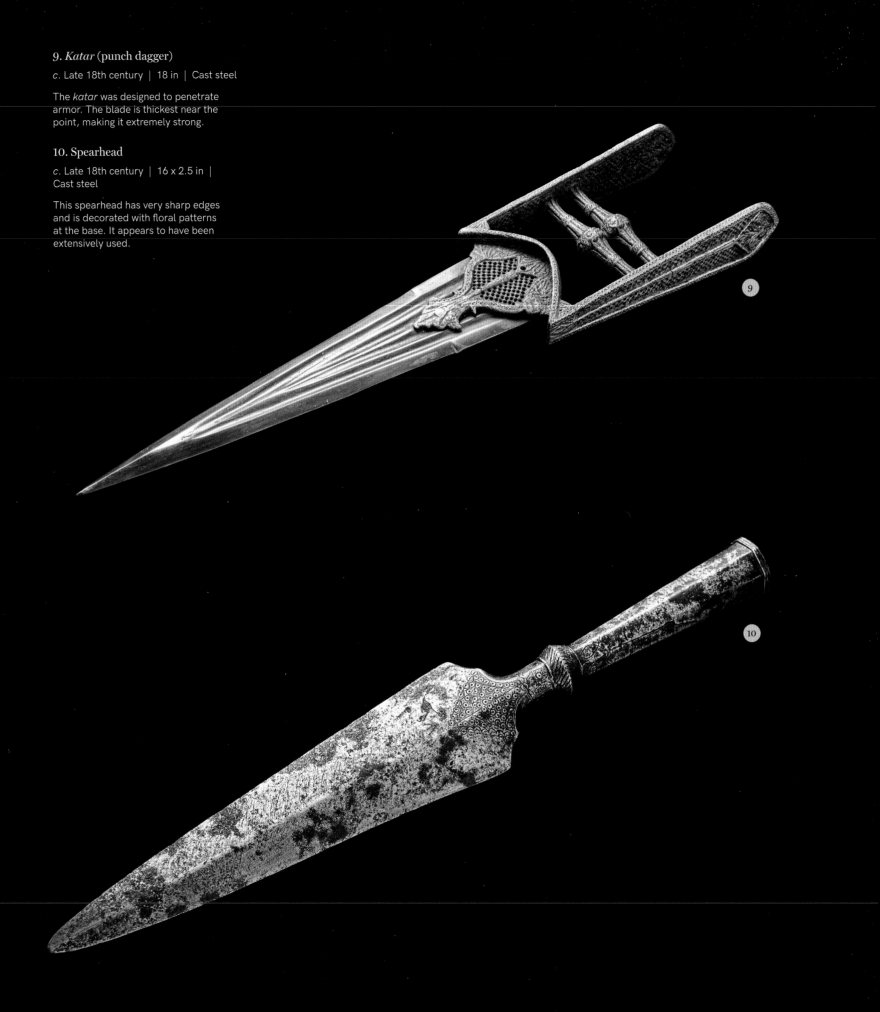

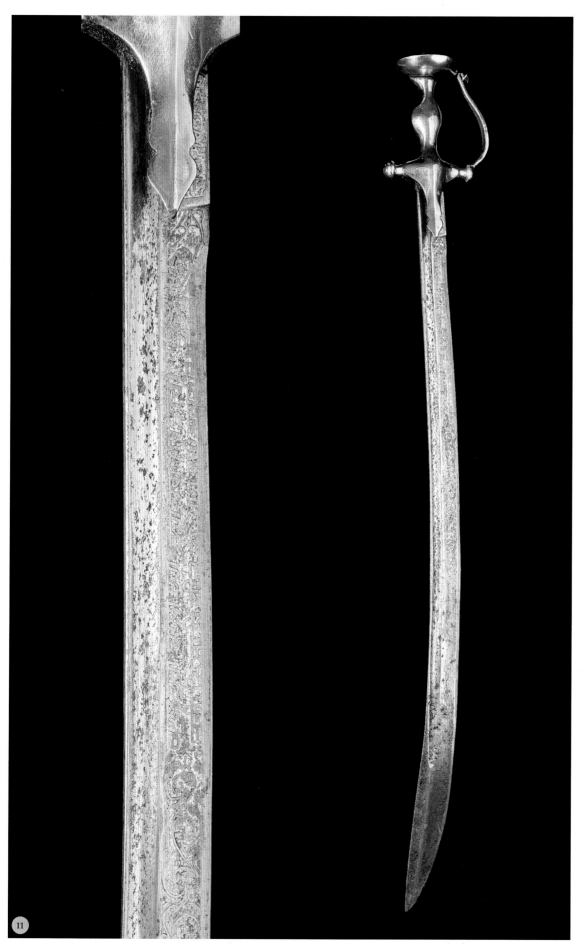

11. Sword

c. 1720-90 | 38.5 x 2.5 in | Cast steel

The shape and decorative pattern on this sword are typical of the Sikh *misl* period. The inscription along the cutting edge, attributed to Guru Gobind Singh, visible only in part, reads: "You are the sword, you are the arrow. You are the symbol of victory." The original hilt of this sword has been replaced.

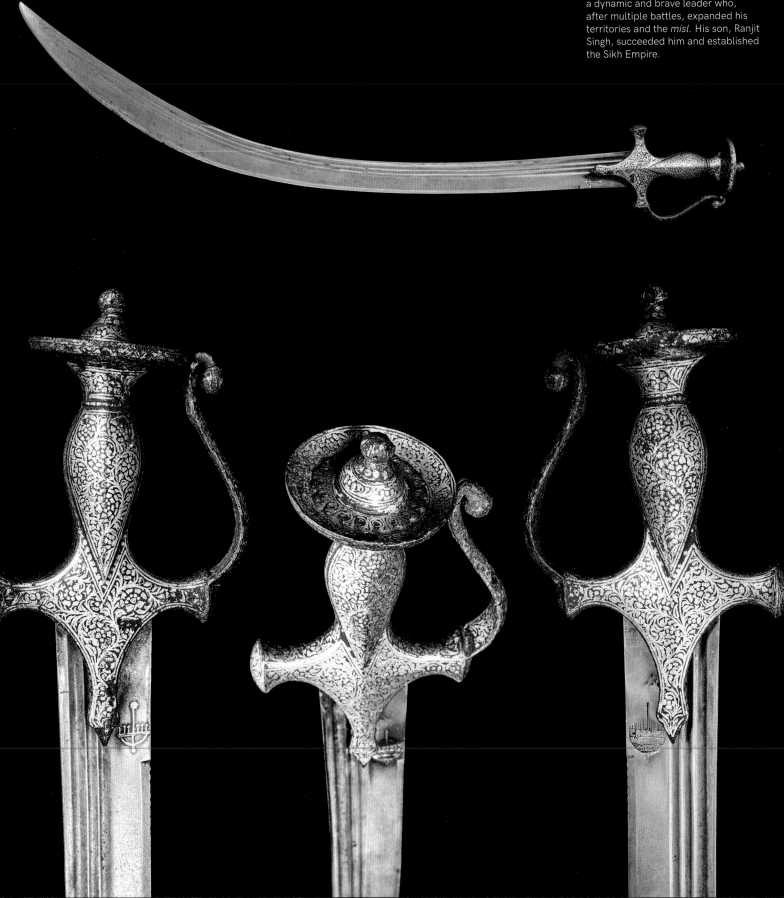

13

BHANGIAN DI TOPH

Also known as Zamzama, this massive gun (an 80 pounder, 14 ft, $4\frac{1}{2}$ in long, with a bore diameter of $9\frac{1}{2}$ in) belonged to the Bhangi Misl. Cast in Lahore (*c.* 1757) in copper and brass by Shah Nazir initially for the Afghan leader Ahmad Shah Durrani, it had been immortalized by Rudyard Kipling in his novel *Kim* (1901). It was perhaps the largest specimen of Indian cannon casting and is celebrated in Sikh historical annals. Also referred to as "a fire-raining dragon," this cannon carried a ball weighing approximately 88 pounds.

14

13. Zamzama cannon, Lahore

c. Late 1800s | 7.5 x 9.5 in | Albumen print

14. Miniature model of Zamzama cannon

c. Early 1900s | 7 x 4 in | Wood and metal

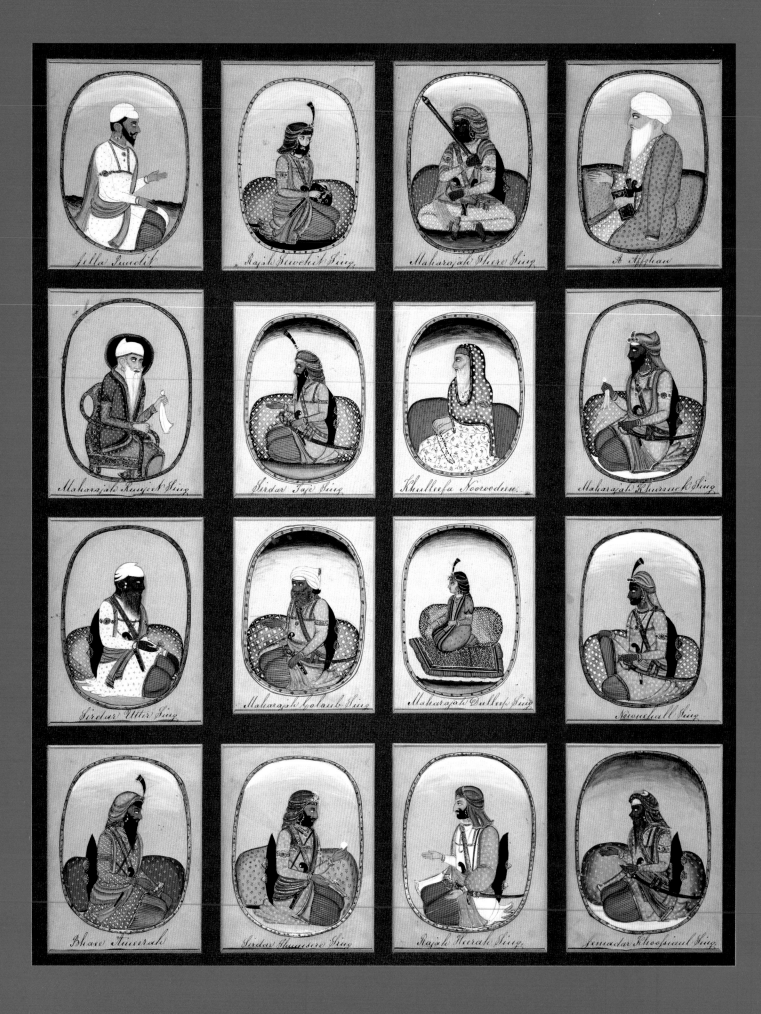

4

BUILDING A SIKH EMPIRE: THE LIFE AND TIMES OF RANJIT SINGH

"NEVER WAS SO LARGE AN EMPIRE FOUNDED BY ONE MAN WITH SO LITTLE CRIMINALITY."[1]

Baron Charles Hugel describing Ranjit Singh's empire

R anjit Singh (1780–1839), popularly known as "Sher-e-Punjab" or "Lion of Punjab," is traditionally celebrated for his exceptional leadership. He was at the forefront of the Sikh Empire, becoming its first maharaja (great king) in 1801, and he ruled it through the first half of the nineteenth century. The establishment of a stable and prosperous state in the northwest Indian subcontinent by a native of the soil was a truly remarkable achievement, considering the consistent upheavals and the over 1,000 years of alien rule that this region had experienced. Maharaja Ranjit Singh was loved by his subjects, who were of diverse religions and ethnicities. He threaded them together as one, and they fought for him, creating a domain on par with any other major European power of that time.

Most of Ranjit Singh's empire today lies in present-day Pakistan. I was able to recently visit his birthplace in Gujranwala, the forts, the battlegrounds, and two famous structures he built – Hazuri Bagh – where he held his court, and Ath Dara – a building with eight doors where he held his *durbar* (private gatherings). This was indeed an emotional and exhilarating experience. Visiting Sheesh Mahal, the palace of mirrors (which was his residence), and above it, his personal gurdwara (where he died), was equally incredible.

Ranjit Singh's achievements leave us with awe and appreciation for a semi-literate boy who grew up quickly after losing his father at the age of twelve and became the undisputed ruler of the region. He had to swiftly adapt to protect his kingdom from the mighty British Empire, which eventually formulated a peace treaty with him. This left him as the only sovereign ruler in the Indian subcontinent that the British could not subjugate while he was alive.

Let us take a closer look at his rise to power and his political career. Ranjit Singh fought his first battle alongside his father at age ten. After his father's death, he became the leader of the Sukerchakia Misl and was proclaimed as the "Maharaja of Punjab" at age twenty-one. Ranjit Singh successfully absorbed the Sikh *misls* and took over other rulers to create the Sikh Empire. He formed alliances through marriages and friendships, a strategy that helped him in his early conquests. His mentor and guide in his earlier years was Sada Kaur, the head of the Kanhaiya Misl, who was a courageous and remarkable leader and who also happened to be his mother-in-law. On the invitation of the town elders and with her guidance at the age of nineteen, Ranjit Singh succeeded in taking over Lahore. Helped by Sada Kaur and by his friend Fateh Singh Ahluwalia of the Ahluwalia Misl, he captured Amritsar in 1802, becoming the undisputed leader of Punjab.

In 1807, Ranjit Singh's forces attacked the Muslim-ruled Kasur and won it over from Afghan rulers. Ranjit Singh signed a treaty of friendship with the British in 1809 which demarcated the river Sutlej as the boundary between their domains. He conquered the city of Multan in 1818, and the whole Bari Doab (the area between the Ravi and Beas rivers) came under his rule. In 1819, he successfully defeated the Afghan Muslim rulers and annexed the Srinagar and Kashmir regions, stretching his rule into the north and the Jhelum valley, beyond the foothills of the Himalayas. In May 1834, Dost Mohammed of Afghanistan accepted the sovereignty of the Maharaja over Peshawar.

1. Maharaja Ranjit Singh, his sons, grandson, and ministers

Artist unknown | *c.* 1850s | 22 x 18 in; each box is 4.25 x 3.25 in | Watercolor

A collection of sixteen watercolor portraits of Maharaja Ranjit Singh, his family, and leaders of the Lahore *durbar*. Ranjit Singh (1780–1839), popularly known as "Sher-e-Punjab" or "Lion of Punjab," was the leader of the Sikh Empire, which ruled the northwest Indian subcontinent in the early half of the nineteenth century.

Ranjit Singh referred to his reign as "Sarkar Khalsa" (Empire of the Khalsa), and called his court "Darbar Khalsa" (Court of the Khalsa). He dressed simply, did not wear a crown (his turban was his crown), or sit on a throne. He did not get coins minted in his name but in the name of the gurus. He ruled as a representative of the Khalsa to serve his people. He showed great consideration and kindness to fallen foes, giving them a *jagir* (land grant) each as a source of income so they could live comfortably. As Patwant Singh and Jyoti Rai have noted, Ranjit Singh "drew his strength not from the brutal exercise of power but from his humanity, vision, vitality and tolerance.... The powerful impulse that drove Ranjit Singh to create a just, secular and cosmopolitan society for his people was his unshakeable faith in the religion into which he was born."[3] In the words of Henry Prinsep, "in action he has always shown himself personally brave, and collected, but his plans betray no boldness or adventurous hazard."[4]

Ranjit Singh created an army which was led by able generals and was Westernized over time. Before 1822, most of the state conquests were led by men like Mokham Chand, Hari Singh Nalwa, and Misr Dewan Chand.[5] Nalwa has been recognized as one of the greatest military commanders of his time and was involved in most of the invasions. Nalwa, in addition, was an able administrator and governed first Kashmir and later Hazara and Peshawar, which were tumultuous regions and brought stability to them. According to Vanit Nalwa, he acquired the name Nalwa (tiger) because "by the age of fifteen, fully armed he wrestled a tiger to its death" – a truly remarkable feat.[6]

Many dangerous missions were also led by Akali Phoola Singh, the leader of the Akalis (the immortals), whom he used as cavalry. Commenting on the Khalsa soldiers, Joseph Davy Cunnigham, an official of the East India Company, wrote that "the Sikh owes his experience as a soldier, to his own hardihood of character, to that spirit of adaptation which distinguishes every new people, and to that feeling of a common interest and destiny implanted in him by his great teachers."[7]

It is believed that approximately forty-two foreign officers over time were attached to the Khalsa army, including men of French, Italian, German, American, and Spanish origins as well as veterans from Napoleon's army. For instance, Jean François Allard arrived in Lahore in 1822 and rose to be a general in Ranjit Singh's cavalry. Likewise, Paolo Avitabile and Auguste Court joined Ranjit Singh's army in 1826 and 1827, respectively. Both soon became high-ranking officers who served with distinction and were also involved in extensive training of the troops. American Colonel Alexander Gardner also joined the army in 1832.

A royal army, the Fauj-i-Khas, was created. It contained calvary, infantry, and gunnery units and it became known as "the French Legion." Along with this, the Fauj-i-Ain, a regular army, was established. It numbered nearly 70,000 in strength with infantry, cavalry, and artillery, as well as traditional soldiers. The artillery was organized into lighter guns pulled by horses, light swivel guns mounted on camels, and heavier guns pulled by bullock carts. The army included Sikh, Muslim, and Hindu soldiers. General Ventura, who had arrived in Lahore in 1822, trained battalions of infantry, while General Allard trained the cavalry. Punjabi generals Ilahi Bakhsh and Lehna Singh Majithia oversaw the training, command, storage, and supply of the artillery.

Lehna Singh Majithia was one of the ablest administrators in Maharaja Ranjit Singh's court. However, his capability as an administrator was overshadowed by his talent in astronomy, architecture, mathematics, and literature. He, along with General Court, was responsible for the establishment of a cannon foundry in Lahore, which proved to be at par with, if not better than, any other foundry in the world.

Multiple forts were built, especially under Nalwa, on the border with Afghanistan. Describing the reconstruction of Govindghur Fort in Amritsar, William Lewis M'Gregor wrote that,

in it the treasure was deposited, under a guard of 2,000 soldiers, and put under the charge of Emamoodeen... This is the celebrated fort of Govindghur, strongly built of brick and lime, with numerous bastions, and strong iron gates: twenty-five pieces of cannon were likewise placed in the fort.[8]

2. Maharaja Ranjit Singh

Artist unknown | *c.* Late 19th/early 20th century | 18.5 x 6 in | White marble

Standing next to a tree trunk, Maharaja Ranjit Singh is holding a sword in his left hand and with his right hand is pointing upwards in a gesture of giving a command.

Sikhs in Ranjit Singh's empire were 10-15 percent of the total population of 5,350,000. Writing about Ranjit Singh, Hari Ram Gupta has stated that "the love for his subjects was enshrined in his heart" and that "he ruled with unprecedented liberality and never caused bloodshed in the name of religion."[9] Fakir Syed Waheeduddin also wrote about a sense of prosperity and security under Ranjit Singh's rule: "Punishments were humane. For example, there was practically no capital punishment."[10]

The posts in civil and military administration were held by people from all religions. Prominent amongst them were the Fakir brothers and Dogra brothers (Dhian Singh, the longest serving prime minister of the Sikh Empire, was one of them). Grants were given to all religions especially on their holy occasions. Agriculture was the mainstay of the empire's economy with two thirds of the population made up of peasants. The production of Kashmir shawls was encouraged, and these beautiful garments were frequently given as gifts.

Punjabis have traditionally yearned for education and showed great reverence for teachers. Both boys and girls attended primary school, and the literacy rate was quite high. Commenting on Ranjit Singh's policies pertaining to education, Gottlieb Wilhelm Leitner noted that "his great aim is to destroy the monopoly of learning, and of the social or religious ascendancy of one class, and to make education the property of the masses of the community."[11] Funding for schooling came not only from the local community, but also from royal families and the state treasury. The policy of distributing grants to educational centers affiliated with various faiths led to a high level of literacy even amongst the rural populace. Fakir Nur-ud-din, the minister of education compiled a primer entitled *Noor* (Light) that helped one learn basic alphabets, elementary writing in important local languages, and mathematics. Traditional and indigenous education flourished thus contributing to the spread of knowledge and improvement of learning across the social spectrum.

In this golden age of stability, art, architecture, and culture prospered in a secular environment, after decades of uncertainty and anarchy. There was renewed construction of beautiful residences, palaces, religious monuments, along with the laying down of gardens. Amritsar and Lahore

became cosmopolitan cities with traders and influences from Central Asia, France, Britain, Persia, Afghanistan, and Russia. Indigenous industries were revived, and vocational craft schools were opened across the empire where painting, calligraphy, sketching, and drafting were taught. Amritsar, Lahore, Srinagar and other cities were major centers for such activities.

Lahori and Sialkot armories made the finest watered steel weapons. These were chiseled with varied designs and embellished with silver and gold. Besides swords, shields, spears, and matchlocks, these armories produced extremely sophisticated artillery and modern cannons. Multan was famous for its silk, Srinagar for its carpets; Amritsar and Lahore also became carpet weaving and textile manufacturing centers.

Culture and arts were widely promoted. Famous artists such as Imam Baksh, Kehar Singh, and Pahari painters from the families of Nainsukh and Purkhu made Lahore and Amritsar their homes. These artists had different backgrounds and included Punjabis, Paharis, Kashmiris, and Mughals. Western artists also contributed to the region's artistic production. For instance, Emily Eden traveled to Lahore in 1838 with her brother George Eden, who at the time served as governor-general of India. Here she displayed her artistic skills in an exquisite series of portraits entitled "People and Princes of India." Poetry also flourished along with the celebration of festivals.

The maharaja's court could compete in splendor and wealth with any of the royal courts of Europe. Most of their treasures were housed in a *toshakhana* located in Lahore. These included precious stones, such as the famous Kohinoor diamond, jewelry, Kashmir shawls, relics, as well as gifts received or to be presented to dignitaries. Rambagh Palace with its magnificent gardens, fountains, and pavilions was built in Amritsar and served as the maharaja's summer palace.

Maharaja Ranjit Singh, the political and military genius beloved by his subjects, died in 1839. He left behind a vast, prosperous empire equipped with an indomitable military force counting some 150,000 soldiers. It was the last kingdom in the Indian subcontinent not occupied by the British. Ranjit Singh's *samadhi* (funerary monument) in Lahore still attracts visitors and keeps alive memories of a glorious past and an undivided independent Punjab.

REFERENCES & NOTES

1. K.A. Hugel, *Travels in Kashmir and the Panjab, containing a particular account of the government and character of the Sikhs* (London: J. Petheram, 1845), 154.

2. I obtained information about the Sheesh Mahal and the gurdwara above it during a conversation with Anjum Dara, curator of Lahore Fort & Museum, in February 2019.

3. P. Singh and J.M. Rai, *Empire of the Sikhs: The Life and Times of Ranjit Singh* (New Delhi: Hay House India, 2008), p. 119.

4. H. Prinsep, *Origin of the Sikh Power in Punjab* (G. Huttmann: Calcutta, 1834), 179.

5. K. Singh, *A History of the Sikhs (1469–1839)*, vol. 1 (New Delhi: Oxford University Press, 1999), 259.

6. V. Nalwa, *Hari Singh Nalwa,"Champion of the Khalsa ji"* (New Delhi: Manohar, 2009), 24.

7. J.D. Cunningham, *History of the Sikhs* (London: John Murray, 1849), 181.

8. W.L. M'Gregor, *The History of Sikhs* (London: James Madden, 1846), 161.

9. H.R. Gupta, *History of the Sikhs*, vol. 5 (New Delhi: Munshiram Manoharlal Publishers Pvt. Ltd., 2008), 411.

10. F.S. Waheeduddin, *The Real Ranjit Singh* (Amritsar: Punjabi University, 2001), 17.

11. G.W. Leitner, *History of Indigenous Education in the Punjab* (Calcutta, 1882. Reprint, Lahore: Sang-e-meel Publications, 2002), 28.

3. Maharaja Ranjit Singh seated on a chair on a square pedestal

Artist unknown | *c.* Late 19th century | 3.25 x 1.5 in | Carved ivory

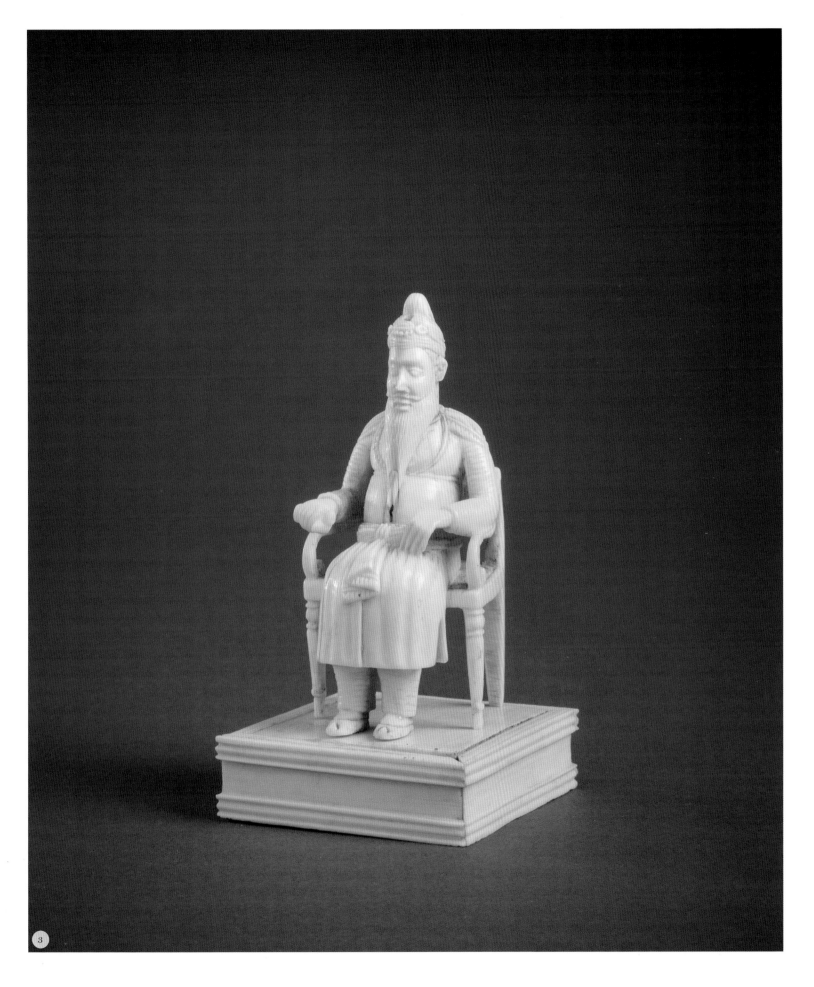

149

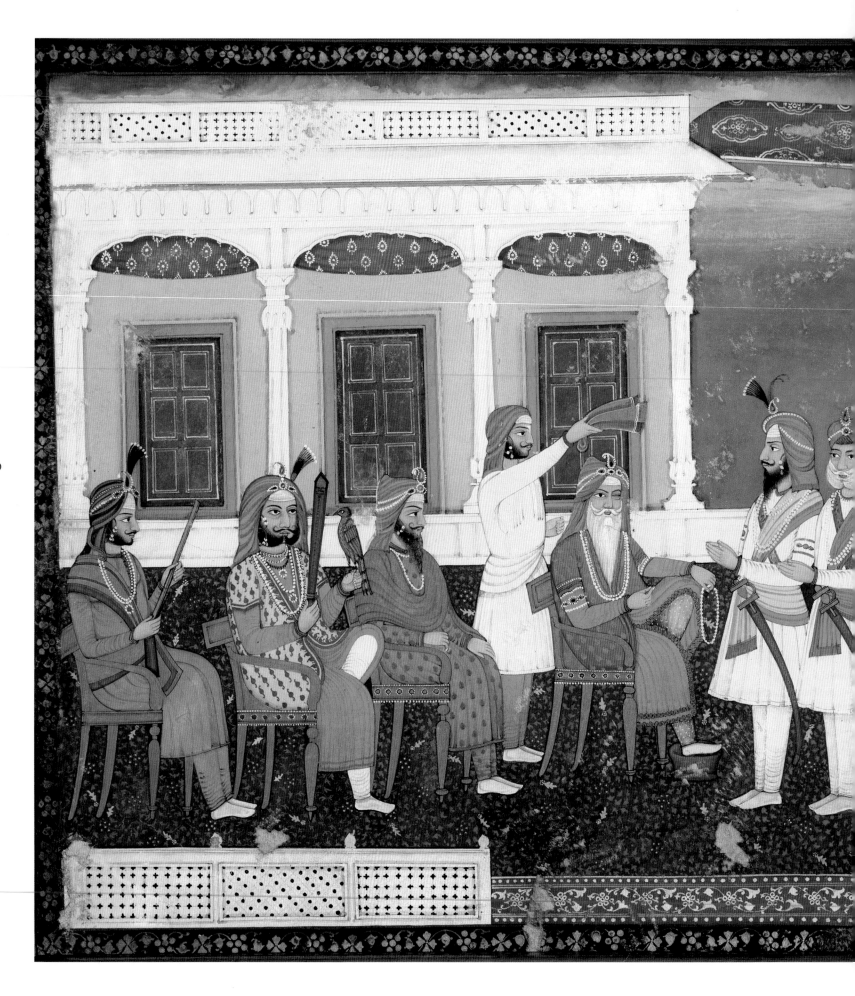

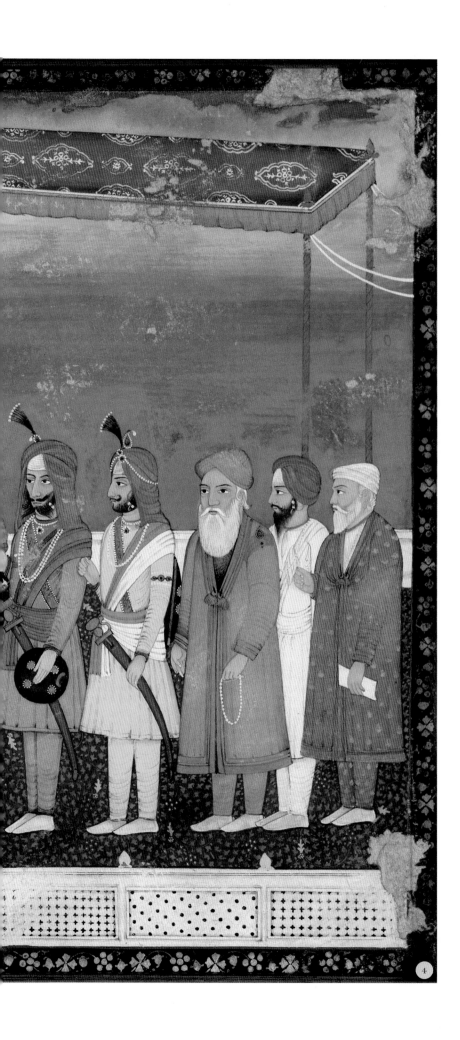

4. Maharaja Ranjit Singh with his sons, grandson, and courtiers

Artist unknown | *c.* 1830–40s |
11 x 17 in | Gouche on paper

Maharaja Ranjit Singh, wearing a
bejeweled turban is the center focus
of the painting. His sons and grandson
are sitting on chairs while the courtiers
stand facing him, probably waiting to
pay their respects.

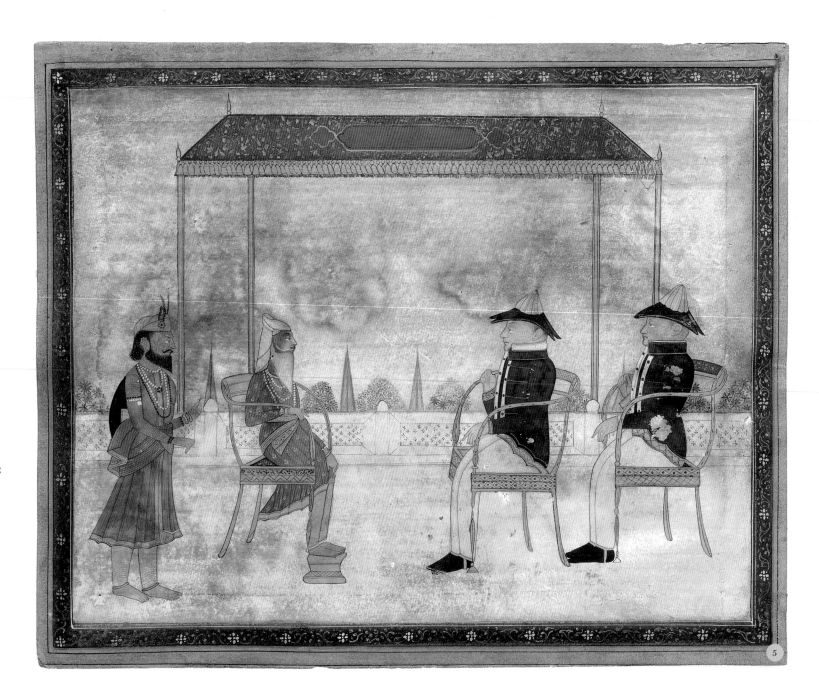

152

5. Maharaja Ranjit Singh with British officers

Artist unknown | 19th century |
8.75 x 10.8 in |
Gouache and gold on paper

153

6. Battle standard (flag)

c. 1820–1840s | 113 x 100 in |
Silk with block printed motifs

The army of the Sikh Empire was
composed of many military units each
with their own battle standards or
flags. It was during the Anglo-Sikh wars
that many battle standards of the Sikh
Empire were captured or found on the
battlefields. Lord Dalhousie bought ten
Khalsa army standards from a sale at
an auction of the *toshakhana* in Lahore.
This flag is one of the remnants from the
Dalhousie collection. On the side visible
is a central gilt solar motif, while the
other side has a depiction of Goddess
Durga on her mount, a tiger.

GOBINDGARH FORT

The fort in Amritsar was built by Gujjar Singh of the Bhangi Misl in the eighteenth century. The fort, which Maharaja Ranjit Singh had strengthened in 1809, had four bastions. At one time it housed Maharaja Ranjit Singh's *toshakhana* and also the Zamzama cannon.

154

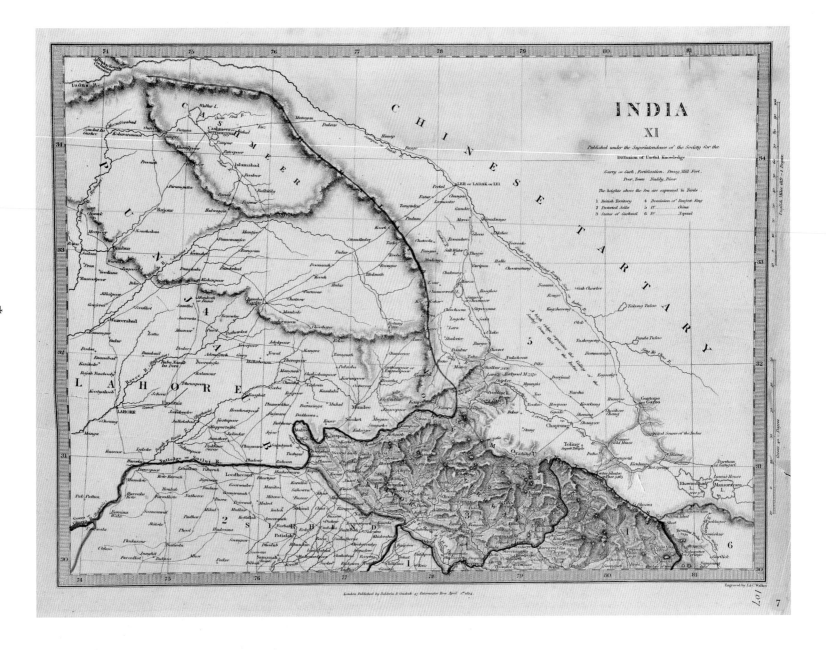

7. Map of northern India and Ranjit Singh's empire

c. 1834 | 14 × 10.5 in

Map showing the boundaries of the Sikh Empire which includes Cashmere [Kashmir], and also the British protected Sikh states. Published in London by Baldwin & Cradock.

8. Gobindgarh Fort

Artist unknown | *c.* Mid-19th century | 7 × 8.5 in | Watercolor on paper

9. "The Fort of Govindghur, near Amritsar" from *Original Sketches in the Punjaub. By a Lady.*

1854 | 7.75 × 10 in | Watercolor

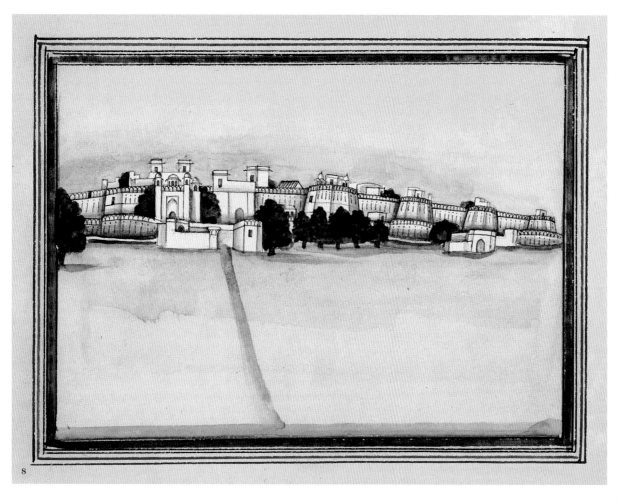

8

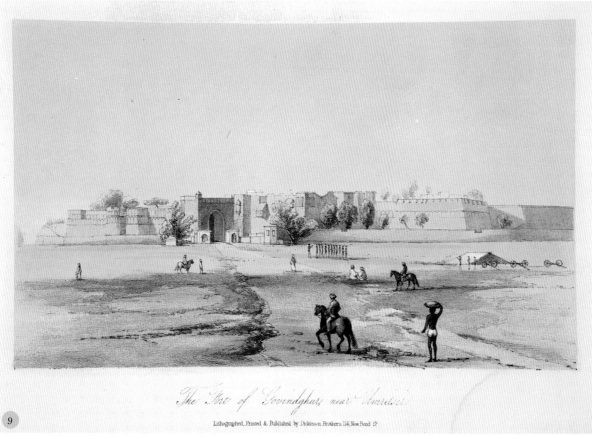

The Fort of Govindghur near Amritsir

Lithographed, Printed & Published by Dickinson Brothers 114, New Bond St.

9

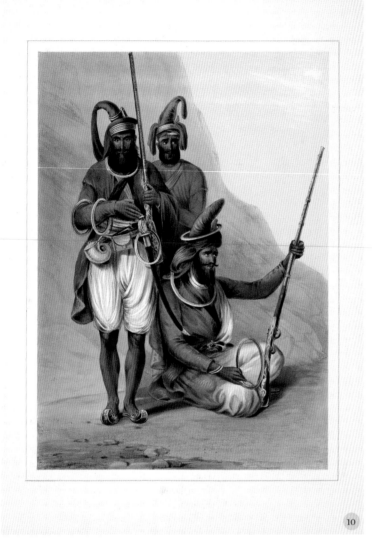

10

11

10. "Akalees" from Portraits of the Princes and People of India

Emily Eden | *c.* 1838 | 22 x 17.5 in | Hand-colored lithograph

Akalees, meaning "immortals" or "timeless," are Sikh religious devotees of the Khalsa, who are remarkable for their acts of courage. They were distinguished by their blue dresses, and high-peaked turbans with rings of steel.

11. Maharaja Ranjit Singh

Emily Eden | *c.* 1838 | 24.4 x 17.5 in | Hand-colored lithograph

Emily Eden, sister of Governor-General Lord Auckland visited Maharaja Ranjit Singh's *durbar* in 1838. While in India, she drew multiple portraits of Indian rulers and their families which were published as lithographs in 1844.

12. Gateway of Ram Bagh

Felice Beato | 1859 | 9 x 11 in |
Albumen print

The gate is the entrance to Maharaja
Ranjit Singh's summer palace at
Amritsar. The palace is situated in the
center of a garden, popularly known
as Ram Bagh, which was modeled
after Shalimar Bagh in Lahore.

31

13

FIRST DOGRA RULER OF JAMMU AND KASHMIR

Raja Gulab Singh (1792–1857) was one of the three influential Dogra brothers in Maharaja Ranjit Singh's court. He worked with the British against Sikh interests after Ranjit Singh's death and was awarded the principality of Jammu and Kashmir for a minimal amount as a recognition of his services.

13. Raja Gulab Singh with women at a village well

Artist unknown | *c.* 1830-40 | 12 x 9.5 in | Kangra or Guler; Gouache and gold dust on paper, inner blue border with gold floral motifs; pink outer border

14. Portrait of Raja Gulab Singh, the first ruler of the princely state of Jammu & Kashmir

Artist unknown | *c.* 1830s | 12 x 9 in | Gouache on paper

15. Raja Gulab Singh seated in a European-style chair on a terrace

Artist unknown | *c.* Mid-19th century | 12 x 8 in | Gouache and gold on paper, border with Kashmiri style illuminated floral decoration

160

16. Sikh prince

Artist unknown | *c.* 1830s |
8 x 6.3 in | Gouache on paper

Kangra-style painting of a Sikh prince
helping a lady from a *chajja* or balcony
onto his elephant.

17. Sikh prince

Artist unknown | *c.* 1830–40s |
10 x 6.5 in | Gouache on paper

A Sikh prince receiving two visitors;
he wears a *kalgi*, or turban ornament,
and is seated on an ornate chair.

**18. A princess in the courtyard
playing with a dove**

Artist unknown | 19th century |
8.75 x 6.5 in | Gouache on paper

SPECIAL COVER

SPECIAL COVER

200 Yrs. of CONQUEST OF KASUR
1807

प्रथम दिवस आवरण FIRST DAY COVER

30.04.2013

हरि सिंह नलवा HARI SINGH NALWA

19. Khalsa Durbar in Lahore, special cover commemorating the Anglo-Sikh Treaty of Lahore

2002 | 4.2 x 7.2 in

20. Battle of Kasur, special cover celebrating the 200th anniversary of Maharaja Ranjit Singh's victory over the Afghans

2007 | 4.2 x 7.2 in

21. Hari Singh Nalwa, first-day cover

2013 | 4.25 x 8.75 in

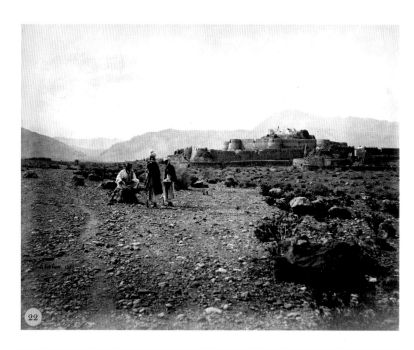

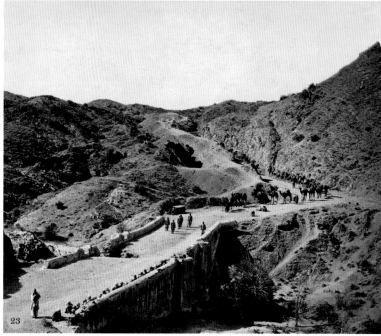

22. View of Jamrud Fort overlooking the Khyber Pass and the entrance of the historic gateway to India

Charles Shepherd | *c.* 1863–66 |
9 x 11.4 in | Albumen print

23. Mackeson's Bridge: a column of troops and camels advance through the Khyber Pass

John Burke | *c.* 1878 |
8.3 x 10.2 in | Albumen print

24. Jamrud Fort

Photographer unknown | *c.* 1930 |
6 x 8 in | Albumen print

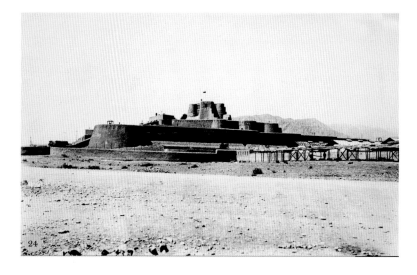

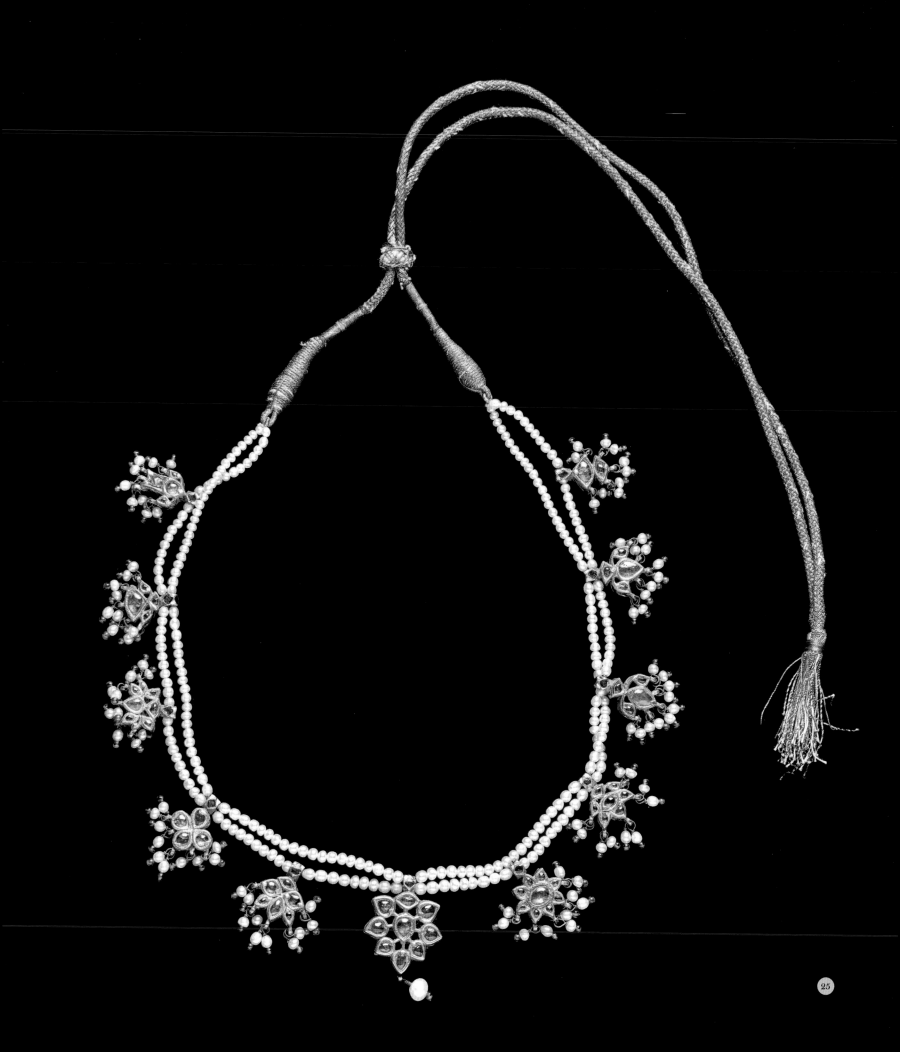

25

25. Seed pearl and jewelled necklace, property of Hari Singh Nalwa

c. 1820–30s | Gold and precious stones

A seed pearl and jewelled necklace comprising two strands of seed pearls with a large floral form pendant in the center. Ten smaller foliate pendants of rubies and emeralds adorn the necklace with each gem set on both sides with hanging seed pearls, metal thread suspension, and pearl strands.

26. Hari Singh Nalwa

Artist unknown | *c.* 1830s | 3.25 x 3 in | Ink and color on paper

Hari Singh Nalwa was the commander-in-chief at the most turbulent northwest frontier of Ranjit Singh's kingdom. He has been recognized as one of the greatest military commanders of his time and was involved in most of the invasions for the expansion of the Sikh kingdom. Hari Singh was also an able administrator, who governed Kashmir, and later Hazara and Peshawar. In this painting he is depicted with a pensive look, wearing simple clothes.

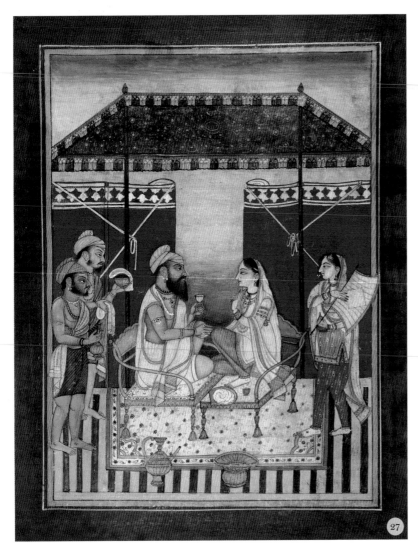

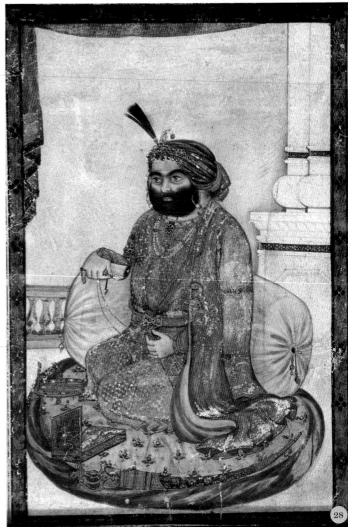

166

27. Desa Singh Majithia with his consort

Artist unknown | c. 19th century | 10.5 x 8.5 in | Guler style; Gouache and gold dust on paper

Desa Singh served Maharaja Ranjit Singh in many of his early campaigns and was appointed as the commandant of the fort of Kangra in 1809. For a few years, he also served as the administrator of Amritsar and its adjoining territories, with management of the Harmandir Sahib as his special task.

28. Sardar Lehna Singh Majithia

Artist unknown | c. 1830s | 6.5 x 5.3 in | Gouache on paper

A minister in Maharaja Ranjit Singh's cabinet and a close counsel to him, Sardar Lehna Singh was considered one of the bravest of his generals. After the death of his father, Desa Singh Majithia, in 1832, he succeeded him and was given his estates and honors. Lehna Singh also made significant contributions as an engineer, mathematician, astronomer, and a poet.

29. Col. Alexander Haughton Campbell Gardner (1785–1877)

Bourne and Shepherd | c. 1864 | 12 x 7.25 in | Albumen print

An American traveler, soldier, and mercenary, Campbell Gardener came to Punjab in 1831, where he was appointed commandant of artillery and subsequently promoted to the rank of colonel. He remained in the Sikh army after Ranjit Singh's death in 1839, until the First Anglo-Sikh War (December 1845–March 1846).

30. General Jean Fracois Allard (1785–1839)

Artist unknown | c. 1830 | 9.25 x 7 in | Lithograph

The French general served in Napoleon's army and in 1822, he entered the service of Maharaja Ranjit Singh. General Allard was commissioned to raise a corps of dragoons and lancers. On completion of this task, he was awarded the rank of general, and became the leader of the European officer corps in the maharaja's service.

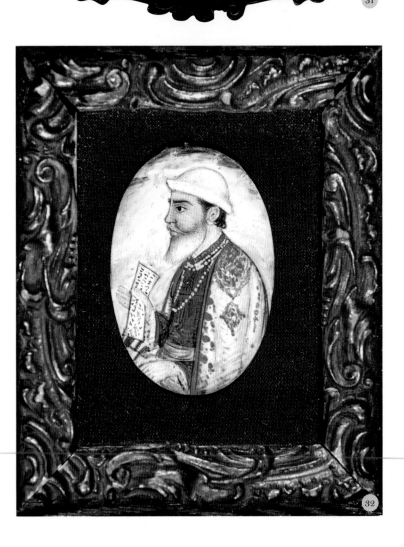

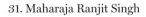

31. Maharaja Ranjit Singh

Artist unknown | *c.* 1850s | 1 x 1 in |
Painting on ivory

32. Fakir Nuruddin, minister in Maharaja Ranjit Singh's court

Artist unknown | *c.* 1850s |
2.25 x 1.75 in | Painting on ivory

33. "Maharaja Runjeet Singh on Horseback," from *The Court and Camp of Runjeet Singh* by W.D. Osborne

1840 | Lithograph

34. Maharaja Ranjit Singh

Artist unknown | *c.* 1930s |
8.3 x 4.7 in | Hand-colored lithograph

35. From *The Court and Camp of Runjeet Singh* by W.D. Osborne

1840 | Lithograph

36. Maharaja Ranjit Singh

Artist unknown | *c.* Mid-19th century |
7.25 x 6 in | Lithograph

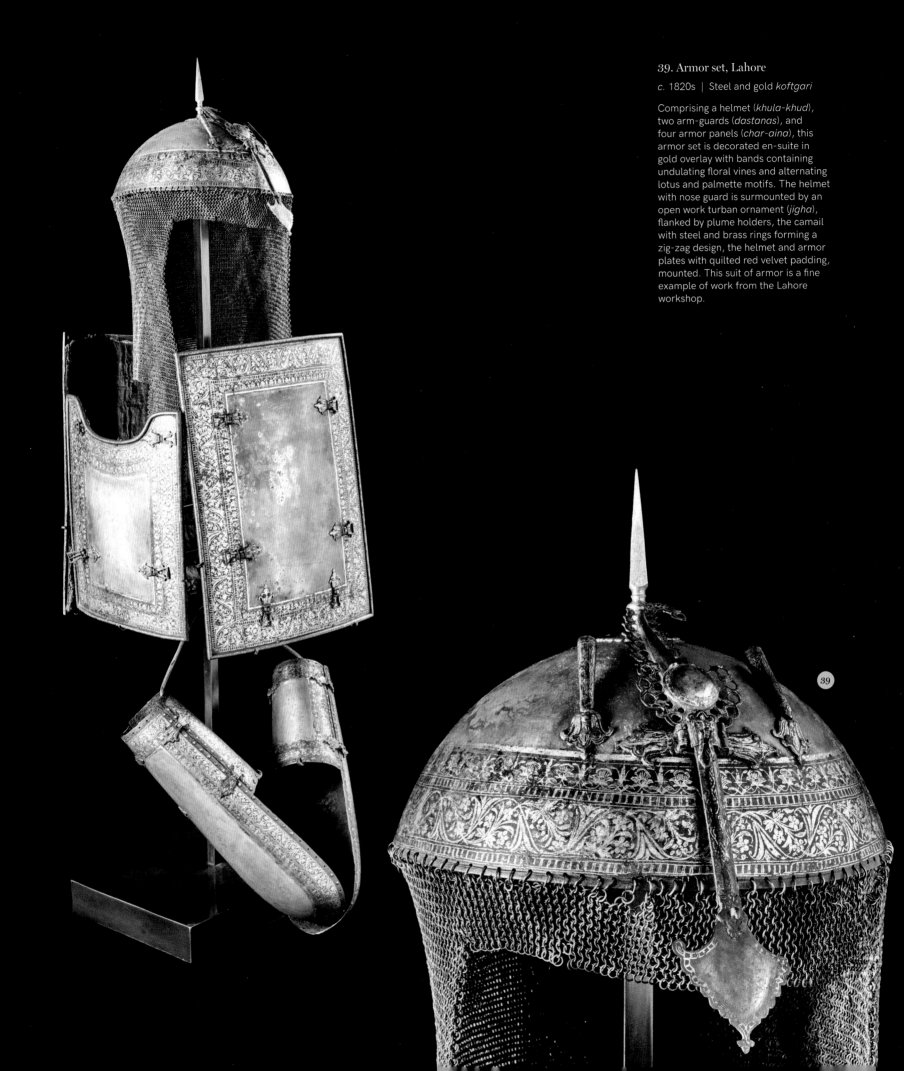

39. Armor set, Lahore

c. 1820s | Steel and gold *koftgari*

Comprising a helmet (*khula-khud*), two arm-guards (*dastanas*), and four armor panels (*char-aina*), this armor set is decorated en-suite in gold overlay with bands containing undulating floral vines and alternating lotus and palmette motifs. The helmet with nose guard is surmounted by an open work turban ornament (*jigha*), flanked by plume holders, the camail with steel and brass rings forming a zig-zag design, the helmet and armor plates with quilted red velvet padding, mounted. This suit of armor is a fine example of work from the Lahore workshop.

39

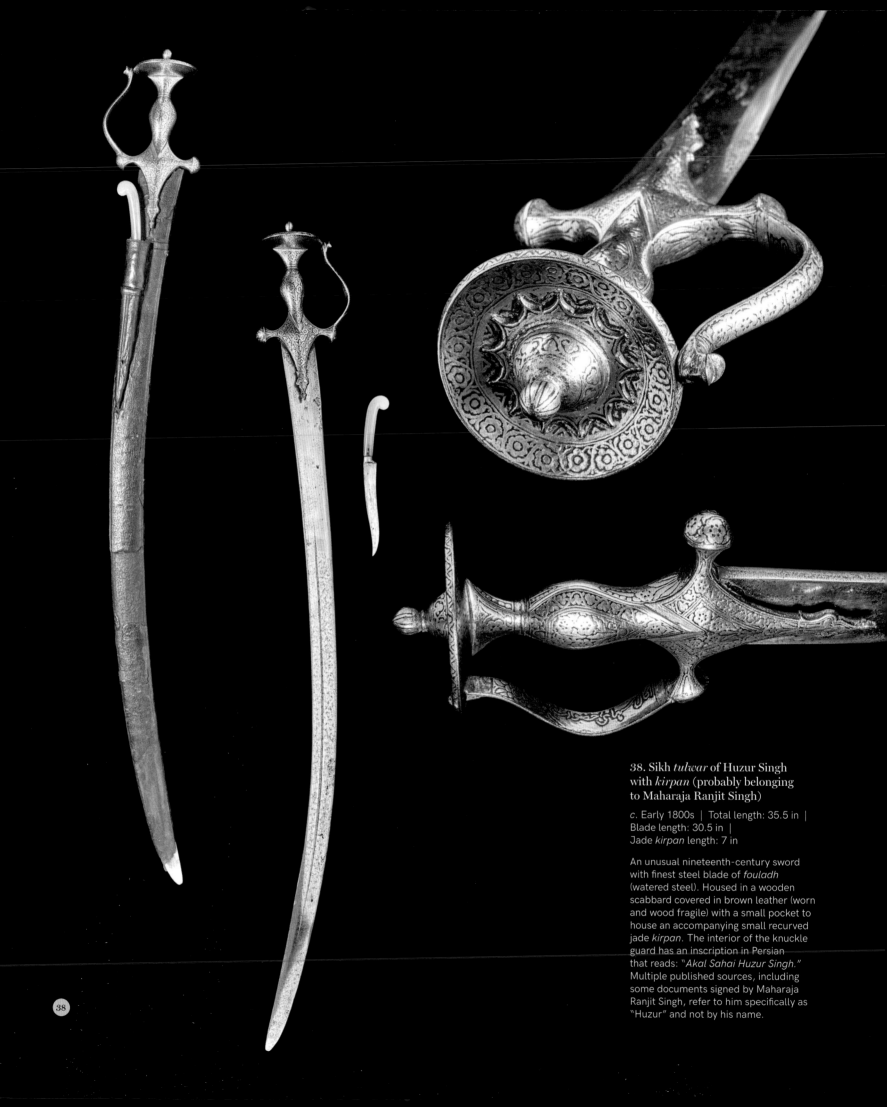

38. Sikh *tulwar* of Huzur Singh with *kirpan* (probably belonging to Maharaja Ranjit Singh)

c. Early 1800s | Total length: 35.5 in | Blade length: 30.5 in | Jade *kirpan* length: 7 in

An unusual nineteenth-century sword with finest steel blade of *fouladh* (watered steel). Housed in a wooden scabbard covered in brown leather (worn and wood fragile) with a small pocket to house an accompanying small recurved jade *kirpan*. The interior of the knuckle guard has an inscription in Persian that reads: "*Akal Sahai Huzur Singh.*" Multiple published sources, including some documents signed by Maharaja Ranjit Singh, refer to him specifically as "Huzur" and not by his name.

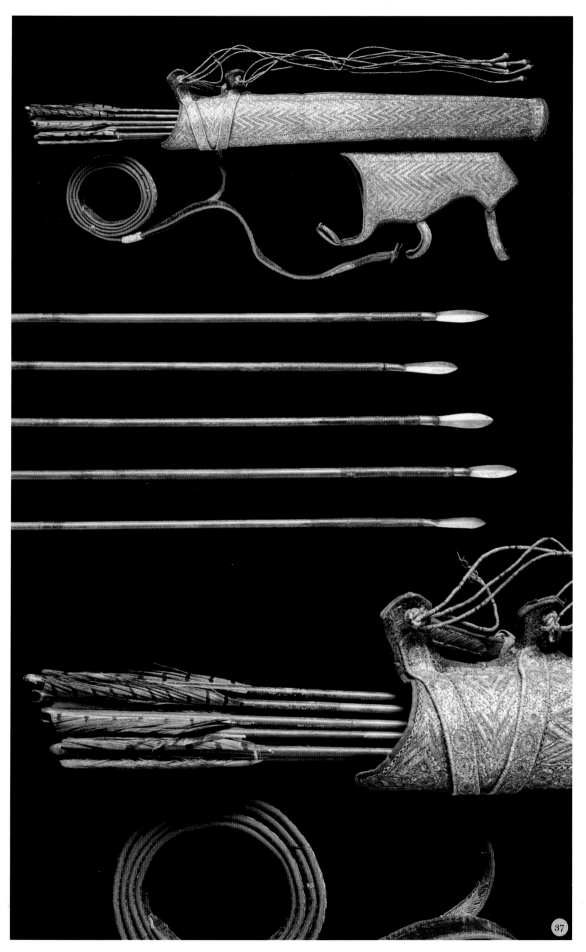

37. Maharaja Ranjit Singh's quiver

c. Mid-1830s

Maharaja Ranjit Singh likely wore this quiver on the occasion of his grandson Nau Nihal Singh's wedding in 1837. The quiver has a tapering form, and its leather body is clad entirely in red velvet embroidered to the front with gold thread and sequins with a panel containing a repeat design of chevron motifs surrounded by a band of rosettes. The velvet-clad leather belt is similarly embroidered with a band of rosettes and terminating in a circular iron buckle, green velvet suspension loop to reverse, and two sets of four tassels to one side. The bow holder as well is embroidered and designed in the same style with three green velvet suspension loops to one side. The quiver holds nine iron-tipped arrows with pheasant feather flights.

37

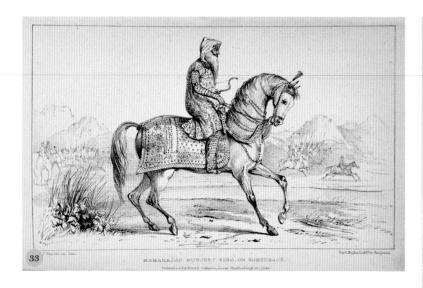

33 MAHARAJAH RUNJEET SING, ON HORSEBACK.

Published by Henry Colburn, Great Marlborough St. 1840.

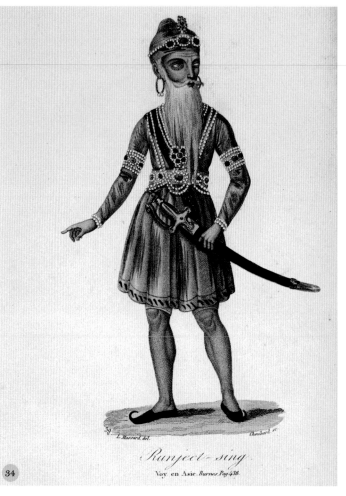

39

L. Massard, del. Chollard, sc.

Runjeet-sing.

Voy. en Asie. Burnes. Pag. 438.

34

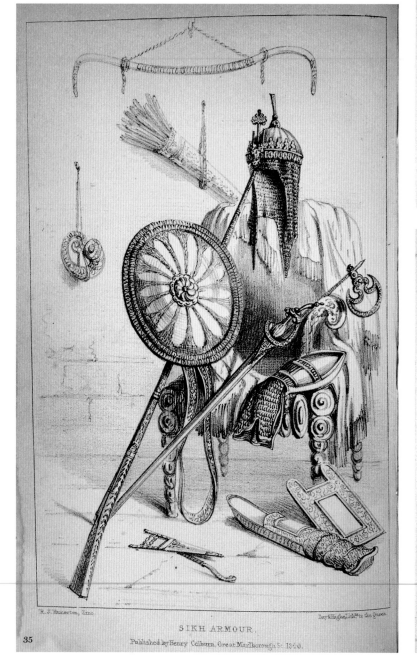

35 SIKH ARMOUR.

Published by Henry Colburn, Great Marlborough St. 1840.

R. J. Hamerton, Zinc. Ivy & Hughes, Lith'rs to the Queen.

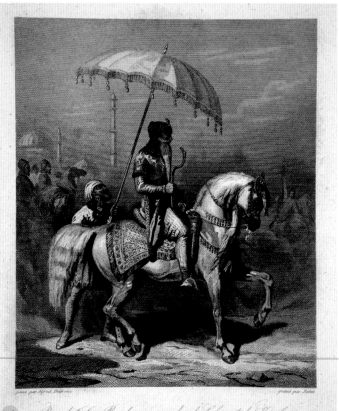

36 *Runjeet Sing Bahadur, maharadja de Lahor et de Kachmir.*

peint par Alfred Dedreux. gravé par Rollet.

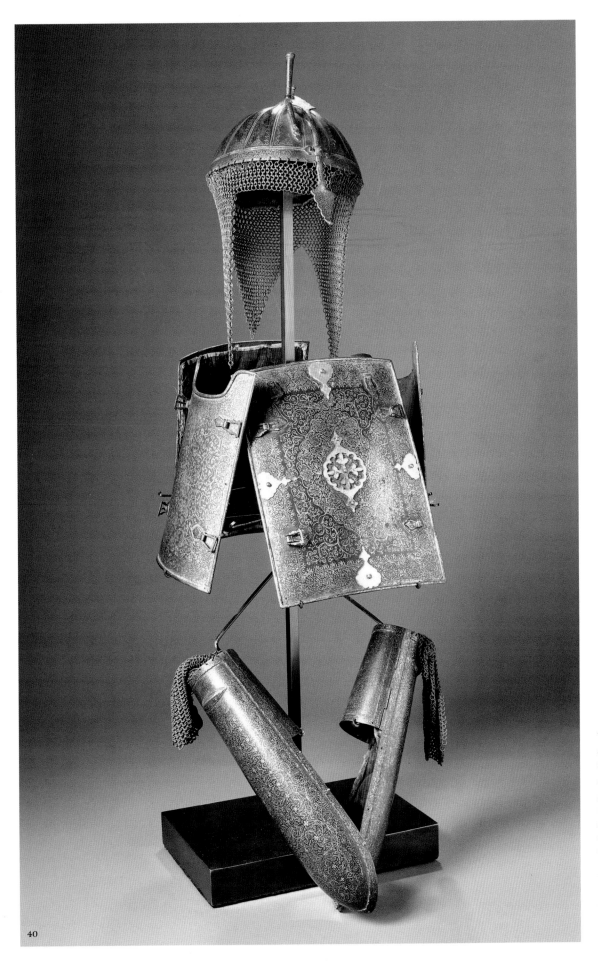

40

40. Armor set, Sialkot

c. Early to mid-19th century |
Steel and gold *koftgari*

With a helmet (*khula-khud*), two
arm-guards (*dastanas*), two shoulder
plates, and two armor panels, this
suit of armor is decorated in gold
overlay with bands. The helmet with
associated nose guard is flanked
by plume holders. The *koftgari*
decoration is typical of work produced
in Sialkot in the nineteenth century.
It is characterized by fine gold wire
work in floral and scrolling motifs,
manifested here in notably dense
patterns with generous use of gold.

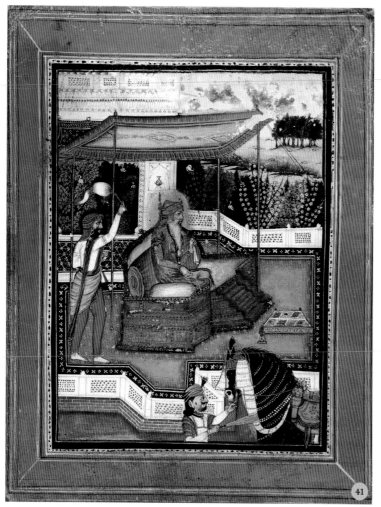

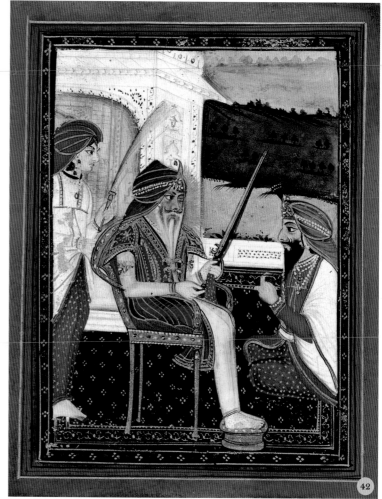

174

41. Maharaja Ranjit Singh
seated on a dais on a palace
terrace; an attendant stands
by him with a fly whisk and a
groom holds his mount

Artist unknown | *c.* 1830-50s |
6.5 x 5 in | Gouache and gold dust
on paper

42. Maharaja Ranjit Singh
holding a hammer lock gun and
seated on a terrace overlooking
a river, a courtier kneels before
him, and an attendant stands
behind holding a fly whisk

Artist unknown | *c.* 1840-50 |
4.7 x 3.8 in | Gouache and gold dust

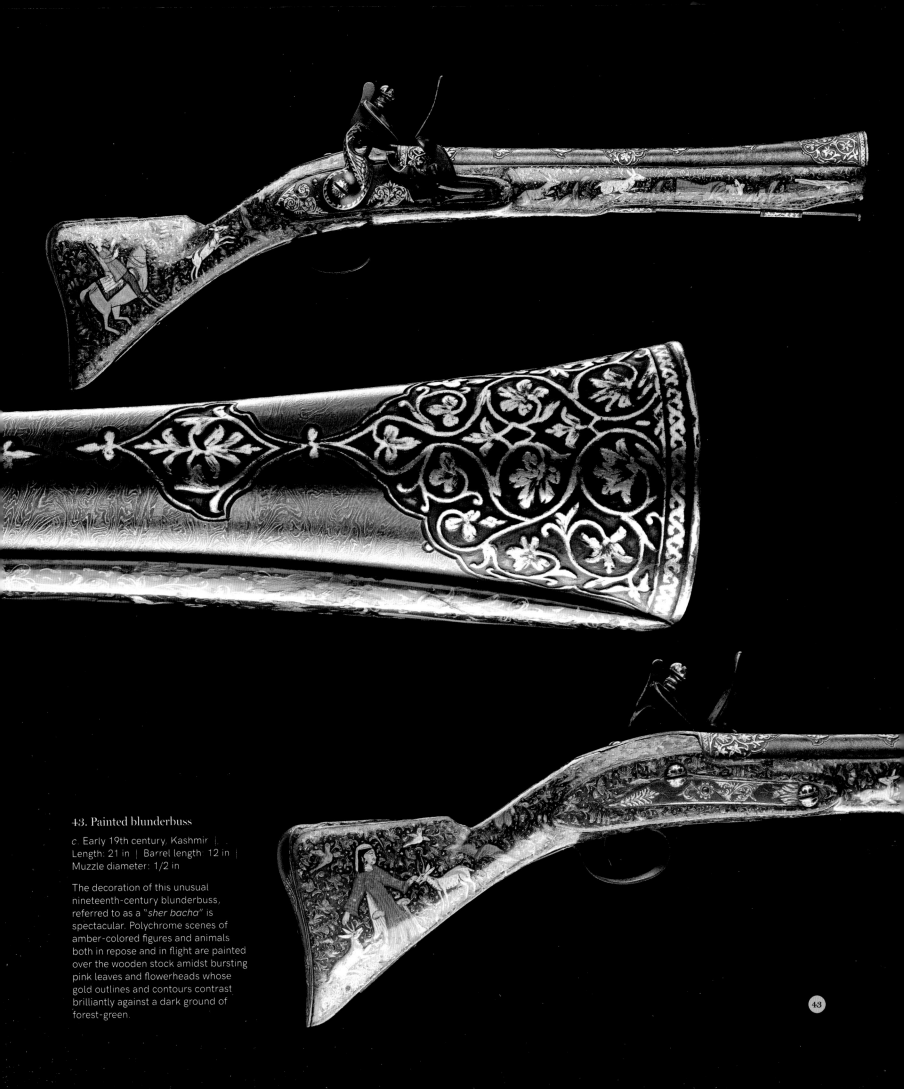

43. Painted blunderbuss

c. Early 19th century, Kashmir
Length: 21 in | Barrel length: 12 in |
Muzzle diameter: 1/2 in

The decoration of this unusual
nineteenth-century blunderbuss,
referred to as a "*sher bacha*" is
spectacular. Polychrome scenes of
amber-colored figures and animals
both in repose and in flight are painted
over the wooden stock amidst bursting
pink leaves and flowerheads whose
gold outlines and contours contrast
brilliantly against a dark ground of
forest-green.

43

HAZURI BAGH, LAHORE

With the Lahore Fort to the east, Badshahi Mosque to the west, the Samadhi of Ranjit Singh to the north, and the Roshnai Gate to the south, the Hazuri Bagh was planned and built under the supervision of Faqir Azizuddin. In the center of the park stands the Hazuri Bagh Baradari, built by Maharaja Ranjit Singh in 1818. Elegantly carved marble pillars support the *baradari*'s delicate cusped arches. The central area, where Ranjit Singh held court, has a mirrored ceiling.

176

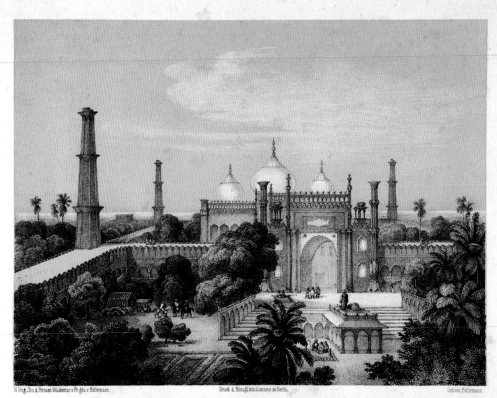

44

44. Hazuri Bagh with Badshahi Mosque in the background, Lahore

Waldemar Von Preussen (Friedrich Wilhelm) | *c.* 1844–46 | 12.5 x 9 in | Lithograph

45. Hazuri Bagh and Lahore Fort

Photographer unknown | *c.* 1870s | 8.25 x 11 in | Albumen print

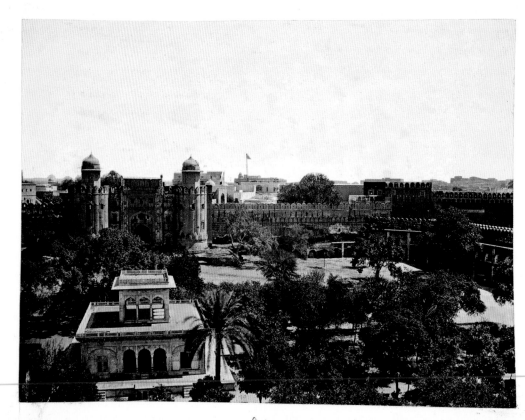

45

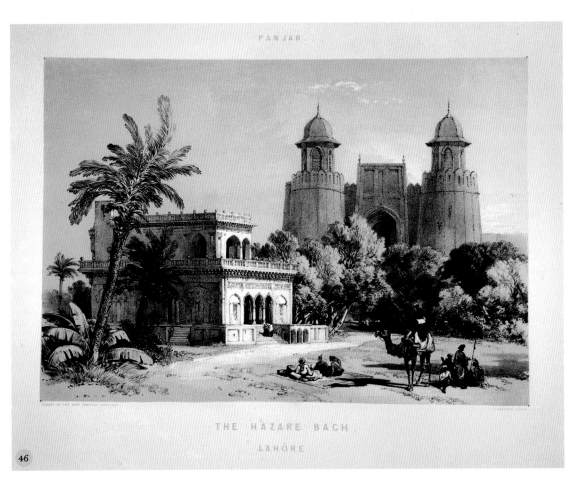

46. "Hazare Bagh" from
Recollections of India. Drawn on
stone by J.D. Harding from the
original drawings

J.D. Harding | *c.* 1847 |
21.3 x 14.4 in | Lithograph

47. "Ath Dara" from *Recollections*
of India. Drawn on stone by
J.D. Harding from the original
drawings

J.D. Harding | *c.* 1847 |
8.8 x 6.3 in | Lithograph

Sikh soldiers receiving their salary
at the royal *durbar*, Ath Dara which
means "Eight Openings," Ath Dara
was built and used as a *kacheri*, or
court, by Maharaja Ranjit Singh. It had
a beautiful ceiling with richly carved
woodwork and mirrors along with
fresco paintings covered with gold.

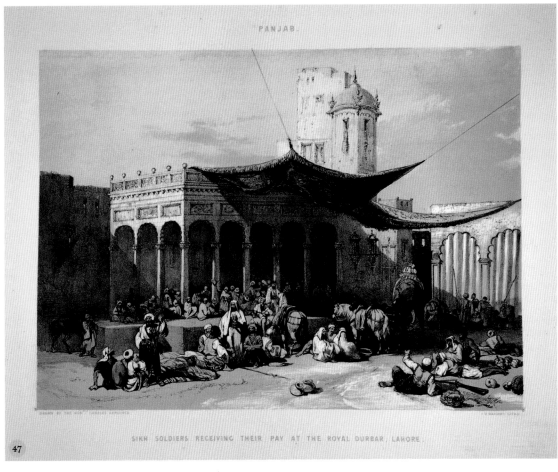

48. Sheesh Mahal, the "Palace of Mirrors"

Photographer unknown | *c.* Early 1900s | 9.5 x 7 in | Albumen print

Located within the Shah Burj block in the northwest corner of Lahore Fort, the hall was reserved for personal use by the imperial family and close aides. The palanquin-shaped building on the roof was considered to be Maharaja Ranjit Singh's personal gurdwara and it is believed that he breathed his last here.

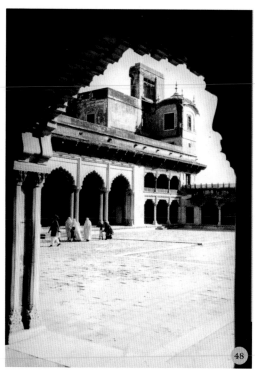

49. A view of the Lahore fort showing Naulakha Pavilion, Badshahi Mosque and Maharaja Ranjit Singh's *samadhi*

Samuel Bourne | *c.* 1863 | 8.75 x 10.75 in | Albumen print

Maharaja Ranjit Singh added several pavilions on the upper ramparts of this fort after the fall of the Mughal dynasty in Punjab. The Lahore Fort is most probably the only monument that represents a complete history of the changing architectural style.

50. Maharaja Ranjit Singh's *samadhi*, Lahore

Samuel Bourne | *c.* 1880s |
8.5 x 11.5 in | Albumen print

The *samadhi* of Maharaja Ranjit Singh, built adjacent to the Lahore Fort, houses the funerary urn of the greatest Sikh emperor. The structure is a beautiful blend of Hindu, Sikh, and Muslim architectural styles. The same complex also houses the *samadhis* of Ranjit Singh's son, Kharak Singh and grandson, Nau Nihal Singh.

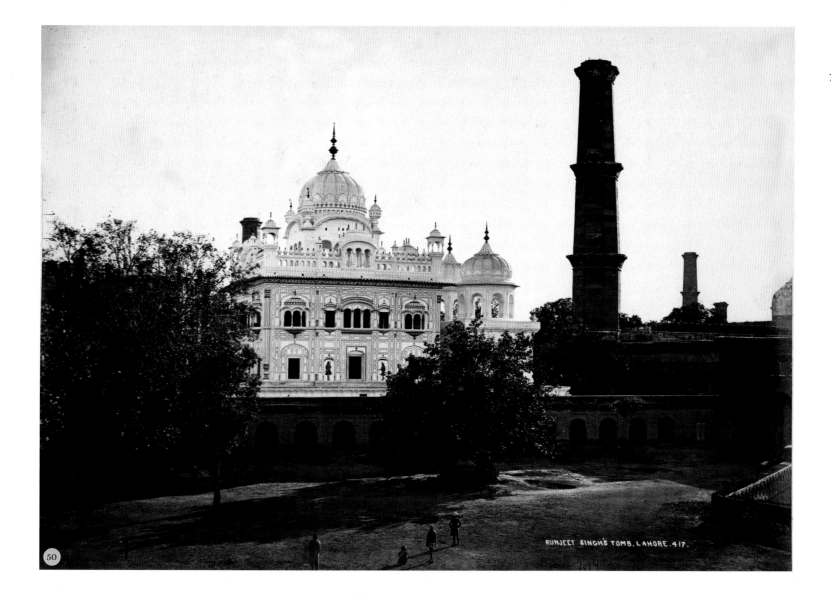

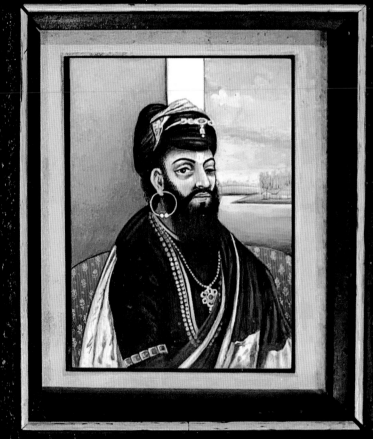

51

51. Maharaja Ranjit Singh

Artist unknown | *c.* 1800–20 |
3.7 x 2.8 in (with frame 9 x 8.26 in) |
Miniature, gouache watercolor
on paper

52. Sikh horseman riding a decorated horse, accompanied by a dog, also decorated

Artist unknown | *c.* Early 19th century |
11.5 x 9.25 in | Gouache on paper

53. Sikh prince riding a piebald horse

Artist unknown | *c.* 1830–40s |
9 x 7 in | Gouache on paper

54. Sikh prince

Artist unknown | *c.* 1830–40s |
8.25 x 6.5 in | Gouache on paper

Painted in the style of the Punjab
plains, the prince is seated in a
pensive mood with a shawl on his
head and a sword by his side.

55. Sikh *raja*

Artist unknown | *c.* 1850s |
10 x 6.5 in | Gouache on paper

A painting from the Punjab plains
of a Sikh *raja* with a falcon sitting
on his right hand. Weapons can be
seen by his side on the carpet. In the
background is a gurdwara.

52

53

54

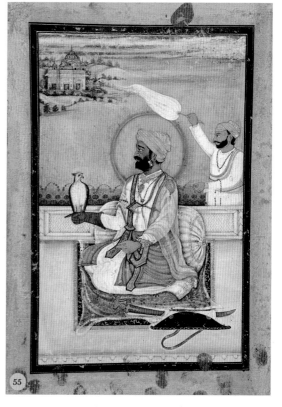

55

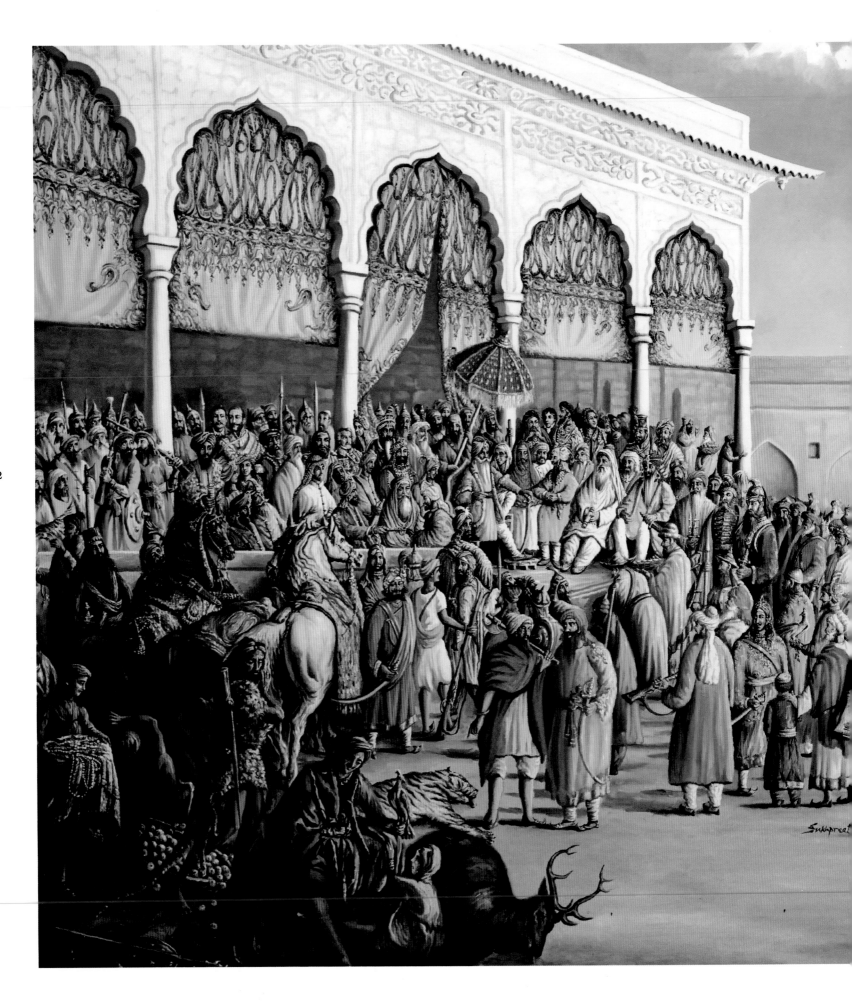

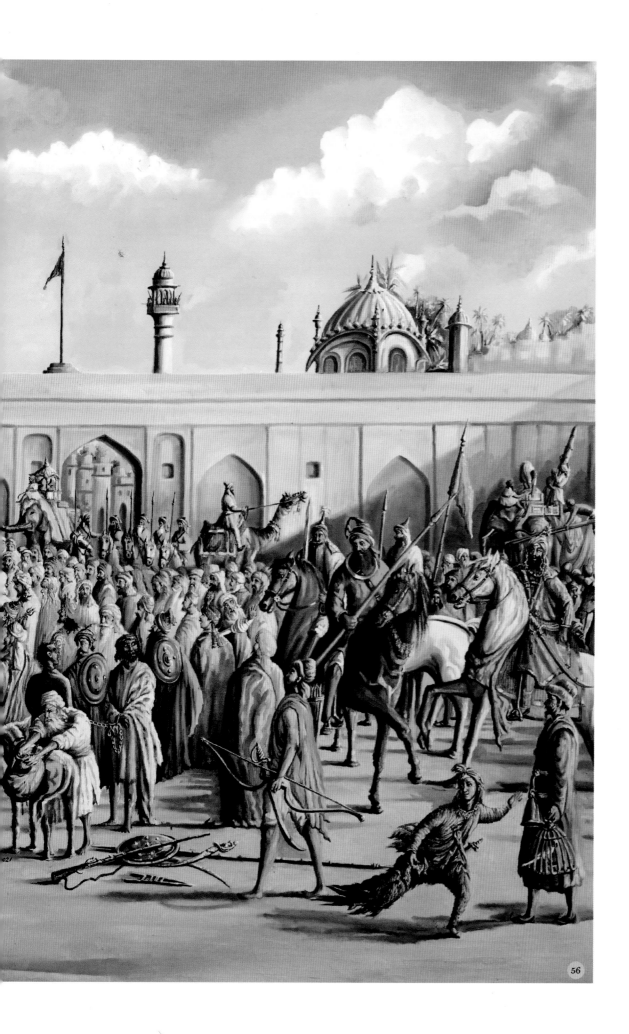

56. Durbar of Maharaja Ranjit Singh

Sukhpreet Singh | 2021 |
78 x 48 in | Oil on canvas

This painting showcases the magnificent open court of Maharaja Ranjit Singh in Lahore. The maharaja is surrounded by his sons, grandson, ministers, high-ranking generals including the ones from Europe.

56

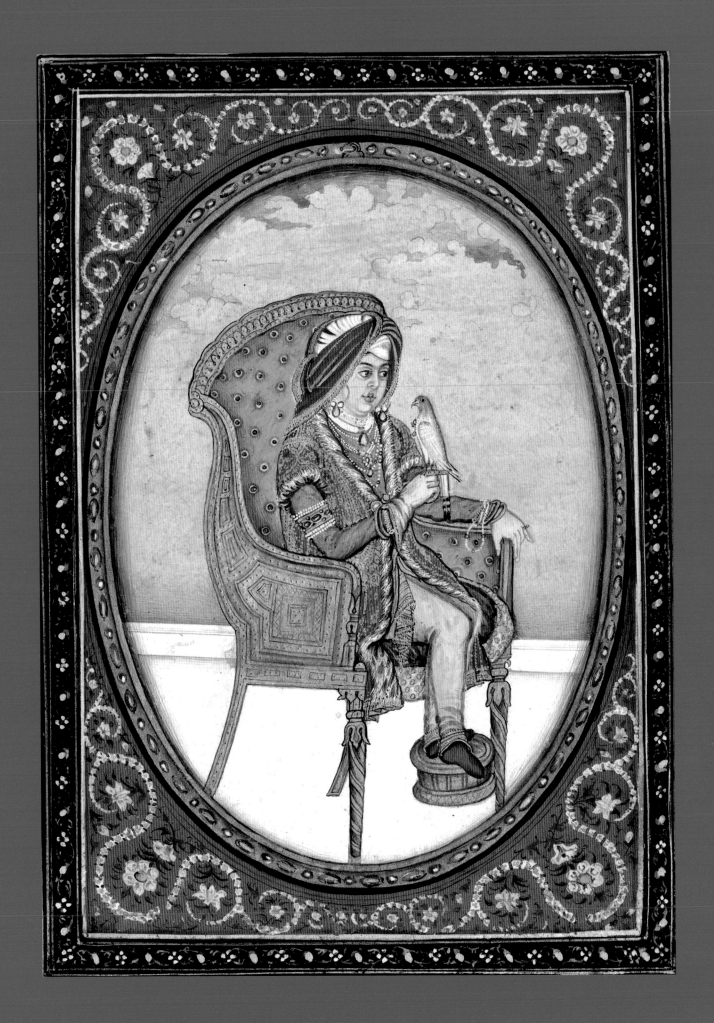

5 ENCOUNTERS WITH THE COLONIAL: THE POST-RANJIT SINGH YEARS

"IF WE MUST PERISH, IT IS BETTER THAT OUR BONES SHOULD BLEACH HONORABLY AT FEROZESHAH THAN AT FEROZEPUR."[1]

Sir Hugh Gough, hero of the Napoleonic War, expressing his despair on the first night of the battle of Ferozeshah

Following Maharaja Ranjit Singh's death in 1839, the empire was severely weakened by internal dissensions, political mismanagement, controversies, as well as betrayal by the Dogras and other chiefs. Ranjit Singh's sons ruled in quick succession. Maharaja Kharak Singh and his son Nau Nihal Singh were in power from June 1839 to November 1840. They were followed by Maharani Chand Kaur (Kharak Singh's wife), who served as the regent until January 1841. Maharaja Sher Singh took over the leadership from January 1841 to September 1843, when he was murdered by his cousins. Subsequently, Rani Jindan (Ranjit Singh's youngest wife) who stepped in as regent for her son, Maharaja Duleep Singh (1838–93), then only five years old. Duleep Singh grew up surrounded by the pomp of the court, wearing the best clothes, donning jewelry, and being treated as a royal. He rode the finest horses and elephants and received education in Persian as well as Gurmukhi. He also studied the Guru Granth Sahib under several tutors. Nonetheless, the horrors of politics soon brought his palace life to an abrupt end.

Political controversies from 1839 onwards led to conflicts and to the death of many in the leadership. The then Prime Minister Dhian Singh, his son Hira Singh, and his brothers Gulab Singh (who escaped to Kashmir with part of the Lahore Durbar wealth) and Suchet Singh were a major part of this discord. The British East India Company was also actively involved in dividing the factions and weakening the empire's central government.

In addition to local artists, two European painters captured the events of this period. The first, the Hungarian painter August Schoefft, sketched multiple portraits and scenes in 1841. His works are presently part of the Bamba Collection at the Lahore Fort. The second, Prince Alexis Soltykoff, a Russian aristocrat visiting Lahore in the early 1840s, published large tinted lithographs depicting spectacular hunting scenes from Punjab and Maharaja Sher Singh on an elephant with his entourage.

After this tumultuous period, Tej Singh became the commander-in-chief and Lal Singh was the prime minister. Both were converts into Sikhism and, therefore, were regarded as opportunists. The restlessness of the Khalsa army and the repeated instigations by the British resulted in the first Anglo-Sikh War (1845–46), after decades of peace between the neighbors. As Joseph D. Cunningham pointed out, "yet further inquiry will show that the policy pursued by the English themselves for several years was not in reality well calculated to insure a continuance of pacific relations, and they cannot be held blameless for a war which they expected and deprecated."[2]

The British and Sikh forces faced each other at different sites, including Mudki, Ferozeshah, Aliwal, and Sabraon. The British were led by Sir Hugh Gough (commander-in-chief), Sir Henry Hardinge (governor-general), and many veterans from the Napoleonic wars. The Sikhs were led by Lal Singh and Tej Singh who conspired with the British, thus playing a major role in the defeat of the Khalsa army. As Burton stated, "But this idea of treachery of the Sikh leaders and their sinister designs towards the Khalsa appears to have been carried to an absurd extent."[3]

1. Maharaja Duleep Singh sitting on a golden chair with a bird perched on his gloved right hand

Artist unknown | *c.* 1840s | 7.4 x 5.3 in | Gouache and gold dust

On the first night of the battle, the British army appeared to be defeated and this would have had significant repercussions for their future in India. In the words of Amarpal Singh, "Gough after due consideration, declared to Hardinge: The thing is impossible. My mind is made up. If we must perish, it is better that our bones should bleach honorably at Ferozeshah than at Ferozepur... [but] Tej Singh was refusing to advance. He had also declined to ransack Ferozepur and destroy the British garrison."[4] As Khushwant Singh has noted, "Lord Gough quickly realized that the Sikh commanders had fulfilled their treacherous promise."[5]

Gulab Singh held out his armies while negotiating with the British. However, there were some Muslim and Sikh leaders including General Sham Singh Attariwala who fought valiantly. There are multiple accounts written by soldiers and generals in the British archives praising the Khalsa army, their accuracy and range in artillery, their bravery in standing up in front of charging squadrons to give a blow before being cut down, and their determination in refusing to surrender. But all this was to no avail because of their leaders who were indecisive or were colluding with the British. The First Anglo-Sikh War resulted in the partial subjugation of the Sikh kingdom and in the cession of Jammu and Kashmir, which became a separate princely state under British suzerainty.

After the British victory, Jullundur Doab, an area of Punjab located between the Beas and Sutlej rivers, was annexed by the colonizers. Those who had colluded with the British were rewarded. For instance, as Johann Martin Honigberger noted, "Cashmere comprising a part of the mountains, was appointed to Gholab Singh, as a reward for the services he rendered."[6] Maharaja Duleep Singh remained the formal ruler; his mother, Rani Jindan, initially acted as a regent, but was soon replaced by a British Resident in Lahore, Sir Henry Lawrence, supported by a Council of Regency. This effectively gave the East India Company control of the government.

In April 1848 a minor uprising took place in Multan and, as General George St Patrick Lawrence of the British army noted, "the unfortunate delay in putting down the revolt... caused the disaffection."[7] This was handled much later in the year. In addition, because of the mistreatment by the British of Generals Raja Chattar Singh and Sher Singh, a part of the Sikh army revolted in what came to be called as the Second Anglo-Sikh War. The Battle of Ramnagar in November 1848 along with the Battle of Chillianwala in January 1849 were a near calamity for Gough and the British. However, on January 22nd, Multan was taken over by General Whish and nearly a month later Gough won a decisive victory in the Battle of Gujerat. These victories led to the annexation of Punjab by Governor-General Dalhousie who had replaced Hardinge. Many disagreed with Lord Dalhousie's decision. For instance, as Priya Atwal has noted, "Lawrence wrote a series of private letters desperately urging Dalhousie not to annex the Punjab."[8] Likewise, Major Bell asserted,

> The British Government, under the guidance of Lord Dalhousie, – annexation being severely premeditated, – turned the treaty of Guardianship to the fullest account, with the Maharajah's troops and resources, and the influence of his name, for the suppression of the rebellion, and then declared the Treaty to be at an end and Punjab 'conquered.'[9]

The British also appropriated the famous Kohinoor diamond and other riches of the Sikh treasury, including jewels housed in the *toshakhana* in Lahore, Kashmiri shawls, relics, the maharaja's golden chair, and the last and wealthiest independent kingdom in greater India. Henry Martens, an English artist, created a set of lithographs depicting different battle scenes, some of which we present in this chapter.

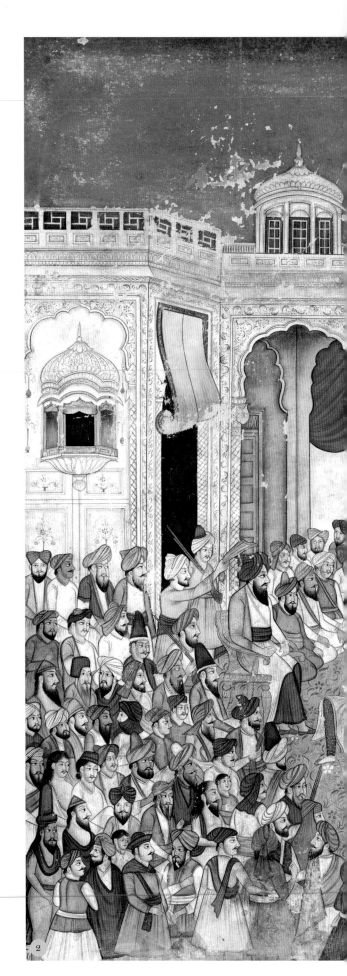

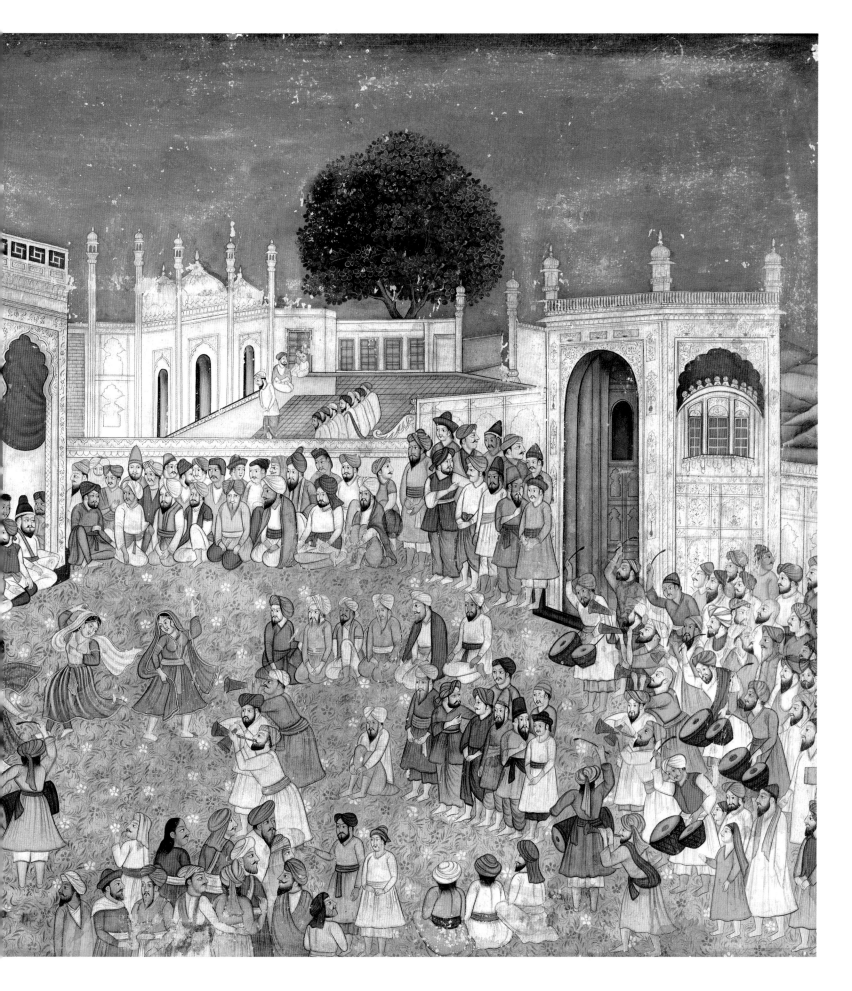

3

2. Scene in Lahore

Artist unknown | *c.* Mid- to late 19th century | 31 x 36 in | Gouache on paper

An important looking and busy gathering in Lahore with dancing girls entertaining a group of men of Hindu, Muslim, and Sikh faiths. Also visible in the background is a mosque with a few people offering namaz.

3. Maharaja Sher Singh

Artist unknown | 19th century | 20 x 15.7 in | Gouache on paper

Rani Jindan, a woman endowed with a great spirit and self-esteem, was first separated from her son, Duleep Singh, and then imprisoned, but eventually managed to escape to Nepal. Governor-General Dalhousie had to say this about her, "Rely upon it, she is worth more than all the soldiers of the state put together."[10] Maharaja Duleep Singh was deposed at the age of ten and was put under the care of Dr. John Login, a devout Christian. Login and his wife exerted great influence on the maharaja in his formative years. The young ruler was forcibly relocated from Lahore to Fatehgarh in December 1849, leaving behind his friends, tutors, family, possessions, never to return to Punjab. Under his tutors' influence, he converted to Christianity before turning fifteen. Subsequently he moved to England for a short trip, which eventually turned into an exile. He was granted a meager pension that left him unsatisfied and which he objected to when he became an adult. Even though he was close to Queen Victoria, his finances were handled by the East India Company. When the British realized that Rani Jindan was no longer a threat, she was allowed to join her son on January 16th, 1861. After a separation of over thirteen years, she met him at Spence's Hotel in Calcutta and returned with him to England. According to Peter Bance, "Mother and son passed the time reminiscing about the former glories and splendours of the Sikh Durbar."[11] Rani Jindan died in a foreign land in 1863.

In 1864, Duleep Singh married Bamba Muller, who was part German, part Ethiopian. They had six children but no grandchildren, and hence the dynasty came to an end. Duleep Singh spent the next twenty years indulging in sports with high society friends. Over time he complained about his treatment by the British, and in a private bitter manuscript, he highlighted that his properties were taken over illegally. He was also forbidden to return to Punjab on the pretext that his presence in the region could lead to instability. Later he realized he had been misled and thus re-embraced Sikhism in 1886. He died a broken man in Paris in 1893 and was buried in Elveden, his estate for many years.

His daughter Princess Sophia Duleep Singh (1876–1948) was a prominent suffragette in the United Kingdom and the goddaughter of Queen Victoria. After her death, her sister Princess Bamba Sutherland (1869–1957) remained the last surviving member of the family. She moved to Lahore where she died. The artwork she collected, presently known as the Bamba collection, housed at the Lahore Fort, include the sketches August Schoefft drew during his stay in Lahore in the 1840s, pictures that continue to evoke the dramatic history of the post-Ranjit Singh era.

REFERENCES & NOTES

1. A. Singh, *The First Anglo-Sikh War* (Gloucestershire: Amberley Publishing, 2014), 87.

2. J.D. Cunningham, *History of the Sikhs* (John Murray: London, 1849), 300–301.

3. R.G. Burton, *The First and Second Sikh Wars* (Yardley: Westholme, 1911, reprint 2008), 19.

4. A. Singh, *The First Anglo-Sikh War* (Gloucestershire: Amberley Publishing, 2014), 87–89.

5. K. Singh, *A History of Sikhs*, vol. 2 (New Delhi: Oxford University Press, 1999), 50.

6. J.M. Honigberger, *Thirty-Five Years in the East* (London: L.H. Baillière, 1852), 127.

7. G. Lawrence, *Reminiscences of Forty-Three Years in India* (Lahore: Sang-e-meel Publications, 1974), 245.

8. P. Atwal, *Royals and Rebels. The Rise and Fall of the Sikh Empire* (Oxford: Oxford University Press, 2020), 204.

9. E. Bell, *The Annexation of the Punjaub and the Maharajah Duleep Singh* (London: Trubner & Co., 1882), 6.

10. P. Singh and J.M. Rai, *Empire of the Sikhs* (New Delhi: Hay House India, 2008), 221.

11. P. Bance, *Sovereign, Squire and Rebel: Maharajah Duleep Singh* (London: Coronet House, 2009), 52.

190

Raja Dina Nath

Kharak Singh

Sher Singh

Raja Lal Singh

Sher Singh Atariwala

Duleep Singh

Dost Muhammad Khan

Ranbir Singh

Nau Nihal Singh

Teja Singh

Mul Raj

4

4. Eleven miniature portraits of mostly Sikh leaders of the Punjab

Artist unknown | *c.* 1850–60s | Gouache heightened with gold on paper

Each miniature of oval form depicts Sikh rulers of the nineteenth century. The rulers are depicted sitting, mostly cross-legged, on a gold throne placed on a blue floral carpet before an open curtain with floral spray. Their names are on the reverse of the portraits.

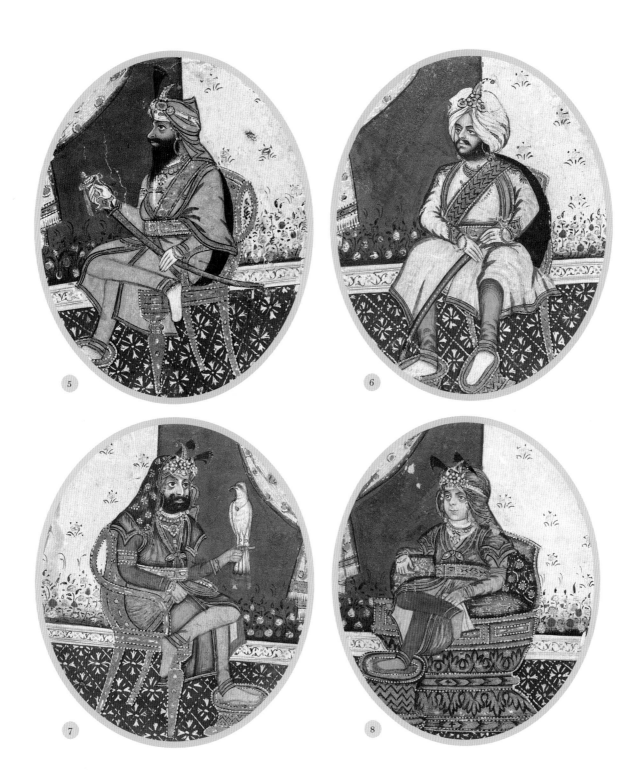

5. Maharaja Kharak Singh

Artist unknown | *c.* 1850-60s |
2.8 x 2.25 in | Gouache on paper

6. Maharaja Nau Nihal Singh

Artist unknown | *c.* 1850-60s |
2.8 x 2.25 in | Gouache on paper

7. Maharaja Sher Singh

Artist unknown | *c.* 1850-60s |
2.8 x 2.25 in | Gouache on paper

8. Maharaja Duleep Singh

Artist unknown | *c.* 1850-60s |
2.8 x 2.25 in | Gouache on paper

THE EMPRESS OF PUNJAB

Maharani Chand Kaur (1802–42) was the wife of Maharaja Kharak Singh, the eldest son and successor of Maharaja Ranjit Singh. She was given the title of Malika Mukkadas (Empress Immaculate) in 1840. After the assassination of Kharak Singh and death of her son Nau Nihal Singh, she became regent of Punjab from November 5th, 1840 to January 18th, 1841 as her daughter-in-law, Sahib Kaur, was pregnant with the child of Nau Nihal Singh. It is likely that this sword (facing page) was made during her short reign.

192

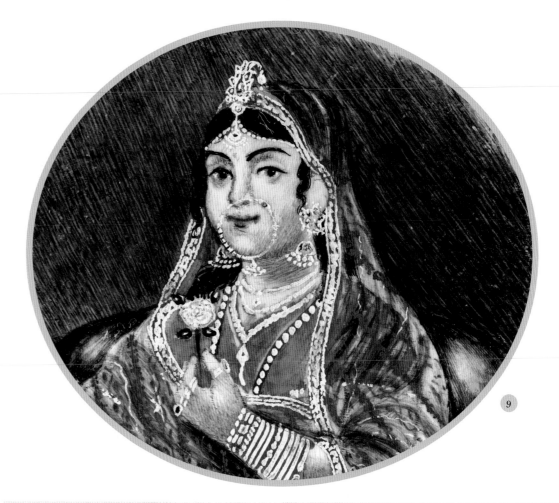

9

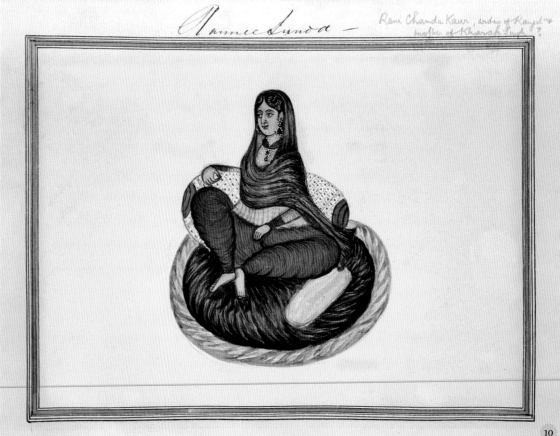

10

9. Miniature of an Indian Royal Sikh princess, possibly Maharani Chand Kaur

Artist unknown | Punjab School; *c.* 1850–60s | D: 1.5 in | Gouache on paper

10. Maharani Chand Kaur

Amal Bahauddin Peshawari | *c.* 1860s | 5.5 x 7.5 in | Watercolor

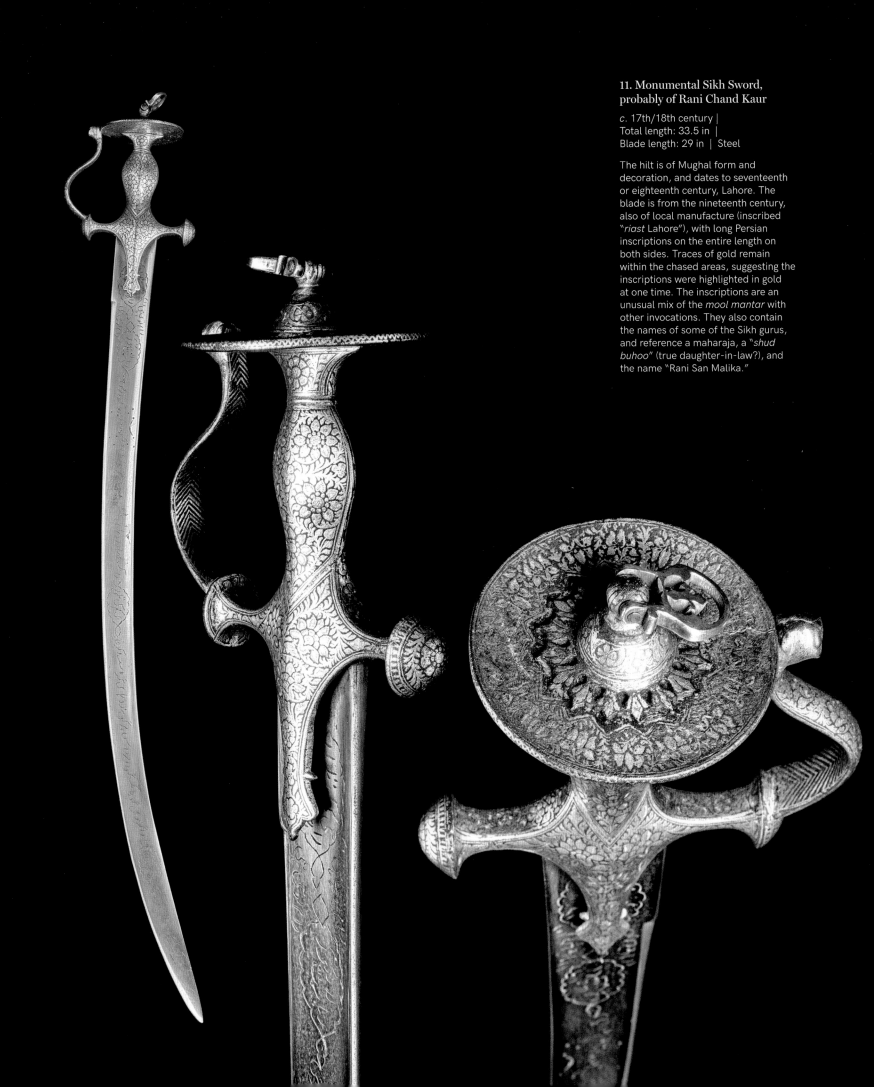

11. Monumental Sikh Sword, probably of Rani Chand Kaur

c. 17th/18th century |
Total length: 33.5 in |
Blade length: 29 in | Steel

The hilt is of Mughal form and decoration, and dates to seventeenth or eighteenth century, Lahore. The blade is from the nineteenth century, also of local manufacture (inscribed "*riast* Lahore"), with long Persian inscriptions on the entire length on both sides. Traces of gold remain within the chased areas, suggesting the inscriptions were highlighted in gold at one time. The inscriptions are an unusual mix of the *mool mantar* with other invocations. They also contain the names of some of the Sikh gurus, and reference a maharaja, a "*shud buhoo*" (true daughter-in-law?), and the name "Rani San Malika."

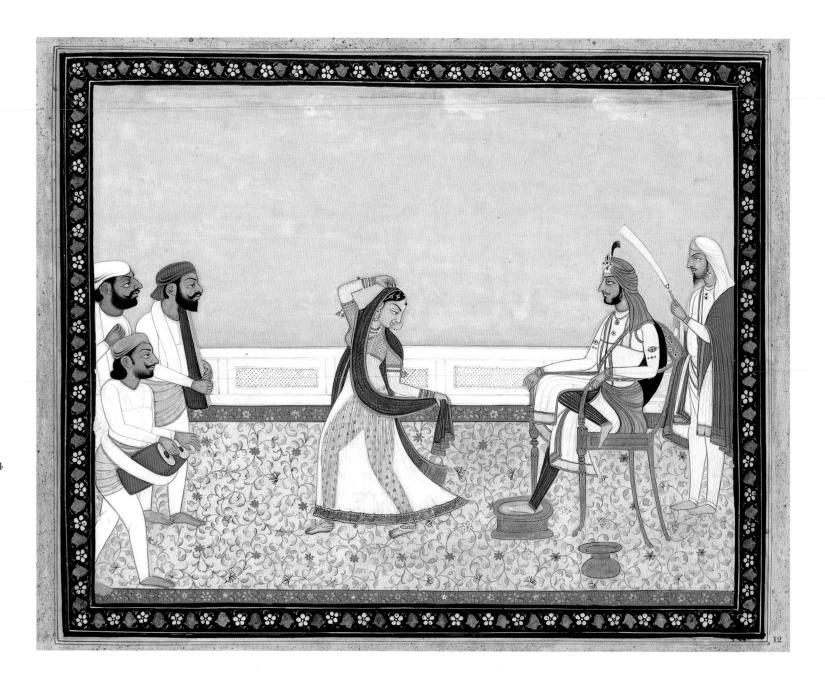

194

12. Nau Nihal Singh, grandson of Maharaja Ranjit Singh

Artist unknown | 19th century |
10 x 12.2 in | Opaque pigments
heightened with gold on paper

The young prince seated on a terrace
is enjoying a *nautch* (dance) performed
by an elegantly dressed dancer with
musicians. The prince was killed by
the fall of an archway (Khuni Darwaza)
while returning from the funeral of his
father, Maharaja Kharak Singh.

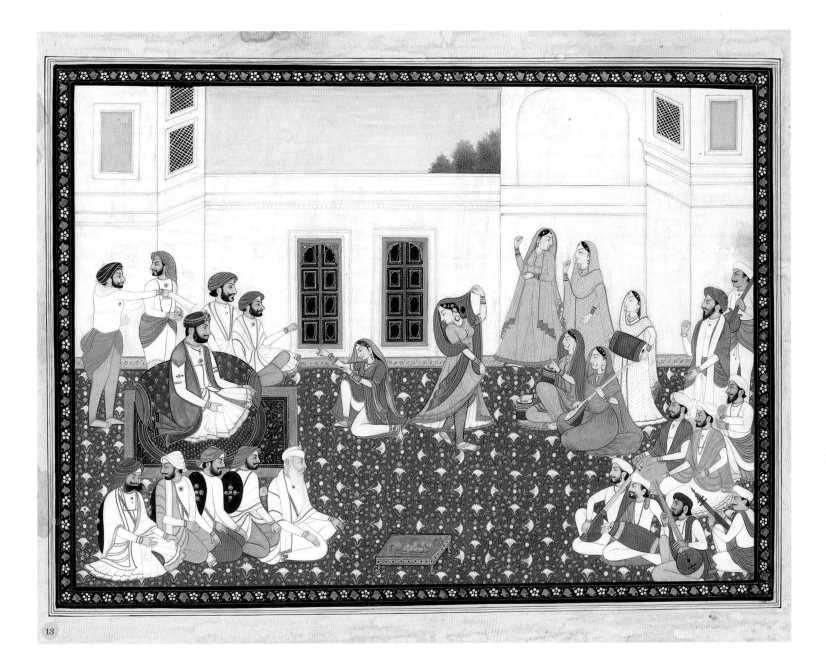

13. Sikh prince with courtiers attending a *nautch*

Artist unknown | 19th century |
14.2 x 18.9 in | Opaque pigments
heightened with gold on paper

A Sikh prince and courtiers can be
seen enjoying a *nautch* performed by
dancers accompanied by men and
women playing musical instruments.

196

14

15

Musalmanee
Singing and Dancing —

16

Nos. 1. 2. 3. Hindoos. Three Sisters, celebrated
Nautch Girls

17

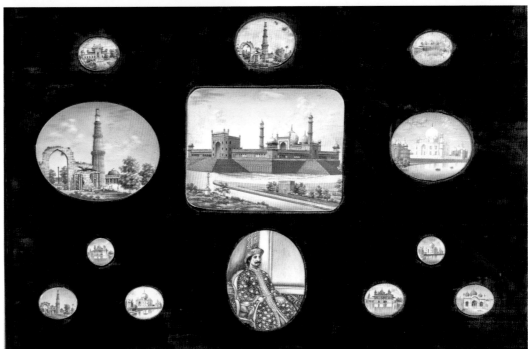

14–17. *Nautch* girls in Punjab or north India

Artist unknown | *c.* 1840s | 5.5 x 4.1 in (each) | Gouache and gold on paper

18. Gift from Raja Hira Singh to Lord Ellenborough (and detail)

c. 1844 | Painting on ivory

Retirement gift for Edward Law, Ist Baron Ellenborough and governor-general of India by Raja Hira Singh. Most probably presented to him on July 1st, 1944, this unusual gift includes miniature watercolors of monuments like the Jama Masjid, Taj Mahal, Qutub Minar, Golden Temple, and, most likely, of Lord Ellenborough.

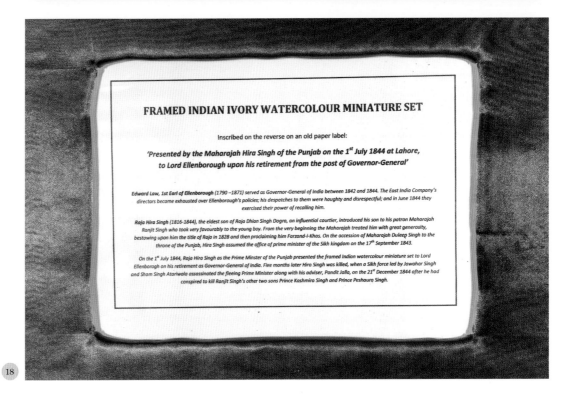

FRAMED INDIAN IVORY WATERCOLOUR MINIATURE SET

Inscribed on the reverse on an old paper label:

'Presented by the Maharajah Hira Singh of the Punjab on the 1st July 1844 at Lahore, to Lord Ellenborough upon his retirement from the post of Governor-General'

Edward Law, 1st Earl of Ellenborough (1790 –1871) served as Governor-General of India between 1842 and 1844. The East India Company's directors became exhausted over Ellenborough's policies; his despatches to them were haughty and disrespectful; and in June 1844 they exercised their power of recalling him.

Raja Hira Singh (1816-1844), the eldest son of Raja Dhian Singh Dogra, an influential courtier, introduced his son to his patron Maharajah Ranjit Singh who took very favourably to the young boy. From the very beginning the Maharajah treated him with great generosity, bestowing upon him the title of Raja in 1828 and then proclaiming him Farzand-i-Khas. On the accession of Maharajah Duleep Singh to the throne of the Punjab, Hira Singh assumed the office of prime minister of the Sikh kingdom on the 17th September 1843.

On the 1st July 1844, Raja Hira Singh as the Prime Minster of the Punjab presented the framed Indian watercolour miniature set to Lord Ellenborogh on his retirement as Governor-General of India. Five months later Hira Singh was killed, when a Sikh force led by Jawahar Singh and Sham Singh Atariwala assassinated the fleeing Prime Minister along with his adviser, Pandit Jalla, on the 21st December 1844 after he had conspired to kill Ranjit Singh's other two sons Prince Kashmira Singh and Prince Peshaura Singh.

18

19. Preparatory sketch of Maharaja Sher Singh with British and Sikh officers and attendants

Artist unknown | 19th century | 16.9 x 27.5 in | Pencil on paper

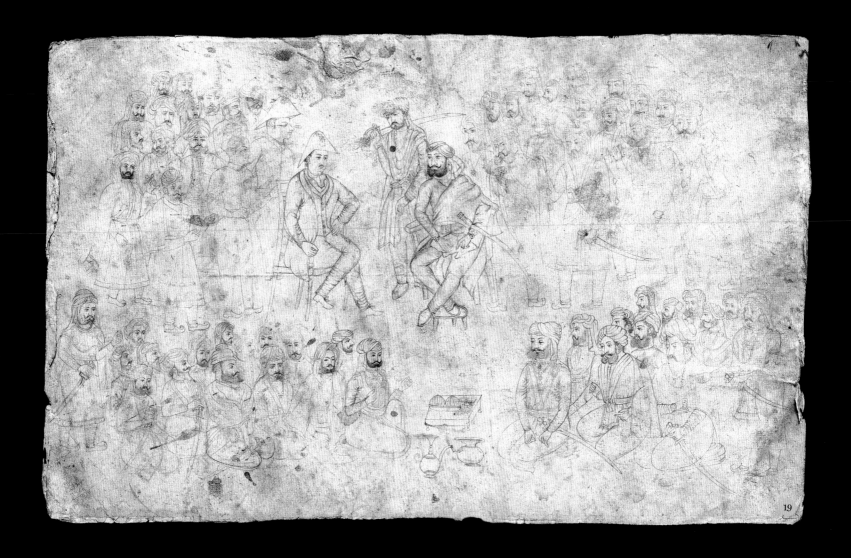

19

20. Raja Heera Singh, son of Raja Dhian Singh, senior minister to the Dogra brothers

Emily Eden | *c.* 1838 | 23 x 17.5 in | Hand-colored lithograph

21. Maharaja Sher Singh, from *The Court and Camp of Runjeet Singh*

William Osborne | *c.* 1840 | Lithograph

22. Maharaja Ranjit Singh's son, Maharaja Sher Singh, who succeeded to power in early 1841

Emily Eden | *c.* 1838 | 22 x 17.5 in | Hand-colored lithograph

23. Maharaja Sher Singh

Artist unknown | *c.* 1830s | 6 x 4.5 in | Ink and color on paper

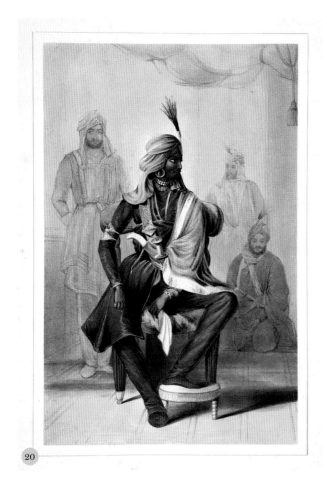

20

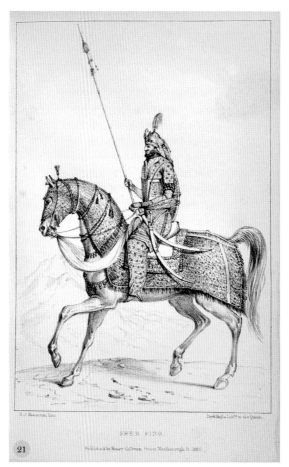

21

SHER SING

H. J. Hamerton, lith.

Day & Haghe Lith™ to the Queen.

Published by Henry Colburn, Great Marlborough St. 1840

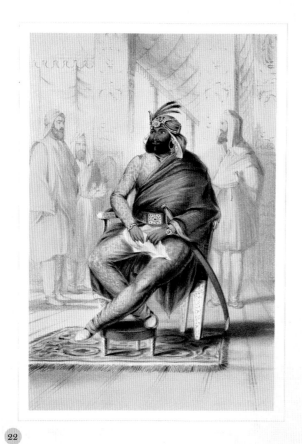

22

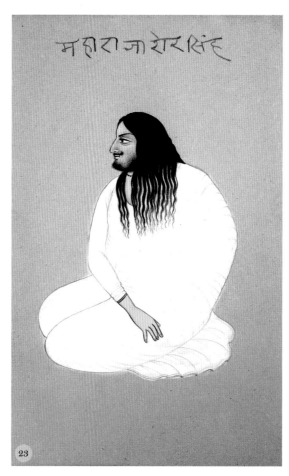

महाराजा शेरसिंह

23

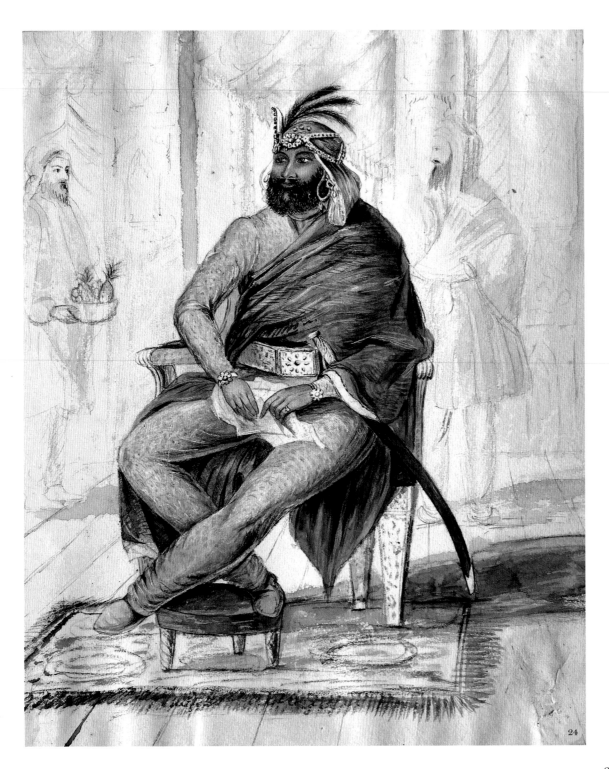

200

24

24. Maharaja Sher Singh

Emily Eden | *c.* 1838 | 12 x 9 in |
Graphite and watercolor on paper

From Emily Eden's *Portraits of the
Princes and People of India*, this is a
rare preparatory sketch of Maharaja
Sher Singh. However, there are
subtle differences with the lithograph
presented in the previous page.

25. Portrait sketches of five Indians

Emily Eden | *c.* 1840 | 15.5 x 11.3 in |
Watercolor

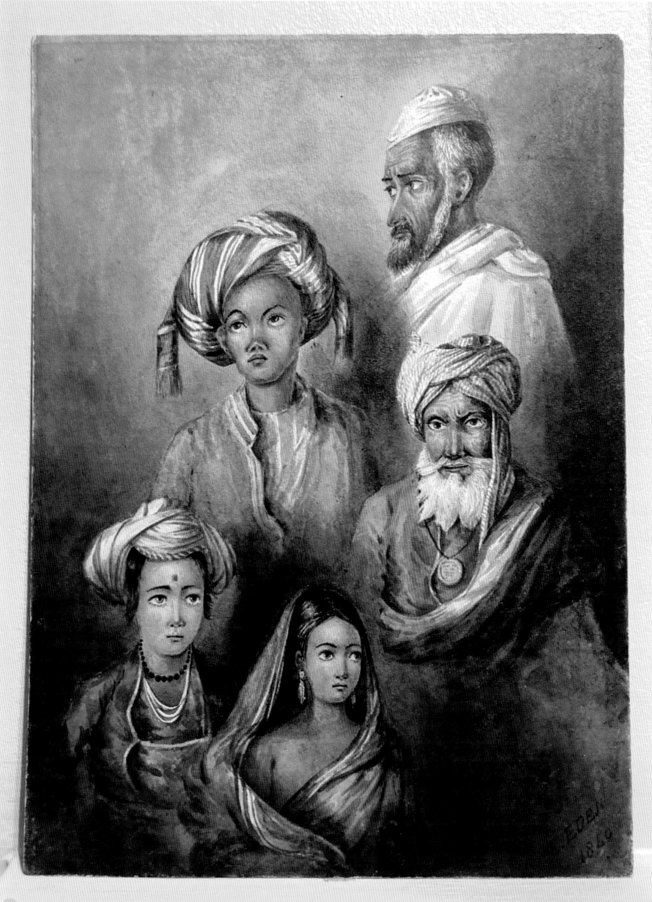

201

25

PRINCE ALEXIS SOLTYKOFF

Alexis Soltykoff (1806–59) was a Russian artist. He traveled to Persia and India and visited the Lahore Durbar during Maharaja Sher Singh's reign. Paintings 26-28 are from his book *Indian Scenes and Characters: Sketched from Life.*

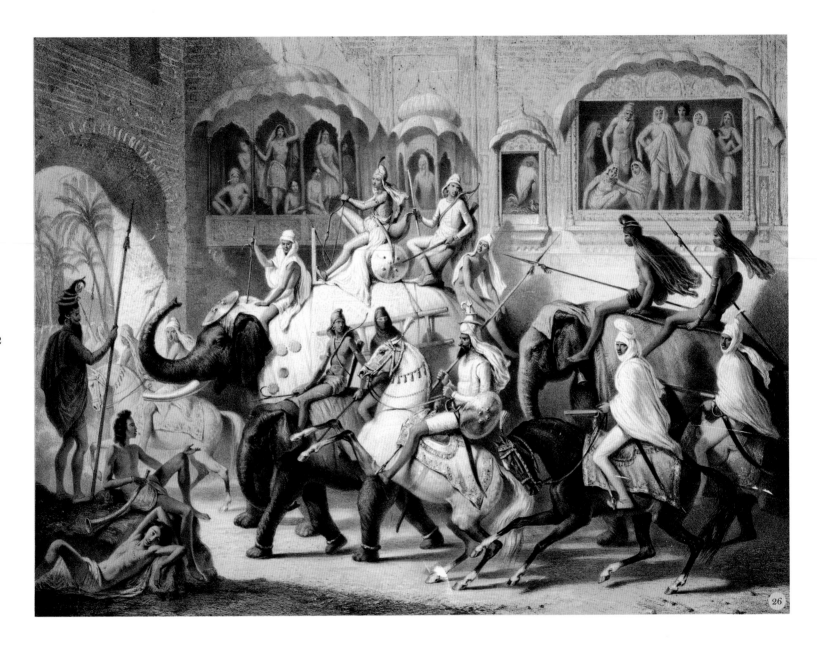

26. A scene from the streets of Lahore where a party of soldiers is passing through while bystanders are looking on

Alexis Soltykoff | *c.* 1842 | 19.5 x 26 in | Lithograph

27. Sikh chieftains on horseback and elephants

Alexis Soltykoff | *c.* 1842 | 12 x 18.5 in | Lithograph

28. Cavalcade of Sikh chieftains on elephants

Alexis Soltykoff | *c.* 1842 | 12 x 18.5 in | Lithograph

The lithograph depicts Raja Dhian Singh and many nobles of Lahore coming to meet the British envoy, Sir George Clerk.

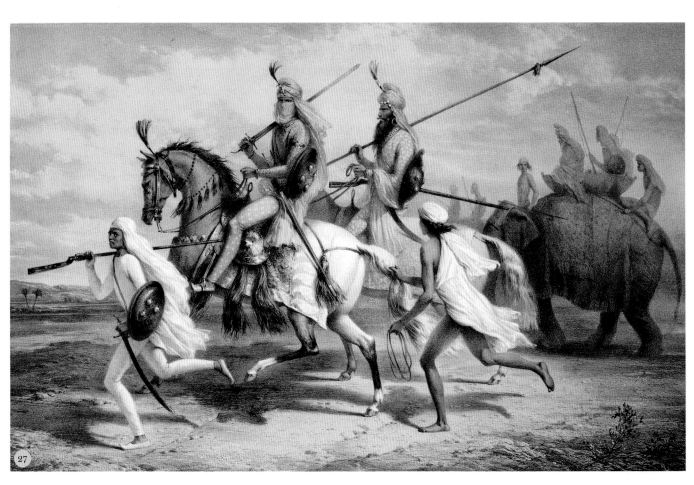

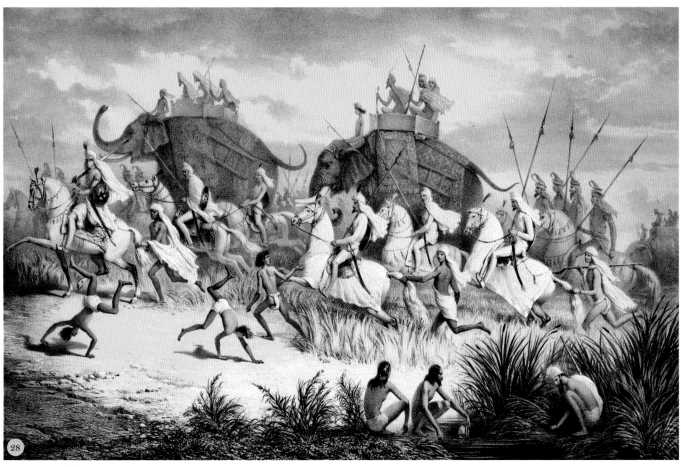

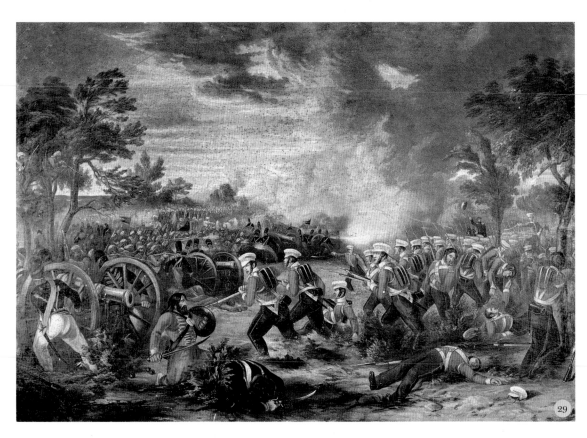

29. Scene from the First Anglo-Sikh War, Mudki

Henry Martens | *c.* 1846 |
29 x 22 in | Lithograph

HM 31st Foot charging the Sikh guns at Mudki. Fought on December 18th, 1845, the British army won an untidy encounter battle, suffering heavy casualties.

30. Scene from the First Anglo-Sikh War, Aliwal

Henry Martens | *c.* 1846 |
29 x 22 in | Lithograph

HM 16th Queen's Lancers charging the Sikh infantry at the Battle of Aliwal on January 28th, 1846. The British were led by Sir Harry Smith, while the Sikhs were led by Ranjodh Singh Majithia. Britain's victory in the battle is sometimes regarded as the turning point in the First Anglo-Sikh War.

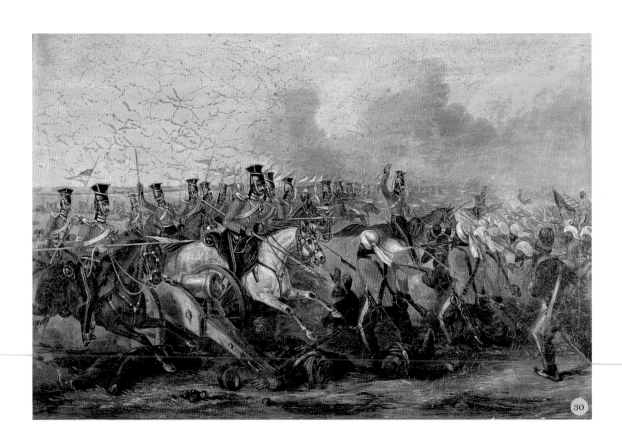

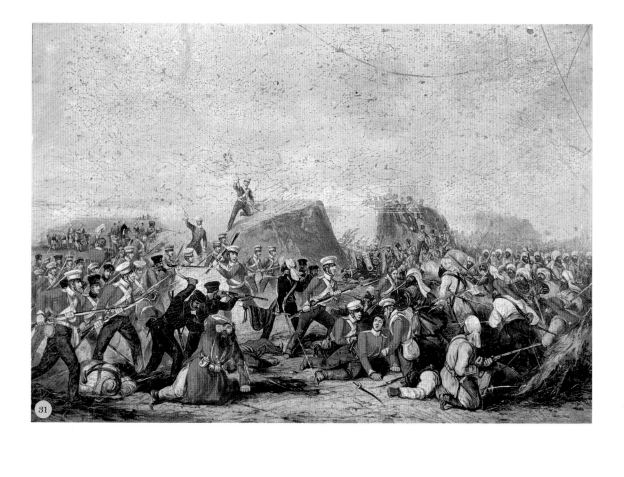

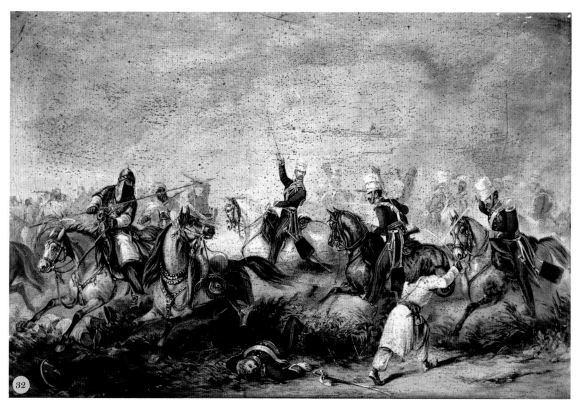

31. Scene from the First Anglo-Sikh War, Sabraon

Henry Martens | *c.* 1846 |
29 x 22 in | Lithograph

HM 31st Foot stormed the Sikh lines at the Battle of Sobraon, fought on February 10th, 1846, between the forces of the East India Company and the Sikh Khalsa army. The Sikhs were defeated, making this the decisive battle of the First Anglo-Sikh War.

32. Scene from the Second Anglo-Sikh War, Chillianwala

Henry Martens | *c.* 1849 |
29 x 22 in | Lithograph

A British officer leads the Grey Squardon of HM 3rd King's Own Light Dragoons in the charge against the Sikh line in the Battle of Chillianwala in January 1849. The battle was one of the bloodiest fought by the British East India Company. Both armies held their positions till the end of the battle and both sides claimed victory. The battle was a strategic check to immediate British ambitions in India and a shock to British military prestige.

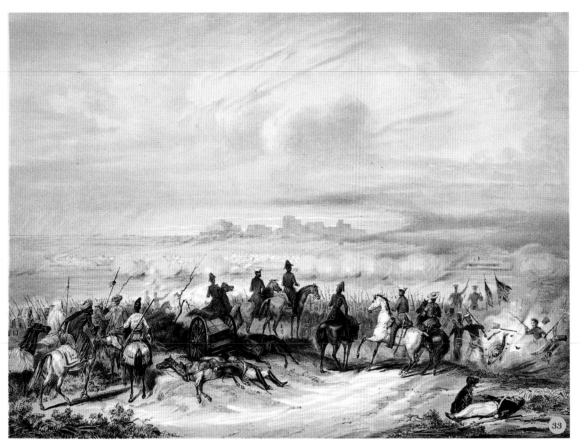

33. Battle of Ferozeshah

Waldemar Von Preussen (Friedrich Wilhelm) | *c.* 1844–46 | 13 x 9.5 in | Lithograph

In this battle, which was fought on December 21st and 22nd, 1845, Sir Hugh Gough and Governor-General Sir Henry Hardinge led the British. The Sikhs were led by Lal Singh. The British emerged victorious due to the treachery of the Sikh leaders.

34. Scene from the First Anglo-Sikh War, Battle of Sobraon

Waldemar Von Preussen (Friedrich Wilhelm) | *c.* 1846 | 13 x 9 in | Lithograph

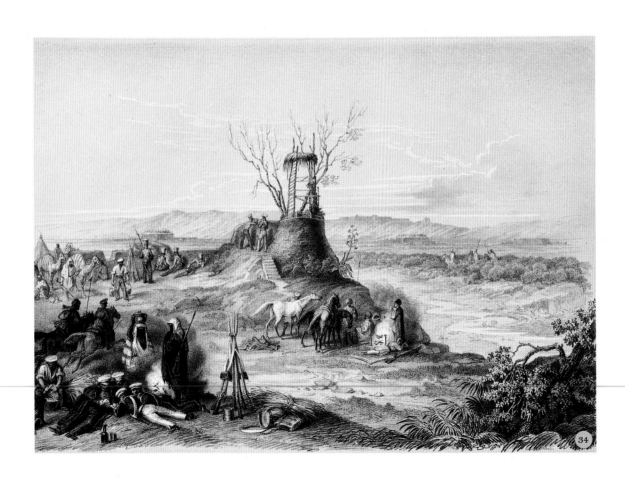

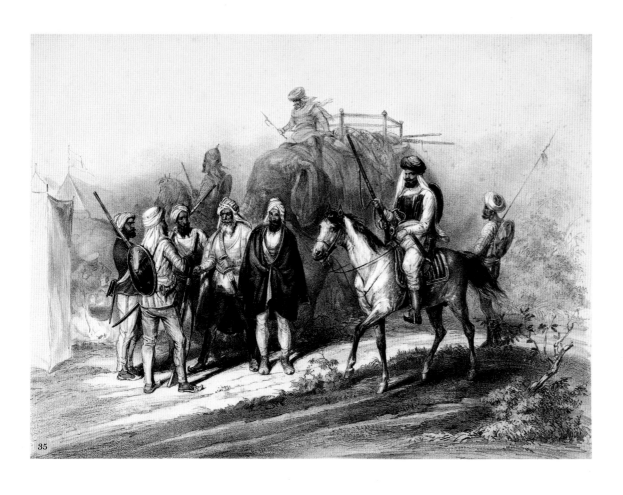

35. A group of Sikh soldiers

Waldemar Von Preussen (Friedrich Wilhelm) | *c.* 1844–46 | 13 x 9.5 in | Lithograph

36. Battle of Ferozeshah, from *Recollections of India*

J.D. Harding | *c.* 1847 | 10.5 x 14.5 in | Lithograph

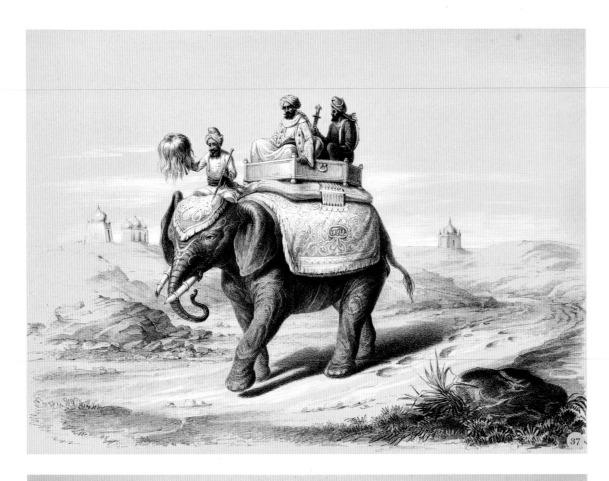

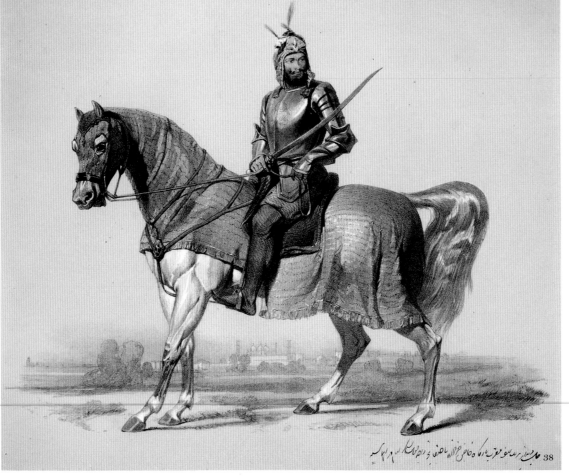

حادیسار رسعو معرب بارکه خاخ عزار ماصف و راه بیک ساک رم رم رم س ۳۸

37. Raja Gulab Singh

Waldemar Von Preussen (Friedrich Wilhelm) | *c.* 1844–46 |
13 x 9.5 in | Lithograph

38. Raja Lal Singh, from *Recollections of India*

J.D. Harding | *c.* 1847 | Lithograph

Raja Lal Singh (d. 1866) was a wazir of the Sikh Empire and commander of the Sikh Khalsa army during the First Anglo-Sikh War. Along with Tej Singh, Lal Singh betrayed the Sikhs during the course of the war.

39. General Sham Singh Attariwala

Artist unknown | *c.* Mid-19th century |
14 x 10 in | Gouache on paper

A rare painting of Sham Singh Attariwala seated under a canopy of marble with two attendants. He is depicted as a sovereign and the painting appears to be inspired by a Mughal royalty painting.

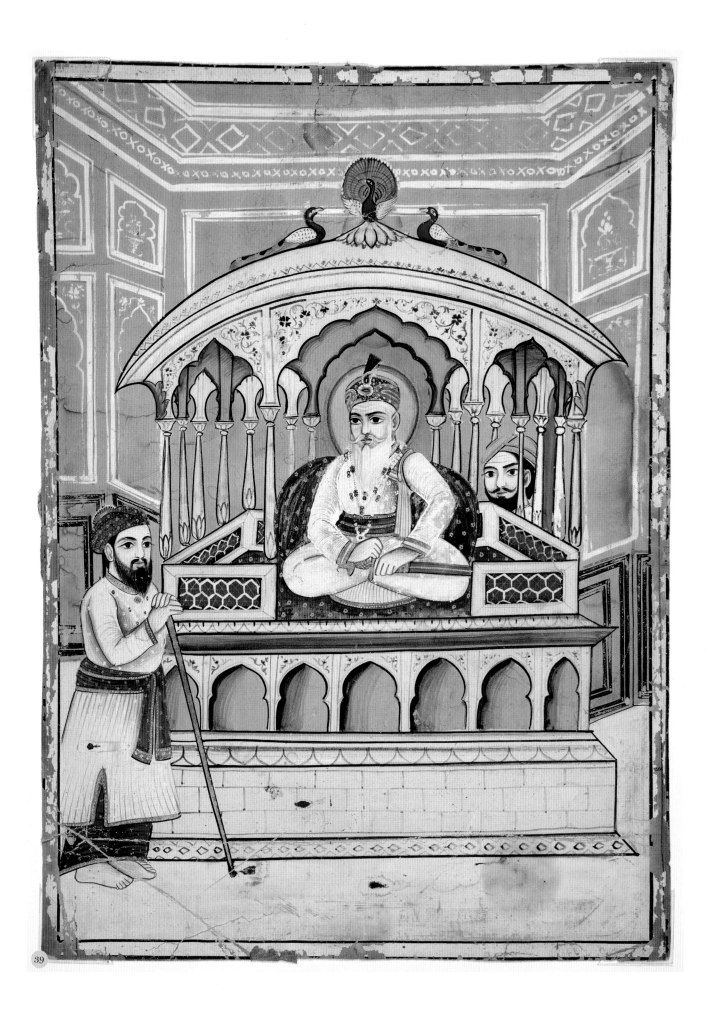

209

40. Diwan Mulraj

Artist unknown | *c.* 1850s |
2.25 x 1.75 in | Painting on ivory

Mulraj Chopra (1814–51) was the
diwan of Multan and leader of the Sikh
rebellion against the British which led
to the Second Anglo-Sikh War.

41. Maharaja Duleep Singh

Artist unknown | *c.* 1840s |
2.36 x 1.97 in | Painting on ivory

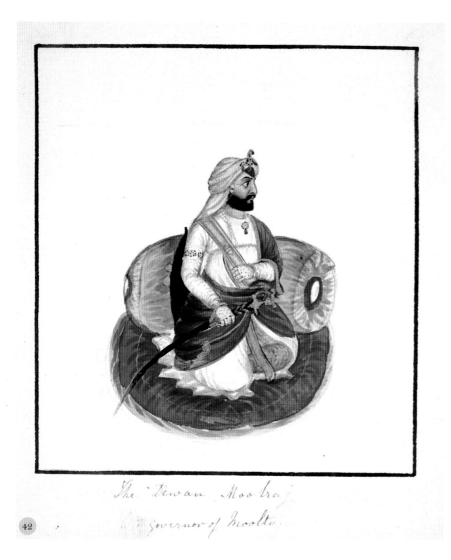

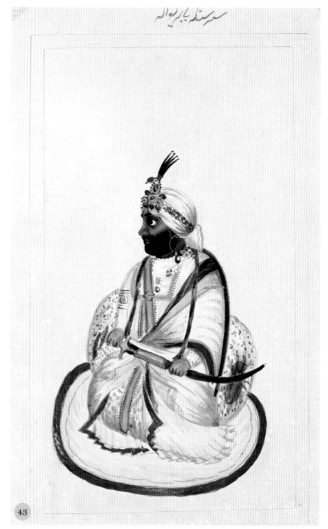

**42. Diwan Mulraj, Governor
of Multan**

Artist unknown | *c.* Mid-19th century |
5.5 x 5 in | Watercolor on paper

43. Raja Sher Singh

Artist unknown | 19th century |
7.5 x 5 in | Watercolor on paper

FROM MOOLTAN, A SERIES OF SKETCHES DURING AND AFTER THE SIEGE

The two paintings on these pages were made by John Dunlop and are part of a series of twenty-one views depicting the five-month long siege of Mooltan (modern-day Multan, Pakistan) during the Second Anglo-Sikh War. Dunlop described Multan as "the largest town in the Sikh territory after Lahore and Amritser."

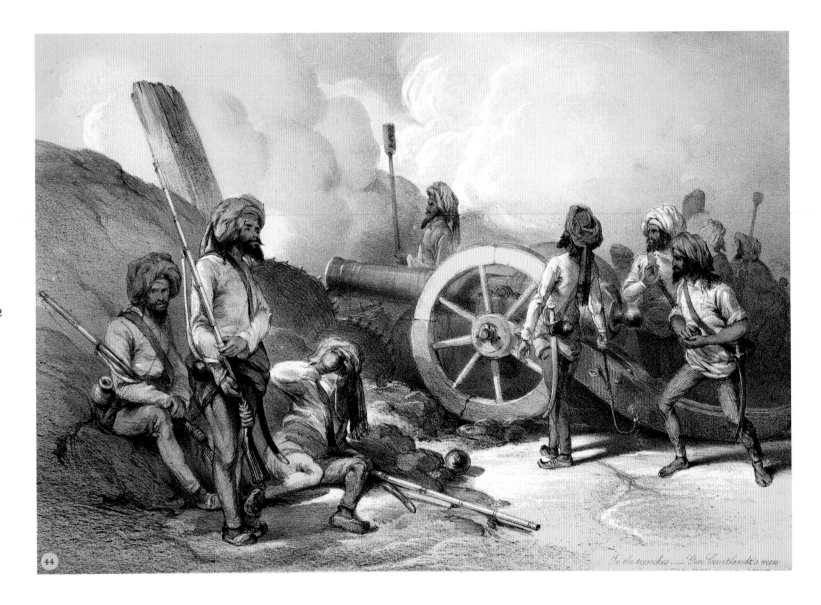

44. "In the trenches Septr 12/48 HM's 32nd Regt."

John Dunlop | *c.* 1849 | 11.2 x 7.5 in | Hand-colored lithograph

45. "Dewan Moolrag [Mulraj] in custody of a part of HM's 32nd Regt."

John Dunlop | *c.* 1849 | 11.75 x 8 in | Hand-colored lithograph

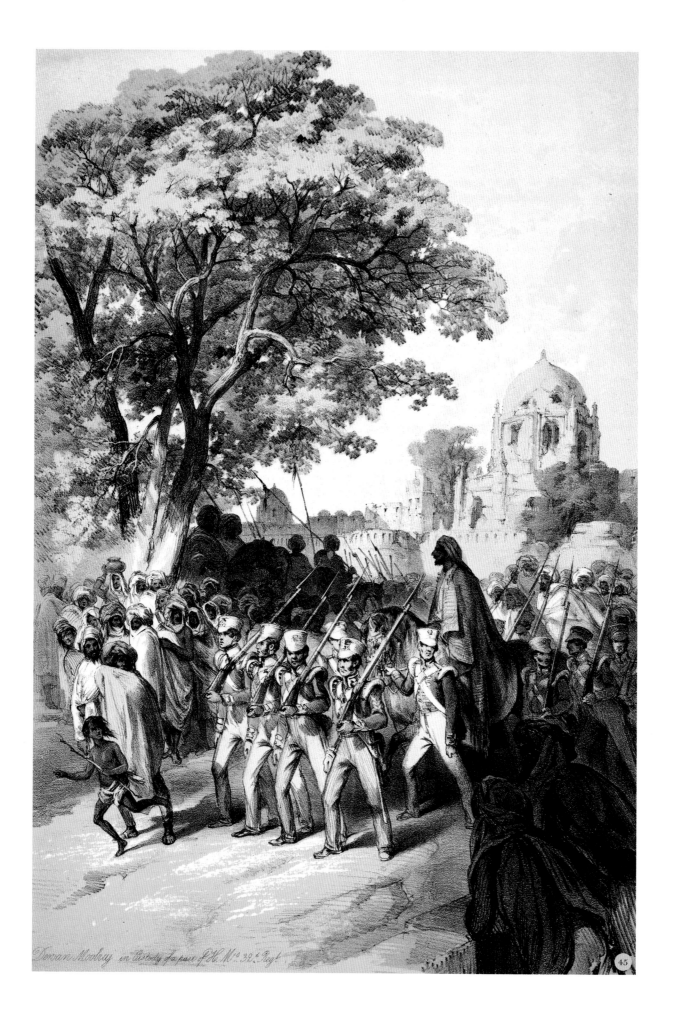

Dewan Moolraj in Custody of a part of H.M.º 32.ª Reg.t

213

45

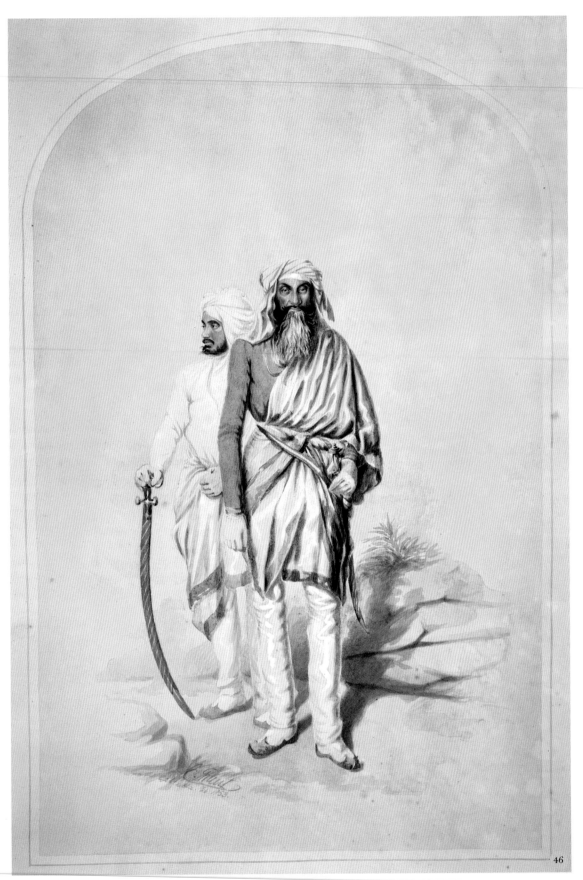

214

46. General Chattar Singh Attariwala, with his second son, Attar Singh

Colesworthy Grant | *c.* 1853 | 26 x 18 in | Watercolor over pencil, heightened with body color and gum arabic on paper

Raja Chattar Singh Attariwala (d. 1855) was governor of the Hazara province and a military commander in the army of the Sikh Empire during the reign of Maharaja Duleep Singh. He fought in the Second Anglo-Sikh War against the British.

46

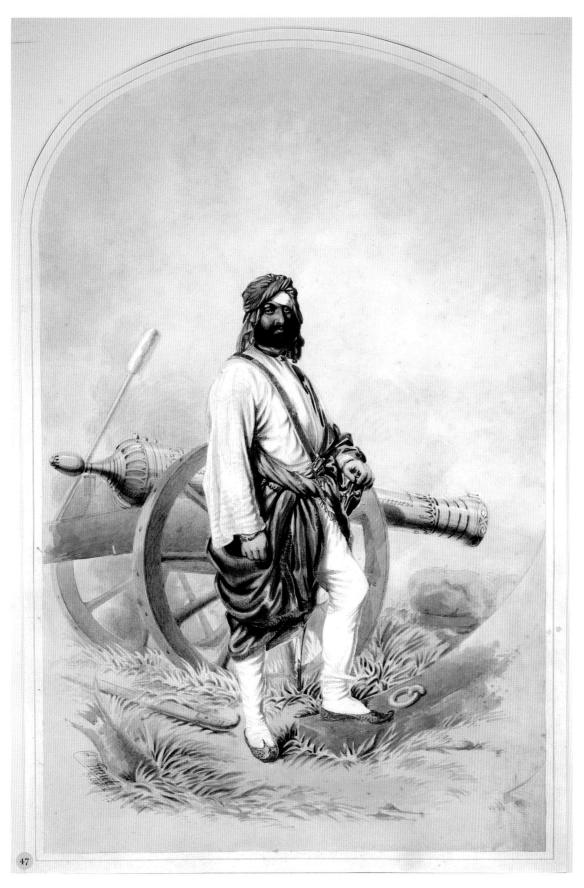

47. Raja Sher Singh Attariwala, Sikh commander and general

Colesworthy Grant | *c.* 1853 |
23 x 15 in | Watercolor over pencil,
heightened with body color and gum
arabic on paper

Sher Singh joined the rebellion against
the British at Multan in October
1848 and proved to be a formidable
commander during the Second Anglo-
Sikh War. The Sikh Khalsa army was
under his command at the Battle of
Chillianwala in January 1849, which
is regarded as one of the hardest
military confrontations in the history
of the British army. After the defeat
in the Battle of Gujerat in February
1849, Sher Singh was imprisoned at
Allahabad and later transferred to Fort
William, Calcutta until January 1854.
He died in Benares whilst in exile
in 1858.

47

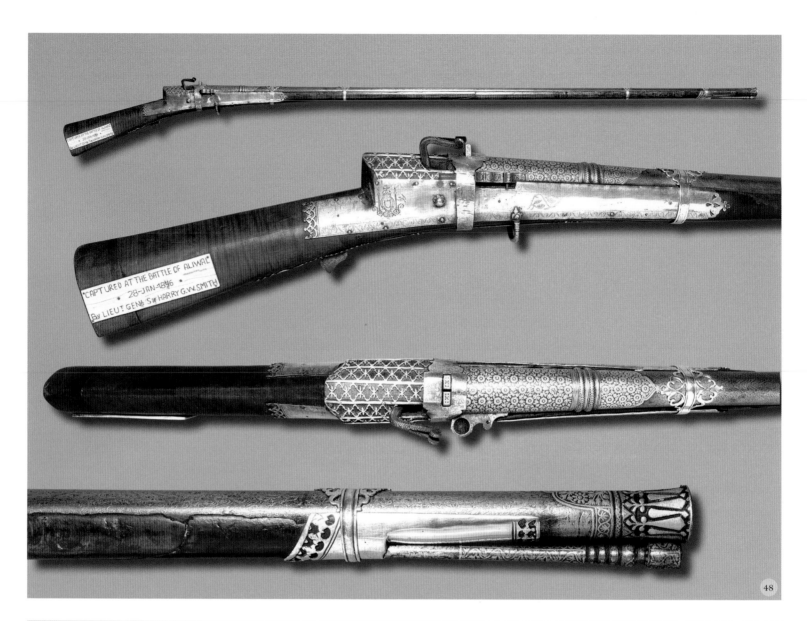

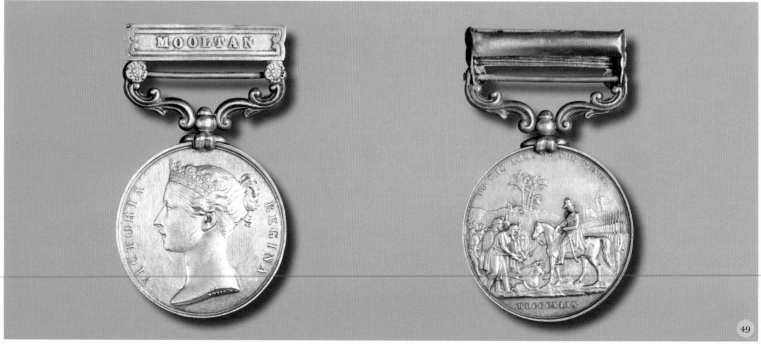

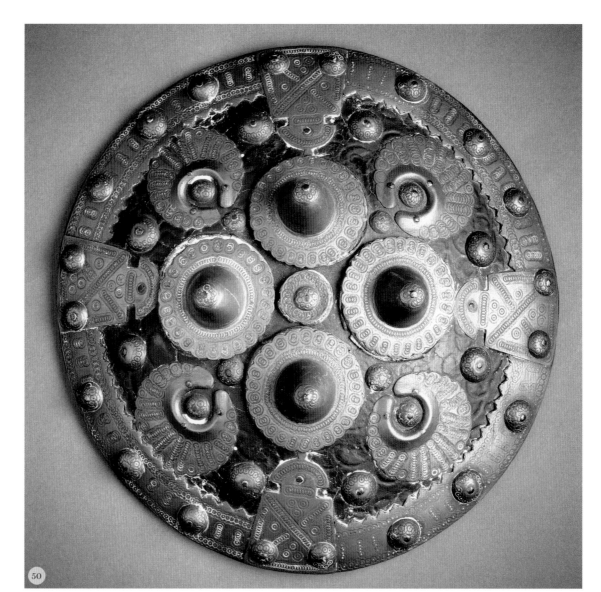

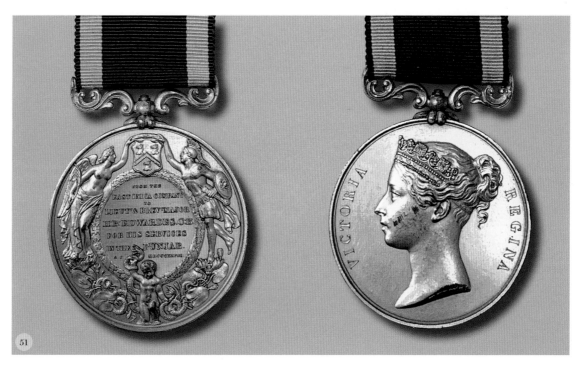

48. Gold *koftgari* and steel matchlock gun

c. 1800–1830s | 70 in | Steel and gold *koftgari*

This matchlock gun is decorated with what appears to be the *nishan sahib,* the Sikh flag. The steel barrel is decorated in gold overlay with undulating bands and vines. This firearm most probably belonged to a chief or very high-ranking official as it has more decorations than usual. It was captured by Lieutenant-General Harry Smith, commander of the British forces, during the Battle of Aliwal in 1846.

49. British campaign medal, Mooltan

c. 1849 | D: 1.4 in | Metalworks

The medal shows a general on horseback receiving a group of Sikhs surrendering before a hill topped with palm trees. It was awarded to Charles Lenden in the Second Anglo-Sikh War.

50. Shield, First Anglo-Sikh War

c. 1840s | D: 11 in

A Sikh shield captured by the British as a war trophy from the First Anglo-Sikh War.

51. A unique gold medal struck for Major Herbert Edwardes for his services in Punjab, 1848

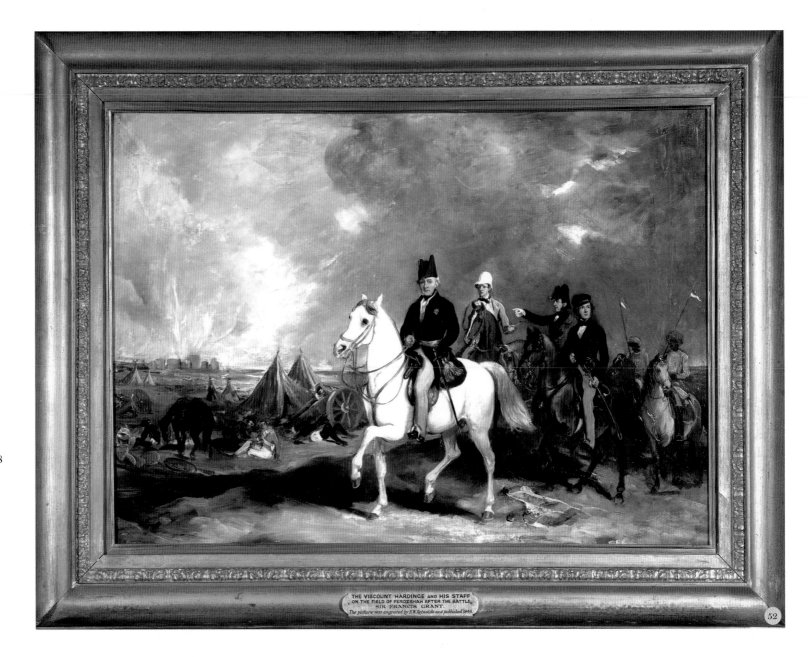

THE VISCOUNT HARDINGE and HIS STAFF
ON THE FIELD OF FEROZSHAH AFTER THE BATTLE.
SIR FRANCIS GRANT.
The picture was engraved by S.W.Reynolds and published 1849.

52

52. Viscount Henry Hardinge, governor-general of India, accompanied by his two sons and ADC Colonel Wood on the battlefield after the victory at Ferozeshah during the First Anglo-Sikh War

Francis Grant | *c.* 1840s | 26 x 34 in | Oil on canvas

This painting is based on a sketch made on the spot by Charles Stewart Hardinge, the eldest son of Lord Hardinge. He appears in this painting immediately behind his father.

53. Brigadier-General Sir Henry Montgomery Lawrence KCB

Artist unknown | *c.* 1840s | 30 x 25 in | Oil on canvas

Sir Henry Lawrence (1806-57) was a British military officer, surveyor, administrator, and statesman in British India. He was appointed to the role of British Resident in Punjab after the First Anglo-Sikh War in March 1848. Describing his experiences in Punjab, he wrote *Adventures of an Officer in the Service of Runjeet Singh*. He died defending Lucknow during the Indian Mutiny in 1857.

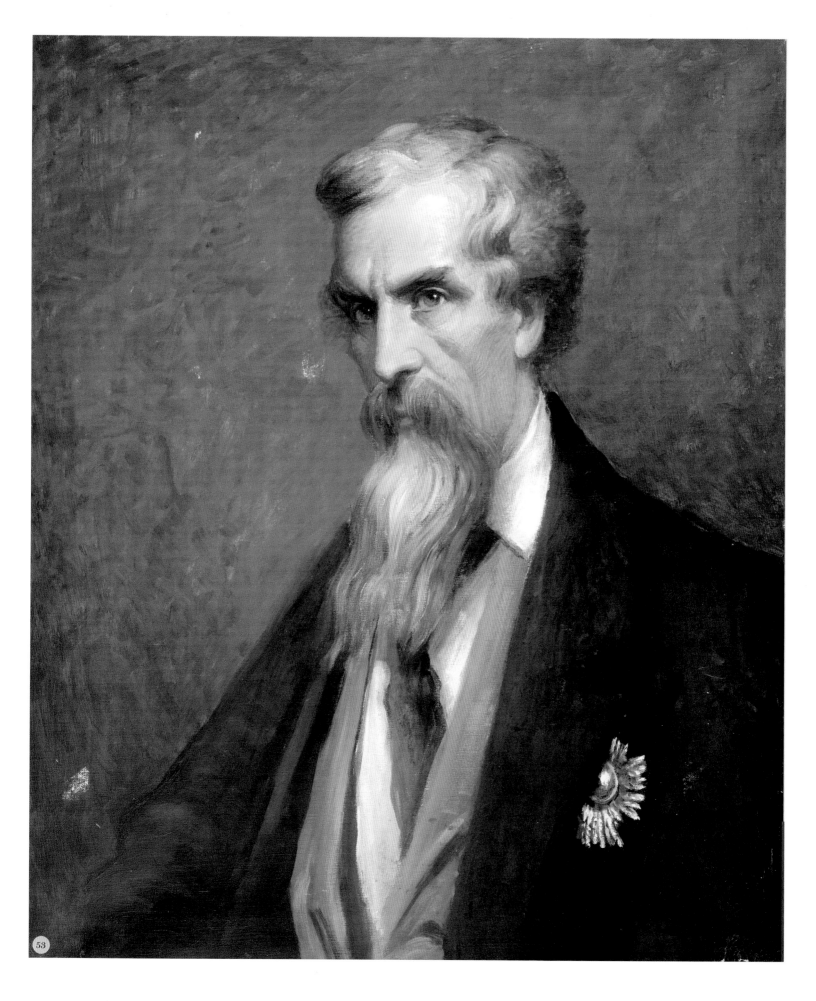

53

54. *Plans of the Captured Seikh Trophies*

Captain Ralph Smythe | 1846 |
16.7 x 22.2 in | Hand-colored
lithographs

Depiction of ordnance captured by
the army of Sutledge [Sutlej] under
the command of General Sir Hugh
Gough and Sir Henry Hardinge, during
the campaign of 1845–1846 with
elevations of gun carriages. This album
includes twenty-eight engraved plates,
ten hand-colored, and one hand-
colored engraved plate of inscriptions.
This is a "personal copy" prepared for
Sir Henry Hardinge.

**55. A room in Henry Hardinge's
residence**

Artist unknown | *c.* 1840–50s |
5 x 8 in | Albumen print

Henry Hardinge was the governor-
general of India during the First Anglo-
Sikh War and was also a veteran of
multiple battles. The photograph here
is most likely taken in his living room
and shows a captured cannon from the
war as well as a painting on the wall of
the Battle of Ferozeshah.

56–61. Sikh cannons

Captain Ralph Smythe | 1846 |
Hand-colored lithograph

220

Pl. 20.

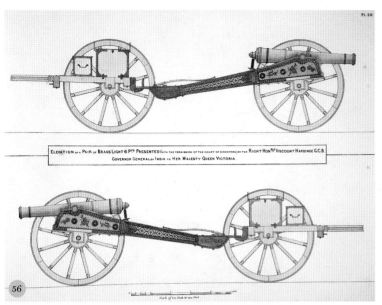

ELEVATION OF A PAIR OF BRASS LIGHT 6 PᵈS PRESENTED (WITH THE PERMISSION OF THE COURT OF DIRECTORS) BY THE RIGHT HONᵇˡᵉ VISCOUNT HARDINGE G.C.B.
GOVERNOR GENERAL OF INDIA TO HER MAJESTY QUEEN VICTORIA.

Scale of two Inch to one Foot.

56

Pl. 21.

ELEVATION of a 9½ Pʳ BRASS GUN and CARRIAGE.

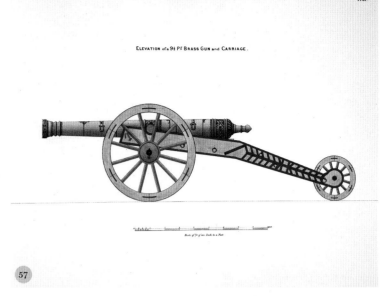

Scale of ¾ of an Inch to a Foot.

57

Two Guns 6 Pʳˢ & their Carriages of this Pattern presented by order of the Court of Directors
to the Govʳ Genˡ Lord Hardinge.

Pl. 28.

ELEVATION OF A BRASS LIGHT 6 Pᵈ AND CARRIAGE.
Fig. 1.

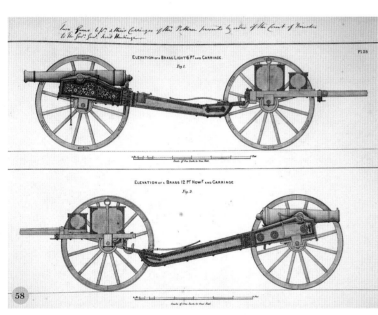

Scale of One Inch to One Foot.

ELEVATION OF A BRASS 12 Pᵈ HOWʳ AND CARRIAGE.
Fig. 2.

Scale of One Inch to One Foot.

58

Pl. 22.

ELEVATION of a BRASS 19½ POUNDER and CARRIAGE.
Fig. 1.

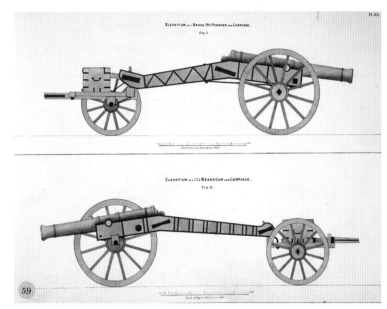

Scale of ¾ of an Inch to one Foot.

ELEVATION of a 13½ BRASS GUN and CARRIAGE.
Fig. 2.

Scale of ¾ of an Inch to one Foot.

59

221

Pl. 23.

ELEVATION OF A LONG BRASS 10 POUNDER AND CARRIAGE.
FIG. 1.

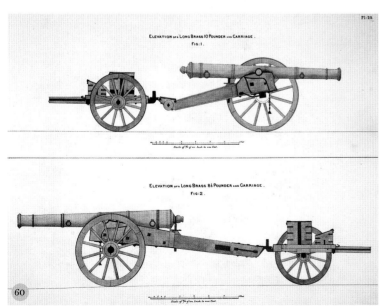

Scale of ¾ of an Inch to one Foot.

ELEVATION OF A LONG BRASS 8½ POUNDER AND CARRIAGE.
FIG. 2.

Scale of ¾ of an Inch to one Foot.

60

Pl. 24.

ELEVATION OF A BRASS 6½ INCH MORTAR ON FIELD CARRIAGE.
Fig. 1.

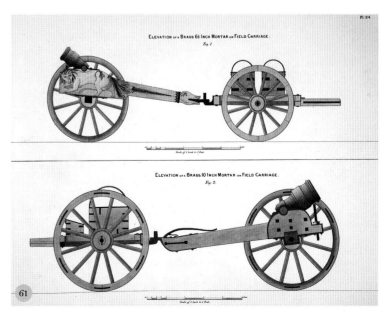

Scale of 1 Inch to 1 Foot.

ELEVATION OF A BRASS 10 INCH MORTAR ON FIELD CARRIAGE.
Fig. 2.

Scale of 1 Inch to 1 Foot.

61

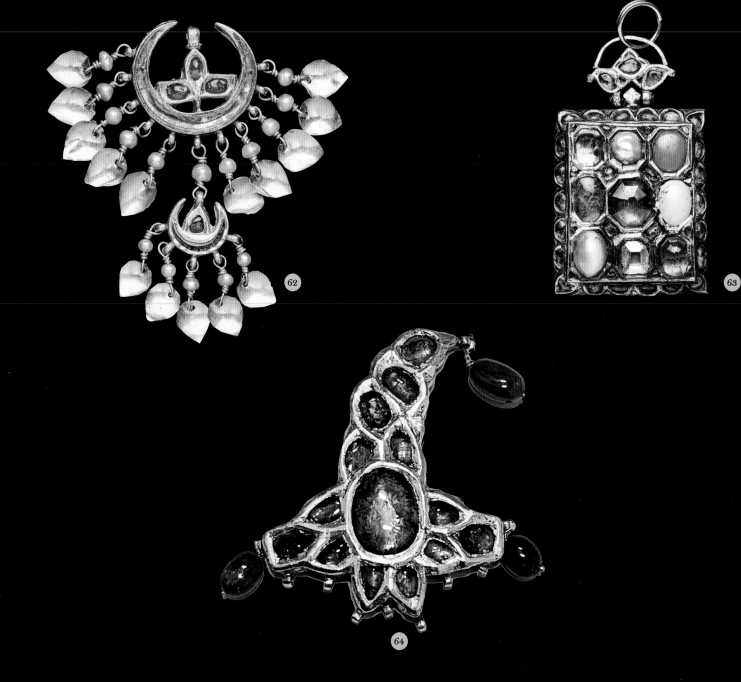

62. *Chand tika*

c. 1830–40s |
Gold and precious stones

A gem-set gold forehead pendant
from the collection of Maharani
Jindan Kaur, which later went into
the possession of her granddaughter
Princess Sophia Duleep Singh.
The upper element in the form of
a crescent set with rock crystal is
surmounted by a three-petaled flower
motif set with rubies with extensions
of seed pearls and gold foliate.

63. *Navaratna* locket

c. 1830s |
Gold and precious stones

A locket set belonging to Rani Jindan
Kaur with nine precious stones: ruby,
pearl, red coral, emerald, yellow
sapphire, diamond, blue sapphire,
hessonite, and cat's eye. The nine
gems provide astrological balance
to the wearer, with each stone
symbolizing one of the then-known
planets or phases of the moon.

64. *Kalgi*

c. 1840s |
Gold and precious stones

This gold turban ornament
embellished with emeralds and rubies
looks perfect for a young prince. The
original would have had a tassel to
tie it around a turban. This was worn
by Prince Fredrick Duleep Singh, and
earlier likely by his father, Maharaja
Duleep Singh.

HUGO V. PEDERSEN
1870-1959

65

65. Rani Jindan Kaur

Hugo Vilfred Pedersen | *c.* 1905 |
18 x 14.5 in (with frame) |
Oil on canvas

The youngest wife of Maharaja Ranjit
Singh and mother of the last Sikh
Emperor, Maharaja Duleep Singh, Rani
Jindan became the Regent of Punjab
in 1845 for her underage son, Duleep
Singh. The Queen Mother (or *Mai*), she
was renowned for her great beauty,
bravery, and personal charm.

DHULEEP SING.

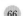

DHULEEP SING.—FROM A COLLODION BY O. O. BRIJARDER, WOLVERHAMPTON.

THE FALLS OF GARSUPPAH.

224

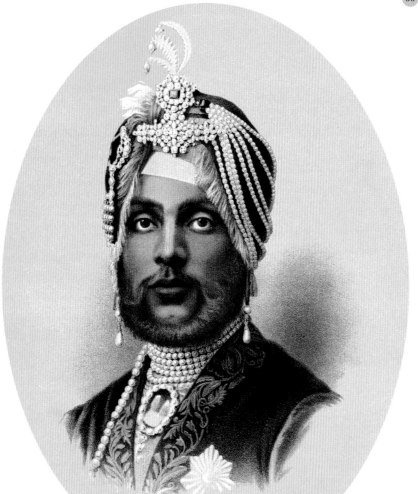

Dhulip Singh

66

68

69

1862

affectionately yours
Dhuleep Singh

70

71

66. Maharaja Duleep Singh, *The Illustrated News*, London

Illustrated News London published an article on Maharaja Duleep Singh in February 1856 while he was in England. The opening sentence of the article reads: "The life of every Eastern Prince is a romance, intrigue, murder, a throne, or a dungeon, are the usual phases of existence through which they pass."

67. Maharaja Duleep Singh

1859 | 10.5 x 8 in | Chromolithograph

68–70. Maharaja Duleep Singh with signature

Portrait, 1859 (above); Portrait, 1863-64 (below); Signature, 1862

Albumen print

71. *Panjangla*

c. 1830-40 | Gold and precious stones

Worn through two fingers as rings with the braid wrapped around the wrist while the center piece rests on the back of the palm, this set of jewelry possibly came from the personal collection of Maharani Jindan Kaur. It was later in the possession of Princess Bamba Duleep Singh.

72 and 73. Album probably belonging to Princess Bamba Sutherland

c. Late 1800s | 6.25 x 5.5 in

Maharani Bamba, Lady Duleep Singh (born Bamba Müller; 1848–87), was the wife of Maharaja Duleep Singh. The photograph shows five of her children. The couple had three sons and three daughters whom they brought up at Elveden Hall in Suffolk, England. Their six children were Victor Albert Jay (1866–1918), Frederick Victor (1868–1926), Bamba Sophia Jindan (1869–1957), Catherina Hilda (1871–1942), Sophia Alexandra (1876–1948), and Albert Edward Alexander (1879–93). Victor and Frederick both joined the British army, whilst Frederick became a Fellow of the Society of Antiquaries of London. One of their daughters, Bamba Sophia Jindan, returned to Lahore as the wife of a Dr. Sutherland. She was known as Princess Bamba Sutherland and died in Lahore in 1957.

74. Commemorative stamp, "Sophia Duleep Singh sells *The Suffragette*, 1913"

2018 | 1 x 1.5 in

Princess Sophia Alexandra Duleep Singh was honored by the Royal Mail of the UK with eight special stamps issued on February 15th, 2018, which marked the centenary of the Suffragette Movement.

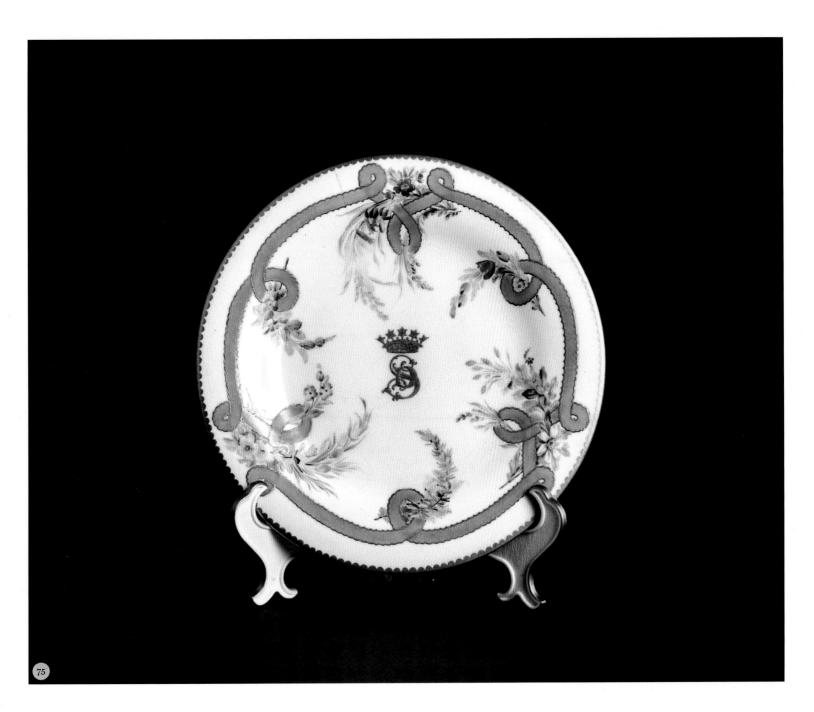

75. Plate of Maharaja Duleep Singh's family, with initials D&S in center

19th century | Ceramic

A porcelain plate belonging to Maharaja Duleep Singh decorated with the maharaja's gilt crest. The inscription on the reverse reads: 155 New Bond Street London; WP & G Phillips Late Chamberlain. The plate was passed down from Maharaja Duleep Singh to Prince Frederick, and finally to the eldest daughter, Princess Bamba Sutherland, who gave it to her housekeeper at Hampton House, Blo Norton, Norfolk in the 1950s.

6 THE MAKING OF A MARTIAL RACE: MILITARY TRADITIONS IN SIKHISM[1]

"...THE NAME OF YOUR RACE HAS BECOME ALMOST SYNONYMOUS IN THE ENGLISH LANGUAGE WITH TRADITIONS OF DESPERATE COURAGE AND UNFLINCHING LOYALTY."[2]

Lord Curzon, viceroy of India in Lahore, commenting on Sikh soldiers' military contributions to the British Raj

Sikhism is founded on a number of core values including displaying courage, sacrificing oneself for the greater good, fighting against injustice, and standing up for human rights. It also has a tradition of activism, starting with the first guru, Guru Nanak, who was imprisoned by the conquering forces of the Mughal emperor Babur (r. 1504–30), and spoke against the tyranny which he witnessed. Guru Nanak states, "If you want to play the game of love then step onto My Path with your head on the palm of your hand. When you place your feet on this Path, give Me your head, and do not listen to what others say" (SGGS, 1412). The gurus spoke against tyranny as well as rituals, and their words were revolutionary at that time. The fifth guru, Guru Arjan, died a martyr and was succeeded by Guru Hargobind who wore the two swords of *miri* and *piri* as symbols of temporal and spiritual authority respectively. Guru Hargobind also began to maintain a military force for defensive purposes, a practice followed by the subsequent gurus.

Guru Tegh Bahadur's martyrdom, caused by his efforts to stop the oppression of Hindus by Mughal rulers and prevent their forced conversion, was an important moment in the long history of Sikhs' fight for the defense of human rights.

The formalization of the Khalsa in 1699, and their associated slogan *"Degh, Tegh, Fateh"* signified the dual responsibility of the Khalsa, namely to provide both food and protection to the needy and oppressed.

The multiple defensive battles fought by Guru Gobind Singh at Chamkaur Sahib saw forty Sikhs take on more than 100,000 soldiers of the Mughal imperial army in December 1704. This conflict ended with the guru losing his eldest sons, Baba Ajit Singh (aged eighteen) and Baba Jujhar Singh (aged fourteen). Guru Gobind Singh's younger sons, Baba Zorawar Singh (aged nine) and Baba Fateh Singh (aged seven) were martyred even more cruelly in the court of the governor of Sihrind, Wazir Khan. Because of their outspoken stance against injustice and their refusal to recant their faith, they were tortured and buried alive in a wall. Guru Gobind Singh subsequently wrote a letter to the Mughal emperor Aurangzeb, titled "Zafarnama" ("Epistole of Victory"), a part of which reads as follows: "When all other methods fail, it is proper to hold the sword in hand."[3]

From 1710 to 1715, Banda Singh Bahadur and his companions led an uprising of the downtrodden in Punjab to fight against injustice and suffering. They were joined by thousands of Sikh followers as well as by persecuted Hindus and Muslims. It required the full might of the organized Mughal army to quell the uprising, and the rebels faced martyrdom and death cheerfully. Despite their defeat the blood of these martyrs was not shed in vain, and eventually their sacrifices spelt the end of Mughal tyranny and oppression. The Khalsa continued to uphold the Sikh spirit of *chardi kala* (eternal optimism), surviving in the jungles and ravines from the early to mid-eighteenth century. With indomitable spirit, the Khalsa forces took on the Persian invader, Nadir Shah, in 1738 by

1. Akalis

Artist unknown | *c.* 1830–40s | 8.5 x 7.5 in | Ink and color on paper

A painting of Akalis (also known as Nihangs) combing their hair, playing a board game, and grinding *sukha degh*, a kind of herb considered a martry's sacrament. Another warrior stands fully armed. Such scenes are rare and appear to be a pictorial record of their activities.

using guerrilla tactics while he and his troops were returning from Delhi through Punjab, and they succeeded in rescuing thousands of captured Hindu women. Subsequent battles with Ahmad Shah, the Afghani leader of the Durrani Empire, and his successors led to the closure of the Khyber Pass by the end of the eighteenth century, after over 800 years of invasions into northern India by various kingdoms. In the multiple conflicts that took place over the course of the eighteenth century, about 200,000 Sikhs lost their lives.

Within the Khalsa army, women were seen as equal partners. Mai Bhago, Sahib Kaur, and Sada Kaur are just few examples of pre-eminent female warrior-saint leaders. In the times of Mir Mannu, the cruel governor of Lahore (1748–53), a few brave women even bore the horrific punishment of having garlands made of their children's limbs placed around their necks.

This tradition of military bravery continued during Maharaja Ranjit Singh's time and through the Anglo-Sikh wars (1845–1849). Although the Khalsa soldiers' courage was well known, it was the Akalis who were assigned the most dangerous missions due to their unparalleled daring spirit and excellent fighting skills. In this regard, Henry Steinbach stated, "It is not an uncommon thing to see them [the Akalis] riding about with a drawn sword in one hand, two more in their belt, a matchlock at their back, and three or four quoits fastened round their turbans."[4] Furthermore, George Carmichael Smyth commented on the Akali warrior, stressing how "he cared little for wealth, but was content with the mere necessities of existence."[5]

Having realized the Sikhs' military prowess and considering them a martial race, the British increased the enrollment of Sikh soldiers in the army. Sikh soldiers exhibited bravery and valor and fought their battles while wearing distinctive uniforms that included the turban and other symbols of Sikhism. Recognizing the close connection between military values and spirituality in Sikh religion, the British preferentially recruited Sikh soldiers and encouraged them to maintain their articles of faith. Though they comprised just 1 per cent of the Indian population, Sikhs represented approximately 18–20 percent of the British Indian army. They were deployed in the North-Western Provinces (present-day Pakistan) and took part in the Anglo-Afghan wars (1839–1919).

In the Battle of Saragarhi, in September 1897, twenty-one Sikh soldiers fought against over 10,000 Afghans and tribesmen, causing over 500 casualties among the enemy troops.[6] These twenty-one soldiers were recognized in the British parliament posthumously and bestowed with the Indian Order of Merit for gallantry. Sikh soldiers were also involved in quelling the Boxer Rebellion (1899–1901) in China and were deployed in multiple British colonies in Africa, as well as in Hong Kong and other parts of East Asia in the late nineteenth and early twentieth centuries.

As a significant voluntary force raised by the British Indian army, Sikh soldiers played a major role in both the First and Second World Wars. As General Frank Messervy observed:

In the last two World Wars, 83,005 turban-wearing Sikh soldiers were killed and 109,045 were wounded. They all died or were wounded for the freedom of Britain and the world, and during shell fire, with no other protection but the turban, the symbol of their faith.[7]

During the First World War, Sikh soldiers were active in Neuve Chapelle, Mesopotamia, Somme, Gallipoli, and Egypt. In the Second World War, they contributed to the war effort in Iraq, Syria, Persia, North Africa, Burma, and Malaya. They were heavily decorated, and after the war they were recognized with multiple monuments and memorials commemorating their sacrifices. They fought wars

230

2. Miniature portrait of a Sikh warrior (Akali, possibly Phoola Singh) with a matchlock

Artist unknown | 19th century | 3 x 2.25 in | Painting on ivory

2

in which their homeland was not involved, serving a nation which mistreated their countrymen at home, and ultimately they gave away their lives without hesitation.

In the Sikh tradition, the Khalsa "saint soldiers" are often described as the "Army of the Immortals" (Akal Purakh ki Fauj) and considered to be combatants born to serve the world and its communities, a goal set by the gurus. Arms, armor, and warrior traditions are well and truly engrained in the Sikh psyche. The first thing that enters the mouth of a baby born into a Sikh family is the sweet nectar of water and sugar crystals (*amrit*) that has been stirred with a small dagger (*kirpan*). This birth ceremony is referred to as the *Janam Sanskar*. The preparation of *amrit* is accompanied by a prayer which is uttered by the parent who stirs the liquid. Tradition holds that the parent stirring the mixture should also sit in the *bir-asan* or warrior-position. Expectant mothers are encouraged to recite Sikh hymns and historical stories that may infuse warrior-like qualities in the unborn baby. A quote from Bhai Sukha Singh's "Gurbilas Patshahi 10" well illustrates the centrality of military tradition in the Sikh mind:

> Without weapons and Kesh (long hair) – you are nothing but a sheep – who can be led anywhere by the ear/ An order has come from the master, without un-cut hair and weapons do not come before me.[8]

3. Akalis

Artist unknown | *c.* Early 1800s | 13.25 x 9.5 in | Watercolor

Akalis are Sikh religious devotees. They were largely employed in the Sikh armies and were known for their remarkable acts of courage. In this painting they are all wearing the famed steel blue-colored turbans.

1897

232

Sikh soldiers today continue their martial tradition through service in multiple countries besides India.

The martial aspect of Sikhism finds representation in a number of weapons, photographs, and paintings which are part of the Khanuja Family Collection. Many of these objects are unique and hold great historical value. Antique weaponry is an essential part of any collection of Sikh artifacts, just as it was, and arguably still is, essential to the conventional Sikh way of life and the tradition of the saint soldiers.

One of the more unusual Sikh weapons is the *chakkar*, which Ravinder Reddy describes as follows,

Chakkars are usually made of flattened steel, sharp on the outside perimeter, and are sometimes serrated. A *chakkar* is hurled by spinning on a finger or throwing it like a frisbee. There are records of these effectively thrown over 100 meters (300 feet). Several *chakkars* of varying diameters were carried by the Akali on a pointy indigo-colored turban-*dustarbungga*.[9]

Besides *chakkars*, swords also form a significant part of this collection. The most common sword in India is the *tulwar*, which is typically made with a single-edged, slightly curved blade. An iron hilt, usually formed with a bulbous grip and a pair of langets, sits at the base, along with a pommel disk at the top, which allows for a snug grip in the wielder's hand. The hilt is often fitted with a knuckle bow for protection. *Tulwars* made in Punjab during the time of the Sikh Empire can sometimes be recognized by their decoration, but positively identifiable Sikh swords are rarely found outside museum collections. The ones that can be identified were usually commissioned for important Sikh individuals.

The Khanuja Family Collection has several notable examples of *tulwars*. Their origins can be confirmed by the inscriptions found on the inside of the knuckle guard, usually in Gurmukhi and invariably beginning with the protective phrase "*Akal Sahai*" ("with Divine grace"), followed by the owner's name and date. Swords that exhibit Persian inscriptions together with Sikh symbols or decorative features are rare. The group of inscribed swords within the Khanuja Family Collection are thought to have been made at the height of the Sikh Empire (1799–1849). They share a pattern of distinct *koftgari* (damascene) decoration, and subtle design characteristics in their hilts. The sword of Raja Nihal Singh of Kapurthala (see chapter 7), for example, shows a highly characteristic Sikh hilt, with the grip and pommel disk having been chiseled with bordered segments which were then filled with flower heads in gold. Further hallmarks of a Sikh sword include sprays of flowers applied in exceptionally thick gold, a testament not only to the Sikh owner's wealth, but also to the prosperity of the Sikh Empire. Swords that have these attributes, but not an inscription, can also be considered to be from the "Sikh-era."

233

REFERENCES & NOTES

1. We are thankful to Runjeet Singh from Royal Leamington Spa, United Kingdom, who has spent years collecting Sikh arms and armor and has entrusted us with his prized possessions. We thank him for his assistance with this essay as well.

2. G. Curzon, *Speeches by Lord Curzon of Kedleston, 1898–1901* (Calcutta: Thacker, Spink & Co. 1901), 30.

3. "Sri Dasam Granth Sahib," Search Gurbani, accessed on August 23rd, 2021. https://www.searchgurbani.com/dasam-granth/page/2750

4. H. Steinbach, *The Punjaub: A Brief Account of the Country of the Sikhs* (London: Smith, Elder & Co., 1845), 69.

5. G.C. Smyth, *A History of the Reigning Family of Lahore* (First published in 1847. Reprint, Lahore: Sang-e-meel Publications, 1996), 204.

6. B.S. Singh, *Gurbilas Patshahi 10*, edited by Gursharan Kaur Jaggi (Patiala: Bhasha Vibhag, 1989), 364.

7. S. Aulakh, *Sikh Warriors in World Wars* (Amritsar: Printwell, 2016), 56.

8. B.S. Holland, *Sikhs in World War I* (Ludhiana: GS Distributors, 2013), 23.

9. R. Reddy, *Arms & Armour of India, Nepal & Sri Lanka* (London: Hali Publications, 2018), 292.

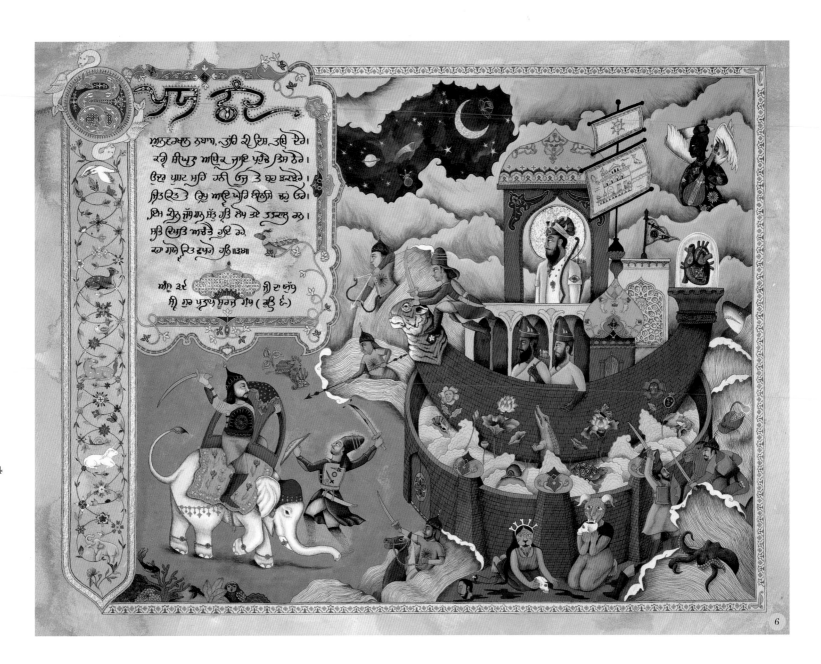

234

6. The valor of the older princes (Chamkaur Sahib)

Keerat Kaur | 2021 | 20 x 26 in |
Gouache, acrylic, gold leaf and silver
leaf on textured paper

An illuminated painting metaphorically
visualizing the Battle of Chamkaur, as
told by Kavi Santokh Singh in *Suraj
Prakash Granth* (Chapters 34–40,
Book 6). The key moments highlighted
in the painting are the entry of Guru
Gobind Singh and his Sikhs into the
garhi (small fort) where they took
refuge, as well as to the martyrdom
of his two elder sons, Sahibzada Ajit
Singh and Sahibzada Jujhar Singh,
while fighting the Mughal forces.

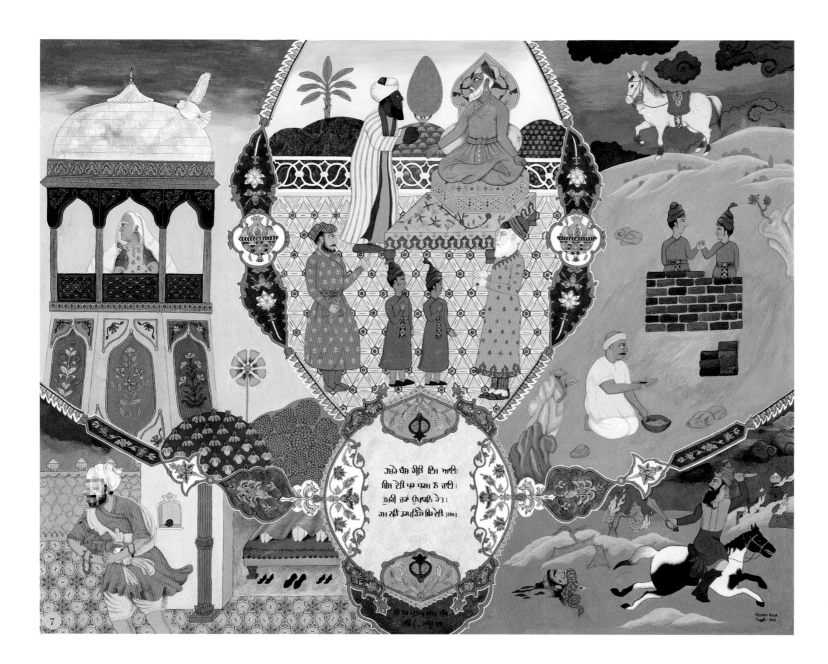

7. The valor of the younger princes (Sihrind)

Keerat Kaur | 2020 | 18 x 24 in | Gouache and acrylic on board

An illuminated painting showing a passage from *Suraj Prakash Granth* that describes the defiance of the two young princes, Baba Zorawar Singh and Baba Fateh Singh, in front of the Mughal court. These two young sons of Guru Gobind Singh, Zorawar (nine years old) and Fateh (seven years old), were offered safe passage from Sihrind if they embraced Islam. Both refused, and so Wazir Khan sentenced them to death. They were bricked alive and are considered as two of the most hallowed martyrs in Sikh history.

8. Sikh women saint soldiers

Arpana Caur | 2020 |
11.5 x 16.5 in |
Pencil and pastel on paper

Mai Bhago fought against the Mughals in 1705. She killed several enemy soldiers on the battlefield, and is revered as a saint warrior.

Rani Sada Kaur (1762–1832) was chief of the Kanhaiya Misl from 1789 to 1821. An intelligent and ambitious woman, she was also the mother-in-law of Maharaja Ranjit Singh and played an important role in his rise to power in Punjab.

Bibi Sahib Kaur (1771–1801) was a warrior and leader who played a prominent role in the history of the Cis-Sutlej states from 1793 to 1801. She was the elder sister of Raja Sahib Singh of Patiala.

Rani Jindan Kaur (1816–1863) was regent of the Sikh Empire from 1843 until 1846. Renowned for her beauty and strength of purpose, she was the mother of the last maharaja, Duleep Singh.

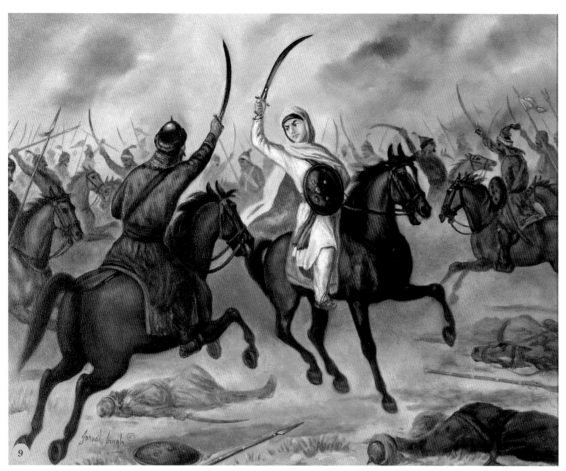

9. Mai Bhago, Battle of Mukstar

Jarnail Singh | 2017 | 28 x 34 in | Oil on canvas

Mai Bhago, also known as Mata Bhag Kaur, led forty Sikh soldiers against the Mughals in 1705. She was the sole survivor of the Battle of Khidrana, or the Battle of Muktsar, fought on December 29th, 1705.

10. Sada Kaur with Ranjit Singh storming the Lahore fort, 1799

Jarnail Singh | 2017 | 28 x 34 in | Oil on canvas

Sardarni Sada Kaur was the wife of Gurbaksh Singh Kanhaiya, the heir of Jai Singh Kanhaiya, who was the leader of the Kanhaiya Misl. After her husband's death in 1785 and her father-in-law's in 1789, she became the chief of the Kanhaiya Misl.

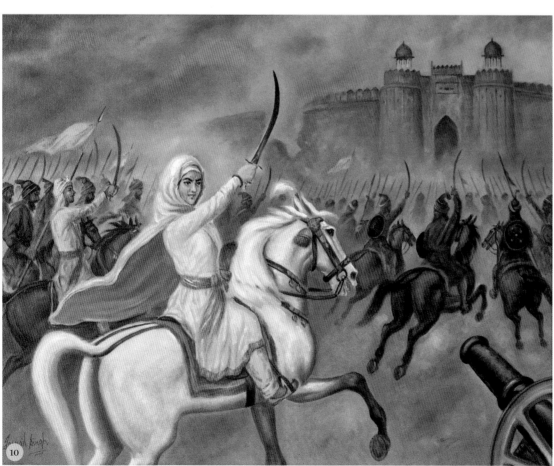

11. Akali Hira Singh Nihang, a scripture reader (*granthi*) attached to the Sikh units in the expedition to relieve General Charles George Gordon in Khartoum, Sudan

Felice Beato | *c.* 1885 | 8.3 x 9.3 in | Albumen print

12. A small quoit used either as a *kara*, or more likely at the top of a *dastar bunga* (towering fortress), a style of turban used by the Akali Nihangs

19th century | 1 x 4.75 in | Steel

13. A small but wide quoit with some evidence of use, probably worn close to the top of a *dastar bunga*, likely a very effective throwing quoit

18th century | 1.5 x 8.75 in | Steel

14. A well-used quoit with marks and indentations

c. Late 18th/early 19th century | 1 x 7.5 in | Steel

15. A well-used quoit with five notches cut into the inner circumference and with a copper solder. Of rustic form, it is rudimentary, but obviously effective

18th century | 0.9 x 8.4 in | Steel

16. Watered steel quoit of small proportions polished with some small area of pitting

c. Late 18th/early 19th century | 0.9 x 8.5 in | Steel

17. As an essential part of their faith, the warriors used the turban to store their expansive range of weapons. Sometimes this quoit was worn over a *dastar bunga*

19th century | 0.75 x 9 in | Steel

18 and 19. A pair of quoits, each having their own unique irregularities in curvature and shape, but probably made in a large armory workshop. They display a tight crystalline wootz steel pattern, a type of Indian steel that was produced until the end of the nineteenth century

19th century | 1 x 10.75 in | Steel

20. A very finely made heavy quoit. The join, copper braised, is a neat line with light pitting indicating good age

19th century | 0.8 x 11 in | Steel

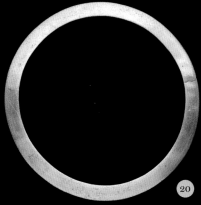

21. A classical quoit marked on one side twice with the "tree symbol," and twice with three circular markings. This is a tight crucible steel pattern, with good original age patina

19th century | 0.75 x 11.75 in | Steel

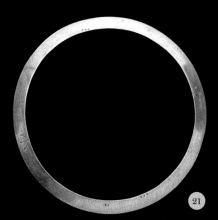

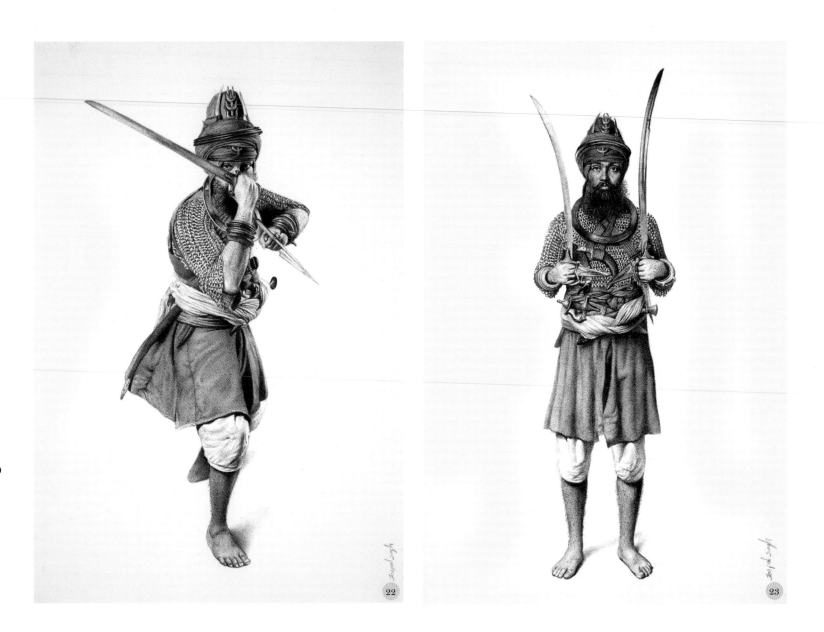

22. Akali

Jaspal Singh | 2020 | 8 x 5.5 in |
Ball pen on 100 percent cotton
hot-pressed paper

An Akali Nihang in action on the
battlefield wearing *sanjoh* (chainmail
armor).

23. Akali

Jaspal Singh | 2020 | 8 x 5.5 in |
Ball pen on 100 percent cotton hot-
pressed paper

An Akali Nihang ready for battle,
body covered in the panoply of war.
Concealed weapons can be seen
inside the *dumalla* (turban), *chakra*
on his neck, and *jungi kare* (battle
bracelets).

24. Akali

Jaspal Singh | 2020 | 8 x 5.5 in |
Ball pen on 100 percent cotton
hot-pressed paper

An Akali Nihang with his face
looking upwards in blessing-seeking
gesture, so he can win the war with
the benediction of *Akal Purakh*, the
omnipresent Divine.

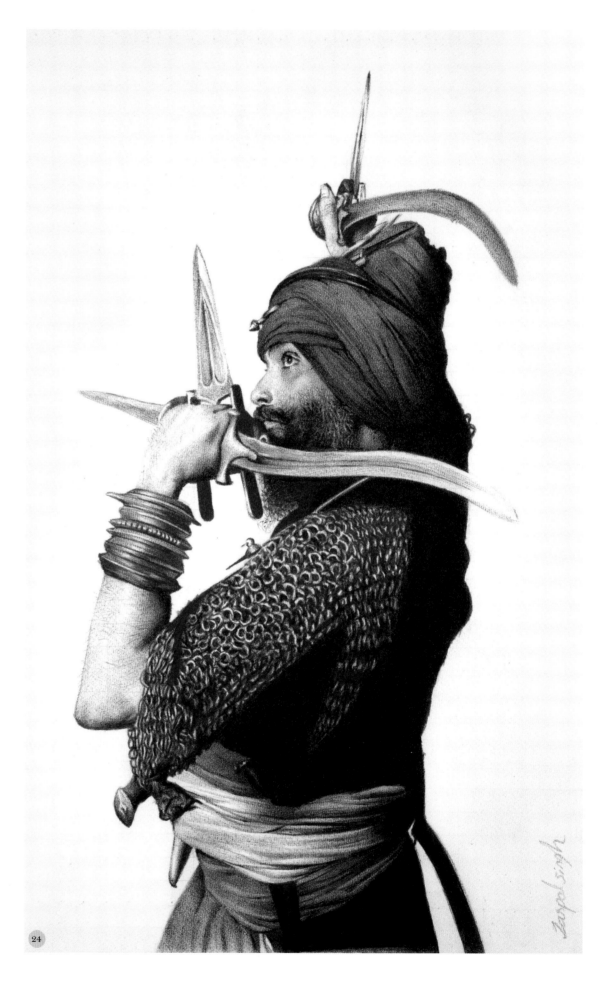

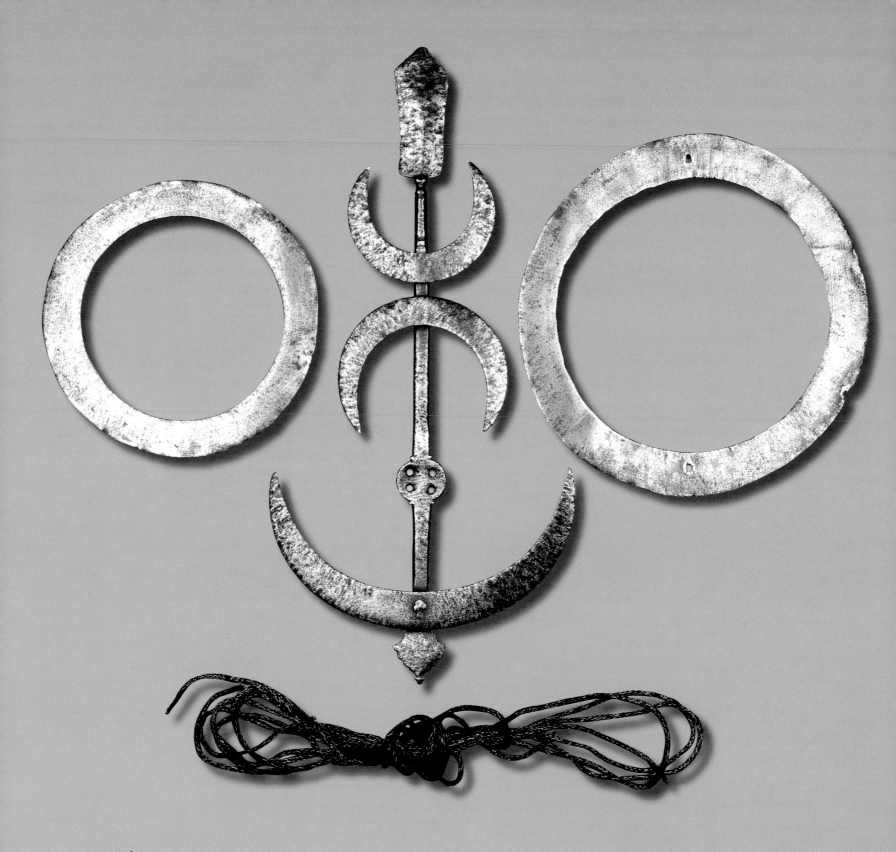

25. *Gajgah*

c. Late 18th century | Steel

The *gajgah* (above and facing page) refers to a set of arms that decorated the front of the towering *dastar bunga* of Akalis.

The central stem of the *gajgah* has its head fashioned as a double-edged dagger (*bhagauti*), a nasal guard finial at its base, and an upward curving crescent (*adi chand*). An under-turban (*keski*) is twisted around the long hair and carefully wound to give the turban its peaked appearance with the end forming the *farla*. To provide thickness and support at the base, a second turban is tied. Quoits and braided wire are used to secure everything in place.

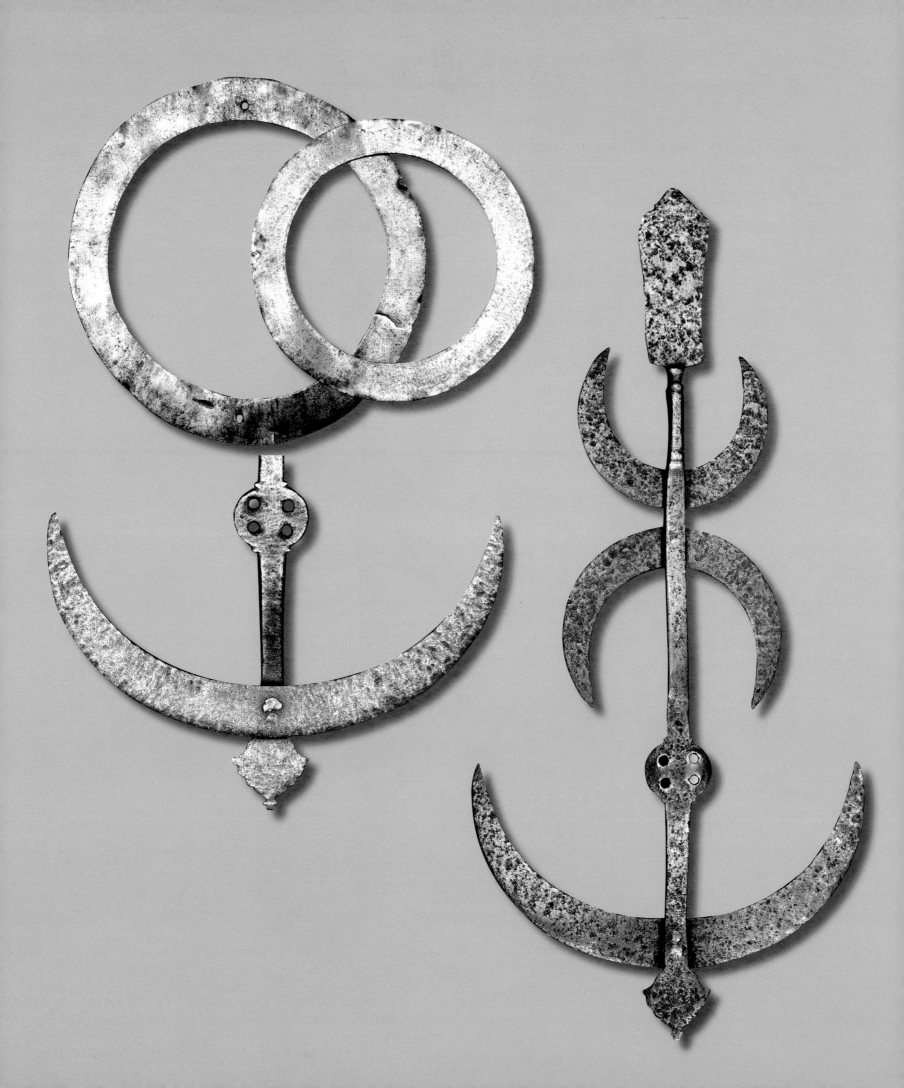

26. Gold *koftgari* steel quoit (*chakram*)

c. 19th/20th century | 1 x 10.25 in | Steel

The outer edge is sharpened and decorated with a band bearing inscriptions in Gurmukhi. The reverse is decorated with an undulating band. The inscription in Gurmukhi reads: "God is One; The Supreme God is the protector of my forehead; God is the protector of my hands and body; God is the protector of my soul; God of the Universe has saved my wealth and feet.

The Merciful Guru has protected everything, and destroyed my fear and suffering. God is the lover of his devotees, the Master of the masterless. Nanak has entered the Sanctuary of the imperishable Primal God. Guru Nanak to Guru Gobind Singh are the true manifestation of the Light (avtars). The city of Abchal Nagar, the Victory belongs to Divine."

27. A steel shield (*dhal*) decorated with gold *koftgari* and applied silver animals to the border

19th century | D: 17 in | Steel

28. Sikh-style *katar*, punch dagger with arched blade strap

c. 18th century | Total length: 17.25 in | Blade length: 9.5 in | Steel

This beautiful *katar* has an arched blade strap and a wonderfully chiseled flower. The steel is of very high quality *fuladh* (wootz), and the side bars are decorated with flowers in two colors of gold.

29. *Koftgari* and steel *katar*

c. Early 19th century | 10 in | Steel

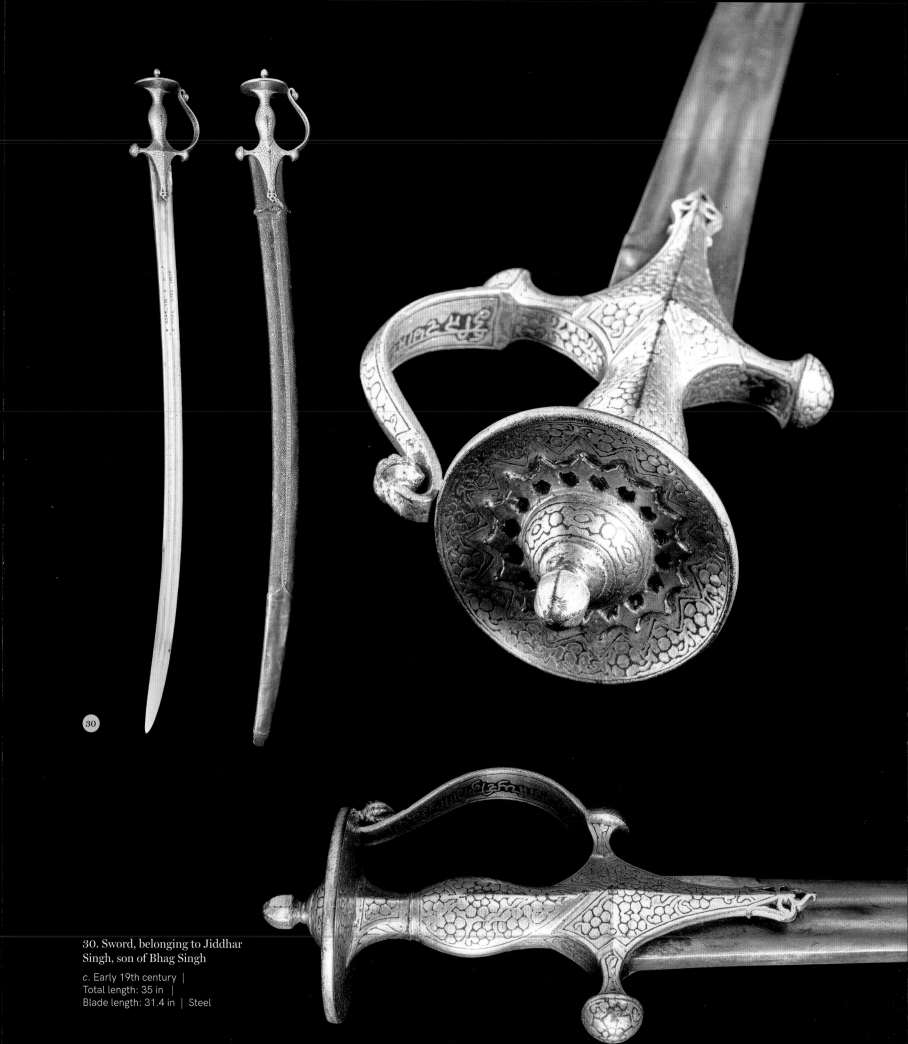

30. Sword, belonging to Jiddhar
Singh, son of Bhag Singh

c. Early 19th century |
Total length: 35 in |
Blade length: 31.4 in | Steel

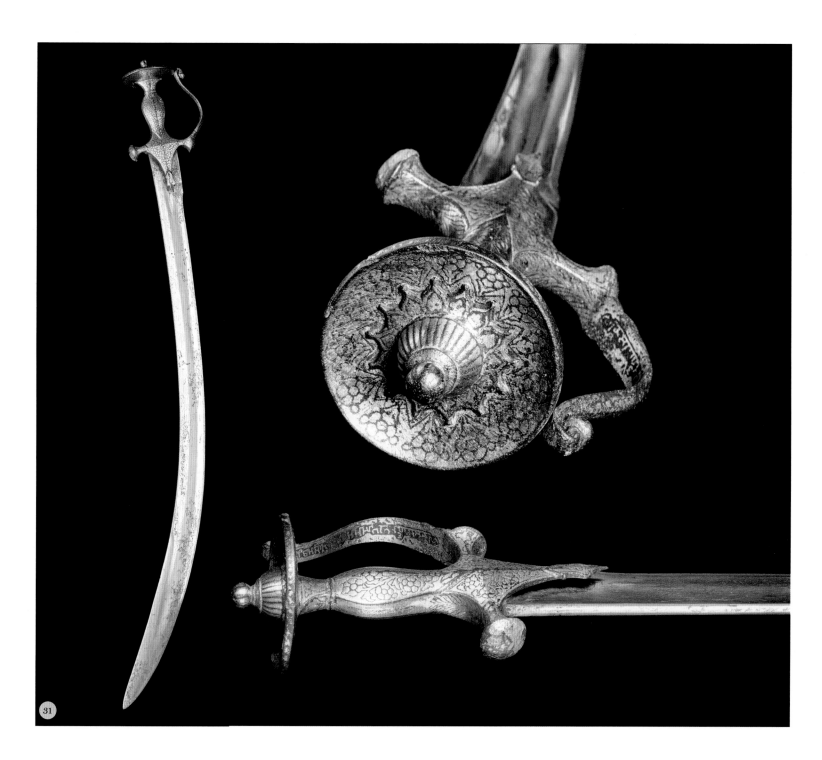

31. Sword [partially illegible inscription: Akāl (sahai) (__na?) Singh Mehmadpurīā Samat]

c. Early 19th century | Total length: 33.5 in | Blade length: 29 in | Steel

A *tulwar* belonging to a Sikh from Mehmadpur. Short, light, and flexible blade with polish in good condition. The hilt, with its 95 percent gold intact, is decorated with floral sprays and short stubby quillons with arrow-shaped langets.

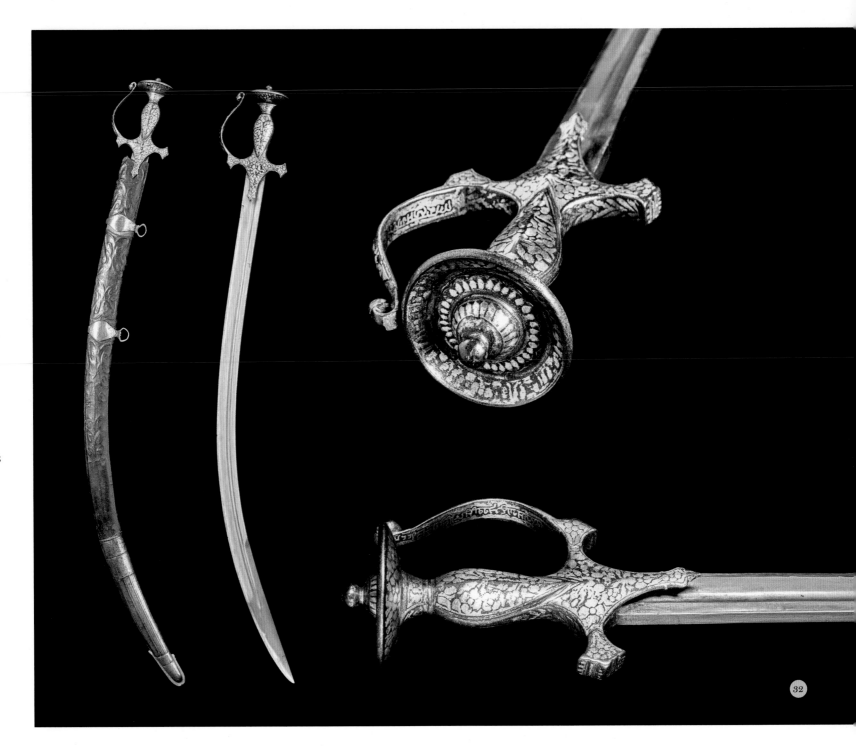

32. Sword

c. 1828 | Total length: 32.5 in | Blade length: 28 in | Steel

The hilt presents some gold wear, but is otherwise in
excellent condition. Simple floral sprays can be found on
the surfaces. The quillons are flattened and fan-shaped,
the shoulders decorated with cypress tree leaves, and the
langets arrow-shaped. The knuckle guard terminates with
a drooping acorn, with an inscription in Gurmukhi on the
inside of the knuckle guard. The inscrption reads: "Akāl
Sāhei Mohar (or Johar) Singh Thindh Samat 1885."

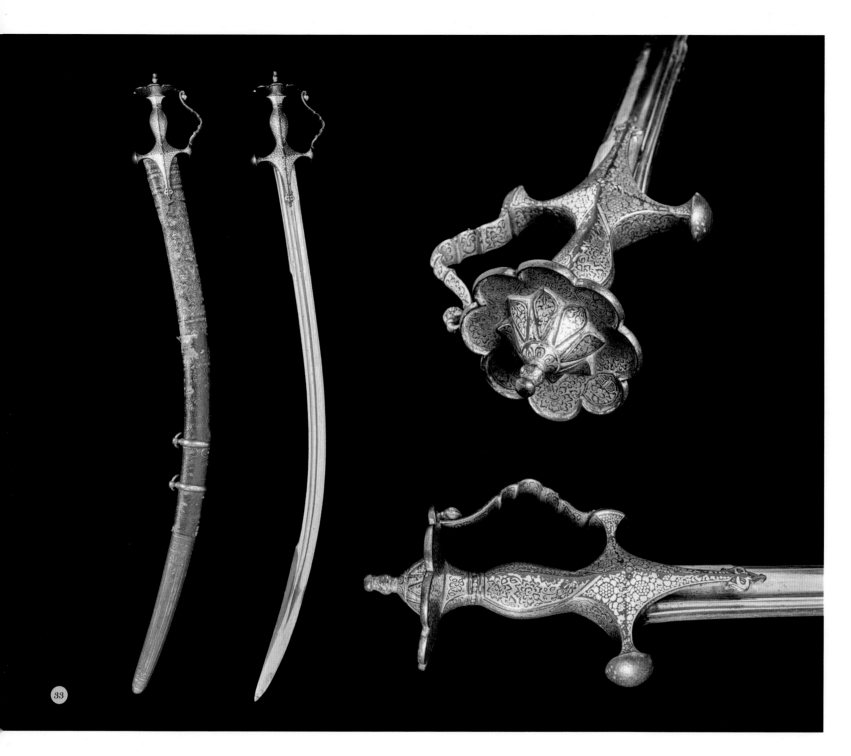

**33. A Sikh-style sword with
arched knuckle guard**

c. Early 19th century | Total length: 35 in
Blade length: 30.5 in | Steel

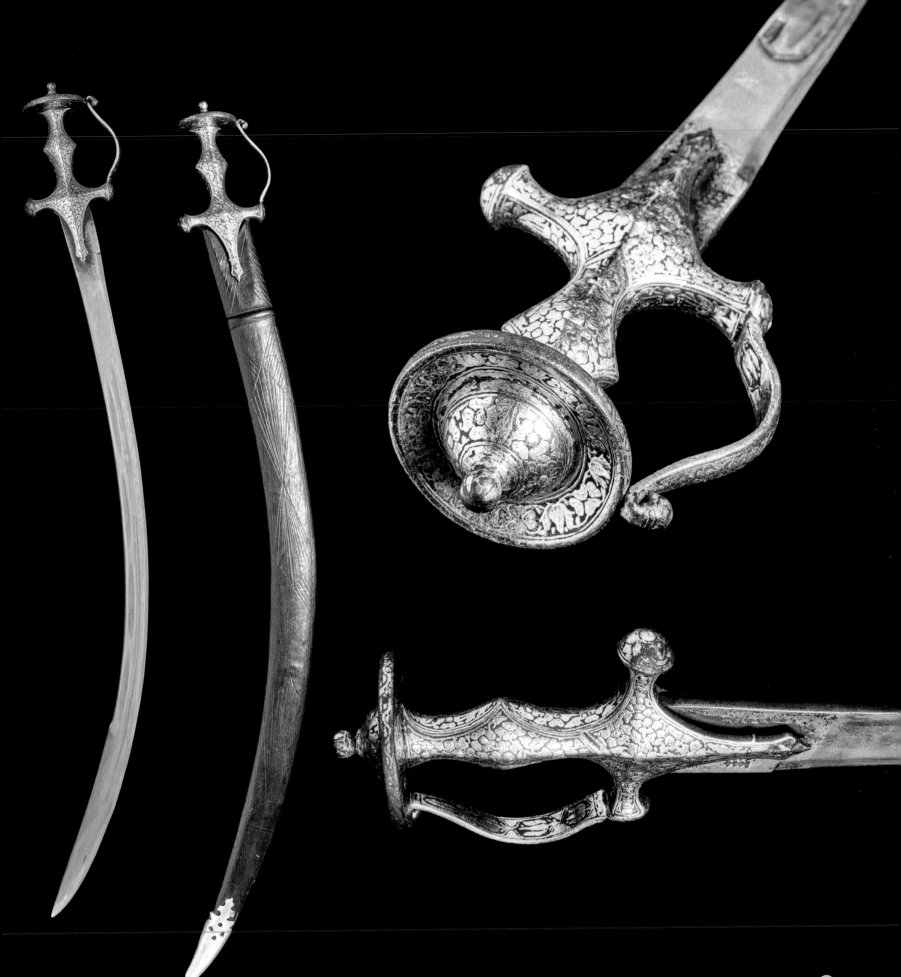

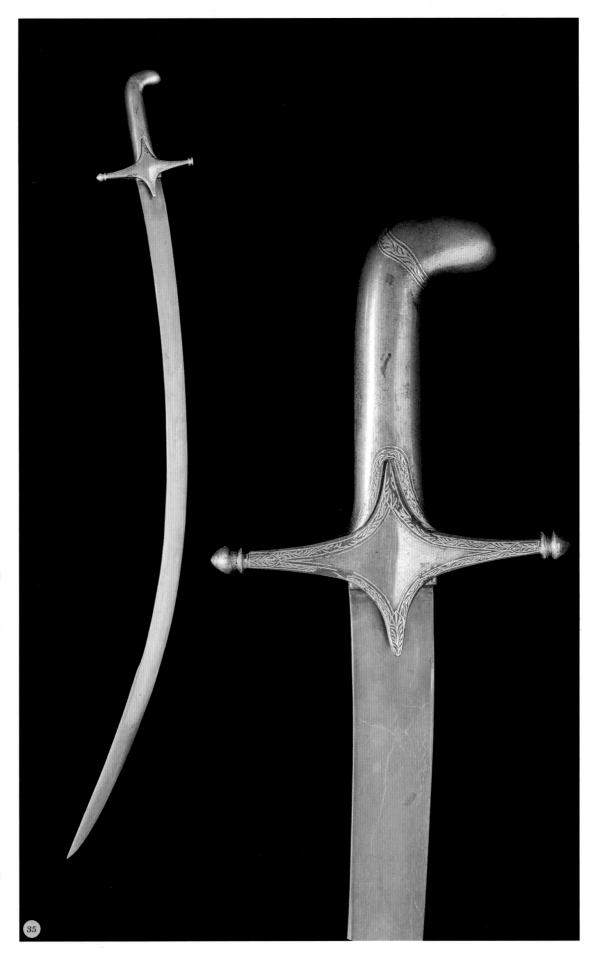

34. Sikh-style *tulwar*

c. 1820–30s | Total length: 33 in | Blade length: 29 in | Steel

Housed in a modern wooden scabbard covered in leather, the *tulwar* grip is in a typical "Sikh" form, heavily decorated in gold, with floral sprays and foliage, short stubby quillons, and arrow-shaped langets. A sweeping knuckle bow terminates in a dropping acorn with a row of flowers inside the knuckle guard.

35. *Shamshir*, Lahore

c. Mid-19th century | Total length: 36 in | Blade length: 31 in | Steel

In addition to its rarity and historical gravitas, this sword presents a pleasing harmony for the fact that its hilt and blade are so well matched in their form, proportion, and artistry. The burnished steel hilt is of "pistol-grip" form; its medial brim decorated in gold *koftgari* with a bordered band of undulating foliage which is repeated around the edges of the cross-guard. Delineated arch panels containing leaved stems in gold occupy the simple, elegant langets and precede the bud-shaped quillons.

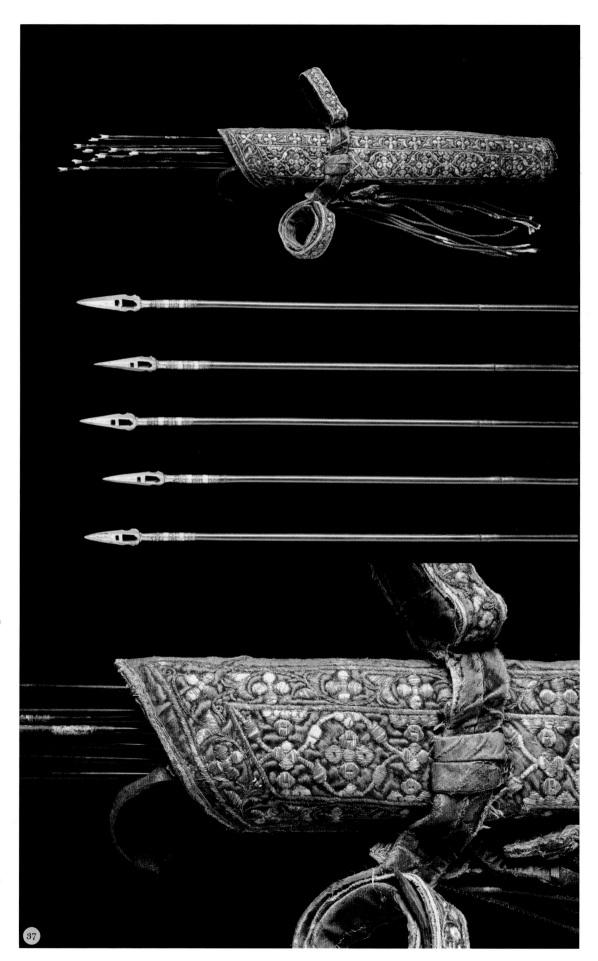

36. Steel bow, Punjab

19th century | 37.3 in | Steel

The main surface of this steel bow flourishes with a mesmerizing array of spiraling foliate patterns, which in turn frame a continuous series of curved cartouches each containing further leafy splays in silver and a stylized flowerhead with petals in spirals of gold. The centrally swollen grip section is threaded to allow the bow to be conveniently disassembled for storage or transportation. Originally, the notches at each end would likely have been tied with a silk bowstring.

37. Quiver

19th century

A group of twelve arrows, each fitted with an arrow head cut to represent the shape of a *katar*. The tail ends have been painted red and green, and though the feathers are lost, it is obvious that the arrows were originally fletched. The arrows' bulbous nocks are made from ivory and painted vermillion over their interiors. The quiver is red velvet with gilt silver-thread embroidery.

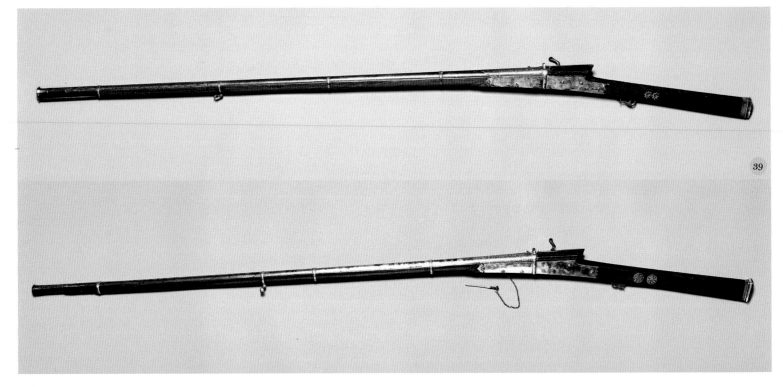

38. Spears, set of *barshas*

18th century | 89 in |
Steel and wood

A *karpa barsha*, literally meaning "cobra spear," with painted wooden shaft, steel blade and leather scabbard and fitted with brass encasings at its base and point that are cut and chased to depict outflowing acanthus leaves and intersecting lotus flowers atop a banded geometric pattern.

39. Gold *koftgari* matchlock rifle (*torador*), Lahore

c. 1800 | 67 in | Steel with gold inlay

40. Gold *koftgari* matchlock musket, Lahore

c. 1800 | 67 in | Steel with gold inlay

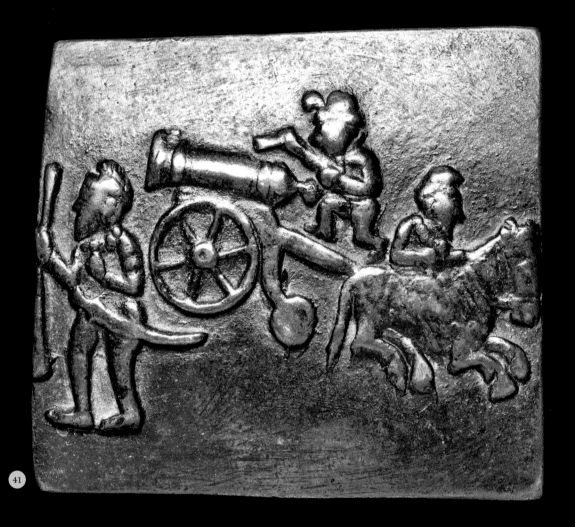

41. A belt buckle depicting Sikh soldiers, Lahore

c. 1830s | 3.75 x 3.3 in | Steel

Cast in heavy relief, this belt buckle depicts an infantryman, an artilleryman, and a cavalryman. On its reverse it has two hooks and a belt loop. This buckle probably formed part of the uniform of a soldier in the elite brigade known as the Fauj-i-khas, the first unit of Ranjit Singh's army to be dressed in European-style uniforms incorporating infantry, cavalry, and artillery.

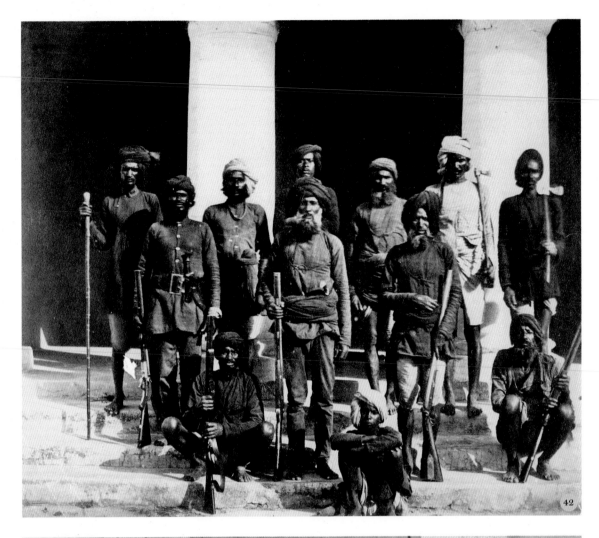

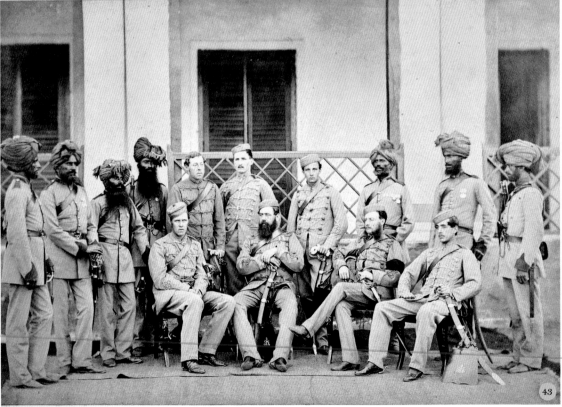

42. A rare photograph of Sikh soldiers before their uniforms were standardized in the various units

Photographer unknown |
c. 1860–62 | 7.5 x 6.5 in |
Albumen print

43. Soldiers wearing the Indian Mutiny medal

Photographer unknown | *c.* Late 1850s
Early 1860s | 18 x 12 in |
Albumen print

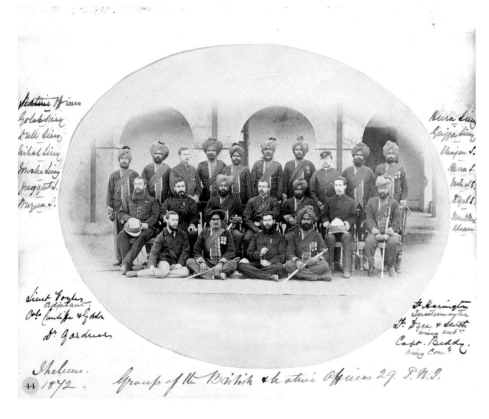

44. An unusual oval photograph of British Indian army officers with their names on the margins, Jhelum

Photographer unknown | *c.* 1872 | 7.5 x 6 in | Albumen print

45. Obscending (100 feet) erected by Bengal Sappers of Roorkee. The Bengal Sappers were engineers stationed around Sherpur cantonment in Kabul

Photographer unknown | *c.* 1879 | 10 x 7.5 in

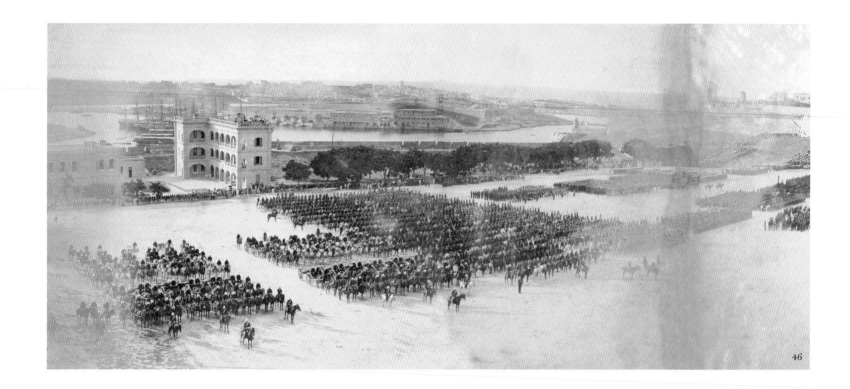

46

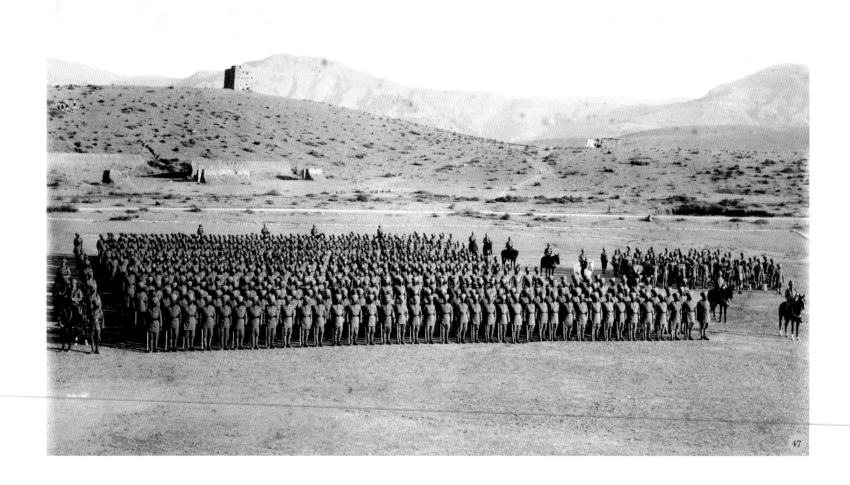

47

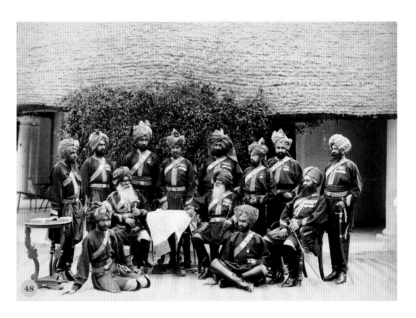

46. A three-part panorama
showing the Malta Expeditionary
Force in parade, which included
several regiments of Indian cavalry
and infantry, such as the Sikh
cavalrymen of Hodson's Horse in
Malta

Photographer unknown | *c.* 1878 |
9.5 x 20.8 in | Albumen print

47. Sikh troops in North West Frontier Province

Photographer unknown |
c. Late 19th century |
8.25 x 11.5 in | Albumen print

48. Probyn's Horse

Photographer unknown | *c.* 1884 |
9 x 12 in | Albumen print

Noted for its bravery, 5th King
Edward's Own Lancers, commanded
by Lieutenant Dighton Macnaghten
Probyn of the British Indian army, was
popularly known as Probyn's Horse.

49. Sikh soldiers in Sudan

Photographer unknown | *c.* 1885–90 |
4 x 3.25 in | Albumen print

50. Sikh soldiers with British officers in Sudan

Photographer unknown |
c. 1885–90 | 4 x 3.25 in |
Albumen print

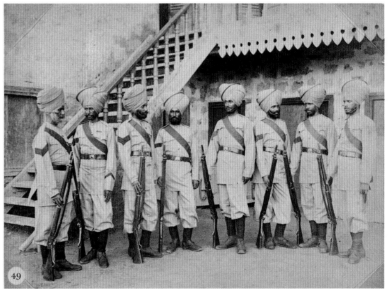

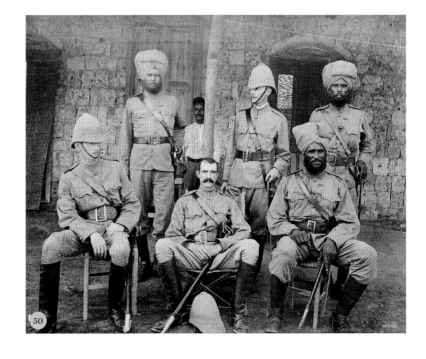

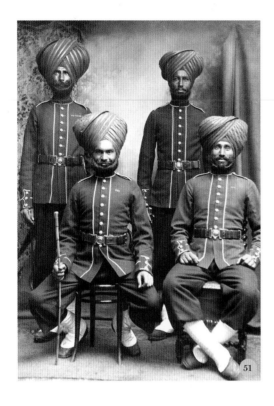

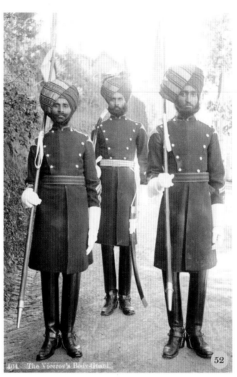

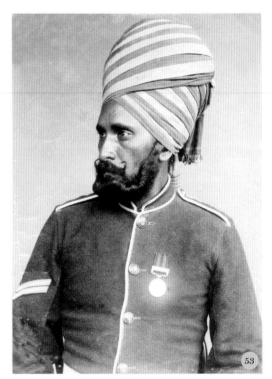

51. Sikh soldiers

Photographer unknown |
19th century | 5.8 x 4.25 in |
Albumen print

**52. Viceroy's Sikh bodyguards,
possibly at Simla**

Photographer unknown |
c. 1900 | 5.9 x 4 in |
Albumen print

**53. Sikh officer of the Malay State
Guides, Malay**

Photographer unknown |
Early 1900s |
5.1 x 3.6 in | Albumen print

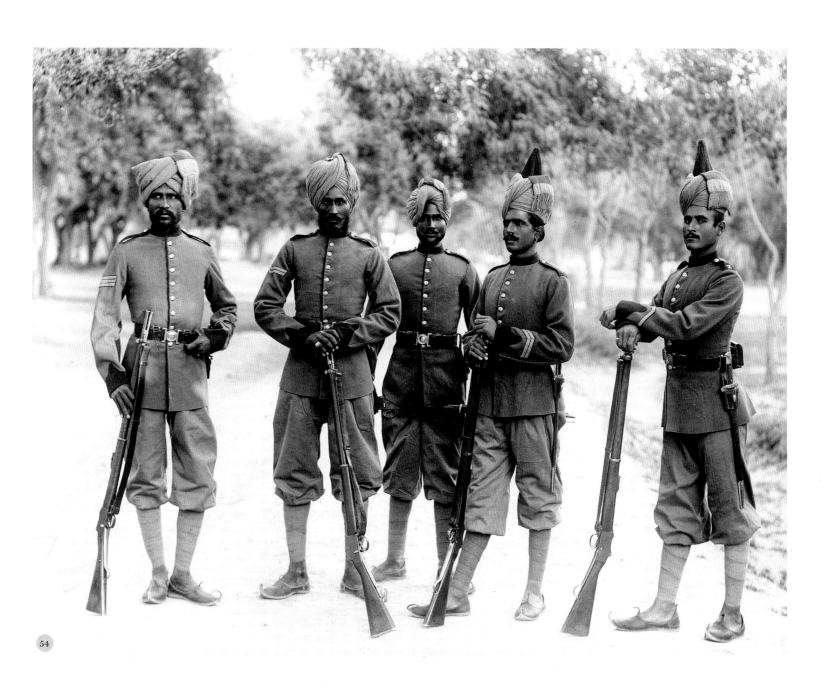

54. Men of the 2nd Regiment of
Sikh infantry, Punjab Frontier
Force, later 52nd Sikhs (Frontier
Force), possibly in Bannu, North
West Frontier Province

Photographer unknown | *c.* 1890s |
8.2 x 10.9 in | Albumen print

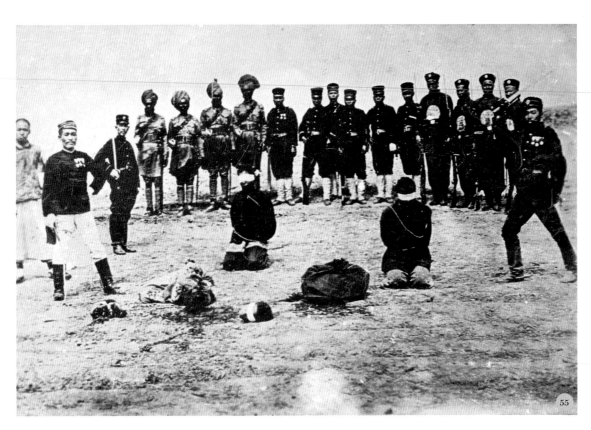

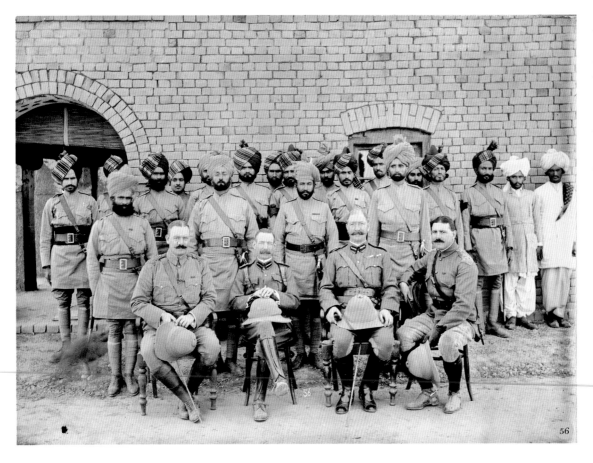

55. Boxer Rebellion, China

Photographer unknown | *c.* 1900 | 3.6 x 5.75 in | Albumen print

The Boxer Rebellion was an anti-imperialist, anti-foreign, and anti-Christian uprising that took place in China between 1899 and 1901, toward the end of the Qing dynasty. Sikh soldiers deployed in the British Indian army served during this uprising.

56. Sikh and other soldiers of 56th Silladar Camel Corps

Photographer unknown | 1905 | 10 x 13.5 in | Albumen print

57. Sikh soldiers, a panorama

Photographer unknown | *c.* Early 20th century | 21 x 3.75 in | Albumen print

58. British Indian army, probably in the North West Frontier Province

Photographer unknown | *c.* Early 20th century | 8 x 11 in | Albumen print

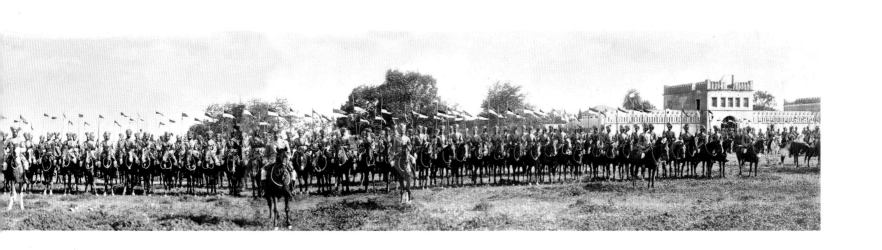

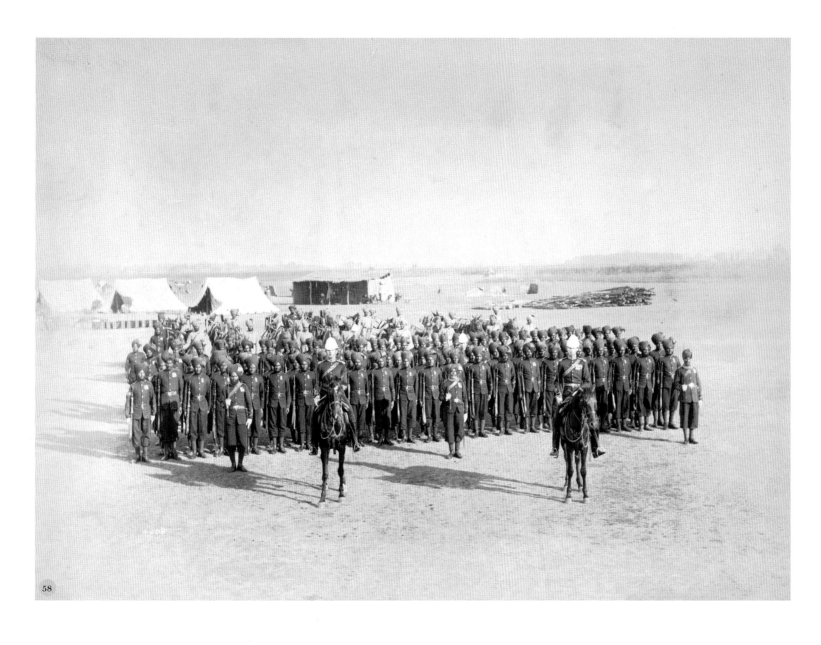

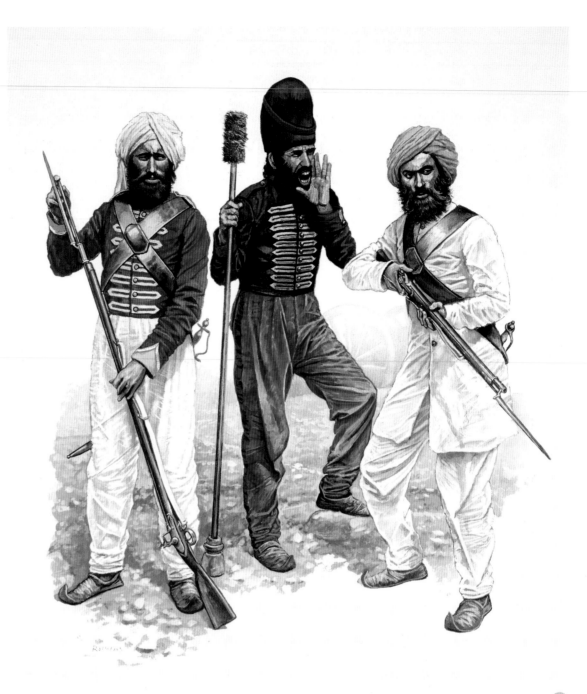

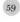

59. "India Sikh infantry and artillery" from *Queen Victoria's Enemies*

Richard Scollins | 1990 | 13 x 11 in | Watercolor

With text by Ian Knight, this special edition on India *Queen Victoria's Enemies: India* looks at the "dramatic and brutal history of the East India Company's exploits against Queen Victoria's Indian enemies."

60. Battle of Saragarhi, North West Frontier Province

Jarnail Singh | 2017 | 28 x 34 in (with frame) | Oil on canvas

The Battle of Saragarhi was fought on September 12th, 1897 between the British Raj and Afghan tribesmen. Led by Havildar Ishar Singh, twenty-one Sikh soldiers were pitted against over 8,000 Afridi and Orakzai tribals but they managed to hold the fort for seven hours.

61. Postal envelope commemorating the 100th anniversary of the Battle of Saragarhi

1997 | 4.4 x 8 in

Saragarhi was the communication tower between Fort Lockhart and Fort Gulistan in the North West Frontier Province. The tower helped to link up the two important forts which housed a large number of British troops.

62. Saragarhi Memorial, Ferozepur

Early 1900s | 5.5 x 3.5 in | Postcard

The Saragarhi Memorial gurdwara was built in 1924 to honor the Sikh soldiers of 36th Sikh Regiment (now 4th Sikh Battalion) for their valor and bravery. Surrounded by cannons, the walls of the gurdwara are engraved with names of the twenty-one soldiers.

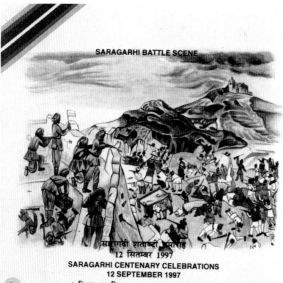

SARAGARHI BATTLE SCENE

12 सितम्बर 1997

SARAGARHI CENTENARY CELEBRATIONS
12 SEPTEMBER 1997

4 सिख़ बटालियन 4 SIKH REGIMENT

ISSUED BY THE ARMY POSTAL SERVICE
12 SEPTEMBER 1997

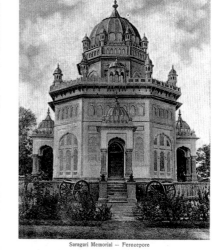

Saragari Memorial — Ferozepore

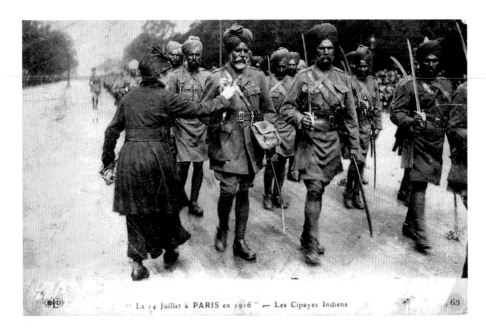

"Le 14 Juillet à PARIS en 1916" — Les Cipayes Indiens 63

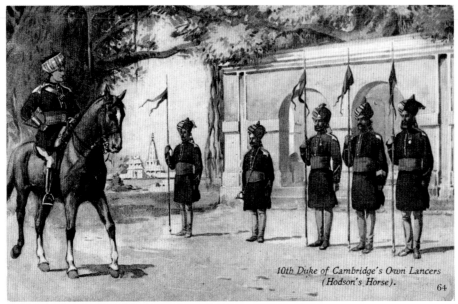

10th Duke of Cambridge's Own Lancers
(Hodson's Horse).
64

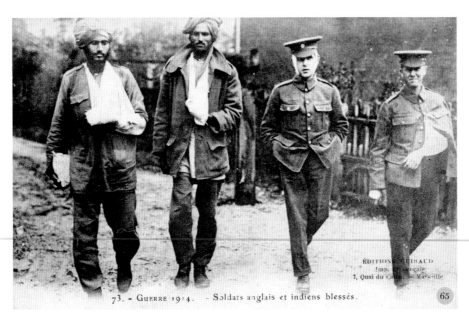

73. - GUERRE 1914. - Soldats anglais et indiens blessés. 65

266

63. British Indian army in Paris

1916 | 3.5 x 5.5 in | Postcard

**64. British Indian army,
Hodson's Horse**

Early 1900s | 3.5 x 5.5 in | Postcard

**65. British Indian army
in Marseille**

Early 1900s | 3.5 x 5.5 in | Postcard

66–69. First World War postcards

1914–18 | 5.25 x 3.5 in (each)

1st Duke of York's Own Lancers (Skinner's Horse)

Artillery Gunner Mountain Battery.

45th Rattrays Sikhs (Drum Major)

Queens Own Corps of Guides 66 (Cavalry) Duffadar

67

15th Sikhs.

For the first time in their stirring history the Sikhs will be engaged in European warfare by taking the field beside their comrades of the British Army against the Germans.

VERS LA VICTOIRE

552

68 HONNEUR aux ALLIÉS

HONNEUR aux soldats d'AFRIQUE et des INDES

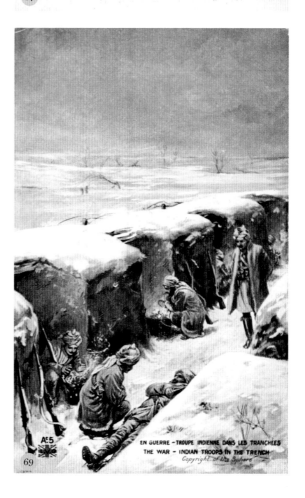

69 EN GUERRE - TROUPE INDIENNE DANS LES TRANCHÉES
THE WAR - INDIAN TROOPS IN THE TRENCH
Copyright of The Sphere

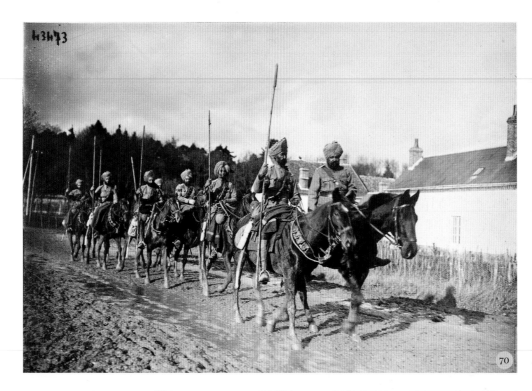

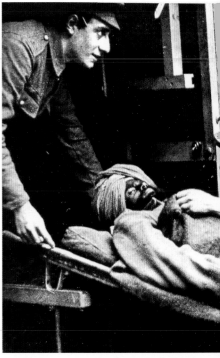

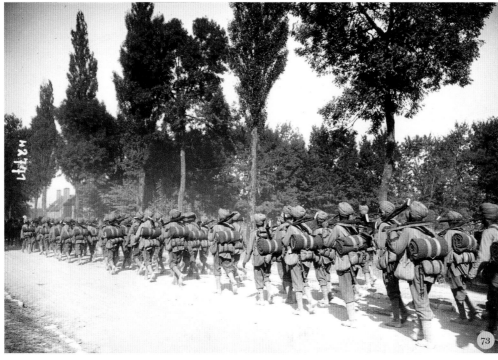

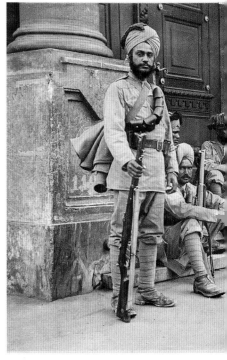

70. Sikh soldiers in France

Photographer unknown | 1914–18 |
5 x 7 in | Albumen print

71. An injured Sikh soldier being
transported by an ambulance,
France

Photographer unknown | 1914–18 |
4 x 6 in | Albumen print

72. Sikh soldiers washing clothes
in a camp during the First World
War, France

Photographer unknown | 1914–18 |
6.4 x 8.5 in | Albumen print

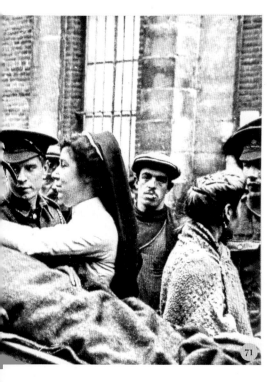

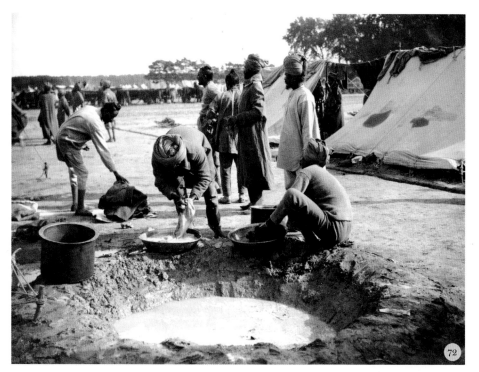

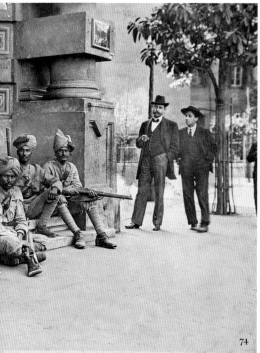

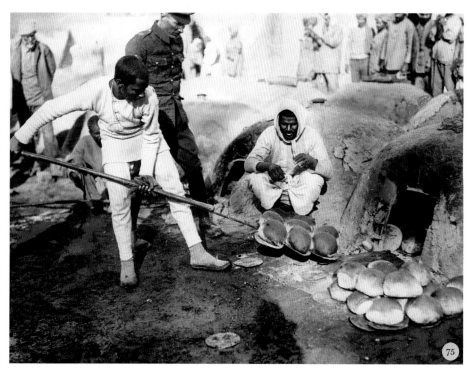

**73. Sikh soldiers on the
march in France**

Photographer unknown | 1914–18 |
7 x 5 in | Albumen print

**74. Sikh soldiers outside a
bank in Cairo**

Photographer unknown | 1914–18 |
6 x 9.75 in | Albumen print

**75. Indian soldiers baking bread
in mud ovens in a field kitchen**

Photographer unknown |
1914–18 | 7.5 x 10 in |
Albumen print

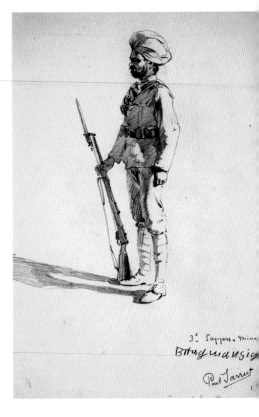

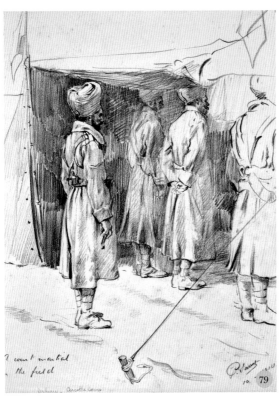

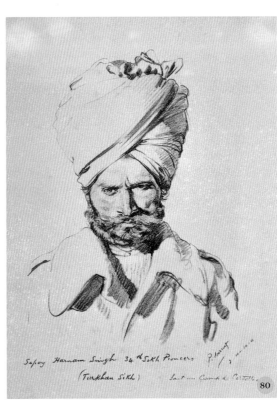

77. Sikh soldiers

Paul Sarrut | *c.* 1914 |
11 x 8.5 in | Lithograph

78. Sikh soldier

Paul Sarrut | *c.* 1914 |
12.5 x 9 in | Lithograph

79. Sikh soldiers

Paul Sarrut | *c.* 1914 |
11 x 8 in | Pencil on paper

80. Sepoy Harnam Singh

Paul Sarrut | *c.* 1914 | 12.5 x 9 in |
Pencil on paper

81. Sikh soldiers

Paul Sarrut | *c.* 1914 |
12.5 x 7.5 in | Lithograph

82. Sikh soldiers

Paul Sarrut | *c.* 1914 |
11.5 x 7.5 in | Lithograph

83. Sikh soldiers

Paul Sarrut | *c.* 1914 |
9.75 x 12.75 in | Lithograph

**76. Drawing of a Sikh soldier,
signed and also inscribed "Jshar
Singh" (Sikhs) in Gurmukhi,
probably by Jshar Singh himself**

Rod Vacha | 1914 | 14 x 9 in |
Ink on paper

WAR SKETCHES

While the Indian troops were in France, they caught the attention of a local French artist, Paul Sarrut, who spent time observing and sketching them in detail. These paintings, 77 to 83, are from *British and Indian Troops in Northern France: 70 War Sketches* by Sarrut.

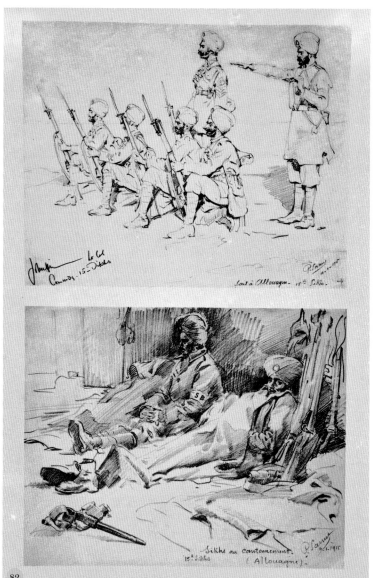

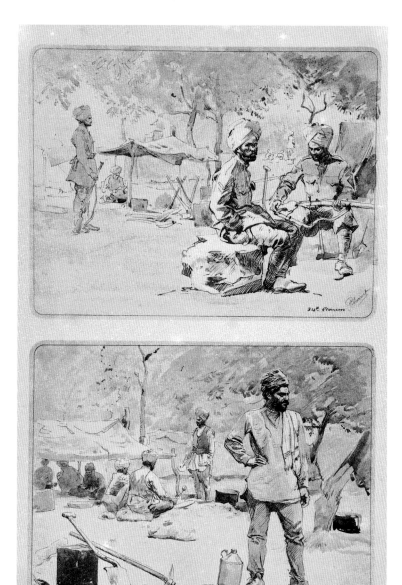

81

82

83

WARRIORS OF THE FIRST WORLD WAR, FROM
DEUTSCHLANDS GEGNER IM WELTKRIEGE 1914-1918

During the Great War, Thomas Baumgartner, a Bavarian artist, was asked to craft portraits of high-ranking Bavarian and other German officers, as well as a series of paintings of captured Allied troops highlighting their uniforms.

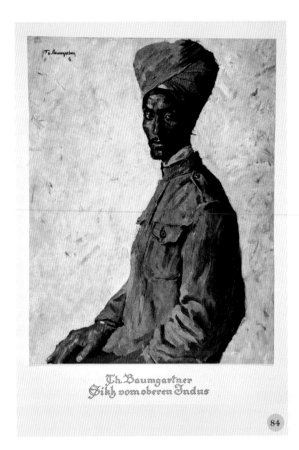

Th. Baumgartner
Sikh vom oberen Indus

84

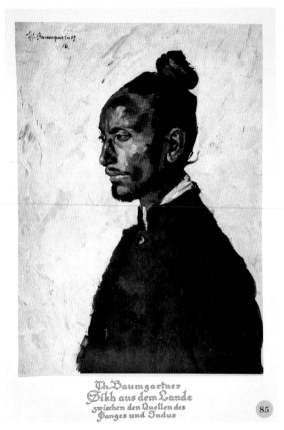

Th. Baumgartner
Sikh aus dem Lande
zwischen den Quellen des
Ganges und Indus

85

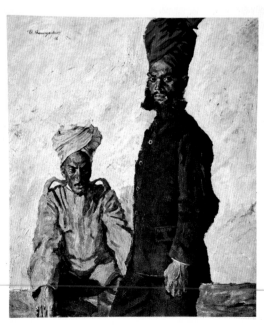

Th. Baumgartner
Sikh und Brahmane

86

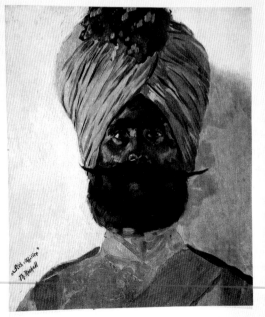

Th. Rocholl
Sikh-Offizier

87

84. "Sikh from the Upper Indus"

Thomas Baumgartner | *c.* 1920 |
9.2 x 7.8 in | Lithograph

85. "Sikh from the country between the springs of the Ganges and the Indus"

Thomas Baumgartner | *c.* 1920 |
9.2 x 7.8 in | Lithograph

86. "Sikh and Brahman"

Thomas Baumgartner | *c.* 1920 |
9.2 x 7.8 in | Lithograph

87. "Sikh Officer"

Theodor Rocholl | *c.* 1914–18 |
9.2 x 7.8 in | Lithograph

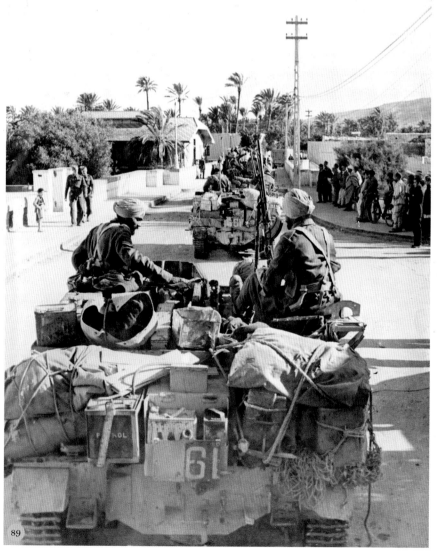

88. Maharaja Bhupinder Singh of Patiala (second row, third from left) with other leaders and British army officers at the 10th anniversary of Armistice Day

Photographer unknown | 1928 | 9 x 11 in | Albumen print

89. Transport loaded with Indian troops and stores arriving in Derna, a port city in eastern Libya, during the Second World War

Photographer unknown | *c.* 1941 | 10 x 8 in | Albumen print

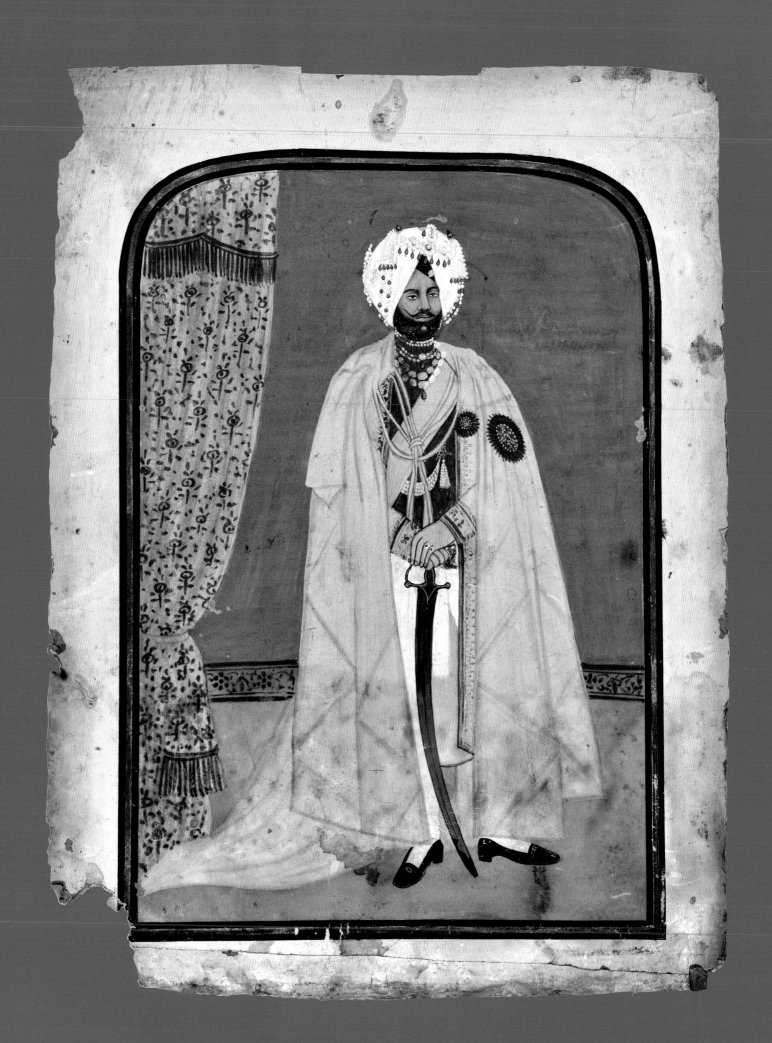

7 PRINCELY STATES OF PUNJAB: ARTS AND ARTIFACTS

"Bibi Sahib Kour... drawing her sword, declared that the Sikhs would be forever disgraced if they allowed her, a woman and the sister of their Chief, to be slain, for she was determined never to retreat. This gallantry so shamed and encouraged the soldiers, that they returned with renewed fury to the fight..."[1]

Lepel H. Griffin (British administrator and diplomat during the British Raj period in India)

1. Maharaja Mohinder Singh of Patiala

Artist unknown | c. 1870 | 11.5 x 8 in | Gouache and gold dust

Dressed in the robes of a Knight Grand Commander of the Order of the Star of India, Mohinder Singh was the son of Maharaja Narinder Singh of Patiala. During his rule, he tried to improve his state by funding colleges and building a new canal, and provided relief for famine-stricken areas. In 1875 he established Mohindra College in Patiala.

Princely states, also known as "native states," were governed by local rulers as subsidiary alliances with the British Raj. Many princely states existed in Punjab and they survived as semi-autonomous units even after the fall of Ranjit Singh's Lahore Durbar in 1849. All of them were referred to as Cis-Sutlej (except Kapurthala), a name that indicated the area lying between the Sutlej and Jamuna rivers. The major states were Patiala, Nabha, and Jind, whose rulers shared Chaudhri Phul as a common ancestor. The Muslim state of Malerkotla, as well as Faridkot and Kaithal were also considered as Cis-Sutlej states.

275

The Cis-Sutlej states had come under the protection of the British in 1809, when the East India Company signed a treaty with Maharaja Ranjit Singh, establishing the Satluj river as the demarcation line between the Lahore Durbar and the British territories. These princely states continued to hold onto some amount of independent power which was curtailed with time. In this chapter, we focus on four princely states, namely Patiala, Nabha, Jind (collectively known as Phulkian states), and Kapurthala.

The years between the beginning of the 1800s and the end of the 1840s were the golden age of Lahore Durbar. After 1840s, some of the artists, craftsmen, poets, cultural maestros, and musicians flocked to the princely states where such activities were still flourishing. For instance, Sikh painters Kehar Singh and Kapur Singh produced most of their works in the mid to late 1800s. While the former was known for his figure depictions portrayed with a fine sense of volume, the latter excelled at capturing details. Architecture also flourished, with palaces, buildings, religious temples, hospitals, educational institutions, and gardens being built. Stunning frescoes depicting epic scenes from the Mahabharata and the *Gita Govinda* featuring Radha and Krishna, along with the life and travels of the gurus adorned the walls of palaces. The ingenuity and artistic traditions of Punjab continued to survive in the princely states. Although the rulers of these states were mainly Sikh, many among their administrators were not. This led to the flowering of eclectic cultures associated with different religious traditions. The era of the princely states came to an end in 1947, when they were integrated within the newly independent Indian nation.

PATIALA

At a time when Afghan invaders kept attacking Punjab, Ala Singh, the first king of Patiala, carved out a territory for himself in the midst of all the instability. A fearless and enterprising ruler, he laid the foundation of the Patiala fort (known as Qila Mubarak) in 1763, around which the present city

of Patiala developed. He died two years later and was succeeded by his grandson Amar Singh, who also displayed great courage and ingenuity. Even though he died prematurely at thirty-five, he was able to make Patiala the most powerful among the Cis-Sutlej states. As Lepel Griffin observed, "If Amar Singh had lived, or had been succeeded by rulers as able as himself, the Cis-Sutlej states might have been preserved, both against Lahore monarchy on the one hand and the British Government on the other."[2]

Jassa Singh Ahluwalia, the leader of the Dal Khalsa, had a close relationship with Ala Singh and also personally baptized his successor, Amar Singh, who had deep reverence for him. These rulers were followed by Sahib Singh whose fortunes were saved by the gallantry of his sister Bibi Sahib Kaur, who successfully led the Sikhs against the vastly superior Maratha forces in 1794. In fact, the Patiala kingdom has a history of remarkable female leaders, including Rani Fattoh (Ala Singh's wife), Rani Rajinder Kaur, and Aus Kaur.

Other rajas followed. Karam Singh brought stability to the state, strengthening his relationship with the British and handling his domestic affairs proficiently. He was followed by Maharaja Narinder Singh (r. 1845–62), who according to Nikky G.K. Singh, "as the most enlightened ruler of Patiala, was a great patron of arts" and who transformed Patiala into "a cultural hub for painters, poets, musicians, builders, craftsmen, and gardeners from different religious backgrounds and different parts of north India."[3] As a consequence, Pahari, Rajasthani, and Muslim painters made Patiala their new abode. Major buildings and palaces were built during his reign, including Sheesh Mahal which features exquisite mural work and its unusual mirror embellishments. Around the same time, Narinder Singh commissioned the construction of the Bansar Bagh, where an artificial lake and gardens were created. He also commissioned the construction of Hindu temples and Sikh gurdwaras. In 1859, he built the Durbar Hall (a grand audience hall) a structure used for ceremonial purposes adorned with its beautiful interiors and glittering chandeliers.

The Patiala *gharana* (family) of music became well known, with major classical singers finding a new home for their work. The Patiala court also encouraged literary activities, and leading poets and intellectuals from other regions came to settle in the state. Miniature painting was also patronized, and craftsmen producing jewelry, dyed and embroidered textiles, and footwear chose Patiala to establish their workshops.

Maharaja Mohinder Singh (r. 1862–76) strove to promote education and established Mohindra College. He also built the Sirhind canal, improving irrigation for farming. He was followed by Maharaja Rajinder Singh (r. 1876–1900) and Maharaja Bhupinder Singh (r. 1900–38). The latter also embarked on architectural and construction projects and served as Chancellor of the Indian Chamber of Princes from 1926 to 1931. During the First World War, he actively promoted the interests of the British, who conferred the rank of Major General on him in 1918 as an honor. A patron of sports, he captained the Indian cricket team in 1911. He amassed a fascinating collection of jewels, including the famous Patiala necklace made by Cartier. He was succeeded by Maharaja Yadavindra Singh who founded Yadavindra Public school and served as president of the Indian Olympic Association from 1938 to 1960 and as chairman of the Indian Horticulture Development Council.

NABHA

Nabha was the second largest of the Cis-Sutlej states. Hamir Singh founded the town of Nabha in 1755 which later expanded to Nabha state. He was followed by Raja Jaswant Singh, Raja Devinder Singh, Bharpur Singh, and Bhagwan Singh. The next successor, Maharaja Hira Singh (r. 1871–1911), was a nephew but not a direct member of the ruling family. He contributed significantly to Nabha's economic, military, and political consolidation. His son, Maharaja Ripudaman Singh, collaborated with other Sikh reformers, including Kahn Singh Nabha and Bhai Vir Singh to get control of the Sikh gurdwaras. He also succeeded in introducing the Anand Marriage Bill in the Imperial Legislative Council thus legalizing the Sikh form of marriage which went to replace the

276

2. Maharaja Jagatjit Singh, Kapurthala

Frank O. Salisbury | *c.* Early 1930s | 21 x 15 in | Pastel on paper

Sir Jagatjit Singh Sahib Bahadur GCSI GCIE GBE (1872-1949) was the ruling maharaja of the princely state of Kapurthala from 1877 until his death in 1949. He ascended the throne on October 16th, 1877 and assumed full ruling powers on November 24th, 1890. An avid world-traveler, he greatly admired French culture. He built palaces and gardens in the city of Kapurthala and modeled the Jagatjit Palace, his main residence, on the Palace of Versailles, transforming his capital into the "Paris of the East."

277

Hindu form of marriage.[4] But the British government was not pleased by his reformist policies and deposed him in 1923, replacing him with his son, Partap Singh.

JIND

Jind was one of the smaller Cis-Sutlej states whose origins trace back to its founder and first ruler Raja Gajpat Singh (r. 1763–89). In 1774, Raja Gajpat Singh's daughter, Raj Kaur, married Mahan Singh, and their son, Ranjit Singh, later became the first maharaja of Punjab. Gajpat Singh was a close confidante of Maharaja Ranjit Singh, who had a deep reverence for him and relied on his advice, especially during the early years of his reign. Gajpat Singh was succeeded by Rajas Bhag Singh, Fateh Singh, Sangat Singh, and Sarup Singh. Raja Raghbir Singh (1834–87), who reigned from 1864 to 1887, was a great patron of the arts and a promoter of local talents. He established his main residence at Sangrur and began a long campaign to remodel his state. He rebuilt the Sangrur bazaar, constructed gardens, temples, water tanks, as well as public buildings, and paved roads. Historic sites such as the ones associated with the Mahabharata attracted artists fascinated by their rich heritage. Raja Ranbir Singh was Jind's last ruler, governing the state from 1899 to 1947. A progressive ruler, he built schools and hospitals, established charities for widows and orphans, and instituted free primary education in Jind. He also supplied troops for the World Wars and pursued a military career, eventually rising to the rank of Brigadier.

KAPURTHALA

Kapurthala was founded by the Ahluwalia dynasty, which traces its origins to Jassa Singh (1718–83), arguably the greatest Sikh leader of his time. As the leader of the Dal Khalsa, he personally guided the various Sikh *misls*. His bravery, piety, and leadership on and off the battlefield were renowned. His vision and fortitude helped to establish and secure Punjab for the Sikhs. He was succeeded by Raja Fateh Singh Ahluwalia, one of Maharaja Ranjit Singh's closest friend and confidantes, who accompanied the first Sikh emperor on most of his early conquests. Later, being concerned that his territories might be taken over by Maharaja Ranjit Singh, Raja Fateh Singh Ahluwalia sought protection from the British.

Raja Nihal Singh, who succeeded Raja Fateh Singh in 1836, sided with the Sikh forces in the First Anglo-Sikh War. For this reason, he was penalized by the British who annexed some of his territories. He was followed by his son Raja Randhir Singh (r. 1852–70) and by his grandson Maharaja Kharak Singh (r. 1870–77).

Maharaja Jagatjit Singh ascended to power in 1877 and remained Kapurthala's ruler until 1947. He was well educated, traveled widely, was enlightened with worldly exposure to European leaders and royalty, having spent some time in France. He introduced the modern sewage and water systems in the cities as well as a telephone system in 1901.

Maharaja Jagatjit Singh also set up free compulsory primary education in 1918, agricultural cooperative credit societies in 1920, and encouraged multiple industries. He built beautiful buildings and religious places for all his subjects in the state. One impressive example is the celebrated Jagatjit Palace, which was built in 1906 by the French architect Alexandre Marcel and was modeled on Versailles and Fontainebleau. Beautifully crafted and aesthetically superb, the palace was a showpiece of its time, with its majestic gardens. As H.H. Sukhjit Singh has noted,

> Maharaja Jagatjit Singh's secular spirit and vision is captured in a breathtaking monument, the 'Moorish Mosque' which was built between 1926–1930. This remains a profound testimony to his commitment to represent all his subjects irrespective of denomination or creed and to fulfil their religious needs.[5]

Many paintings, photographs, and artifacts related to these princely states have made their way into the Khanuja Family Collection and we display a selection in this chapter. Of particular

3. Maharaja Rajinder Singh (1872–1900) (left) and Maharaja Narinder Singh (1824–62) (right) of Patiala

Artist unknown | *c.* 19th century | 4 x 3 in (each) | Paintings on ivory

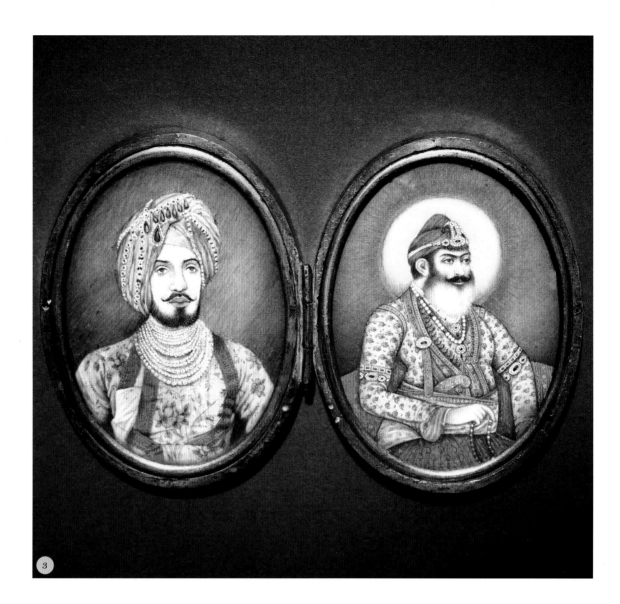

interest are a few photographs from an album belonging to the royal collection of Kapurthala, Raja Nihal Singh's sword and *katar*, and a jewel-embedded sword belonging to Maharaja Bhupinder Singh and presented to him by the Chamber of Princes of India in 1918. Seen together, these objects highlight the rich heritage of the princely states and their patronage of fine arts and crafts.

REFERENCES & NOTES

1. L.H. Griffin, *The Rajas of the Punjab* (Delhi: 1870. Reprint, Lahore: Sang-e Meel Publications, 2006), 76.

2. *Ibid.*, 53.

3. N.G.K. Singh, "Sikh Art", in *The Oxford Handbook of Sikh Studies*, eds. Pashaura Singh and Louis E. Fenech (Oxford: Oxford University Press, 2014), 426.

4. J.S. Grewal and I. Banga, *A Political Biography of Maharaja Ripudaman Singh of Nabha* (New Delhi: Oxford University Press, 2018), 36.

5. H.H.S. Singh and Cynthia Meera Frederick, *Prince Patron and Patriarch: Maharaja Jagatjit Singh of Kapurthala* (New Delhi: Roli Books, 2019), 137.

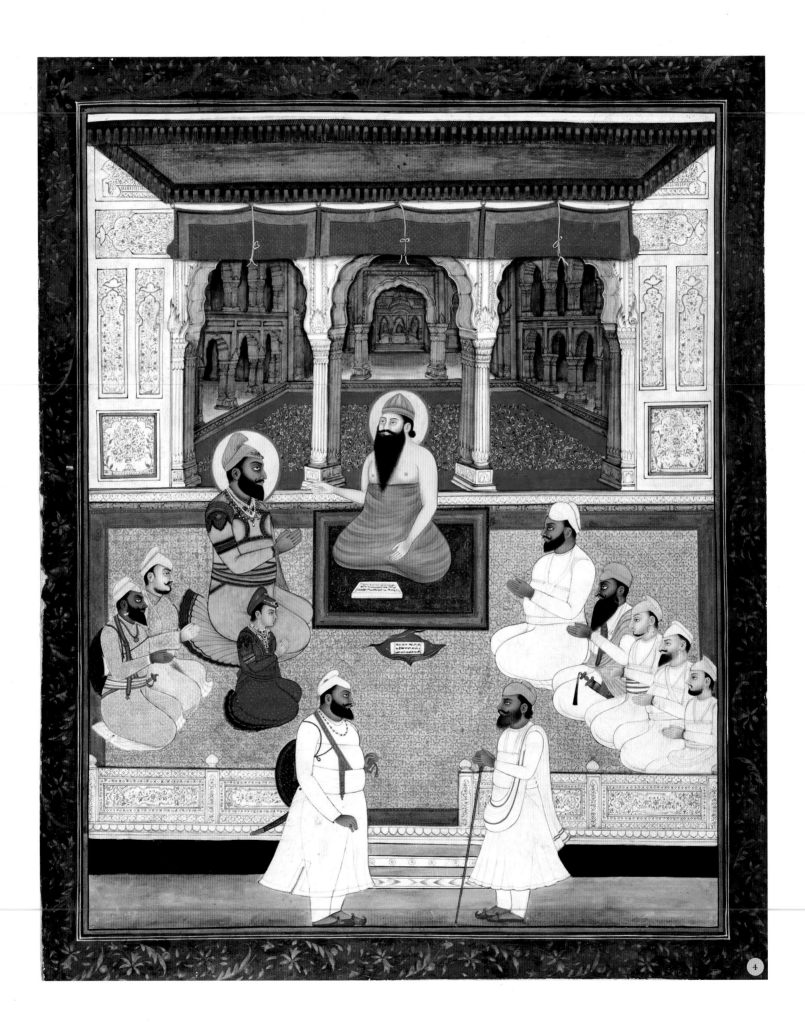

PATIALA

Patiala was established in 1763 by Ala Singh (1691–1765). In 1810, its rulers were accorded the honorific title of Maharaja-e Rajgan (great ruler) by the British, which was reserved for their most important states.

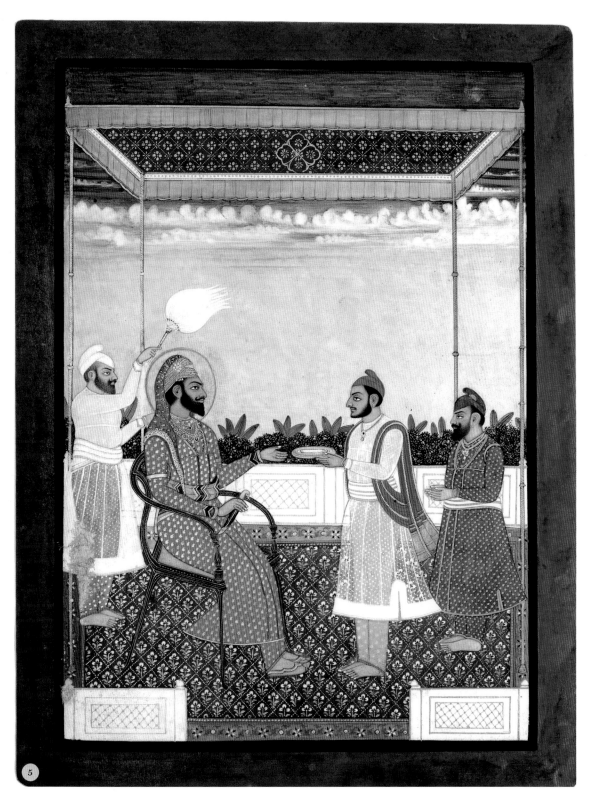

5

4. Maharaja Karam Singh of Patiala talking with his son Narinder Singh, surrounded by courtiers and attendants

Artist unknown | *c.* 1840–50 | 17.25 x 14.5 in | Gouache and gold dust

5. Maharaja Narinder Singh

Artist unknown | 19th century | 12 x 8.9 in | Gouache and gold on paper

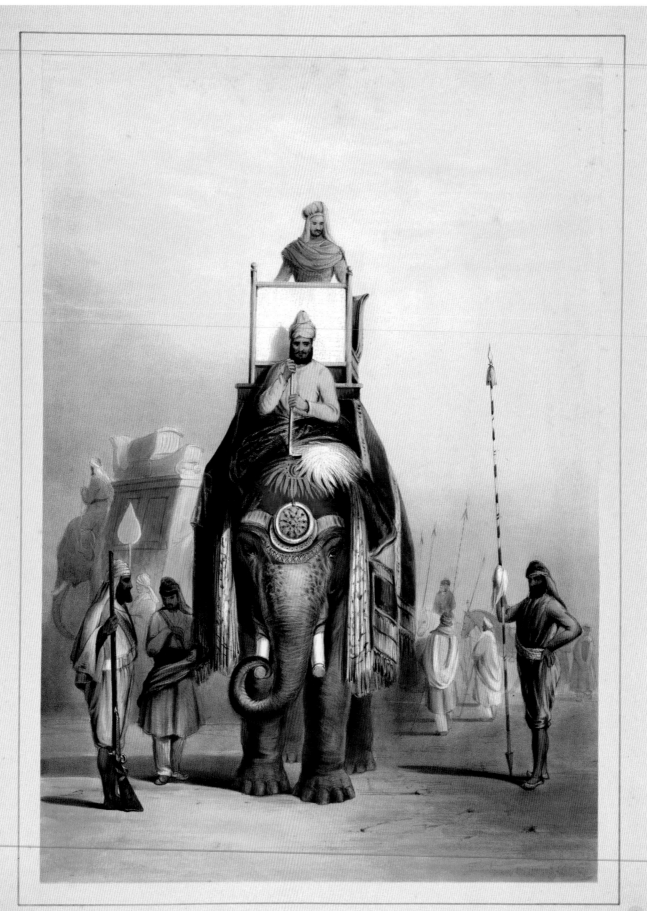

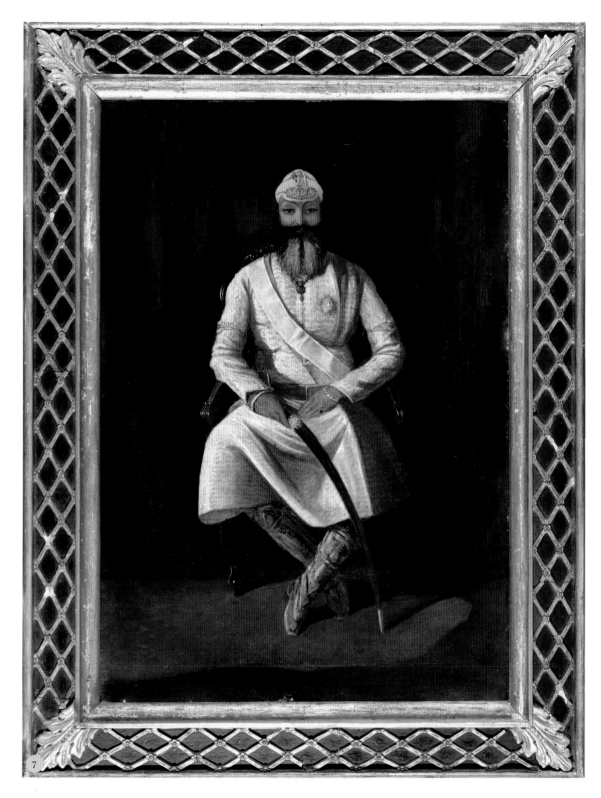

6. Maharaja Karam Singh

Emily Eden | 1839 | 22 x 17.5 in |
Hand-colored lithograph

7. Maharaja Narinder Singh

George Landseer | *c.* 1862 |
30 x 23 in | Oil on canvas

Narinder Singh, who is known
for his major contributions to the
development of Patiala, is depicted
here sitting in full regalia.

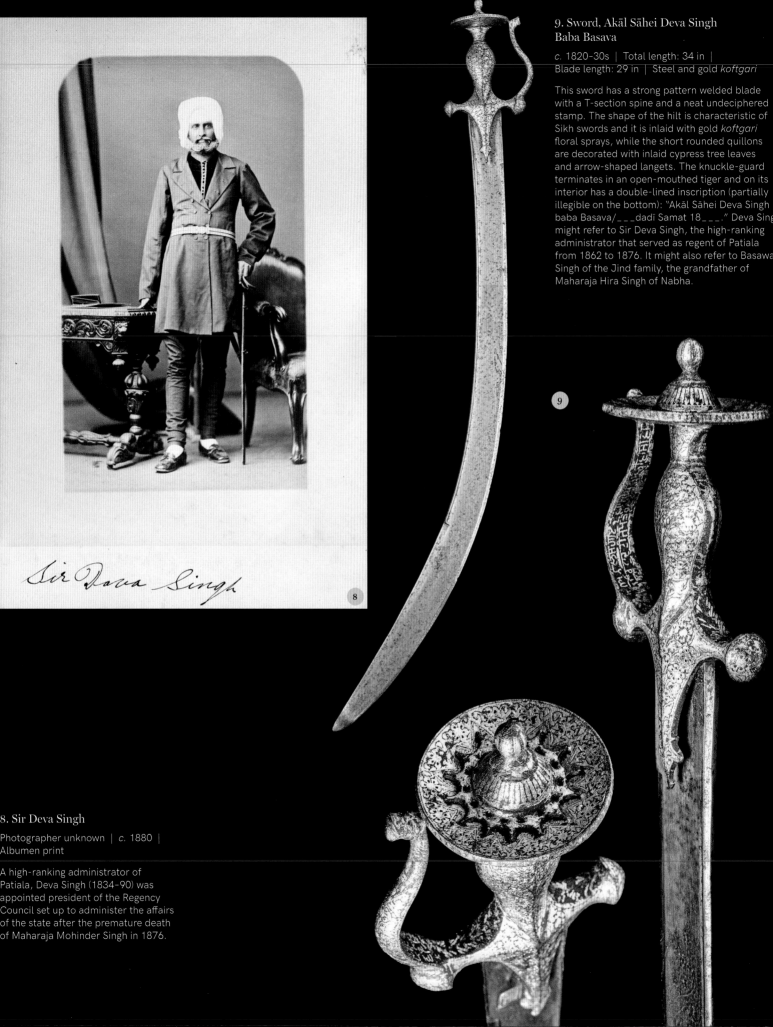

9. Sword, Akāl Sāhei Deva Singh Baba Basava

c. 1820–30s | Total length: 34 in |
Blade length: 29 in | Steel and gold *koftgari*

This sword has a strong pattern welded blade with a T-section spine and a neat undeciphered stamp. The shape of the hilt is characteristic of Sikh swords and it is inlaid with gold *koftgari* floral sprays, while the short rounded quillons are decorated with inlaid cypress tree leaves and arrow-shaped langets. The knuckle-guard terminates in an open-mouthed tiger and on its interior has a double-lined inscription (partially illegible on the bottom): "Akāl Sāhei Deva Singh baba Basava/___dadī Samat 18___." Deva Sing might refer to Sir Deva Singh, the high-ranking administrator that served as regent of Patiala from 1862 to 1876. It might also refer to Basawa Singh of the Jind family, the grandfather of Maharaja Hira Singh of Nabha.

8. Sir Deva Singh

Photographer unknown | *c.* 1880 |
Albumen print

A high-ranking administrator of Patiala, Deva Singh (1834–90) was appointed president of the Regency Council set up to administer the affairs of the state after the premature death of Maharaja Mohinder Singh in 1876.

285

10. Maharaja Mohinder Singh in full state regalia

Photographer unknown | *c.* 1874 | 13 x 10 in | Albumen print

11. Maharaja Rajinder Singh (left)

Photographer unknown | *c.* Late 19th century | 12 x 9 in | Albumen print

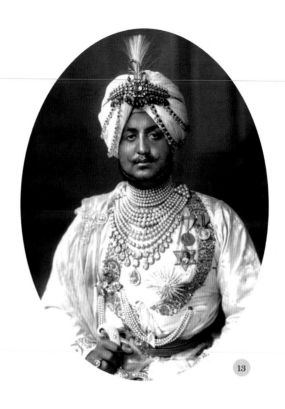

12. Maharaja Bhupinder Singh as a young boy

Photographer unknown | *c.* Late 19th century | 5.5 x 4 in | Albumen print

13. Maharaja Bhupinder Singh

Carl Vandyk | 1912 | 11 x 8.6 in | Albumen print | Signed by Bhupinder Singh

14. Royal Elephant of Maharaja Bhupinder Singh

Photographer unknown | 1903 | 7.4 x 11.2 in | Albumen print

A bedecked elephant belonging to the eleven-year-old Maharaja Bhupinder Singh of Patiala, paying homage to the Emperor of India, King Edward VII.

286

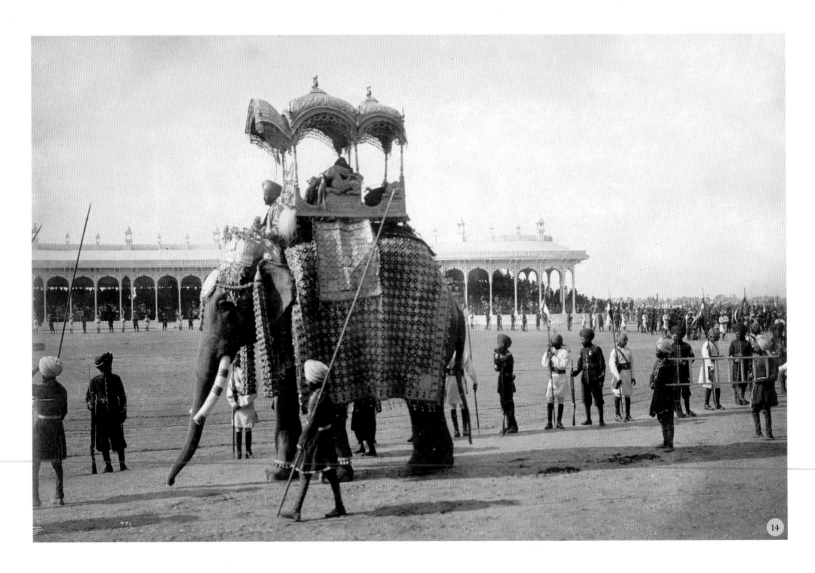

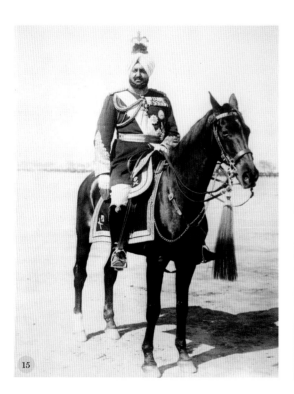

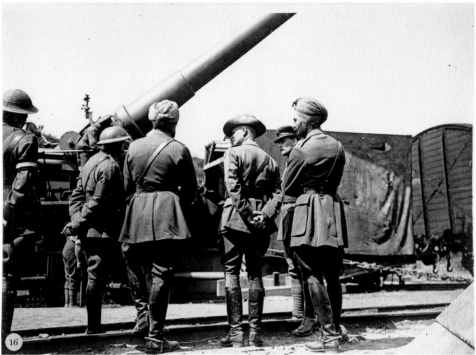

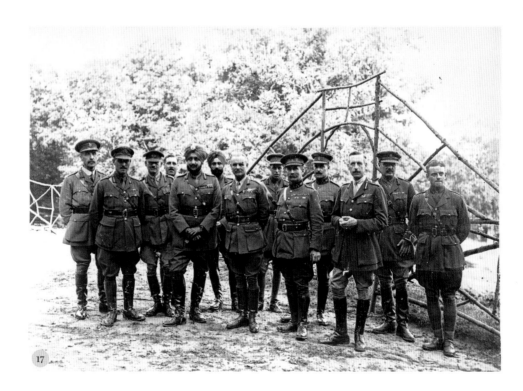

15. Maharaja Bhupinder Singh on horseback inspecting state troops, during a visit from the Prince of Wales to Patiala in February 1922

Photographer unknown | 1922 | 8.2 x 6.35 in | Albumen print

16. Maharaja Bhupinder Singh visiting troops during the First World War

Photographer unknown | c. 1914–18 | 6 x 8 in | Albumen print

17. Maharaja Bhupinder Singh with Col W.R. Birdwood, GOC-in-C, 5th Army on the Western Front

Photographer unknown | 1918 | 6 x 8 in | Albumen print

PRESENTED TO MAJ. GENERAL
H.H. MAHARAJA SIR BHUPENDAR SINGH
MAHINDER BAHADUR, G.C.I.E., G.B.E., OF PATIALA
BY HIS BROTHER RULING PRINCES
ON HIS SUCCESSFUL AND SAFE RETURN HOME
AFTER PARTICIPATION IN THE IMPERIAL WAR CONFERENCE
1918

18. Sword, Maharaja Bhupinder Singh

1918 | Total length: 37 in |
Blade length: 33 in | Steel and gold

This sword, with a hilt in solid 17-carat gold, has the coat of arms of the royal family of Patiala, which along with two other princely states, was accorded a 21-gun salute, the highest form of gun salute that could be accorded to a state during the British rule. The coat of arms is in gold with enamel work. This sword was presented by the Chamber of Princes to HH The Maharaja of Patiala Bhupinder Singh.

18

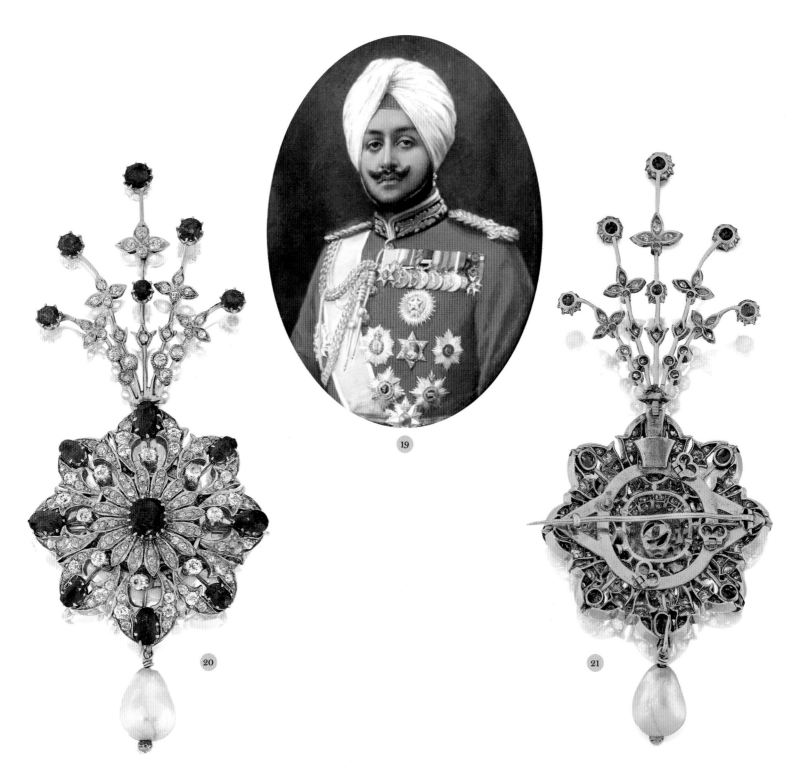

19. Maharaja Bhupinder Singh

Artist unknown | Early 20th
century | 5.5 x 3.1 in |
Painting on ivory

20-21. *Sarpech* (front and back)

c. 1910 | Gold and precious stones

A diamond- and ruby-set gold
sarpech, formerly the property of
Maharaja Bhupinder Singh, set with
133 diamonds, fifteen Burmese rubies,
and a large natural pearl.

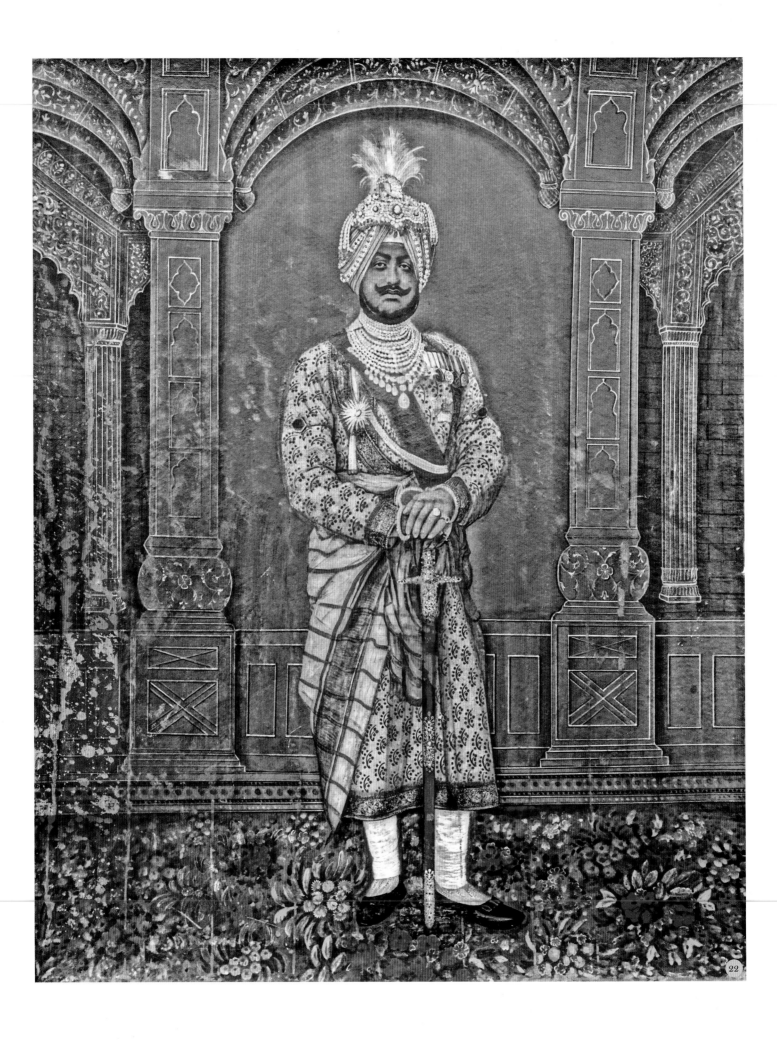

22

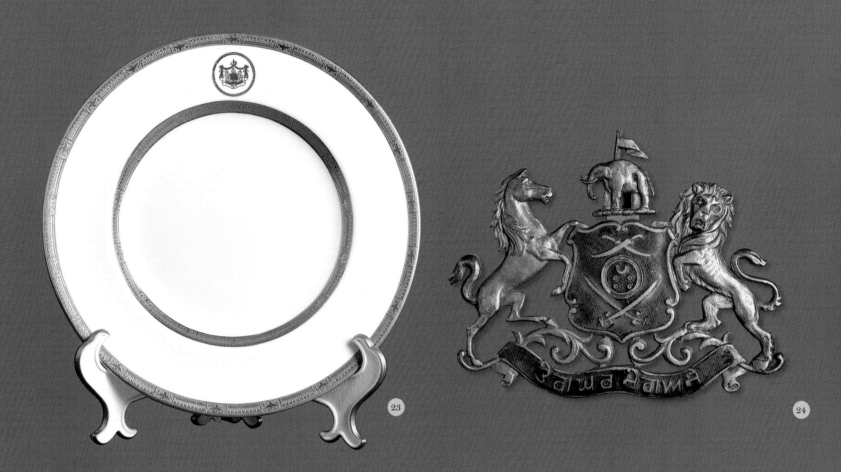

22. A portrait of Maharaja Bhupinder Singh

1910 | 30 x 24 in | Oil on board

23. Dining plate, Patiala royal family

20th century | D: 9.5 in | Ceramics

This plate is part of a set of four Royal Worcester Porcelain dinner service plates, made in England. It is in cream and white with gilt bands on the edges and raised neoclassical designs containing the arms of Patiala rulers.

24. Crest of Patiala State

c. 1925-30 | 2.7 x 2.4 in | Metalworks

Designed by Spink & Sons, the crest shows a horse, a lion, elephant, crossed swords complete with a shield. The blue enamel inlay with Gurmukhi text reads, *Tera Ghar Mera Assay* (your home is my refuge).

25. Commemorative first-day cover celebrating the 300th anniversary of 15 Punjab (Patiala)

2005 | 4.2 x 7.8 in

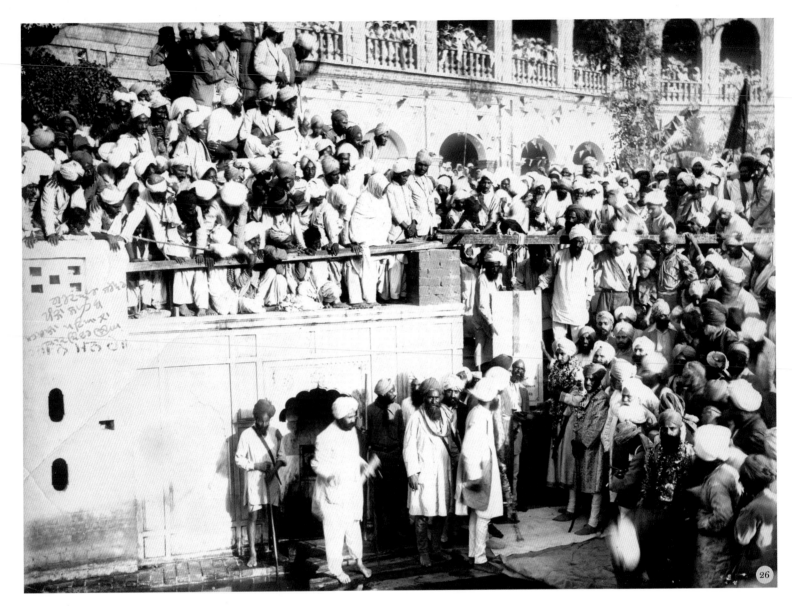

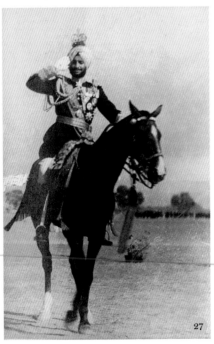

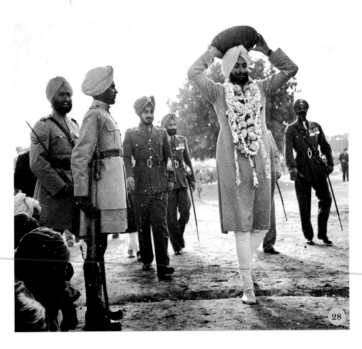

26. Maharaja Yadavindra Singh at Gurdwara Punja Sahib, Hasan Abdal (now in Pakistan)

Photographer unknown |
c. 1930–40s | 8.5 x 11.5 in |
Albumen print

27. Maharaja Yadavindra Singh, riding a horse during a state visit

Photographer unknown | 1940 |
10 x 6.75 in | Albumen print

28. Maharaja Yadavindra Singh at Fatehgarh Sahib

Photographer unknown | c. 1945 |
8.2 x 6.2 in | Albumen print

A rare picture of the maharaja laying the foundation of Gurdwara Fatehgarh Sahib, by carrying the first basket of earth for the building of the shrine. This was the site where the two younger sons of the tenth guru, Guru Gobind Singh, were martyred.

NABHA

One of the Phulkian states in the Punjab, Nabha was founded in 1763 and was the second largest of the Cis-Sutlej states.

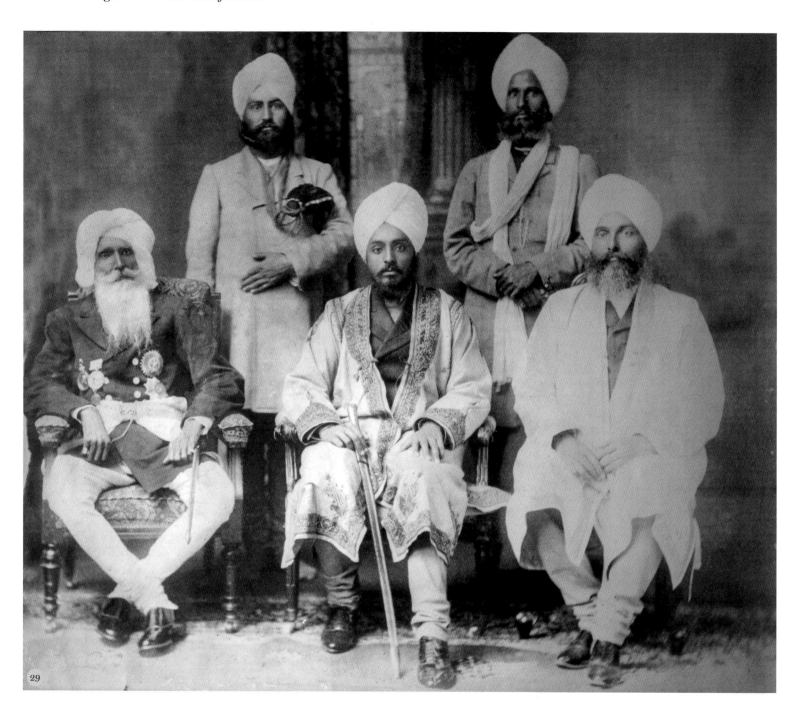

29. (Seated from left to right) Maharaja Hira Singh,
Tikka Ripudaman Singh, and Bhai Kahn Singh

Photographer unknown | *c*. Late 19th/early 20th century |
15.5 x 18.5 in | Albumen print

Maharaja Ripudaman Singh was one of the leaders in the reform movement among the Sikhs. He sponsored the Anand Marriage Act and worked towards the legislation for the management of Sikh gurdwaras. Bhai Kahn Singh was one of the towering intellectuals of the nineteenth century, whose writings and actions had a profound influence on the people of Punjab and played a major role in shaping the Sikh identity during his time.

294

30. Maharaja Bhagwan Singh

Photographer unknown | *c.* 1860s |
5.5 x 4 in | Albumen print

31. Maharaja Hira Singh in full state regalia

Bourne and Shepherd | *c.* 1880s |
5.8 x 4.4 in | Albumen print

32. Maharaja Hira Singh seated on a gilded throne with his legs resting on a footstool

Photographer unknown |
c. 1903 | 5.5 x 4 in |
Albumen print laid on a card

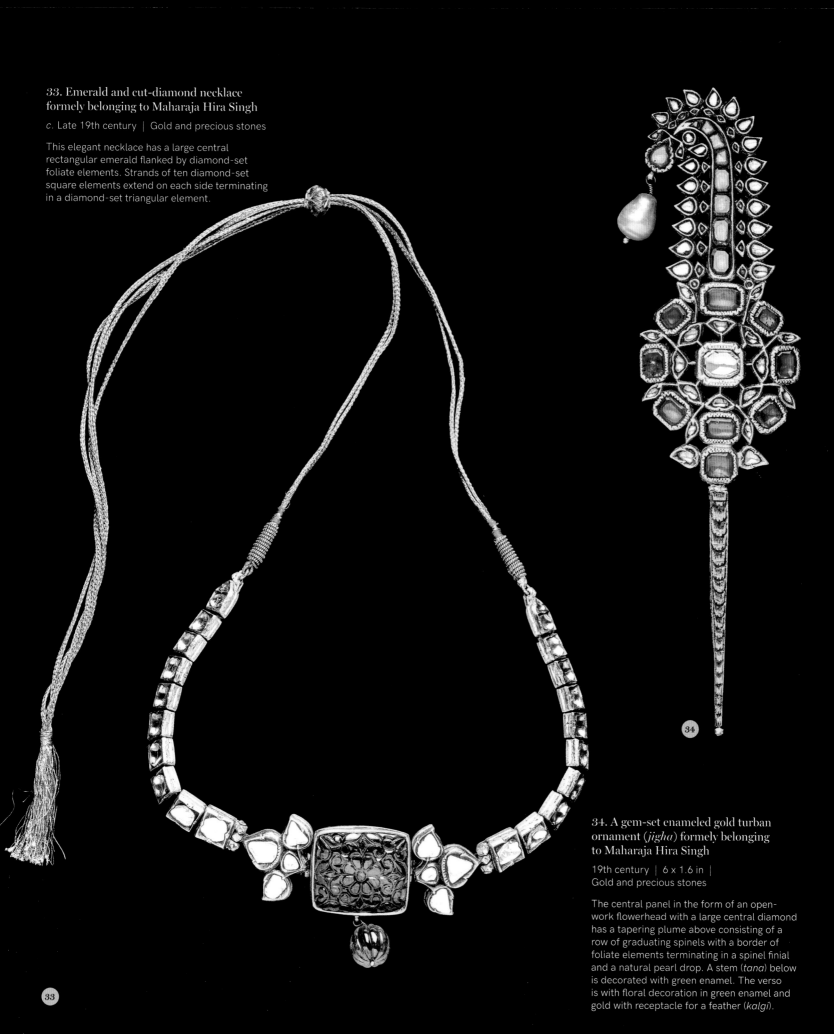

33. Emerald and cut-diamond necklace formely belonging to Maharaja Hira Singh

c. Late 19th century | Gold and precious stones

This elegant necklace has a large central rectangular emerald flanked by diamond-set foliate elements. Strands of ten diamond-set square elements extend on each side terminating in a diamond-set triangular element.

33

34. A gem-set enameled gold turban ornament (*jigha*) formely belonging to Maharaja Hira Singh

19th century | 6 x 1.6 in | Gold and precious stones

The central panel in the form of an open-work flowerhead with a large central diamond has a tapering plume above consisting of a row of graduating spinels with a border of foliate elements terminating in a spinel finial and a natural pearl drop. A stem (*tana*) below is decorated with green enamel. The verso is with floral decoration in green enamel and gold with receptacle for a feather (*kalgi*).

34

JIND

The princely state of Jind was founded in 1793 by Gajpat Singh, great-grandson of Choudhary Phul, leader of the Phulkian Misl.

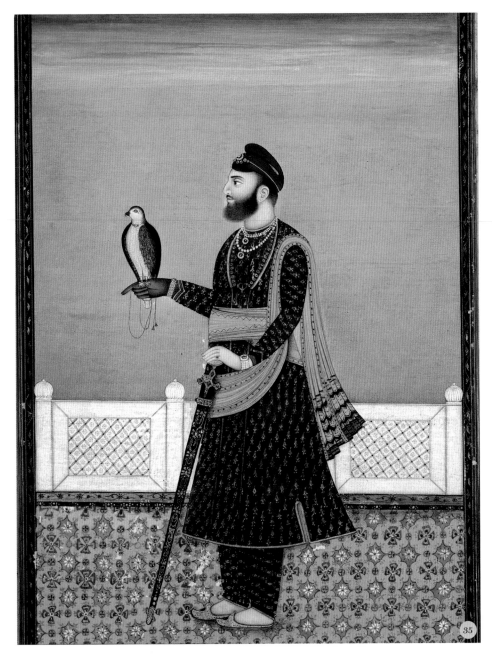

35. Raja Sangat Singh

Artist unknown | *c.* 1820–30s |
14.5 x 9 in | Gouache on paper

Wearing a crimson cloak (*jama*) and matching turban, the raja is standing with a hawk resting on his right hand and supporting a straight sword with the left hand.

36. Raja Ranbir Singh

Photographer unknown | Early 20th century | 11.2 x 9 in | Albumen print

37. Raja of Jind with family and guests

Photographer unknown |
Early 20th century | 11.5 x 8.25 in |
Albumen print

38. Wedding of heir apparent, Jind

Photographer unknown |
Early 20th century |
8.5 x 11.5 in | Albumen print

Shri Yuvraj Singh accompanied by Shri Raja Kumar Sahib and Their Highnesses the Maharaja of Patiala and Raja of Jind returning from Sehra Bandi Durbar.

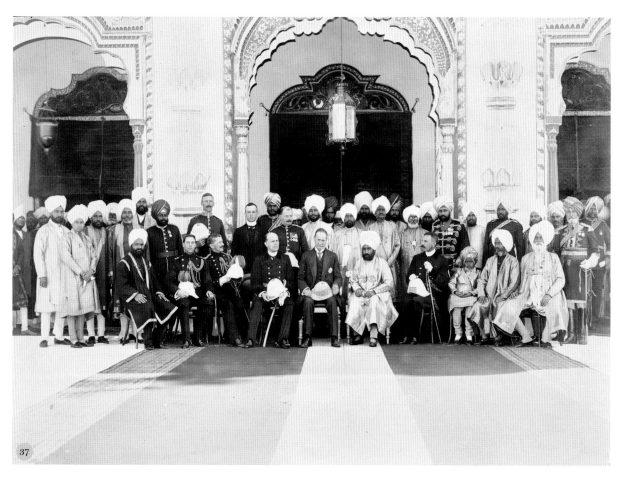

37

297

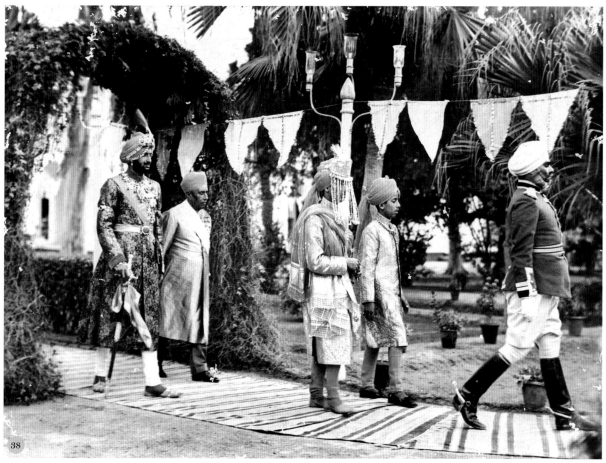

38

KAPURTHALA

The princely state of Kapurthala was ruled by Ahluwalia rulers. Its founder, Sardar Jassa Singh Ahluwalia, was also the leader of Dal Khalsa and guided the formation of Sikh *misls*.

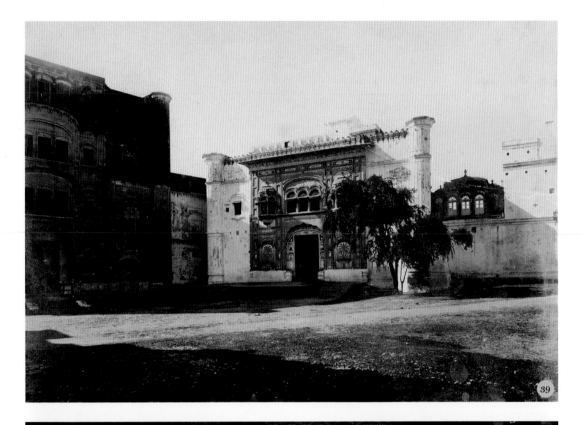

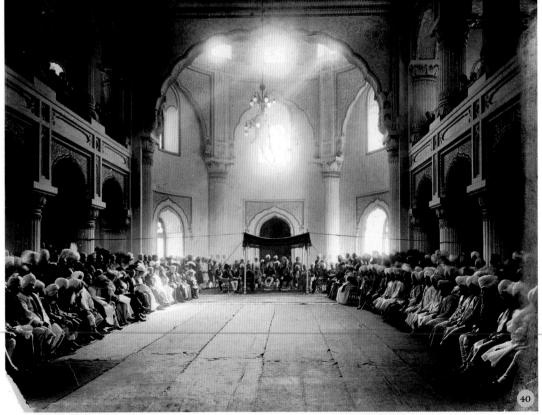

39. Jalau-Khana (Old Palace), Kapurthala

Photographer unknown | Early 20th century | 8.5 x 11 in | Albumen print

40. *Haveli* of Jassa Singh Ahluwalia, Kapurthala

Photographer unknown | Early 20th century | 8.75 x 11.5 in | Albumen print

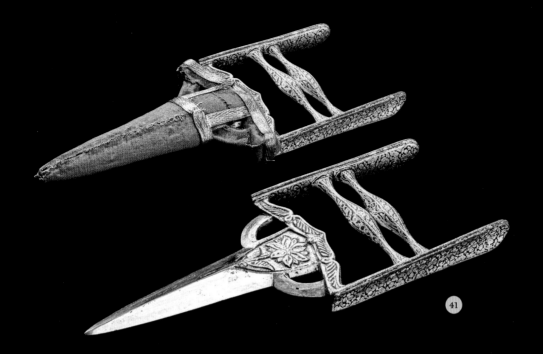

41. *Katar*, Raja Nihal Singh, Kapurthala

Mid-19th century | 9.5 in | Steel and gold *koftgari*

This unique *katar* is a piece of art. The *koftgari* floral patterns are beautifully organized between lines on the grips, just as on the grip of a *tulwar*. The triangular blade has an exaggerated armour piercing point with a chiseled flower at the base. The heel of the blade is set with two curved blades on either side, perhaps attempting to resemble a quoit.

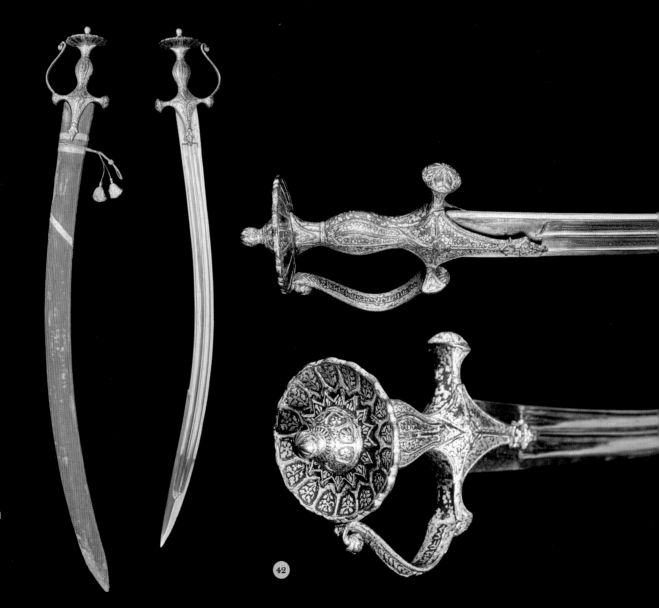

42. Sword, Raja Nihal Singh, Kapurthala

c. Mid-19th century | 32 in | Steel with gold and silver braid

The *tulwar* and *katar* scabbards are covered in red silk velvet and finished with gold and silver braid in a chevron design. The *tulwar* has a highly unusual blade with two recessed panels and an armour piercing tip. The knuckle guard terminating in a drooping acorn is inscribed on the interior in Gurmukhi: "Akāl Sāh Nehāl Si(n)gh Samat 18xx."

43. Maharaja Jagatjit Singh of Kapurthala as a young boy

Photographer unknown | Late 19th century | 5.5 x 4 in | Albumen print

Jagatjit Singh Sahib Bahadur (1872–1949) was the ruling maharaja of the princely state of Kapurthala in the British Empire of India from 1877 until India's independence in 1947.

44. Kapurthala princes

Photographer unknown | c. 1905–06 | 6.4 x 10.2 in | Albumen print

Prince Tika Paramjit of Kapurthala seated in center with his brothers Prince Mahjit (behind him), and Prince Karamjit (on the right) at the Chateau, Mussoorie.

45. Elysee Palace, Kapurthala

Photographer unknown | *c.* 1897 |
6 x 8.25 in | Albumen print

Rani Kanari, wife of Maharaja Jagatjit
Singh on a carriage outside the Elysee
Palace, Kapurthala. Built in 1862, it
was the official residence of Maharaja
Jagatjit Singh's Indian wives.

46. Maharani Brinda Devi of Kapurthala, wearing the famed half-moon jewel

Signed photograph; photographer
unknown | Early 20th century |
7.5 x 5.8 in | Albumen print

OTHER PRINCELY STATES

Kalsia was founded by Gurbaksh Singh Sandhu in 1760.

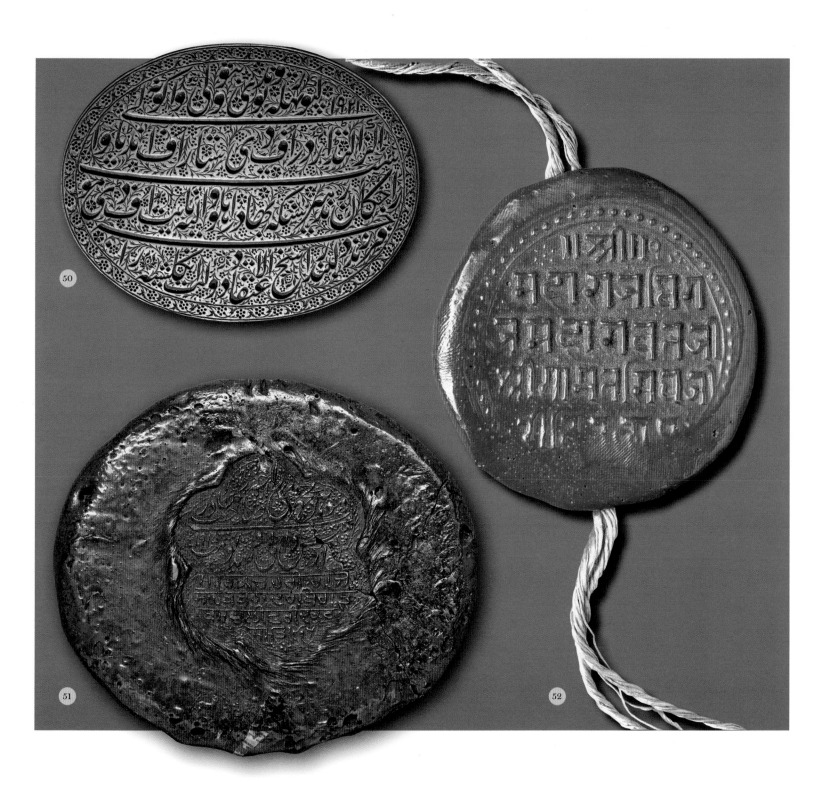

47. Raja Ravi Sher Singh of Kalsia (third from left) with Governor William Malcolm Hailey (fourth from left)

Photographer unknown | c. 1928 | 8.6 x 11.25 in | Albumen print

48. Royalties of Punjab

Photographer unknown | Late 19th century | 5.5 x 4 in | Albumen print

49. Royalties of Punjab

Photographer unknown | Late 19th century | 5.5 x 4 in | Albumen print

50. A silver seal made for Raja Randhir Singh of Kapurthala

c. 1864–65 | 3 x 4 in | Silver

Engraved with four lines of inscriptions in Nastaliq on a ground of scrolling tendrils issuing lotuses and other flowers, the seal has a border with an undulating floral vine.

51. A rare Sikh seal of the Raja of Faridkot in Gurmukhi and Farsi

19th century | 3.5 x 4 in

52. A circular wax seal of a Raja of Jind, moulded with inscription in Nagari

19th century | D: 2 in

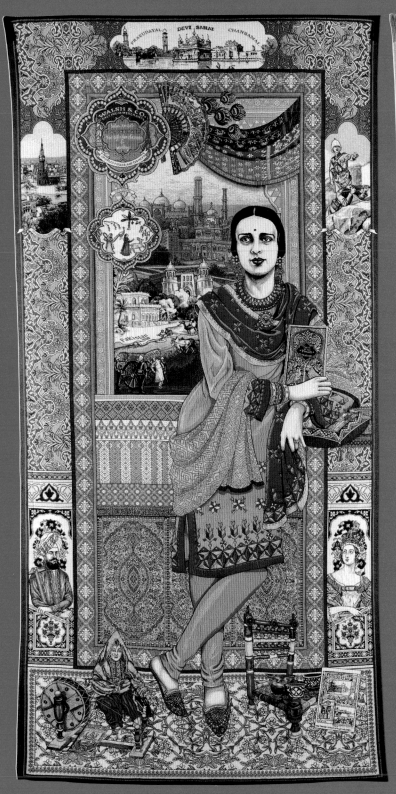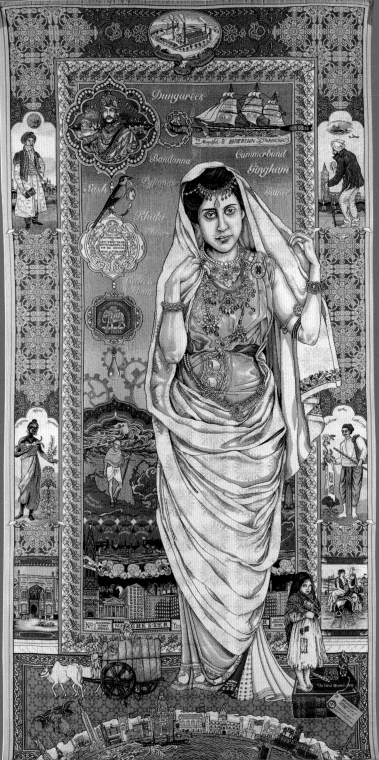

8 EMBROIDERED AND WOVEN MASTERPIECES: TEXTILE TRADITIONS OF GREATER PUNJAB

"A *BAGH*...WOULD TAKE SEVERAL YEARS TO COMPLETE AND WAS EMBROIDERED WITH SPECIAL CARE TO BE USED LATER AT THE GRANDCHILD'S WEDDING, AFTER WHICH IT WOULD BE KEPT AS A FAMILY TREASURE."[1]

John Gillow and Nicholas Barnard, *Indian Textiles*

Punjab has a rich history of textiles, which are homespun and rooted in the indigenous rural culture of the region. If we extend our view to greater Punjab, which at one time included Kashmir, Ladakh, Kangra, and the northwestern regions adjoining Afghanistan, we can add many other categories to the list of local textile traditions. In this chapter, however, we discuss only some examples of textiles which have a fair representation in the Khanuja Family Collection. The number of samples we present in the following pages is limited, but we hope to show the full collection in a separate manuscript to be published in the near future.

PHULKARIS

Among the many textile traditions that have flourished in Punjab, *phulkari* is one of the most sought after. Though the word *phulkari* means "floral work," the designs include not only flowers but also other motifs and geometrical shapes. The main characteristics of *phulkari* embroidery is the use of darn stitch on a coarse cotton cloth with colored silken thread. While in classical *phulkari* some of the cloth parts are visible, in *bagh* the embroidery covers the entire garment so that its base is not visible.

There are deep cultural and emotional bonds associated with *phulkari*. As Anu H. Gupta and Shalina Mehta have observed, "phulkari was a quintessential part of [a] young woman's trousseau."[2] In earlier times, after the birth of a girl, mothers and grandmothers would start embroidering *baghs* and *phulkaris*, which were to be given to the new-born when she became a bride. In the afternoon, while the men were in the fields, women would gather, and along with other social activities, would work on this kind of embroidery. Usually, each one of them would stitch their own *phulkaris* and train their daughters in this activity. This was a prime example of communal bonding that helped to create everlasting memories. It was a common scene prior to the Indian subcontinent partition of 1947, but unfortunately, it has become more uncommon in contemporary times. As S.S. Hitkari, a textile scholar, noted,

> To the household lady, embroidering Baghs and Phulkaris not only afforded an opportunity for self-expression and an outlet for her abundant energy, but also provided her with something which [she] could use both as a shawl in winters and personal decoration on the occasions of marriages and festivals.[2]

1. Slaves of Fashion

© The Singh Twins | Craft and Conflict Tapestry (Slaves of Fashion series) 2017 | 88.5 x 44.3 in | Cotton

Left: Central to the artwork is a portrait of Amrita Sher-Gil who is hailed as one of the most celebrated Indian artists of the twentieth century.

Right: This artwork explores key social, political, economic, technological and cultural changes linked to the Indo-British story of cotton. Central to the composition is a portrait of Princess Sophia Duleep Singh whose personal heritage, life, and family history connect to the complex narrative of cotton, as part of the wider story of Indian textiles, exploitation, and the Sikh Empire.

305

TYPES OF INDIAN WOMEN. No. 3. JAT SIKH WOMEN OF PUNJAB. SPINNING COTTON.

Phulkaris were embroidered by all communities in Punjab, although some specific patterns are known to be from certain regions of Punjab.

The *phulkari* textile tradition includes different categories. One of them is the *chope*, which is embroidered on a red base with yellow threads. The only motifs embellished on both the edges are a series of triangles with the base towards the border and the top pointing inwards. Maternal grandmothers embroidered *chopes* as a labor of love on the occasion of a granddaughter's birth and gifted the cloth to them when they got married.

Among other forms of *phulkari*, there is *darshan dwar*, which refers to a gate from where one can see the Divine. A woman would embroider this kind of *bagh* as a garment to be worn when visiting a religious place. *Darshan dwars* were always embroidered on a red-colored base cloth. Human figures, plants, animals, birds, and flower motifs were commonly used. The *phulkari* known as *sainchi*, a specialty of the Malwa region, were decorated with embroidered motifs derived from the rural life of Punjab as well as with human figures, animals, and birds. *Phulkaris* embroidered on a white-colored base cloth were called *thirma* and were symbols of purity, usually worn by older women and widows.

Another variety of *phulkari* that requires significant expertise is the *bawan bagh* (the word *bawan* means "fifty-two"). In this kind of *bagh*, the base cloth was divided into boxes – sometimes fifty-two, although most had fewer boxes – and each of them were embroidered with different designs and bright colors. Another unusual textile we describe here is *chand bagh* (moon garden) constituted of shimmering white silk stitches floating against a dark background.

The production of traditional *baghs* and *phulkaris* became less common after the Partition, due in part to the breakdown of the social life of local communities and the political and economic

2. Women spinning cotton
Early 1900s | 3.5 x 7 in

3. Women in Punjab create innumerable alluring and interesting designs and patterns by their skillful manipulation of the darn stitch creating *phulkaris* and *baghs*
Arpana Caur | 2020 | 69 x 37 in | Oil on canvas

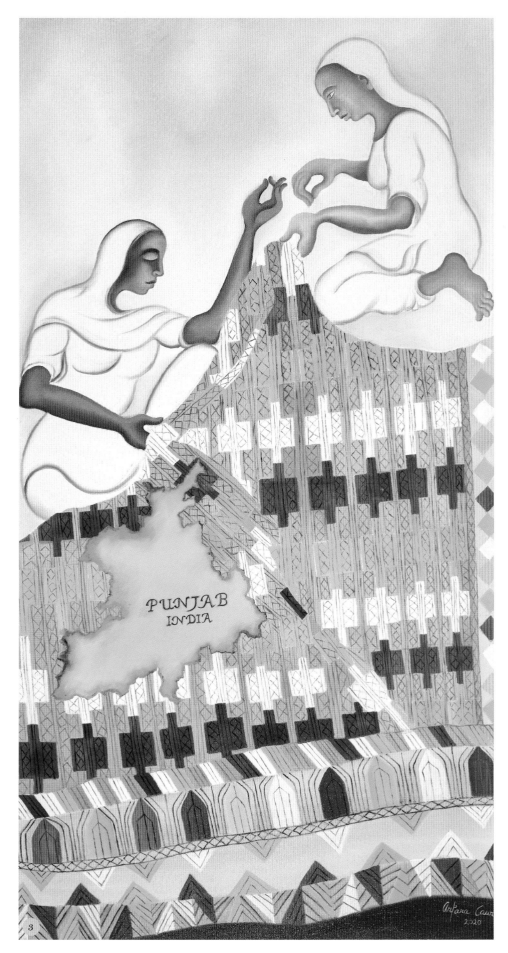

instability that followed, causing the loss of a great cultural tradition. Stressing the importance of *phulkari*, Cristin McKnight Sethi writes,

> some phulkaris have remained in Punjabi families and are cherished heirlooms objects, passed from one generation to the next. For many families, they are potent symbols of womanhood, of the connections between families during the important occasion of marriage, and of Punjabi identity.[3]

RUMALS

Embroidered handicrafts from Punjab and its neighboring regions include a range of *rumals* or handkerchiefs. One example is the *chamba rumal*, embroidered handicrafts made in the shapes of square and rectangle using very fine handmade silk. It was used as a ceremonial cover or gift offering. In B.N. Goswamy's words, "every single theme that one's eyes alight upon these wonderful rumals recalls to ones's mind some Pahari painting or the other one has seen Krishna dancing his eternal rasa with gopis, Rukmini's wedding..."[4] The tradition of *rumal* originated in the early eighteenth century and Chamba as well as the areas surrounding it were involved in the production of these embroidered textiles that radiated unending charm and simplicity. Textile scholars John Gillow and Nicholas Barnard explain, "When an offering was made to temple gods or gifts exchanged between the families of a bride and groom, an embroidered rumal was always used as wrapping."[5]

Another type of *rumal* is the *rumalla sahib*, a square or rectangular piece of silk used to cover the Sri Guru Granth Sahib. *Rumalla sahibs* are sometimes brought as gifts by the devotees especially on important private occasions or religious days. The ones we present here are likely from the late nineteenth or early twentieth century. A particularly unusual one depicts Guru Gobind Singh with Panj Piyaras (the five beloved ones) and it is stitched with metallic threading. There is another depicting the ten gurus with Bhai Bala holding a fly whisk and Bhai Mardana holding his *rabab*. The gurus on this textile are depicted with East Asian facial features, a fact suggesting that this piece was likely produced by Chinese craftsmen in a style called *chini kalam*.

KASHMIR SHAWLS

Kashmir shawls have had the most commercial usage out of all the textiles produced in the region. These woven shawls were produced in Kashmir and, according to tradition, the founder of the industry was Zayn-ul-ābidīn, a fifteenth-century ruler of Kashmir who introduced weavers from Turkistan. Kashmir shawls are woven partly or wholly from goat hair called *pashm* found in the high-altitude plateaus of Tibet and Ladakh. As John Irvin has noted, "worn by Indians as a shoulder-mantle, the shawl was essentially a male garment."[6] The technique of twill tapestry was laborious and time-consuming. One shawl could take months to be woven and it required multiple specialists, the most critical ones being the *naqqash* (pattern maker), the *tarah guru* (color caller), and the *talim guru* (pattern master). Some of the pieces were spun separately and a *rafugar* (darner) brought them together in fine stitching, usually not visible to the naked eye. Although most were made in Kashmir, over time centers developed in other areas such as Lahore, Amritsar, and Ludhiana. But due to the inability to get similar *pashm*, the quality of the shawls was not as good.

Frank Ames has classified Kashmir shawls into four distinctive periods: Mughals, Afghans, Sikh, and Dogra, highlighting the stylistic changes that took place during these reigns. For instance, the earliest shawls of which fragments survive had the end border with free-spaced flowering plants. During the early eighteenth century, the flowerings increased and took on vase-like shapes called *buta*. During the Afghan period, the *buta* became more rigid and vase shaped with a sharp curvature and repetitions. The style of Kashmir shawls changed dramatically during the Sikh period, which saw a break from conservative patterns. As Ames explains, Kashmir shawls' "unleashed exuberance of playful geometry or arches, and circles, suffuses these graphic swirls with a kinetic energy that cannot help but evoke feelings of mysticism and awe."[7] These shawls where primarily made for the local nobility but were also exported to Russia, Persia, and Europe (France in particular). It is a well-known fact that Ranjit Singh's French generals were exporting shawls to France. As Ames notes,

> The Sikhs took control of Kashmir in 1819 and soon after, a dramatically new shawl fashion developed in three ways. First, the pattern began taking over a significant portion of the shawl's surface, causing the palla height to be greatly enlarged. Secondly, freely spaced designs were mostly eliminated in favor of dense and tightly packed floral arrangements – a style that adhered to horror vacui mindset. Thirdly, a particular style, based on symbols and geometry than natural flowers, evolved.[8]

During this time, embroidered shawls called *amlikars* with intricate needlework on plain pashmina consisting of minute and elaborate patterns also started becoming popular.

Maharaja Ranjit Singh had an immense collection of Kashmir shawls which he presented to visiting dignitaries as robes of honor. Following his visit to Maharaja Ranjit Singh in 1838, William G. Osborne recorded the following, "The floor was covered with rich shawl carpets, and gorgeous shawl canopy, embroidered with gold and precious stones, supported on golden pillars, covered three parts of the hall."[9]

The great innovations of the Dogra period were the *dorukha shawls*, which appeared in 1860s. These present a unique combination of twill-tapestry weave and embroidery that created a double-sided wrap with different designs and colors.

In the following pages we introduce a few of the shawls in the Khanuja Family Collection from the early eighteenth to the late nineteenth century. The shawl belonging to Emily Hardinge, the governor-general's wife, woven in 1846, deserves a special mention for its beauty and unique decorations.

308

4. Workshop for weaving Kashmiri shawls

Attributed to Bishan Singh | 1866 | 12.2 x 20 in | Opaque pigments heightened with gold on paper

This painting of weavers was most likely commissioned by the French East India company to be exhibited at the Paris Universal Exhibition of 1867.

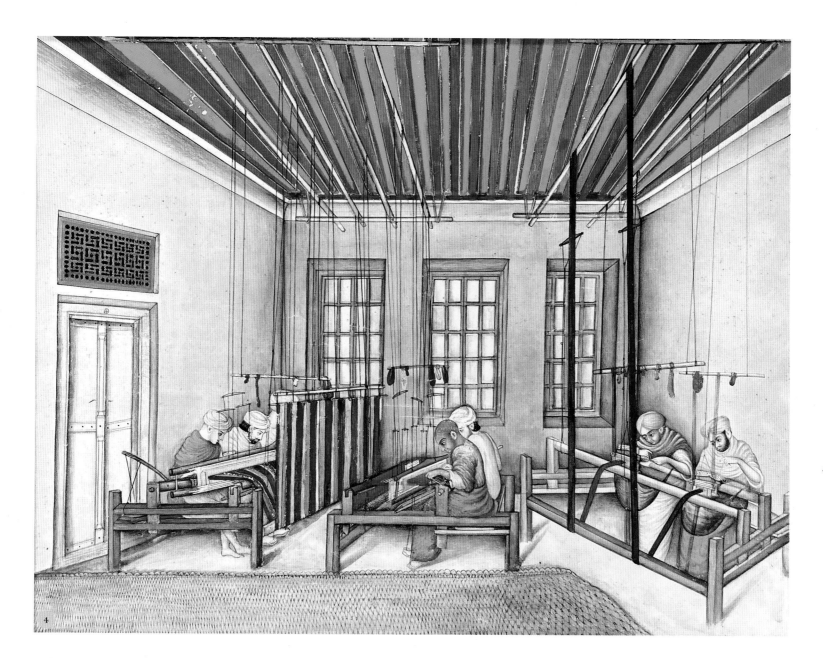

309

REFERENCES & NOTES

1. J. Gillow and N. Barnard, *Indian Textiles* (London: Thames & Hudson, 2008), 150.

2. A.H. Gupta and S. Mehta, *Phulkari from Punjab* (New Delhi: Niyogi Books, 2019), 7.

3. S.S. Hitkari, *Phulkari: The Folk Art of Punjab* (New Delhi: Punjab Press, 1980), 38.

4. C.M. Sethi, *Phulkari: The Embroidered Textiles of Punjab* (Philadelphia: Philadelphia Museum of Art, 2016), 32.

5. B.N. Goswamy, *Piety and Splendour: Sikh Heritage in Art* (New Delhi National Museum, 2000), 227.

6. J. Gillow and N. Barnard, *Indian Textiles* (London: Thames & Hudson, 2008), 158.

7. J. Irwin, *The Kashmir Shawl* (London: Her Majesty's Stationery Office, 1973), 1.

8. F. Ames, *Woven Masterpieces of Sikh Heritage: The Stylistic Development of the Kashmir Shawl under Maharaja Ranjit Singh 1780–1839* (London: Antique Collector's Club, 2010), 69.

9. *Ibid*, 155.

10. W.G. Osborne, *Court and Camp of Ranjeet Singh* (London: Henry Colburn, 1840), 72.

*We thank Frank Ames for helping us with captions to most of the Kashmir shawls.

PHULKARI

Literally meaning "floral work" or "working with flowers," *phulkari* is one of the most popular embroidery techniques of Punjab.

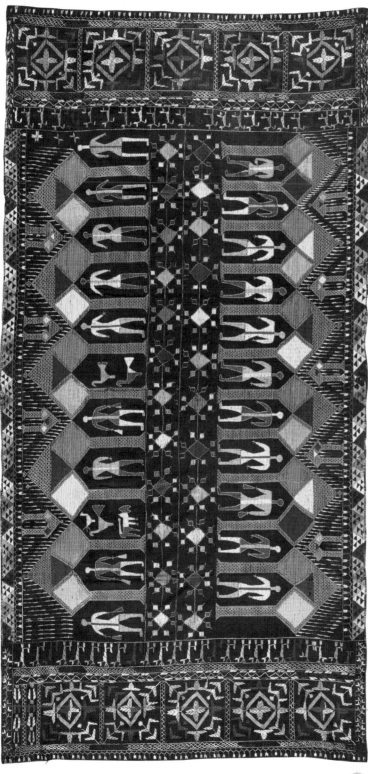

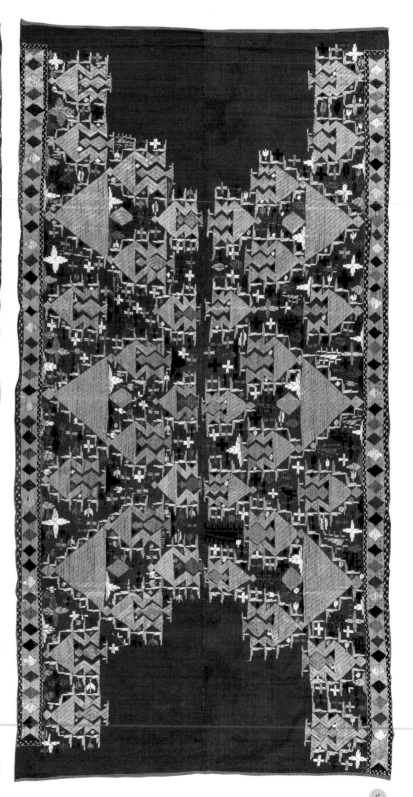

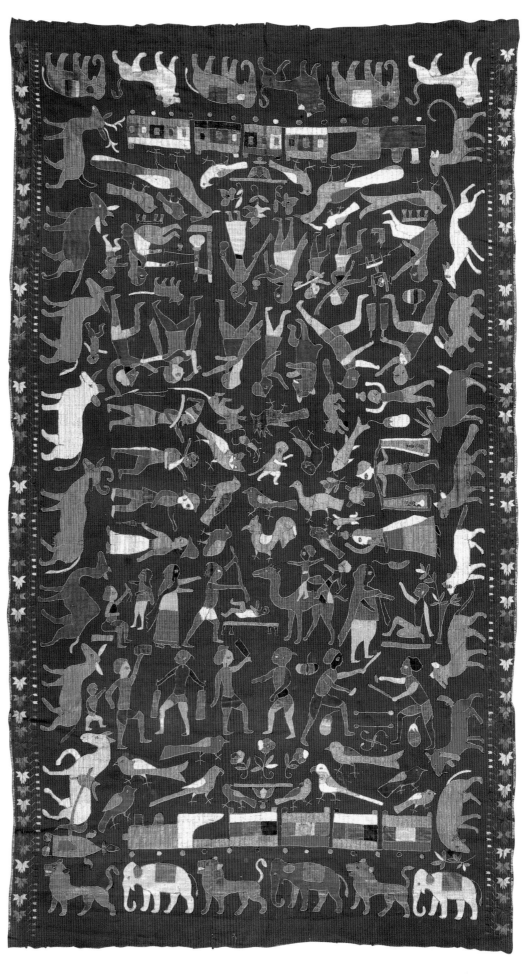

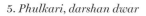

5. *Phulkari, darshan dwar*

East Punjab | *c.* Early 20th century |
79.9 x 47.6 in | Silk floss on plain
weave cotton

The *phulkari* features motifs with
humans in doorways, peacocks,
animals, and plants.

6. *Sarpallu phulkari*

Punjab | *c.* Early to mid-20th century |
85 x 43.25 in | Silk floss and cotton
thread on plain weave cotton

Most likely a wedding shawl in the
auspicious colors of red and yellow,
with forms appearing like triangular
armlets.

7. *Phulkari, sainchi* (and detail)

East Punjab | *c.* Early to mid-20th
century | 92.5 x 52 in | Silk floss on
plain weave cotton

This *phulkari* has motifs with animals,
entertainers, and women busy in their
domestic activities.

312

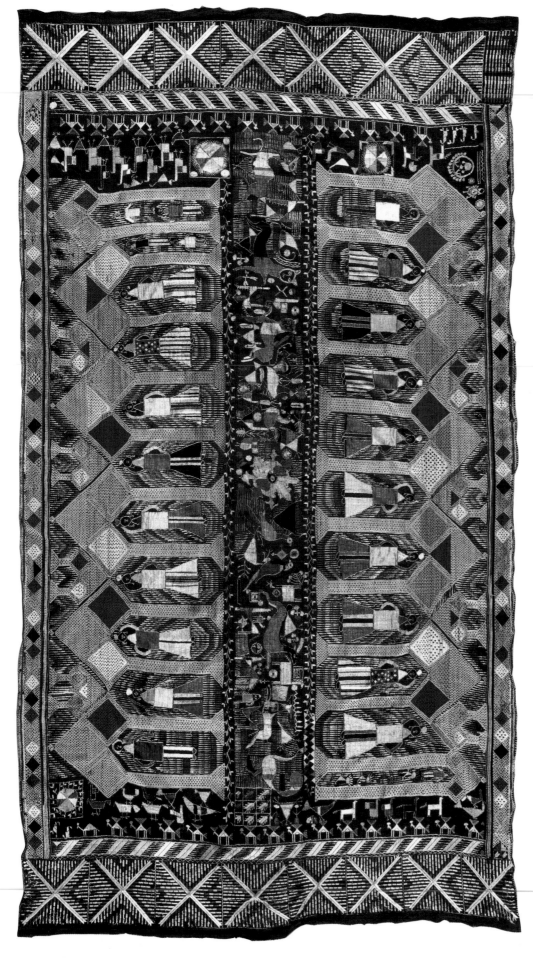

8

8. *Phulkari, darshan dwar* (and details)

East Punjab | *c.* Early to mid-20th century | 92 x 52.5 in | Silk floss on plain weave cotton

The artist of this *darshan dwar* depicted several male and female figures standing in and around large architectural forms that resemble doorways (*dwar*). The male figures appear dressed in brightly-colored turbans, while the female figures wear earrings, long striped skirts, and balance vessels on their heads.

9. *Phulkari, ghunghat* (veil)

Punjab | *c.* Early to mid-20th century | 90 x 53 in | Silk floss on plain weave cotton

This shawl, used as a *ghungat* (veil) has an unusual triangular design embroidered in the center of the right side of the width. This triangle usually rests on a woman's forehead and can be pulled down to cover the face.

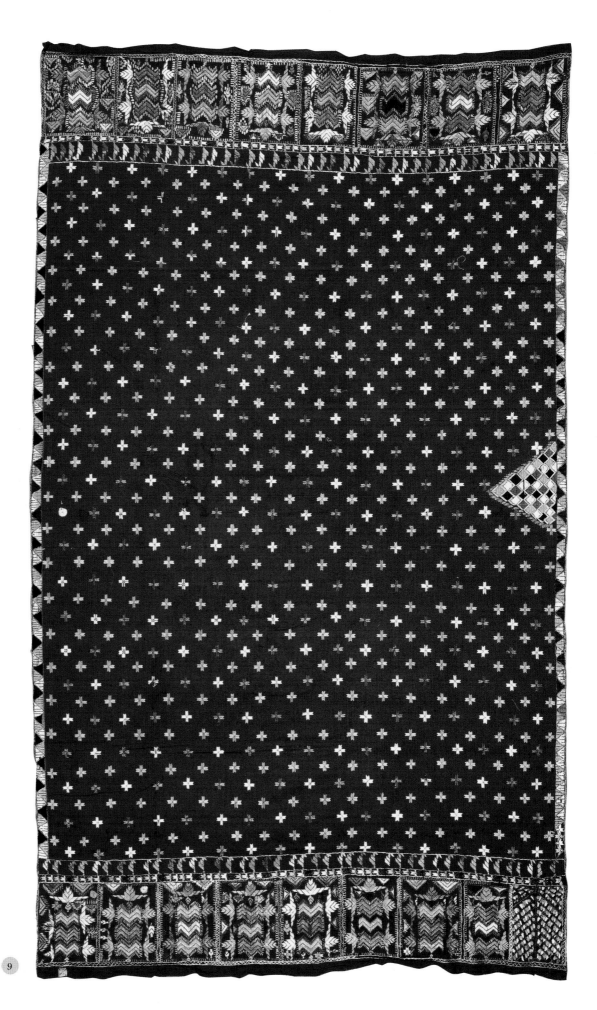

313

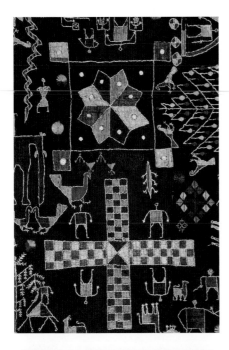

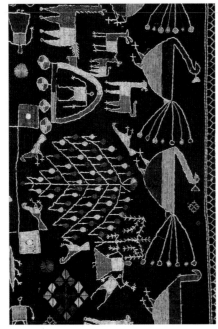

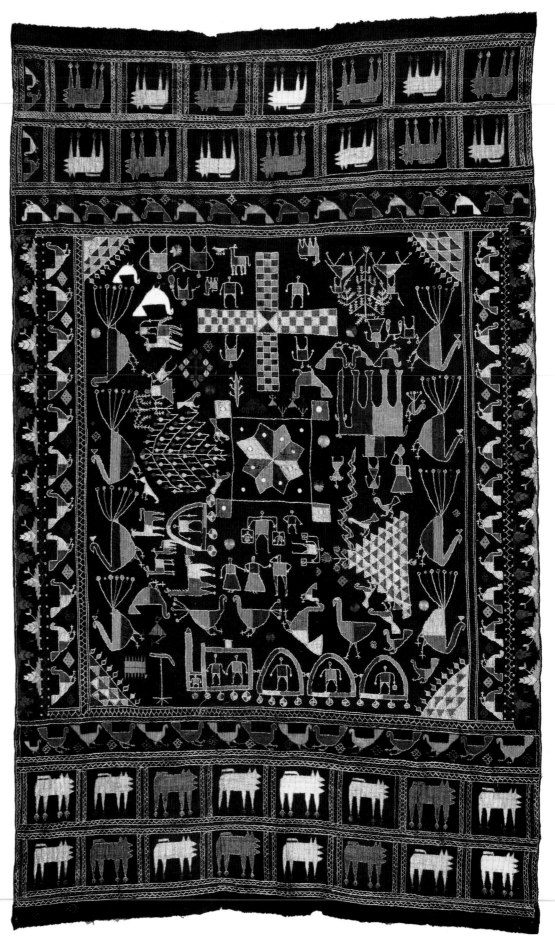

10. *Phulkari, sainchi* (and details)

East Punjab | *c.* Early to mid-20th century | 78 x 48.25 in | Silk floss and cotton thread on plain weave cotton

A variety of figurative motifs embroidered onto a deep blue coarse cotton (*khadder*) base. These include depictions of animals, birds, and human figures.

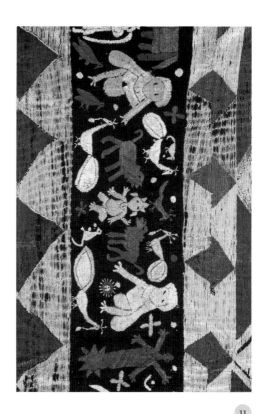

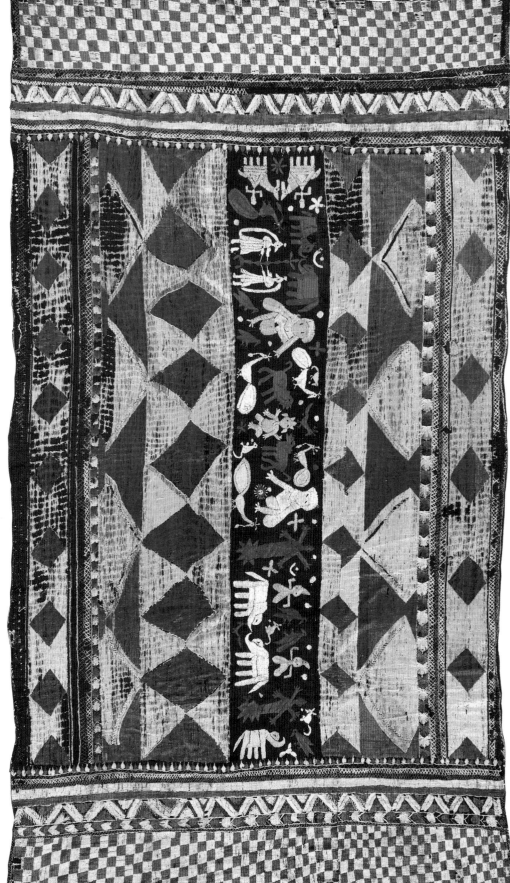

11. *Phulkari, sainchi* (and detail)

East Punjab | *c.* Early to mid-20th century | 101 x 56 in | Silk floss on plain weave cotton

In addition to multiple other motifs, Hindu deities such as Ganesha and Bal Krishna are embroidered in this unique chekerboard-patterened *phulkari*.

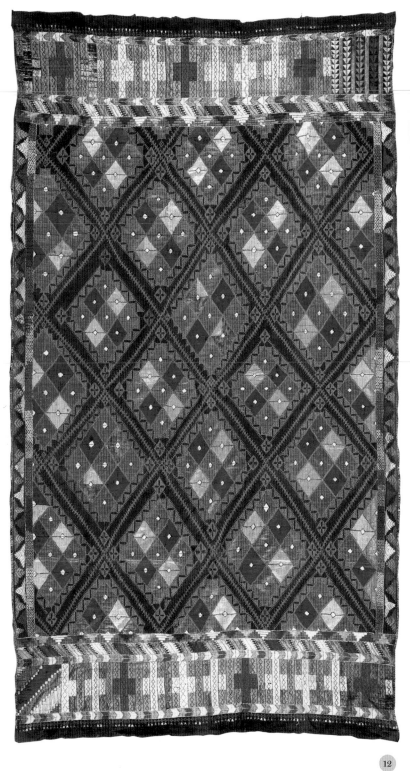

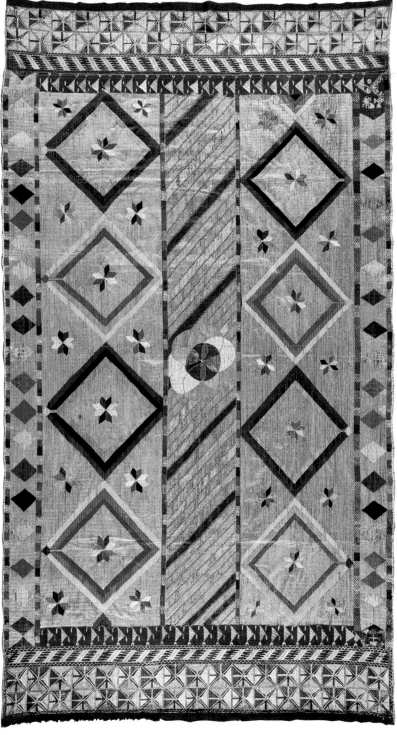

12

13

12. *Phulkari*, hybrid *chope bagh*

Punjab | *c.* Early to mid-20th century | 90 x 50.5 in | Silk floss and cotton thread on plain weave cotton

13. *Phulkari*, diamond shaped motifs

Punjab | *c.* Early 20th century | 93 x 52 in | Silk floss and cotton thread on plain weave cotton

An unusual *bagh* with multicolored eight-pointed star-like forms floating on a ground filled with yellow-colored silk floss and lozenge motifs.

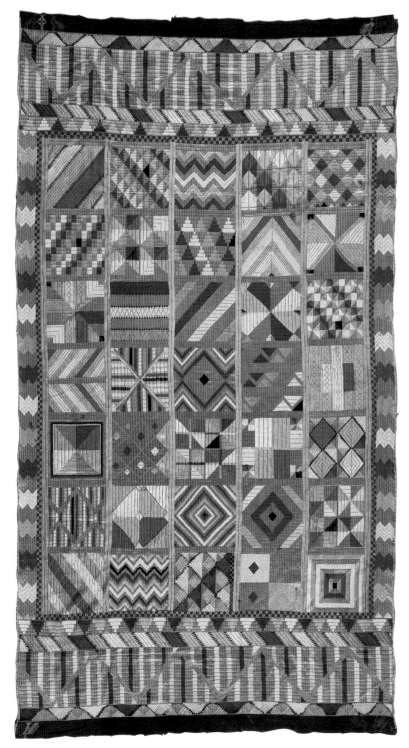

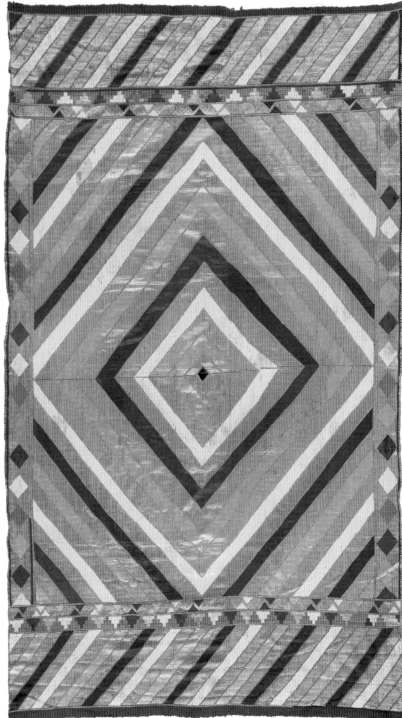

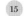

14. *Phulkari, bawan bagh*

East Punjab | *c.* Early to mid-20th century | 94.5 x 52.5 in | Silk floss and cotton thread on plain weave cotton

Made using different *phulkari* patterns, this complex design has fifty-two squares and requires an expert embroiderer.

15. *Phulkari*

Punjab | *c.* Early to mid-20th century | 90.75 x 51 in | Silk floss and cotton thread on plain weave cotton

This *bagh* features concentric diamond or lozenge motifs rendered in magenta, light green, and golden yellow-colored silk floss and white cotton thread.

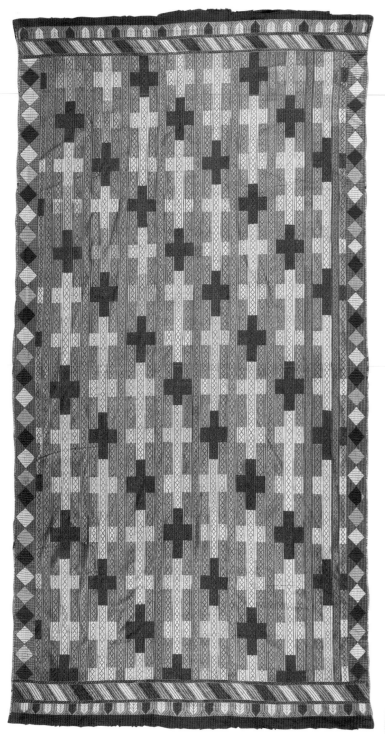

16

17

16. *Phulkari, belan*

Punjab | *c.* Early to mid-20th century | 94.5 x 48.75 in | Silk floss on plain weave cotton |

This *phulkari* is embroidered with motifs representing stylized rolling pins (*belan*), a symbol of domestic life.

17. *Phulkari,* wheat motif

Punjab | *c.* Early to mid-20th century | 91.5 x 48.25 in | Silk floss and cotton thread on plain weave cotton

The motifs featured on this *phulkari* celebrate fertility and prosperity, represented by wheat, the staple grain of Punjab.

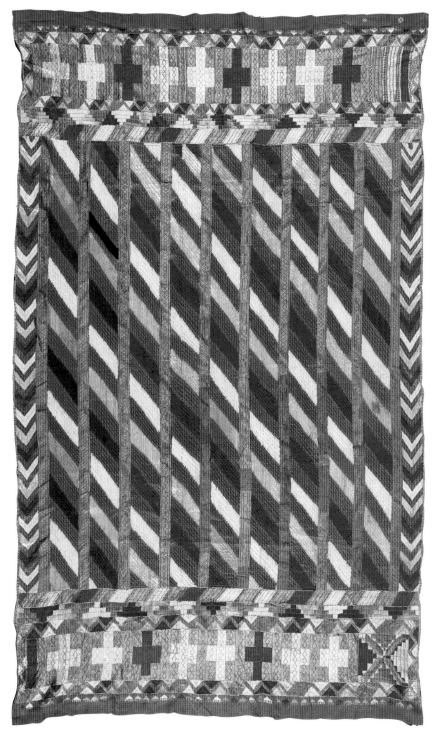

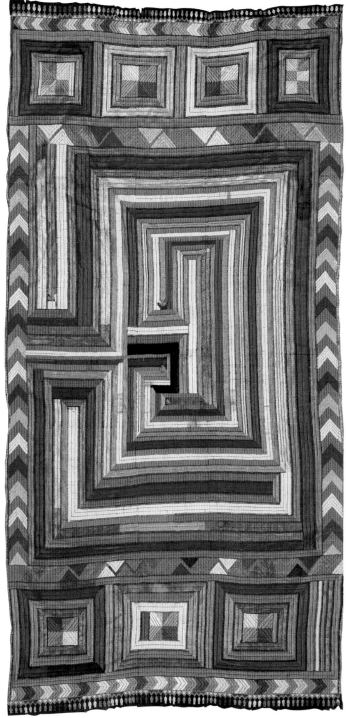

18

19

18. *Phulkari*

Punjab | *c.* Early to mid-20th century |
88 x 51.5 in | Silk floss and cotton
thread on plain weave cotton

The end borders of this *bagh* include a
motif that recalls the rolling pin (*belan*)
(see Figure 16) and frames a striking
composition of green, white, magenta,
and golden-colored diagonal stripes at
the center of the cloth.

19. *Phulkari, bhool bhulaiyan* (maze)

East Punjab | *c.* Early to mid-20th
century | 96.5 x 46.5 in | Silk floss
and cotton thread on plain weave
cotton

This intricate *phulkari* features a
maze-like design with concentric lines
leading to the center.

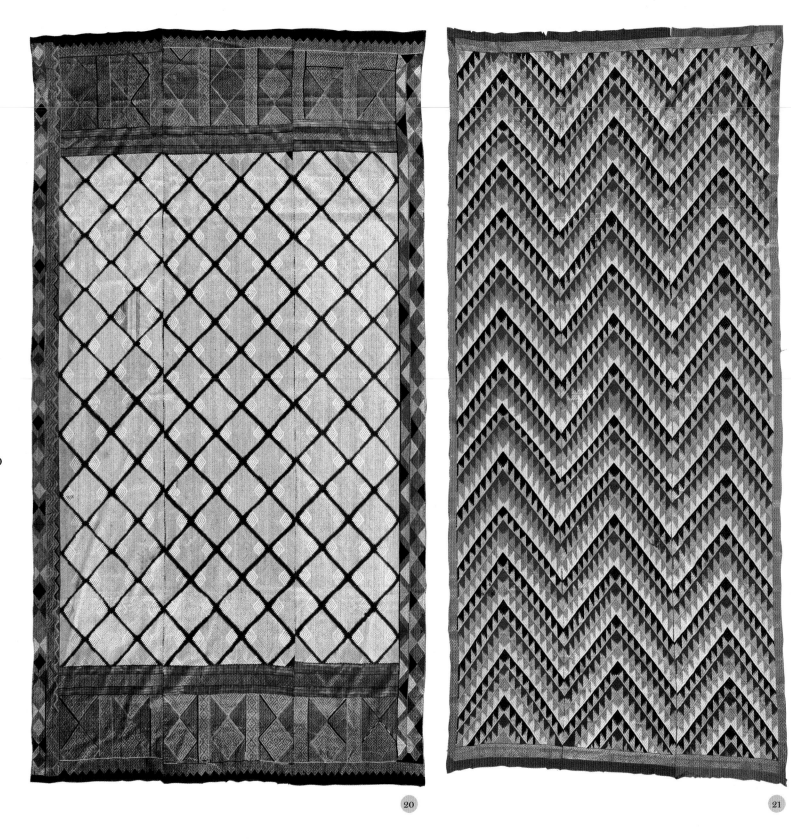

20

21

20. *Phulkari, chand* (moon)

Punjab | *c.* Early 20th century |
93.25 x 51 in | Silk floss on plain
weave cotton

Embroidered with white silk thread to
create a silvery effect that resembles
the luminosity of the moon.

21. *Phulkari, cheh rang* (six colors)

West Punjab | *c.* Early to mid-20th
century | 99.25 x 48 in | Silk floss on
plain weave cotton

Six-colored *lahariya bagh* with
zig-zag pattern.

320

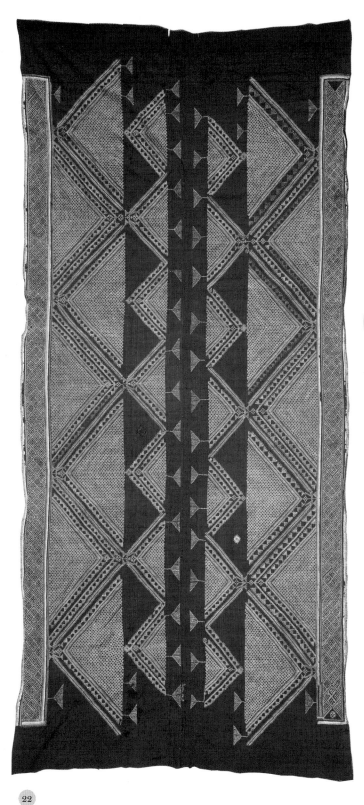

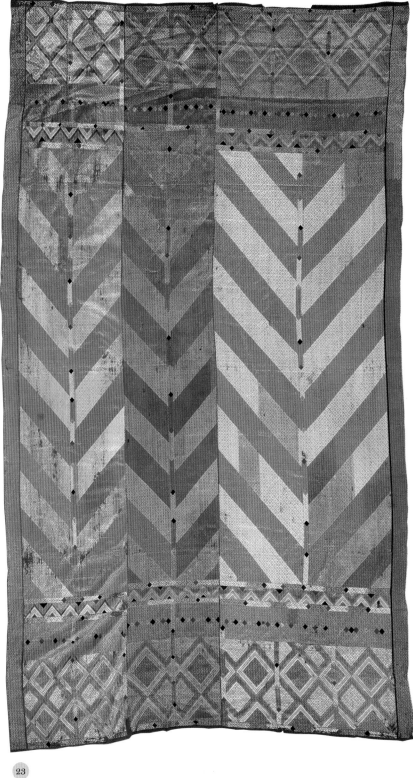

(22)

(23)

22. *Phulkari, chope*

East Punjab | *c.* Early 20th century | 105.5 x 48.5 in | Silk floss on plain weave cotton

This *phulkari* is embroidered with gold thread on red coarse cotton.

23. *Phulkari*

Punjab | *c.* Early to mid-20th century | 103.5 x 57.25 in | Silk floss on plain weave cotton

A *laharia* (wave) pattern on this *bagh* with different shades suggest that silk floss was used from different periods.

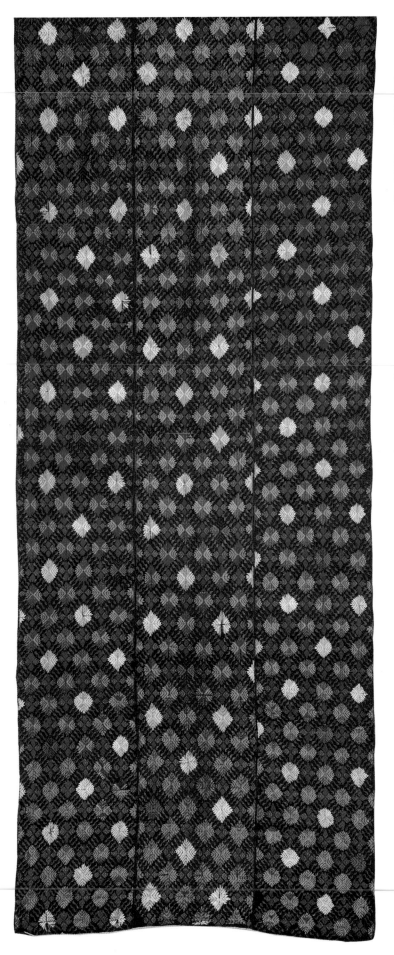

322

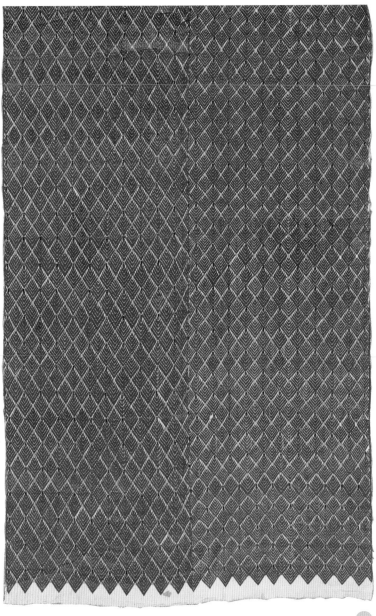

25

24. *Phulkari*

West Punjab, Hazara and Swat region | *c.* Early 20th century | 100 x 40 in | Silk floss on plain weave cotton

This *phulkari* in dark indigo-colored coarse cotton is paired with magenta-colored silk floss.

25. *Phulkari, thirma bagh* with pink serrated outlay

West Punjab, possibly Hazara | *c.* Early to mid-20th century | 71.75 x 48.5 in | Silk floss on plain weave cotton

The bright pink and white palette of this *bagh* is reminiscent of embroidered textiles from Sindh and Swat.

24

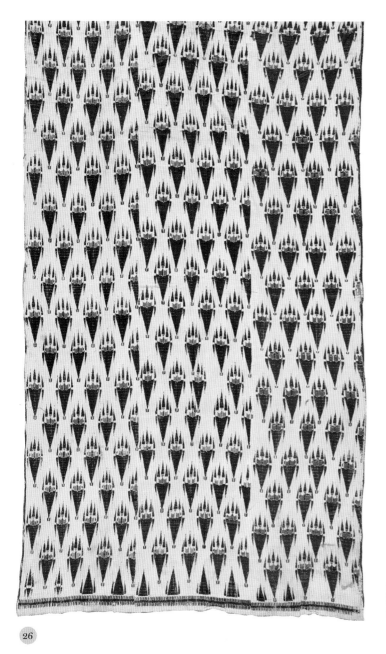

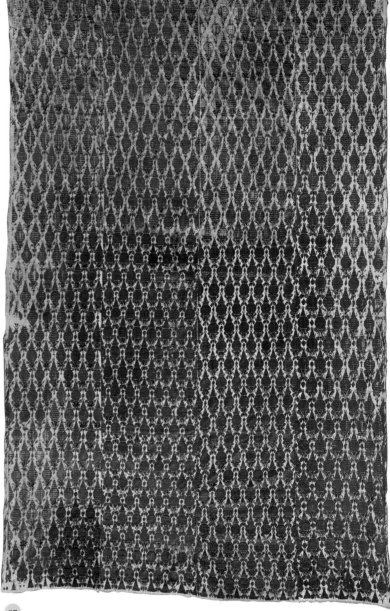

26. *Phulkari, katar* (and detail)

Punjab | *c.* Early 20th century |
99.75 x 54.5 in | Silk floss on plain
weave cotton

This *thirma phulkari* is decorated
with embroidered depictions of
katar or *kirpan*, symbols of
protection and dignity.

27. *Phulkari, thirma* (and detail)

West Punjab | *c.* 19th century |
99 x 62.25 in | Silk floss on plain
weave cotton

An intricate *phulkari* on fine white
coarse cotton base with vessel-like
motifs in red.

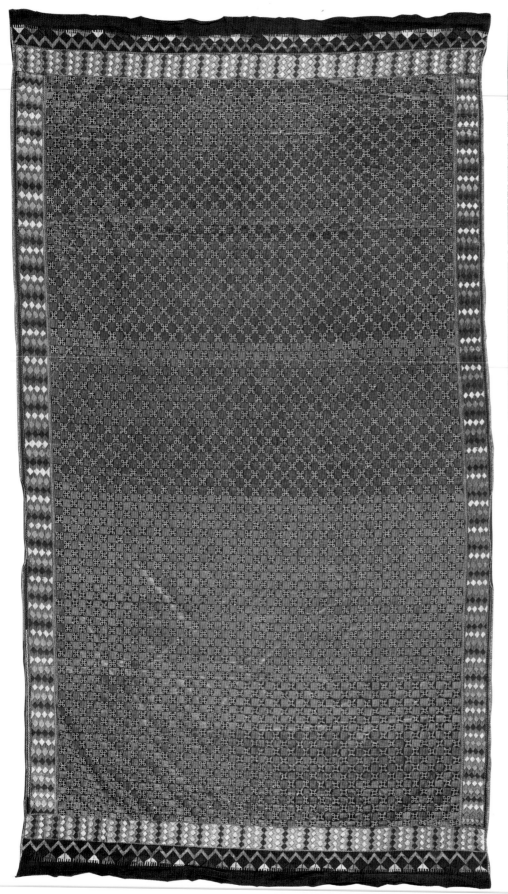

324

28

28. *Phulkari*, checkerboard pattern (and detail)

Punjab | *c.* Early to mid-20th century | 92 x 51.75 in | Silk floss on plain weave cotton

The pattern that dominates the body of this *odhni* visually references woven cotton double cloth (*khes*) made in Punjab and in neighboring Sindh and Balochistan. The end borders of this textile appear like a multicolored fringe of small amulet motifs. These triangular forms are popular in textiles and jewelry throughout India, Pakistan, Afghanistan, and Muslim Central Asia where they are used to protect the wearer and promise fertility.

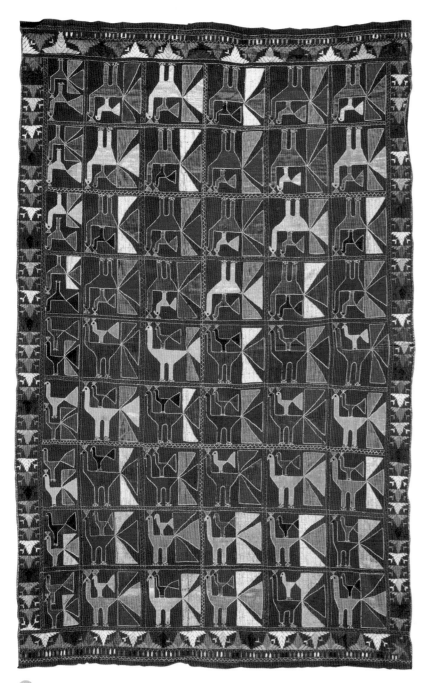

29

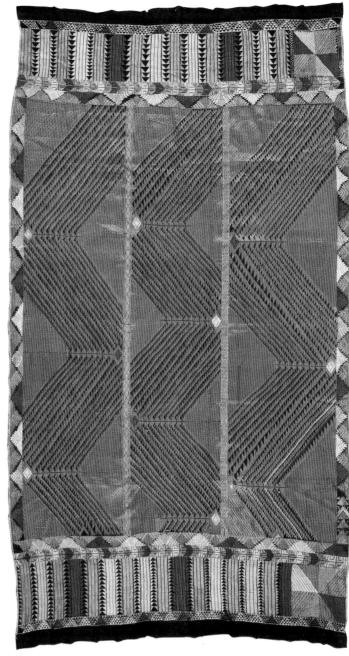

30

29. *Phulkari, mor* (peacock) motif

Punjab | *c.* Early to mid-20th century | 82 x 51.5 in | Silk floss and cotton thread on plain weave cotton

30. *Phulkari*

Punjab | *c.* Early to mid-20th century | 95.5 x 53 in | Silk floss and cotton thread on plain weave cotton

Created using three narrow strips of *khadder* pieced together before being embroidered, this *bagh* uses pattern darning stitches and golden-colored silk floss to create three prominent zig-zag patterns along the central portion of the textile.

RUMAL, CHAMBA

Rumals are embroidered handicrafts made in the shapes of square and rectangles using very fine handmade silk. They are generally used as a ceremonial cover or presented as a gift.

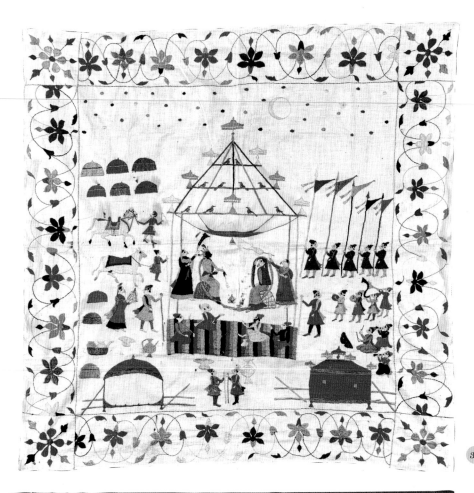

31. Krishna and Rukmini

c. 1880–1900 | 32 x 32 in |
Silk embroidery on cotton

Floss silk embroidery on fine machine-woven cotton depicting the marriage of Krishna and Rukmini.

32. Shiva and Parvati

c. 1800–50 | 35 x 35 in |
Silk embroidery on cotton

A unique depiction of Shiva and Parvati likely straining *bhang* through a cloth. It looks as if the embroidery was meant to depict Shiva in his Ardhanarishvara (half male, half female) form. The two deities are surrounded by beautiful depictions of a flower-filled meadow with peacocks and cypress trees.

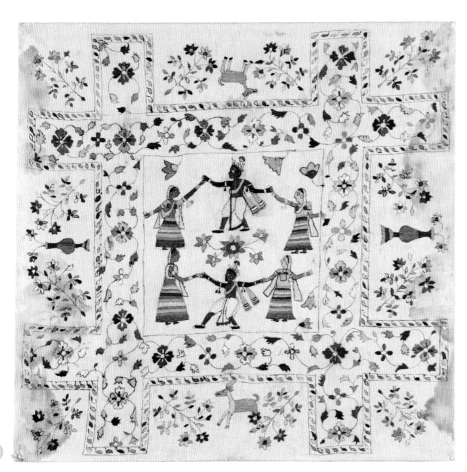

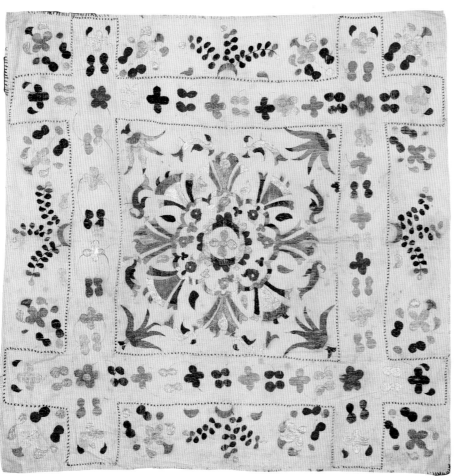

33. Krishna and *gopis*

c. 1800-50 | 26.5 x 27 in |
Silk, cotton and thread

Double-sided (*dorukhi*) silk
embroidery on fine cotton showing the
Ras Lila, the dance between Krishna
and his consorts (*sakhis* or *gopis*).

34. Radha and Krishna

c. 1880-1900 | 17 x 13 in |
Silk embroidery on cotton

35. *Kikli* dance scene

c. 1880-1900 | 32 x 32 in |
Silk embroidery on cotton

Kikli dance scene from Chamba. It is
a form of dance performed by young
girls in which they hold each other's
hand crosswise and rotate swiftly on
their toes.

RUMALLA SAHIB

Rumalla sahib is a Punjabi term for a square or rectangular piece of silk cloth used to cover the Sri Guru Granth Sahib in the gurdwara when it is not being read.

36

36. Guru Nanak with Bhai Mardana and Bhai Bala

c. Early 20th century | 42 x 42 in | Silk, cotton, and thread

37. Guru Nanak with Bhai Bala and Bhai Mardana

c. 1900 | 41 x 41 in | Silk, cotton, and metallic wrapped thread on silk

37

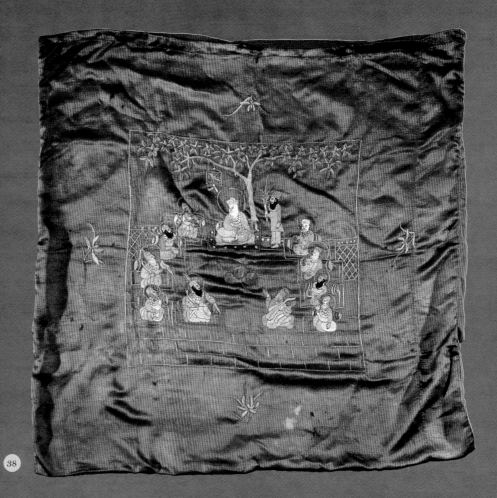

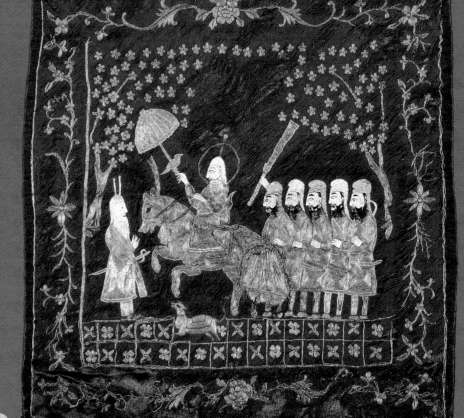

38. Ten Sikh gurus

c. Late 19th century │ Silk and cotton

Intricately embroidered in a style known as *Chini Kalam*, produced by Chinese artists. This work is characterized by the guru's eyes being slightly oriental in appearance.

39. Guru Gobind Singh and the *Panj Piyaras* (the five beloved ones), square form with borders of floral vines

c. Late 19th/early 20th century │ 21 x 20 in │ Silk, cotton, and metallic wrapped thread on silk

KASHMIRI SHAWLS

Exquisite and unique works of art, Kashmiri shawls are woven partly or wholly from goat hair called pashm, found in the high-altitude plateaus of Tibet and Ladakh.

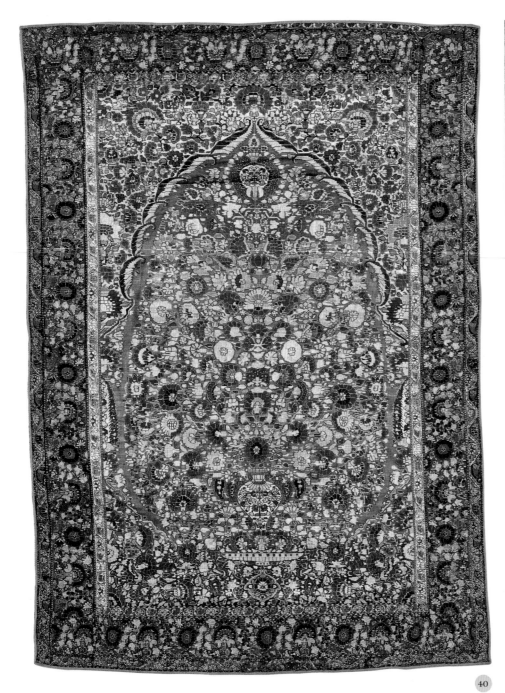

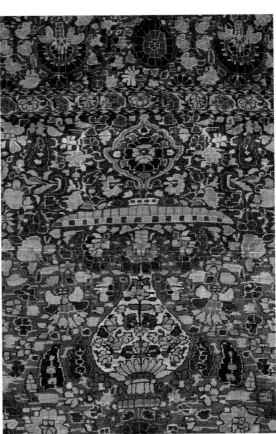

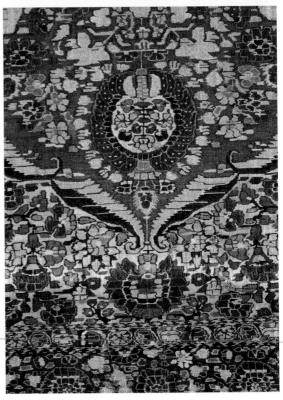

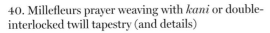

40. Millefleurs prayer weaving with *kani* or double-interlocked twill tapestry (and details)

Second half of 18th century |
42 x 57 in | Pashmina

This is a very rare hanging, dating from the end of India's imperial Mughal period. Millefleur prayer hangings from Kashmir were woven mainly as treasured gifts by and for various potentates of the Indo-Muslim world and were rarely used as prayer mats.

41. Mughal fragment, pashmina (and detail)

Mughal period | *c.* Late 17th century | 60 x 8.7 in | Pashmina

This Mughal fragment with its undecorated ground and freely spaced *botehs* (floral bouquets) represents an important link between well-defined curvilinear *botehs* typical of the mid-eighteenth century and the "unfettered" floral bouquet patterns of the seventeenth century.

42. Kashmiri shawl

Afghan period | *c.* 1790–1810 | 106 x 54 in | Pashmina

This Kashmiri shawl from the Afghan period showcases ten *botehs* with top radial flowers and separated "coif" racemes pattern the *pallus* (borders).

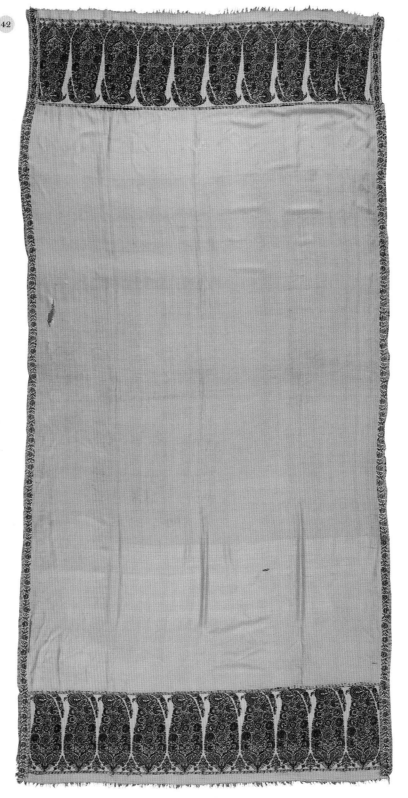

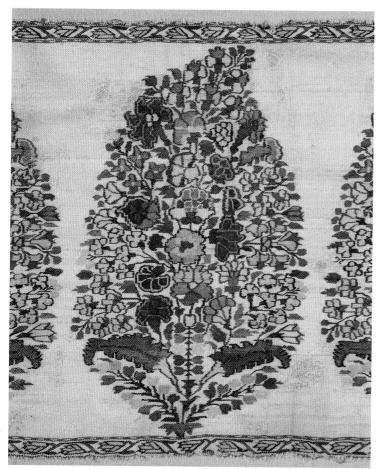

331

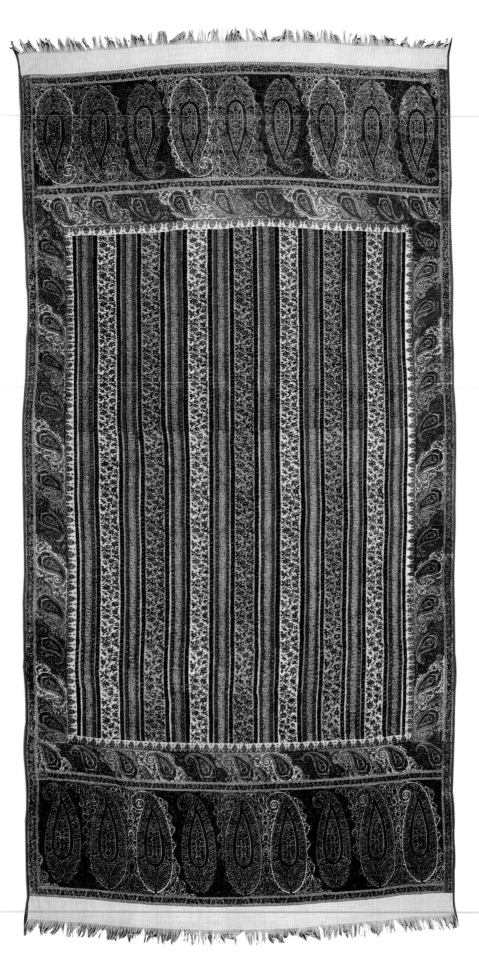

43. Pashmina (and detail)

Sikh period | *c.* 1820–30 |
97 x 52 in | Pashmina

The harlequin pattern of individual *botehs* is set against alternating ground colors of red, saffron yellow, and white. The richly striped (*khatraaz*) field alternates large and smaller bands of saffron yellow, white, red, and light and dark shades of indigo.

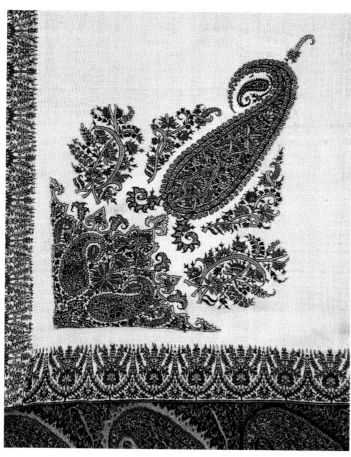

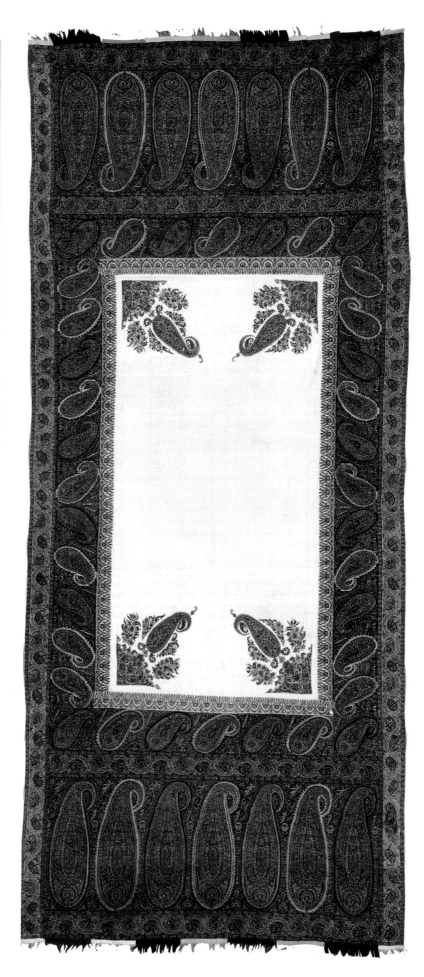

44. Pashmina (and detail)

Sikh period | *c.* 1825 |
122 x 52 in | Pashmina

This pashmina is decorated with seven burly-set, hooked-tip *botehs* in harlequin-outlined colors. Concentric swirls of mosaic-like flower buds fill the *botehs*' interiors. Characteristic of the Sikh period's design vernacular, a thick, hooked vine snakes its way across the *hashyas* interspersed with large red and yellow flower blossoms.

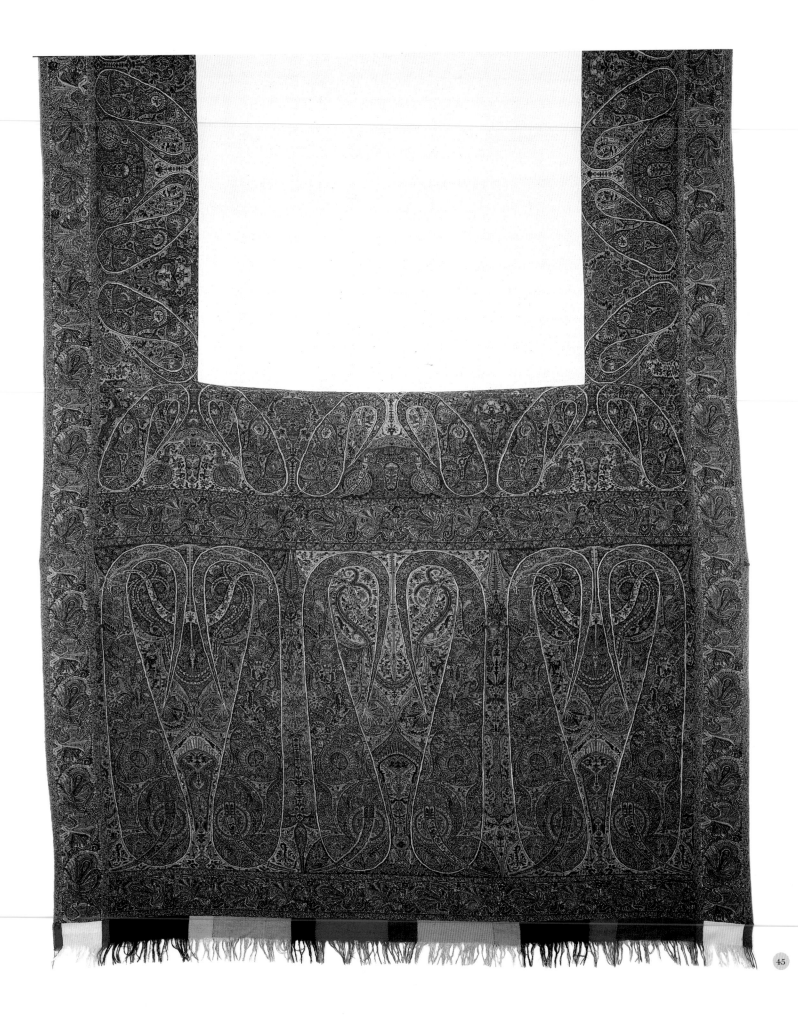

334

45

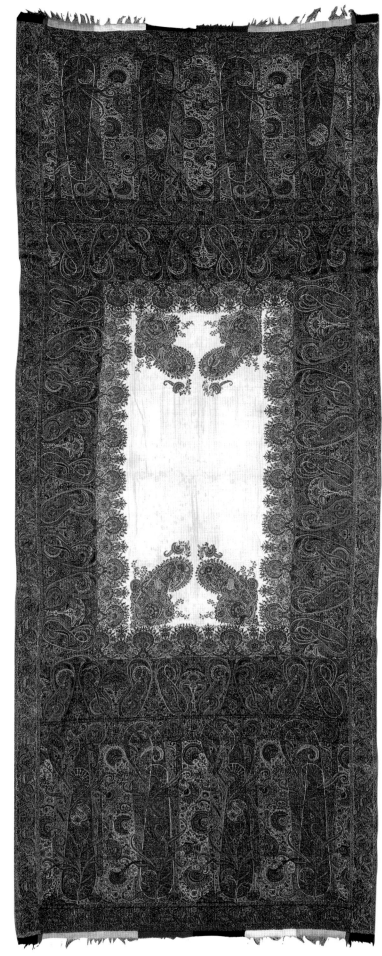

45. Pashmina

Sikh period | *c.* 1830–40 |
129 x 59 in | Pashmina

In this long shawl the end panels are composed of three large pairs of opposing *botehs* or paisleys, white outlined, and with spike-like tips folded over. One observes a recurve bow, its serrated-tip arrow and feathery tail loaded onto the weapon pointed downward. Its undulating string gives the impression of an arrow just released. Below is a quiver packed with seventeen arrows, its narrow bottom resting on a thin necked, bulbous vase. The quiver is flanked by a pair of daggers, their pommels drawn with animal-like heads. They lean against large floral medallions, which most likely represent shields.

46. Pashmina (and detail)

Sikh period | *c.* 1835 |
128 x 52 in | Pashmina

Four tall *botehs* facing left stand erect and imposing against a kaleidoscope of subtle colors. Curled tip, snaking fronds, peacock fans, and roundel blossoms perform their seductive and cajoling choreography across each of the stately *botehs*. One could easily imagine the explosion of fireworks (Diwali) in the sky as these colorful blossoms pop off to the right and left.

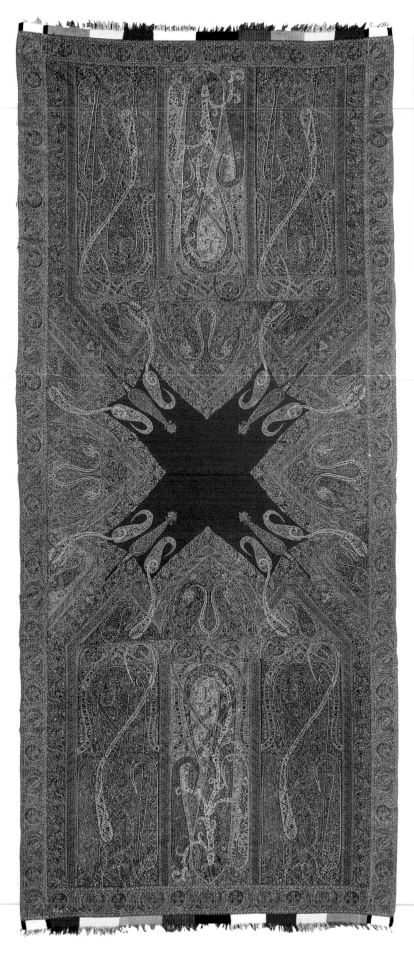

336

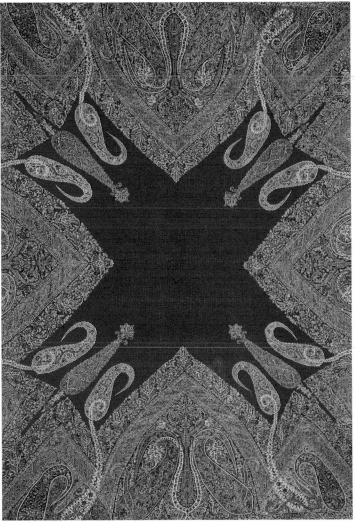

47

47. Pashmina (and detail)

Sikh period | *c.* 1845–60 |
127 x 58 in | Pashmina

The compartmentalized end panels,
or *pallus*, showcase tall *botehs* with
sharply bent tips. The center one of
the three is overlapped with a bold
hooked vine while the other two
flanking ones show much thinner
hooked vines. The shawl is rich in
its variety and use of finely dyed
pashmina.

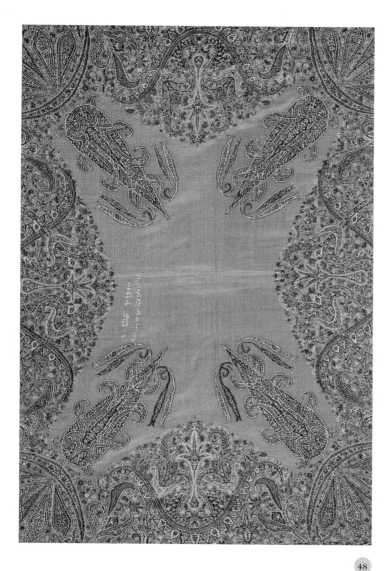

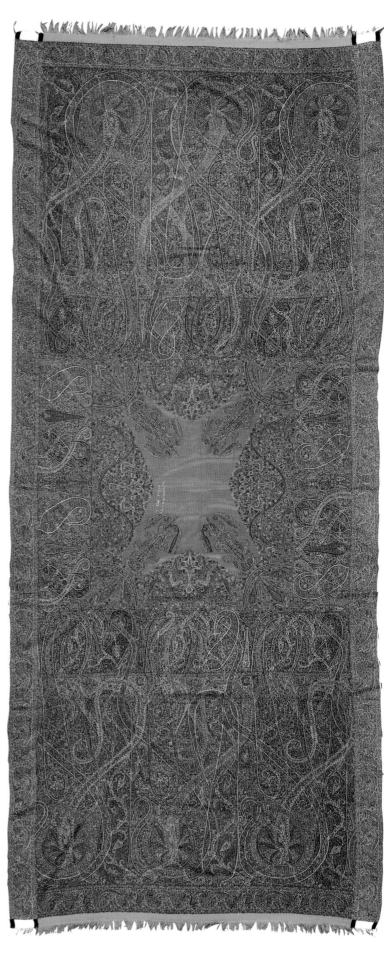

48. Pashmina (and detail)

Sikh period | *c.* 1845 |
127 x 56 in | Pashmina

An elaborate design construction surrounds the intense, green central field showcasing four pointed and scallop-outlined spears, dashing towards the center. The entire shawl comprises six pieces, plus the two vertical *hashyas* for a total of eight pieces.

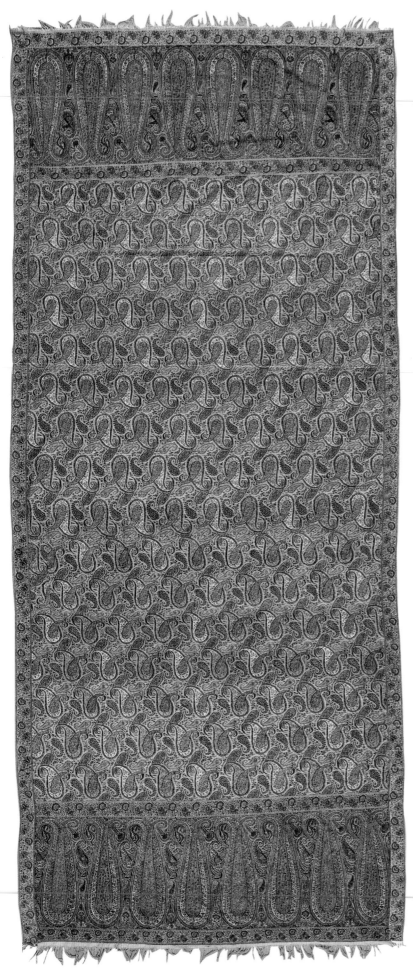

338

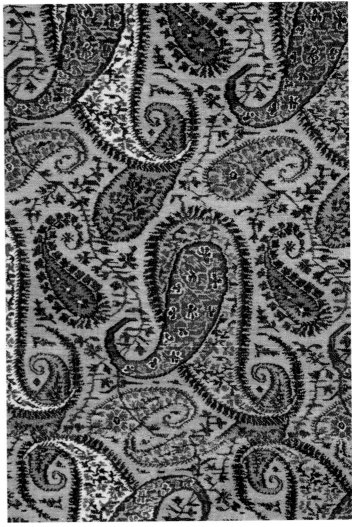

49

49. Pashmina (and detail)

Sikh period | *c.* 1830 |
122 x 53 in | Pashmina

Mother and daughter *butti* in blue and
white diaper the intense saffron field
of this sumptuous *jamawar*. Curled tip
botehs line the end panels against a
ground of "fool's cap" motifs and *buti*.

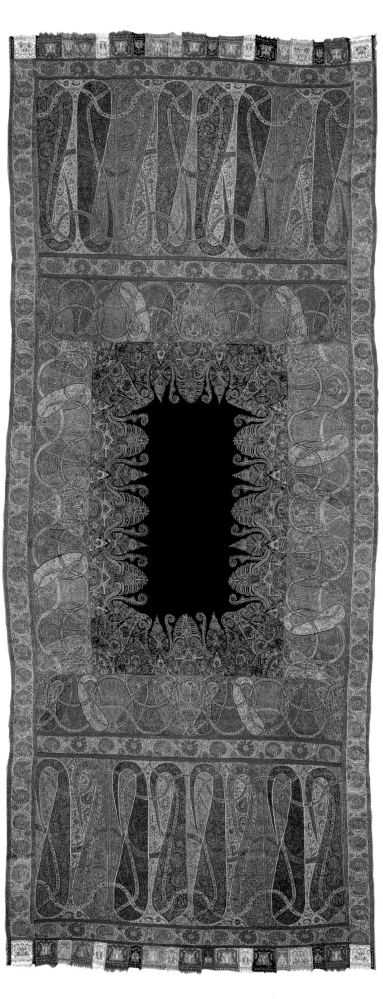

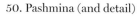

50. Pashmina (and detail)

Sikh period | *c.* 1840 |
133 x 56 in | Pashmina

A large rectangular black center is bordered by a repetition of finely worked, *kani* woven embellishment of green-tinted, large, tear-drop-shaped ferns, pointed star medallions, and sharply, bent-tip paisleys – all with a floral style that closely matches that of the main body.

53

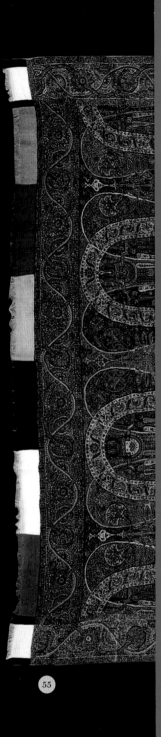

55. Pashmina

Sikh period | *c.* 1835 | 5

The dual sinuosity of the t
through the Punjab. With
brackets the ends of which
the rising crests at the top
chattris (canopy) is quite a
unknown. This shawl was

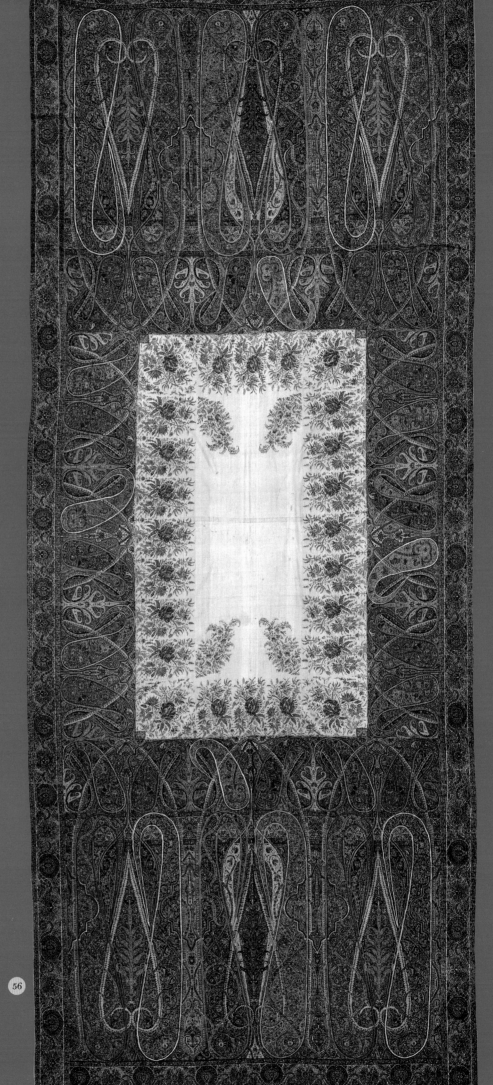

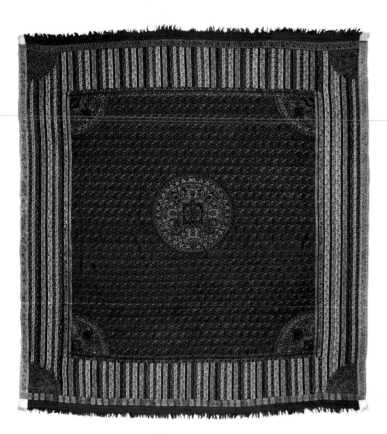

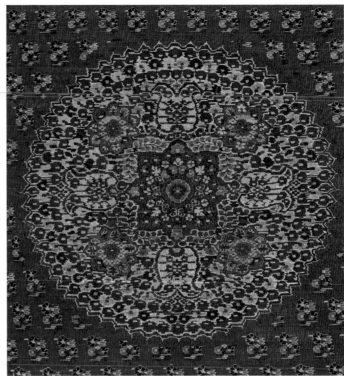

57. Pashmina, moon shawl (and detail)

Afghan period | *c.* 1790–1810 |
75 x 79 in | Pashmina

A pashmina with an intense cosmic image and direct appeal, this is a fine example of one of the most difficult weaves: using the *kani* method to create a perfect circle.

58. Pashmina, moon shawl (and detail)

Mughal period | *c.* 1700 |
48 x 46.5 in | Pashmina

One of the earliest moon shawls known to exist, it depicts a unique form of rose buds within saffron medallions.

59. Pashmina, moon shawl

Dogra period | *c.* 1850 | 72 x 70 | Pashmina

In this moon shawl the mosaic moon "floats" over large green and blue stripes while pink and yellow hook vines drift across the red field.

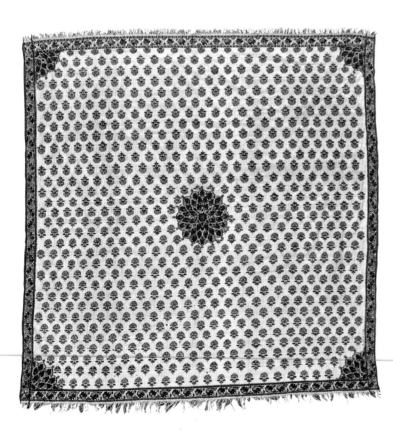

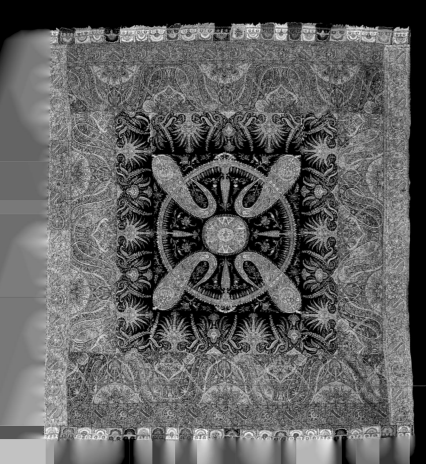

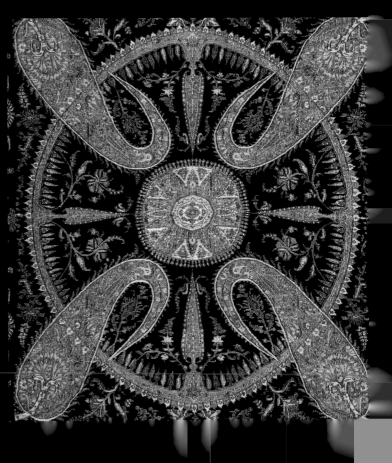

60. *Rumal* (and detail)

Sikh period | *c.* 1840 | 72 x 70 in | Pashmina

This embroidered *rumal* is dominated by a huge *chakra* or wheel streaming with characters and overlaid by a looping star pattern lined with animals.

61. *Rumal* (and detail)

Sikh period | *c.* 1835 | 71 x 66 in | Pashmina

Four large paisleys point towards a bull's eye over a large circle on a black ground with borders of opposing, leaning *botehs* flanking a mound.

62. *Rumal* (and detail)

Dogra period | *c.* 1860 | Pashmina

A *shamsa*, or sunburst medallion explodes in the center with a sea of swirling paisleys against a dramatic black backdrop.

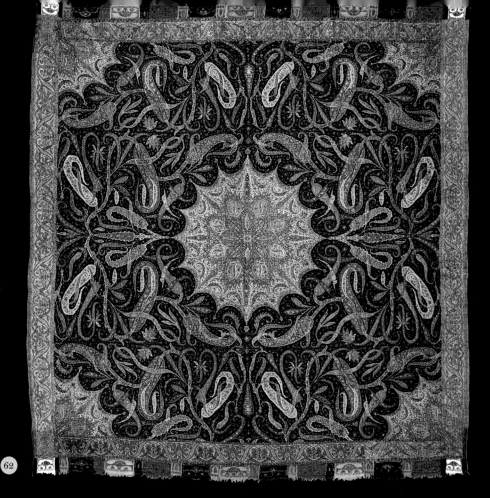

62

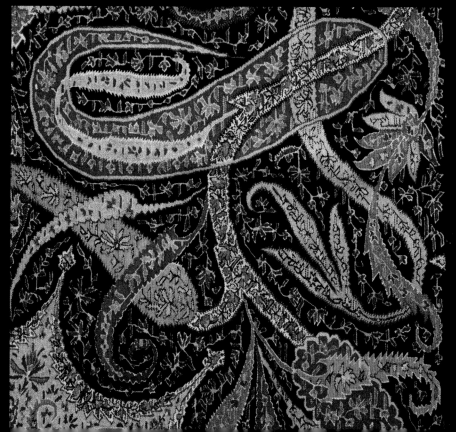

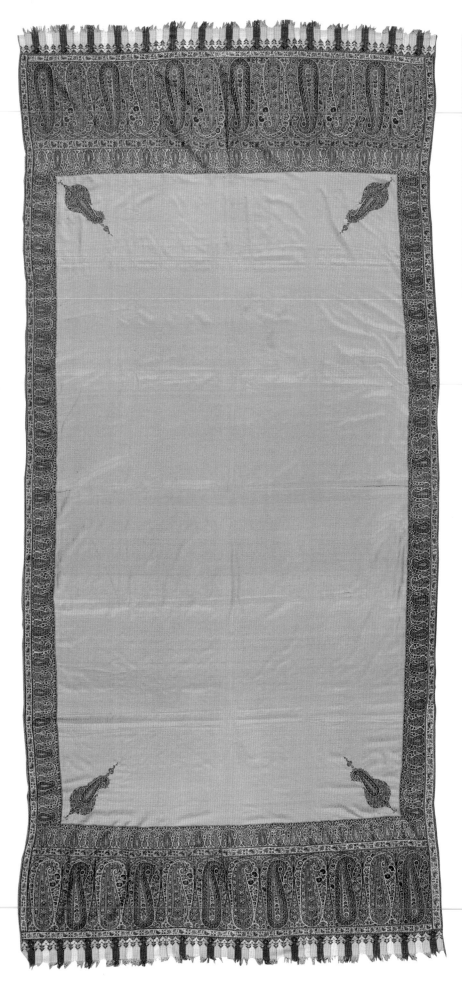

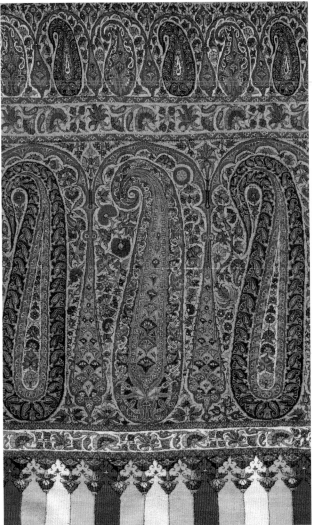

63

63. *Dorukha* pashmina (and detail)

Dogra period | *c.* 1865 |
119 x 59 in | Pashmina

Reversible (*dorukha*), twelve *botehs*,
each encapsulated in its own niche
against an alternating background
of saffron yellow and ecru, pattern
the colorful end panels of this
magnificently woven shawl.

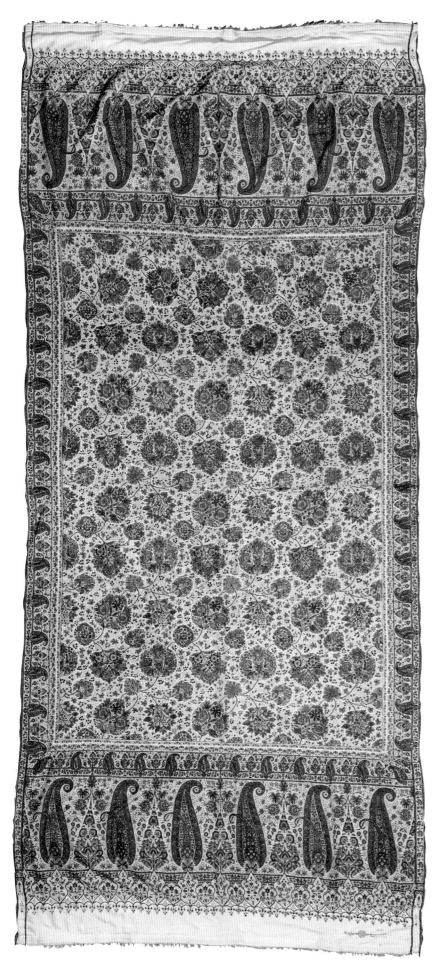

64

**64. Double-sided long shawl,
dorukha (and detail)**

Dogra period | *c.* 1870 |
116 x 50 in | Pashmina

This double-sided *dorukha* shawl is
woven in three panels - the cream
field with bright pink flowers and
green leaves, the end panels with
mother-and-child *boteh* pattern
alternating with conical floral forms,
and embroidered maker's mark on one
end, with top and side borders joined.

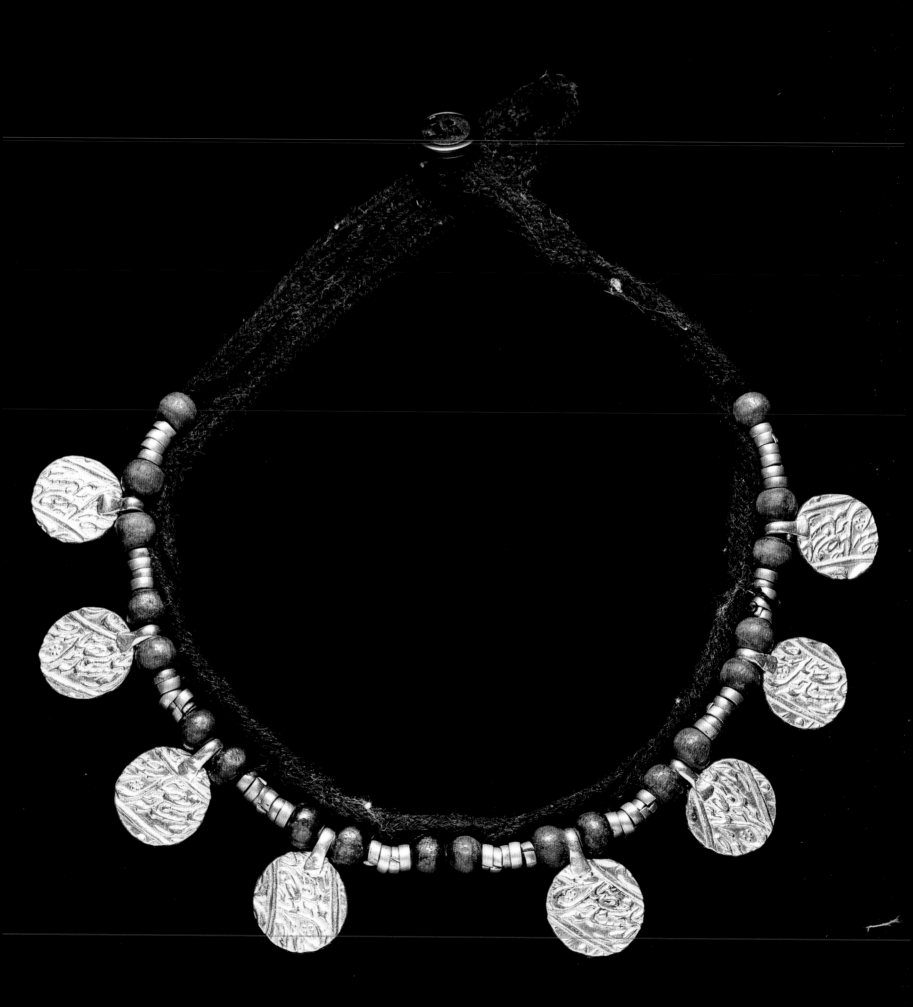

SYMBOLS OF SOVEREIGNTY: SIKH COINAGE

"COIN STRUCK FOR THE TWO WORLDS BY THE GRACE OF THE TRUE LORD, VICTORY OF THE DOUBLE-EDGED SWORD OF THE KING OF KINGS GURU GOBIND SINGH, NANAK SUBMITS THAT THE ALMIGHTY IS THE PROVIDER."[1]

The Nanakshahi couplet, an inscription struck on Sikh coins

The most glorious, yet the most neglected aspect of Sikh heritage is its coinage. Sikhs owe a huge debt of gratitude to Hans Herrli, a Swiss scholar who cast light on the languishing topic of Sikh numismatics for the first time in the year 1993 through the publication of his book *Coins of the Sikhs*.[2]

Appropriately termed as "symbols of Sikh sovereignty" by Dr. Surinder Singh, Sikh coins truly reflect the grandness of the Sikh Empire which, at its zenith, extended from the north of the banks of the Sutlej river up to Leh in the north (thus including the whole of Kashmir) and up to the borders of Afghanistan in the west.[3]

Unique in many ways, Sikh coins are the only coins of that period which did not carry the name of the ruler on them. They were instead dedicated to the Divine through the blessings of the Sikh gurus, a fact that reflects the respect paid to them as providers and protectors. These coins carry on their obverse slight variations of two basic couplets in Persian which, only for the sake of categorization, have been termed as Nanakshahi and Gobindshahi couplets.

The basic Nanakshahi couplet reads:

Sikka Zad Bar Har Do ālam, Fazl Sachchā Sāhib Ast,
Fateh Tegh-é-Gur(u) Gobind Singh Shāh Shāhān, Nānak Wāhib Ast

Coin Struck for the two Worlds by the Grace of the True Lord, Victory of the double-edged sword of the King of Kings Guru Gobind Singh, Nanak submits that the Almighty is the Provider.[4]

The basic Gobindshahi couplet that finds its origin on the seal of Guru Gobind Singh reads:

DeghTeghFateh, Nusrat Be-dirang,
Ya'ftAz Nanak Guru Gobind Singh.

"Degh", signifying abundance of food, (and) "Tegh", signifying armed power and victory are attained by the spontaneous help from (tenth) Nanak Guru Gobind Singh.[5]

1. *Mohurs* (coins), Bhangi Misl

Late 18th century | Gold

These eight gold *mohurs* (coins) from the Bhangi Misl period, centered in Amritsar, which was then under Raja Gulab Singh Bhangi. These are some of the earliest known Sikh coins struck in gold. They have been attached to a necklace (the necklace itself is not original).

Sikh coins were minted in copper, silver, and gold. The denominations in copper were *falus*, paise (or *pao anna*), half paise, two paise and, very rarely, multiple paise. The silver coins were minted in the denominations of rupee, half rupee, quarter rupee and one eight rupee. The gold coins were in the denominations of *mohur*, half *mohur* and, very rarely, double *mohur*. Unlike silver rupees and gold *mohur*, most of the copper coins were not minted under the strict supervision of the state. The script on copper coins was mostly Gurmukhi and less frequently Persian. The script on silver and gold coins was almost invariably Persian. While silver rupees were more in circulation,

Katar (dagger) *Trishul* (trident) *Chattar* (royal umbrella) *Pataka* (flag)

356

silver fractions are extremely rare. Similarly, gold *mohurs* of the Sikhs are exceedingly rare. Double *mohurs* and square coins are also unique.

A distinctive feature of Sikh coins was that the year of minting was recorded using the Vikrami Samvat calendar, which conventionally started fifty-seven years before the beginning of the Common Era (in other words, to convert the Vikrami Samvat calendar to the Gregorian one, one simply needs to subtract fifty-seven years from the Vikrami Samvat date).

Interestingly, it appears that the Sikhs had a strong influence on the Lahore mint even during the rules of Aurangzeb and Shah Alam I. A few silver rupees from this period bear the *khanda* symbol – a Sikh emblem showing a double-edged sword (*khanda*) in the center, a circular throwing weapon (*chakkar*), and two single-edged swords (*kirpan*) crossed at the bottom, only for the years that are significant from a Sikh historical perspective. On Aurangzeb's silver rupees made in the Lahore mint, the *khanda* symbol first appeared in the Hijri year AH 1110 (1699), the year in which the tenth guru, Guru Gobind Singh, baptized the Khalsa. Another coin bears the year AH 1117 (1705), when the tyrannical ruler Aurangzeb died. On the coins of Shah Alam I, the symbol appears in the years AH 1122 and 1124 (*c.* 1710-12), when fierce fighting took place between the forces of Banda Bahadur and the Mughals near Lahore.

Banda Singh Bahadur likely minted the first Sikh coins between 1710 and 1713. These coins are known as "Khalsa coins" and they carry a Nanakshahi couplet on the obverse. They are extremely rare and the ones that have been found bear the dates "year 2" and "year 3" on them.

After the death of Banda Bahadur, the Sikhs took refuge in the jungles and later organized themselves into twelve armed confederations known as *misls* to resist the forces of Ahmad Shah Abdali from Afghanistan and the Mughals. Of these confederations, the Bhangi Misl became the most powerful and successfully defeated the Mughal and Afghan forces. According to Paramdip Khera, "the Sikhs began to produce coins in the traditional mint centers once Mughal power had started to decline and the Afghans had left the Punjab."[6]

In 1765, the Bhangi Misl took control of Lahore and struck the first Sikhs coins with definite attribution. The year on these coins was placed in the Vikrami Samvat era as 1822. The same *misl* occupied Multan in the year 1772 and struck coins there until 1779. In 1775, the Bhangi Misl also

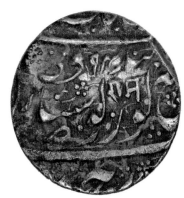
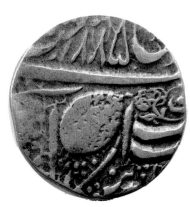

Double Pataka (flag) Om, in crude Devanagri Ram, in Devanagri *Gulab* (rose)

struck coins at Amritsar. Copper coins from the short period of time during which the *misls* likely controlled Najibabad and Jaipur have been found.

Ranjit Singh took control of Lahore in 1799 and in 1801 he conquered Amritsar, where he assumed the title of Maharaja of Punjab. In the ensuing years, Maharaja Ranjit Singh extended his rule to Multan (1818), Kashmir and Dera Jat (1819), Dera Ghazi Khan (1820), Mankera (1822), Muzang (1832), and Peshawar (1834). Coinage started to be minted from these major towns after they became part of the Sikh empire.

Sikh coins are among the most beautiful examples of coinage produced at this time and they reflect the magnificent artistry of the calligraphers of that era. While coins minted in Peshawar are amongst the most well-crafted Sikh coins, the Mora Shahi coins, minted in Amritsar in 1805, are the best example of the splendid artistry of the calligraphers of that time. Their peculiarity is the image of two peacocks which merge with the letters used in the legend. As a result, the image of the two birds remained hidden from the common man's eye until 2014 when Gurprit Singh discovered and explained it in one of his articles.[7]

A common feature of Sikh coins is the presence of the symbol of a leaf, ostensibly that of a Ber tree, which first appeared in 1788 on coins minted in Amritsar. Sikh coins are rich in ornamental symbols, including, but not limited to fish, *kanga* (small comb), face, rosettes, dotted patterns, dagger, moon, star, hand, and *aarsi* (vanity mirror). Following the death of Maharaja Ranjit Singh in 1839, several religious legends such as "Om," "Sat," "Ram," and "Shiv" in Punjabi, Devanagri (Hindi) and Lande (the script used in court documents), as well as symbols such as the *trishul* (trident), *chattar* (royal umbrella), *katar* (dagger), and *pataka* (flag) started to appear.

Copper coins from Amritsar minted during Ranjit Singh's time mostly bear Gurmukhi legends on them, while it is uncommon to find ones with legends in Persian. In rare instances we find coins with a lion on them, a symbol referring to the rule by Sher Singh, son of Ranjit Singh. Copper coins, with the legend "Devki" in Gurmukhi inscribed on some, and others using Persian have also been found. Copper coins from mints other than Amritsar are rare to extremely rare.

One of the most unusual Sikh coin is a gold rupee minted in Multan during the siege of the city by the British in January 1849. These coins are said to have been minted as an emergency measure to pay the salaries of Sikh soldiers. They were minted by melting gold *mohurs* and converting them

to 0.650–0.680 gram pieces. Punjab was annexed in March of 1849 by the British. Soon thereafter the mints were shut down and the silver coins were sent to Calcutta and Bombay to be melted.

Any history of Sikh coinage would be incomplete without mentioning the coins minted by the Sikh rulers of the Cis-Sutlej (south of river Sutlej) states, such as Patiala, Nabha, Kaithal, Faridkot, and Jind. These states minted coins in the name of Ahmed Shah Abdali, and this practice continued even after these states became British Protectorates. Nonetheless, later, Nabha and Patiala states were allowed to mint coins with the Gobindshahi couplet on them, specifically to be used as *nazrana* (gifts) and for religious ceremonies. These were not meant for circulation and are rare.

It is pertinent to mention Sikh religious tokens which are often mistaken for coins. These religious tokens usually have the effigy of Guru Nanak with Bala and Mardana on each of his sides on the obverse and Guru Gobind Singh with a sword and an arrow on the reverse. The reverse side sometimes has the Mool Mantar (first verse of Japji Sahib) or a numerical Tantrik Jantar. These tokens were struck privately and had no official sanction. They were commonly struck in copper, brass and, more rarely, in silver and gold. Some of the very rare tokens have unusual images on them.

The Khanuja Family Collection is fortunate to have more than 800 Sikh coins, including some extremely rare ones such as gold *mohur*s, gold and silver fractions, unusual mints, as well as some unique coins such as square-shaped ones. A selection of these coins is presented in the following pages.

2. Sikh tokens depicting Guru Nanak with Bhai Bala and Bhai Mardana

Early 20th century | Gold

A necklace of eight Sikh religious tokens with images of Guru Nanak with Bhai Bala and Bhai Mardana. Usually mistaken for coins, these tokens were struck privately and had no official sanction. The heart-shaped centerpiece bears the *khanda* symbol.

REFERENCES & NOTES

1. G. Singh, *Coins of the Sikhs (Sri Amritsar Jiyo): A Catalogue of Silver Rupees of the Amritsar Mint* (Chandigarh: The Nanakshahi Trust, 2015), 17.

2. H. Herrlli, *The Coins of the Sikhs* (New Delhi: Munshiram Manoharlal Publishers, 1993).

3. S. Singh, *Sikh Coinage, Symbol of Sikh Sovereignty*, 2nd edition (New Delhi: Manohar Publishers, 2004).

4. See note 1.

5. *Ibid.*, 18.

6. P. Khera, *Catalogue of Sikh Coins in the British Museum* (London: The British Museum, 2011), 9.

7. G.S. Gujral, "The Mystery of the Moran (Mora) Rupees Solved," *Journal of Oriental Numismatic Society* 219 (2014): 26–28.

*We thank Dr. Bernd Becker, the foremost collector of Sikh coins, for allowing us to acquire some rare coins from his collection. Many thanks also to Gurprit Singh, a well-known authority, who has been a great mentor and has been kind enough to review some of the work presented here in this chapter.

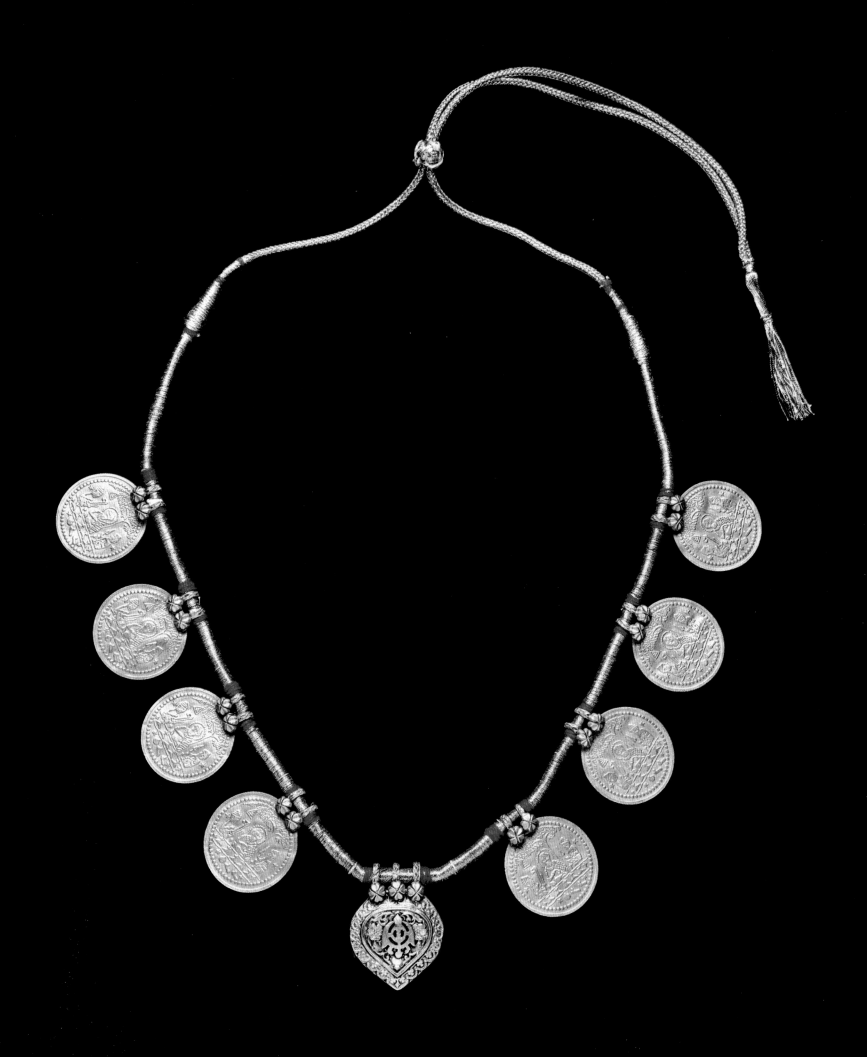

KHANDA ON MUGHAL COINS

1. *Khanda*-like symbol on a coin of Mughal Emperor Aurangzeb

2. *Khanda*-like symbol on coin of Mughal Emperor Shāh Ālam I

COINS ATTRIBUTED TO BANDA BAHADUR

(These are only for depiction purposes and are not in our collection)

360

3. Khalsa coin of Year 2

4. Khalsa coin of Year 3 (Saran Singh Collection)

COPPER COINS OF THE SIKHS

5. Amritsar Persian script

6. Lahore Persian legend

7. Amritsar Gurmukhi legend

8. Leaf on both sides

9. Peshawar Mint

10. Derajat Mint Falus

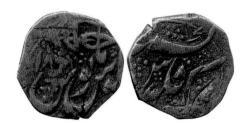

11. Kashmir Mint

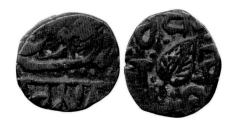

12. Bilingual coin

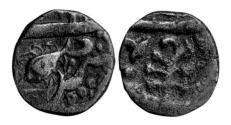

13. Jaipur occupation by *misls*

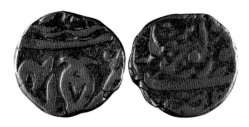

14. Najibabad occupation by *misls*

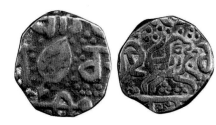

15. Lion for Sher Singh

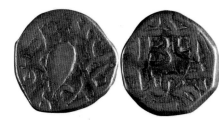

16. Dalip Singh name on flan

361

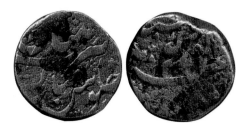

17. Multan, first occupation by *misls*

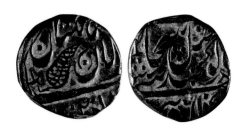

18. Multan, second occupation by Ranjit Singh

19. *Pataka* symbol

20. *Trishul* symbol

21. Devaki in Gurmukhi

22. Devaki in Urdu

* The size of the coins and tokens as depicted in the photos presented in this chapter might be different from their real size.

COINS OF THE SIKHS FROM LAHORE

23. Silver rupee of the first year of rule by Sikh *misls* from Lahore in the year VS 1822 (1765)

24. Rupee of Lahore mint of VS 1856 (1799), the year in which Ranjit Singh took over Lahore from Bhangi Misl

25. Lahore rupee of the Sikhs of VS 1873 (1815) minted during the rule of Maharaja Ranjit Singh

26. Lahore rupee of the Sikhs of the year VS 1885/1902 (1845)

362

PICTORIAL RUPEE FROM THE LAHORE MINT

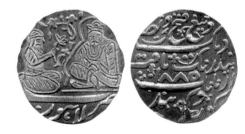

27. Pictorial rupee ostensibly minted for Naunihal Singh's wedding

COINS OF THE SIKHS FROM THE MULTAN MINT

28. Multan, first occupation by *misls* VS 1829 (1772)

29. Multan, first year of second occupation by Ranjit Singh

30. Multan, last year of rule by Sikhs

COINS OF THE SIKHS FROM RARE MINTS

31. Mint Islamgarh

32. Mint Muzang Achhra

33. Mint Dar Jhang

34. Mint Mankera VS 1879 and 1880
(1822 and 1823)

35. Uncertain Mint VS1889 (1832)

36. Mint Nimak (Pind Dadan Khan) VS
1904 and 1905 (1847 and 1848)

37. Mint Dera Ghazi Khan

NANAKSHAHI RUPEES FROM THE AMRITSAR MINT

38. VS 1832 (1775) the first year of issue from Amritsar by Sikh *misls*

39. VS 1842 (1785) with 316, the number of years elapsed since the birth of Guru Nanak, on the obverse

40. VS 1845 (1788) the year in which the leaf symbol was introduced on Sikh coins

364

41. VS 1848 (1791) first year of final design of Amritsar rupees that stayed nearly until the end of Sikh rule

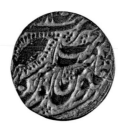

42. VS 1858 (1801) Commemoration signified by decorated leaf

43. VS 1862 (1805) Ber Shahi coin

44. VS 1862 Moran/Mora Shahi coin with clandestinely hidden peacock

45. VS 1862 Phullan Shahi (earlier erroneously called Aarsi)

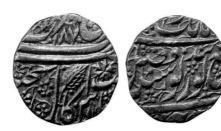

46. VS 1870 (1813) different arrangement of legend on the reverse

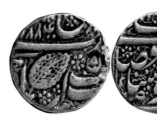

47. VS 1884/86 (1827/29) frozen year series 1884 with actual year of minting VS(18)86 on the obverse

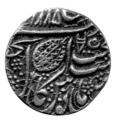

48. Dagger symbol on the reverse

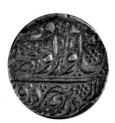

49. Trident on the obverse

50. *Chhattar* on the obverse

51. *Pataka* below *chhattar* on the obverse

52. Double *Pataka* on the obverse

53. "Om" in crude Devanagri on the obverse

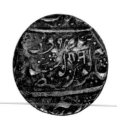

54. "Ram" in Devanagri on the obverse

55. Rose on the reverse

GOBINDSHAHI COINS FROM THE AMRITSAR MINT

————— Early Gobindshahi ————— ————— Late Gobindshahi —————

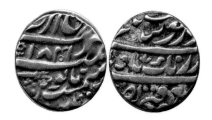 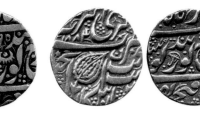

56. Silver rupee of VS 1841 (1784), the first year of minting of coins of early Gobindshahi series

57. VS 1865 (1808), the second last year of minting of early Gobindshahi coins

58. VS 1884/95 (1827/38) the first year of minting Gobindshahi coins in the 1884 frozen year series

59. An umbrella-like symbol on a coin of the year VS 1884/1900 (1827/43) from the Gobindshahi series

KASHMIR MINT

60. Silver rupee of VS 1876 (1819), the first year of rule by the Sikhs, from Kashmir mint

61. Coin with "Har" written in Gurmukhi

62. Flag on coin of Kashmir mint

63. Symbol of sword and quoit symbolizing Mihan Singh Kumedan as governor in the year VS 1897 (1840)

365

PESHAWAR MINT

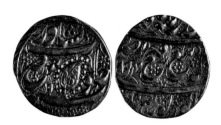

64. Silver rupee of the year VS 1894 (1837)

ANANDGARH MINT

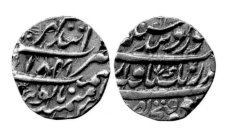

65. Silver rupee of the year VS 1841 (1784) the first year of minting coins from Anandgarh

DERA JAT MINT (DERA ISMAIL KHAN)

66. Mehmoodshahi rupee from Derajat of the year AH 1243 (1827) minted by Nawab Sher Mohammad as a retainer of Ranjit Singh

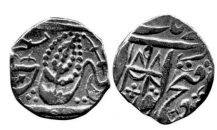

67. Silver rupee of the year VS 1898 (1841) with Gurushahi couplet on obverse

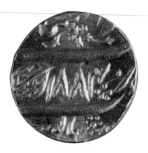
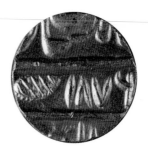
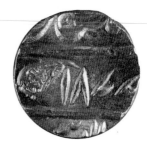

68. Gold *mohur* of Lahore Mint VS 1885/96 (1828/39)

69. Gold *mohur* of Lahore Mint VS 1884/85 (1827/28)

70. Gold *mohur* of Multan Mint VS 1876 (1819)

71. Gold *mohur* of Multan Mint VS 1877 (1820)

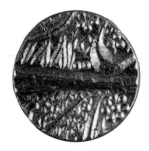

72. Gold *mohur* half of Amritsar VS 1884 (1827)

73. Gold *mohur* of Amritsar Ber Shahi VS 1862 (1805)

74. Phullan-Shahi gold *mohur* of Amritsar VS 1863 (1806)

75. Gold *mohur* half of Amritsar VS 1880 (1823)

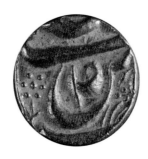
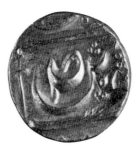
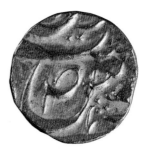

76. Gold *mohur* of Sikh ruler Mahender Singh of Patiala state

77. Gold *mohur* of Sikh ruler Amar Singh of Patiala state

78. Gold *mohur* of Sikh ruler Narinder Singh of Patiala state

79. Gold *mohur* of Sikh ruler of Kaithal state

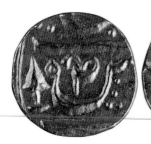

80. Gold *mohur* of Sikh ruler Bhupinder Singh of Patiala state

81. Gold *mohur* of Sikh ruler Hira Singh of Nabha state

82. Gold fraction, uncertain mint

EXTREMELY RARE AND UNIQUE SIKH COINS: FRACTIONS AND OF DIFFERENT SHAPES (INCLUDING MULTAN GOLD RUPEE)

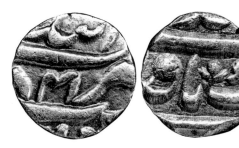

83. Half rupee, Anandgarh Mint

84. Half rupee, Dar Jhang Mint

85. Half rupee, Derajat Mint

86. Half rupee, Amritsar

87. Half rupee, Amritsar

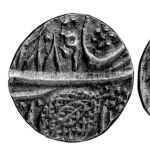

88. Half rupee, uncertain mint

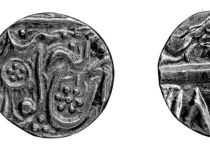

89. Half rupee, Lahore

367

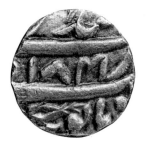

90. Half rupee, Anandgarh Mint

91. Half rupee, Ber Shahi Amritsar Mint

92. Diamond-shaped half rupee, VS 1882 (1825) Amritsar Mint

93. Diamond-shaped half rupee, Dar Jhang Mint

94. Diamond-shaped half rupee, VS 1883 (1826) Amritsar Mint

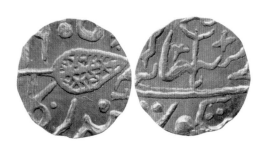

95. An emergency gold rupee of Multan of VS 1905 (1848) minted in Multan Fort during the Second Anglo-Sikh War

96. Half rupee, Lahore VS 1857 (1800)

97. Half rupee, Amritsar VS 1884/91 (1827/34)

COINS OF SIKH RULERS OF VARIOUS CIS-SUTLEJ STATES

Coins Attributed to the Almighty (Gurushahi Coins)

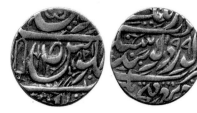

98. Gobindshahi rupee of Patiala state
ruler Narindar Singh

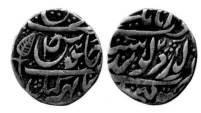

99. Gobindshahi rupee of Nabha state
ruler Bharpur Singh

100. Gobindshahi rupee of Nabha state
ruler Hira Singh

Coins Attributed to Ahmed Shah Abdali

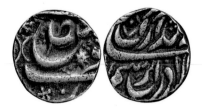

101. Silver rupee of Nabha state ruler
Hira Singh

102. Silver rupee of Kaithal state of VS
1851 (1794) ruler Lall Singh

103. Silver rupee of Kaithal state of
VS 1853 (1796) ruler Lall Singh

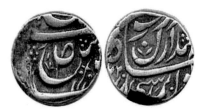

104. Silver rupee of Patiala state ruler
Amar Singh

105. Silver rupee of Patiala state ruler
Karm Singh

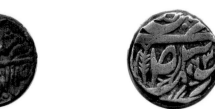

106. Silver rupee of Patiala state ruler
Narindar Singh

107. Silver rupee of Patiala state ruler
Rajender Singh

108. Silver rupee of Patiala state
uncertain ruler

109. Only non-Sikh state Malerkotla ruler
Umar Khan

110. Jind state ruler Raja Gajpat Singh

111. Jind state ruler Raja Fateh Singh

112. Jind state ruler Raja Sarup Singh

VARIOUS TOKENS AND MOTIFS OF THE SIKHS

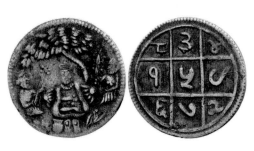

113. Guru Nanak with numbers on the reverse

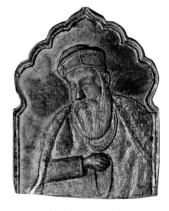

114. Guru Nanak

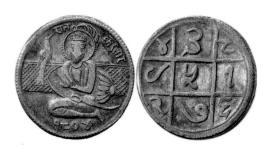

115. Guru Gobind Singh with numbers on the reverse

116. Guru Tegh Bahadur

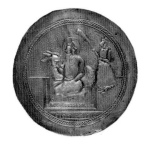

117. Guru Hargobind

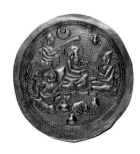

118. Guru Nanak

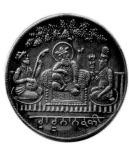

119. Guru Nanak with Mool Mantar on the reverse

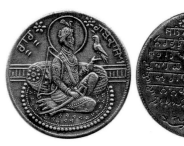

120. Guru Gobind with Mool Mantar on the reverse

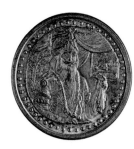

121. Maharaja Ranjit Singh

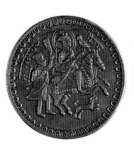

122. Guru Gobind with Mool Mantar on the reverse

123. Guru Tegh Bahadur with Mool Mantar on the reverse

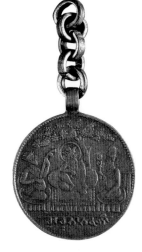

124. Guru Nanak

125. Guru Nanak and Guru Gobind Singh

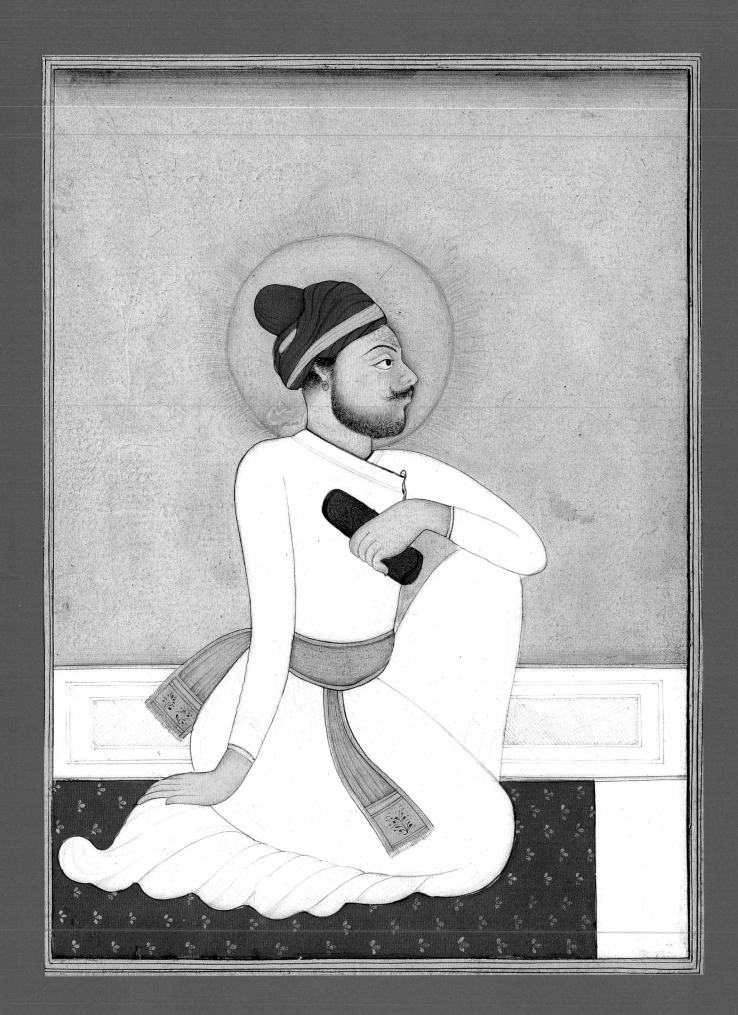

10

MISCELLANEOUS ILLUSTRATIONS IN THE KHANUJA FAMILY COLLECTION

THE LOCKWOOD KIPLING ALBUM

John Lockwood Kipling (1837–1911) was a British artist, curator and school administrator who documented and promoted traditional Indian architecture, arts, and crafts. From 1875 until his retirement in 1893, he served as principal of the Mayo School of Art (now the National College of Arts, Pakistan) and a curator of the Lahore Central Museum.

Kipling compiled an album containing photographs of Amritsar, Lahore, and other sites in India. Signed and dated to Lahore, 1888, Kipling's albums included some 120 photographs, laid down on pages with annotations, sketches, and a handwritten list of contents. These photos provide fascinating glimpses of life in Punjab in the late nineteenth century, captured by renowned photographers such as Samuel Bourne and Lala Deen Dayal, but also by a few unidentified local amateurs. In this chapter we present a selection of photos from Kipling's album, which has been displayed as part of the traveling exhibition *John Lockwood Kipling: Arts and Crafts in the Punjab and London* held at the Victoria and Albert Museum in London from January to April 2017 and at the Bard Gallery in New York from September 2017 to January 2018.

PHOTOGRAPHS AND PAINTINGS OF AMRITSAR AND LAHORE

A number of works in this collection focus on the cities of Amritsar and Lahore which were central to the Sikh Empire. Today, they are also representative of the Punjab that exists on both sides of the Indo-Pakistan border. Amritsar (originally called Ramdaspur) was founded by Guru Ramdas and started to grow under Guru Arjan Dev after the construction of the Harmandir Sahib. The Harmandir Sahib was later protected by Gobindgarh Fort, and the walled city was surrounded by gates. Under Maharaja Ranjit Singh, Amritsar grew to be the largest cosmopolitan and culturally diverse city of Punjab with numerous bazaars doing business with countries including India, Afghanistan, Central Asia, China, Persia, Russia and as well as the European continent. The city became the spiritual capital of the Khalsa empire and an economic powerhouse.

Lahore is the largest city in the Punjab province of present-day Pakistan. The city has a rich history that spans more than thousand years. Lahore was controlled by multiple empires and for a time it served as the capital of the Sikh Empire. The city was a major cultural, cosmopolitan, and heritage center thanks to its multiple mosques, temples, and shrines. In this chapter we present a series of photographs on glass dry plate negatives, depicting the two cities between 1900 and 1910.

PEOPLE AND PERSONALITIES

Another key part of the Khanuja Family Collection are the paintings and photographs depicting important historical figures as well as ordinary people and their lives. The works are in a broad range of styles: anthropological drawings, royal portraits, and modern and contemporary mixed media interpretations. Among them are Arpana Caur's sketches of literary figures and some of the well-known Sikh women from different spheres of life. The collection also features approximately

1. Sikh nobleman seated on terrace, holding a pen box

Chajju | *c.* 1840 | 7.5 x 5.5 in | Gouache and gold on paper

Artist Chajju was the grandson of Nainsukh and son of Nikka, who served in Maharaja Ranjit Singh's court in Lahore.

372

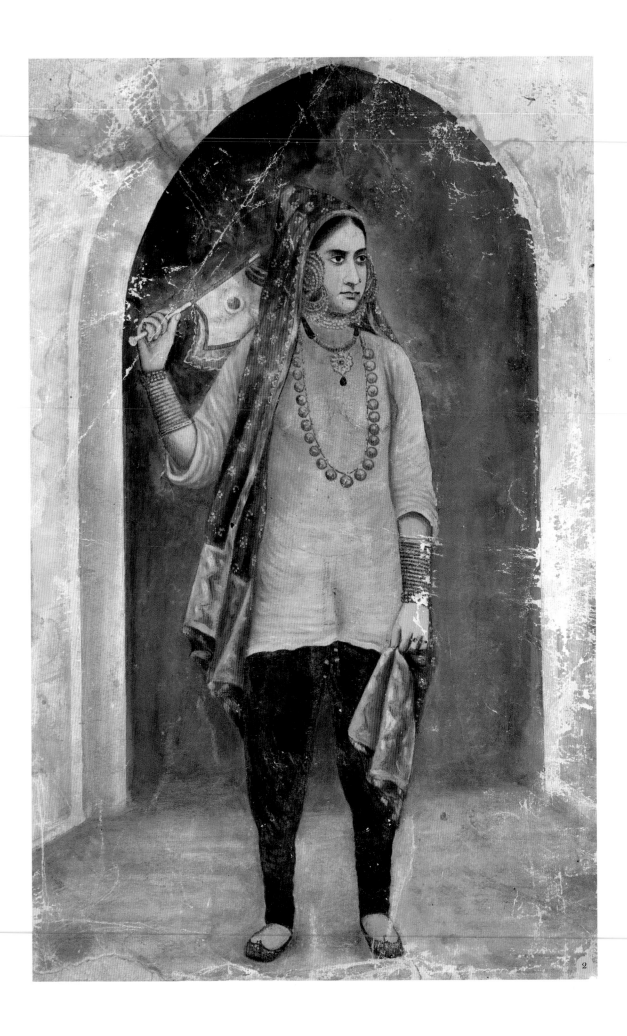

2

sixty watercolor paintings of royalties and people from Punjab by Amal Bahauddin Peshawari which are compiled in an album. In this chapter we also introduce a few of these paintings along with some works from nineteenth-century artists Kapur Singh, Kehar Singh, and Bishan Singh. The latter, in particular, produced unique and captivating artwork thanks to his use of vibrant colors and his mastery at depicting immaculate details.

BHAI RAM SINGH

Active between the end of the nineteenth and the early twentieth century, Bhai Ram Singh was among Punjab's foremost architect of his time. He was a pupil of John Lockwood Kipling and studied at the Mayo School of Art. In 1882–83, he designed a new building for the Mayo School of Art, of which he would later serve as principal from 1903 to 1913. His other important works include the Lahore Museum, Aitchison College, and Punjab University, all situated in Lahore. Additionally, he designed the Governor's House in Simla and worked with Kipling to design the Durbar Room in Osborne House, England, for Queen Victoria. In this chapter, we present a painting depicting Bhai Ram Singh and, behind him, some of his most important works, namely the Khalsa College, the Lahore Museum, and the Osborne House. We also have included some of his sketches and private communication with Buckingham Palace, the Khalsa College, and the Saragarhi Memorial regarding the projects he worked on.

PUNJAB HILLS (PAHARI) PAINTINGS

The term *pahari* (from the mountains) is used by art historians to describe a style of painting mostly done in miniature forms produced between the seventeenth and the nineteenth centuries. Pahari paintings originated in the Himalayan kingdoms of North India, notably Basohli, Mankot, Nurpur, Chamba, Kangra, Guler, Mandi, and Garhwal.

Among the most celebrated artists who produced Pahari paintings was Nainsukh (1710–78), a famous painter in Guler. He was the younger son of painter Pandit Seu, and their family workshop, where his older brother Manaku also worked, dominated that region for a few generations. In the neighboring district of Kangra, another family of artists led by the painter Purkhu emerged during the reign of Sansar Chand (1775–1823). In addition, most of these states had smaller local artists working throughout this period.

Maharaja Ranjit Singh became the ruler of the Himalayan states after defeating the Gurkhas and occupying Kangra Fort in 1809. The Pahari artists continued their traditional art and received the patronage of Sikh chiefs such as Desa Singh Majithia who served as an administrator in the region. In this chapter we present some examples of Pahari paintings that are part of the Khanuja Family Collection. In earlier chapters we show the work of the Pahari painters who did portrayals of the gurus and Sikh chiefs.

SIR JOHN SPENCER LOGIN

Sir John Spencer Login (1809–63) was a Scottish surgeon in British India, best remembered as the guardian of Maharaja Duleep Singh and of the Khalsa kingdom's *Toshakhana*, where the famous Koh-i-Noor diamond was stored, following the annexation of Punjab and the Last Treaty of Lahore. Here we present some of John Login and Lady Login's personal diaries that contain passages pertaining to Duleep Singh. These documents have not been thoroughly studied yet, and further research is necessary to fully appreciate their content.

Other books from the Khanuja Family Collection presented here include a grand illustrated manuscript on the history of Kashmir, most likely from the Lahore court of Ranjit Singh, and some volumes containing watercolors from the period. As in the case of John Login and Lady Login's diaries, these books also deserve further study.

2. A Sikh woman

Artist unknown |
c. Late 19th/Early 20th century |
15.5 x 10 in | Gouache on paper

Sikh woman in traditional dress, *jutti* (footwear), and a *dupatta* that covers her head. She is wearing gold jewelery round her neck, bangles on her wrists, and elaborate filigree earrings. The hand-made decorated fan she is holding is textile-based.

373

THE KIPLING ALBUM

The Lockwood Kipling Album: An album of photographs of Amritsar, Lahore and other sites in India compiled by John Lockwood Kipling, is signed and dated Lahore, 1888. With approximately 120 photographs (here 3–16), it contains images by photographers such as Samuel Bourne, Lala Deen Dayal and also by a number of unidentified photographers.

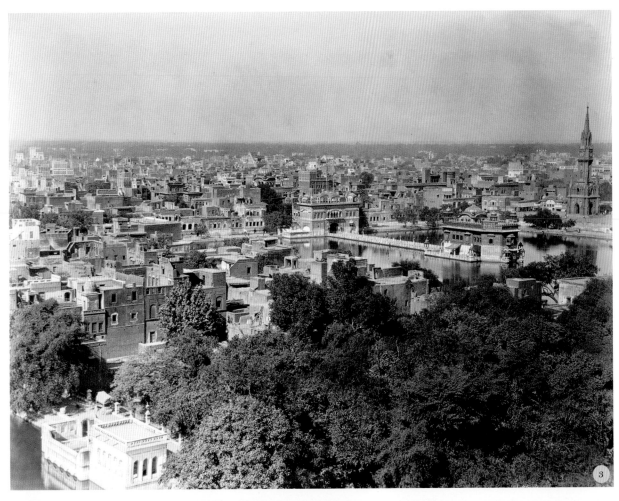

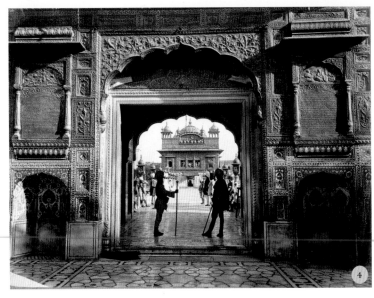

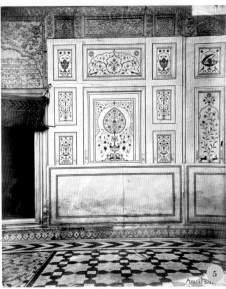

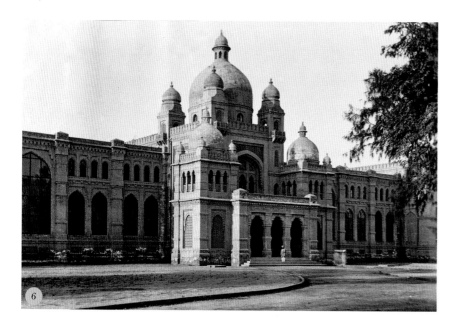

375

3. Panorama, Amritsar

Photographer unknown |
8 x 10.5 in | Albumen print

4. Golden Temple, Amritsar

Photographer unknown |
8 x 10.75 in | Albumen print

5. Marble Inlay, Golden Temple, Amritsar

Photographer unknown |
11.5 x 9.5 in | Albumen print

6. Lahore Museum

Photographer unknown |
5.25 x 7.5 in | Albumen print

7. Anarkali Tomb, Lahore, converted into a church in 1851 by the British

Photographer unknown |
5.5 x 8 in | Albumen print

8. Shalimar Gardens, Lahore

Photographer unknown |
5.5 x 7.6 in | Albumen print

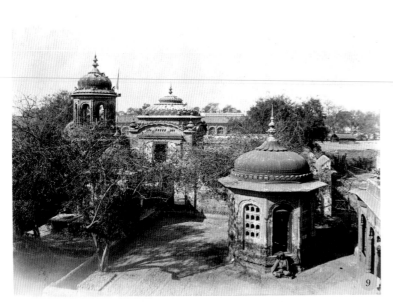

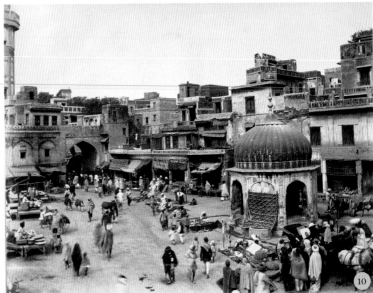

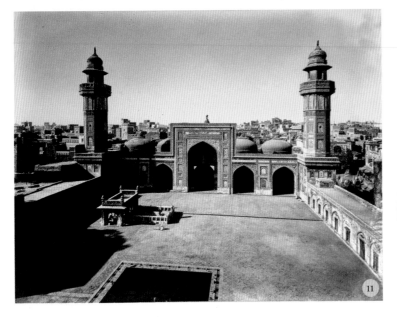

376

9. *Chobara* of Chajju Bhagat, Lahore

Photographer unknown | 8 x 10.6 in | Albumen print

10. Inside Delhi Gate of Lahore city, outer side of Wazir Khan mosque, with the minaret of the mosque on the far left

Photographer unknown | 8 x 10.75 in | Albumen print

11. Wazir Khan mosque, Lahore

Photographer unknown | 8.25 x 11 in | Albumen print

12. Hazoori Bagh, Lahore

Photographer unknown | 8 x 10.5 in | Albumen print

13. Naulakka Pavilion, Lahore

Photographer unknown |
5.5 x 8 in | Albumen print

14. Mochi Gate, Lahore

Photographer unknown |
9 x 9.5 in | Albumen print

15. Carved *chajja* (balcony), Lahore

Photographer unknown |
11.5 x 9 in | Albumen print

16. Carved window, Lahore

Photographer unknown |
7.75 x 8 in | Albumen print

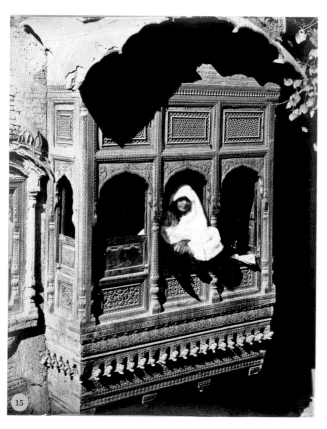

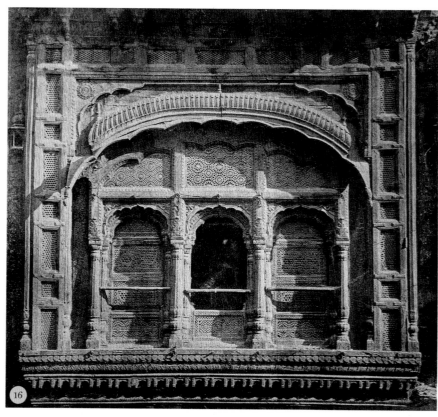

AMRITSAR

Founded by Guru Ramdas in late 1570s, the town was earlier known as Ramdaspur. Guru Ramdas started the excavation of the sacred pool, called the Amrita Saras (Pool of Nectar), from which the city has got its name. To start the city, the guru invited fifty-two traders from different sectors from the nearby villages and towns. Amritsar grew in significance and in population under Guru Arjan Dev after he installed the Adi Granth in the Harmandir Sahib in 1604.

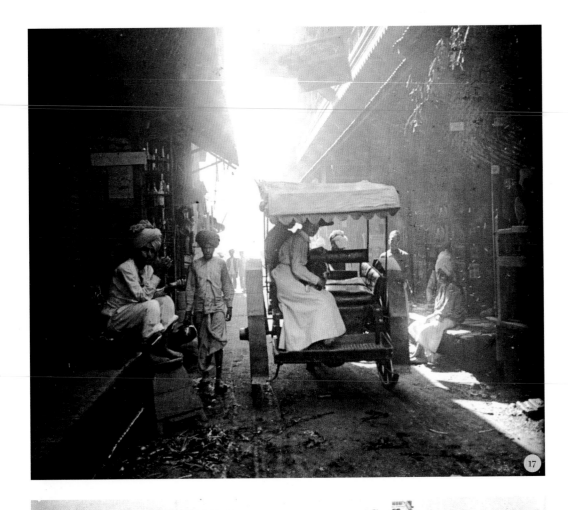

17. Street scene, Miss Smith on *tonga*

Photographer unknown | *c.* 1900-10 | 1.5 x 4 in | Glass plate negative

18. Street scene

Photographer unknown | *c.* 1900-10 | 1.5 x 4 in | Glass plate negative

19. Street scene

Photographer unknown |
c. 1900–10 | 1.5 x 4 in |
Glass plate negative

20. Street scene

Photographer unknown |
c. 1900–10 | 1.5 x 4 in |
Glass plate negative

21. Group of women,
Amritsar street

Photographer unknown |
c. 1900–10 | 1.5 x 4 in |
Glass plate negative

22. Near Rambagh Gate,
Amritsar

Photographer unknown |
c. 1900–10 | 1.5 x 4 in |
Glass plate negative

380

23. Street scene

Photographer unknown |
c. 1900-10 | 1.5 x 4 in |
Glass plate negative

24. Street scene

Photographer unknown |
c. 1900-10 | 1.5 x 4 in |
Glass plate negative

25. Street scene

Photographer unknown |
c. 1900-10 | 1.5 x 4 in |
Glass plate negative

26. Woman in burqa near Rambagh Gate

Photographer unknown |
c. 1900-10 | 1.5 x 4 in |
Glass plate negative

27. Street at Aloowala Katra

Felice Beato | 1859 |
11.7 x 9.5 in | Albumen print

27

LAHORE

A city with a turbulent history, Lahore was part of the Mughal Empire and was expanded during the reign of Shah Jahan. With the decline of Mughal influence, the fort city was soon associated with the rise of the Sikhs and became a center of power during Maharaja Ranjit Singh's reign.

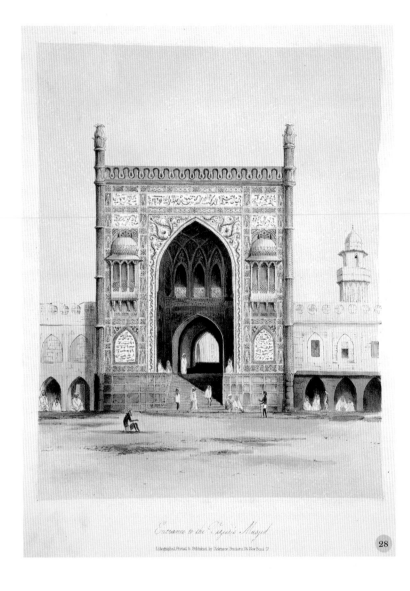

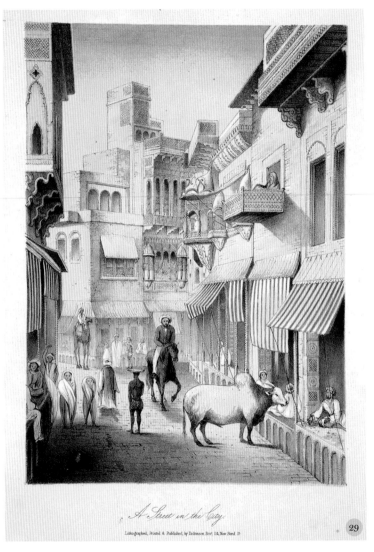

28. Wazir Khan mosque, Lahore from *Original Sketches in the Punjaub. By a Lady.*

c. 1854 | 10.5 x 8.5 in | Hand-colored lithograph

29. A street in Lahore from *Original Sketches in the Punjaub. By a Lady.*

c. 1854 | 10 x 7.5 in | Hand-colored lithograph

FAKIR.

HINDOO: DISCIPLE OF NANUK.

BAREILLY.

(123)

30

A SODHEE.
SIKH.
LAHORE.
(240)

31

SIKH JAT.
OF THE SINDHOO CLAN.
LAHORE.
(233)

32

30. A Nanakpanthi fakir, Bareilly

Photographer unknown |
c. 1865 | 5.1 x 3.7 in | Albumen print

31. A member of the Sodhi family
related to Guru Gobind Singh, Lahore

Photographer unknown |
c. 1865 | 5.3 x 3.8 in | Albumen print

32. A Sikh farmer, Lahore

Photographer unknown | c. 1865 |
6 x 4.4 in | Albumen print

Sophia Duleep Singh

Prakash Kaur

Inderjeet Kaur

Anarkali Kaur

Amrita Pritam

Ajeet Caur

Amrita Shergill

33

33. Outstanding Sikh women

Arpana Caur | 2020 |
11.5 x 16.5 in | Pencil and pastel
on paper

(Clockwise from top left): Sophia
Duleep Singh (social activist),
Prakash Kaur (social activist),
Inderjeet Kaur (social activist),
Anarkali Kaur (women's rights
activist), Amrita Sher-Gil (artist),
Ajeet Kaur (artist), and Amrita
Pritam (litterateur) – all these
women are unique in their own ways
and in their chosen fields.

34. Prof. Puran Singh and Bhai Vir Singh ji

Arpana Caur | 2020 |
8.5 x 11.5 in | Pencil and pastel
on paper

Bhai Vir Singh (1872–1957, on the
right) is celebrated as the "Sixth River
of Panjab." He was a mystic, poet,
novelist, essayist, historian, editor,
publisher, journalist, and a leading
figure in the Singh Sabha movement,
a dynamic Sikh renaissance in late
nineteenth/early twentieth-century
Punjab. Professor Puran Singh (1881–
1931, on the left) was a scientist,
linguist, poet, mystic, thinker, and
aesthete. He was a lover of nature and
wrote poetry in English and Gurmukhi.

35. Literary giants

Arpana Caur | 2020 |
9.75 x 12.75 in | Pencil and pastel
on paper

(From left to right): Kahn Singh
Nabha (1861–1938) was a Sikh
writer and scholar. He played a
crucial role in the Singh Sabha
movement and is well known for
his works, *Mahan Kosh* (known as
the Sikh encyclopedia) and *Hum
Hindu Nahin*. Khushwant Singh
(1915-2014) was a well-known
author, journalist, and editor from
an illustrious family. Devendra
Satyarthi (1908–2003) was an Indian
folklorist and writer of Hindi, Urdu,
and Punjabi literature.

Prof Puran Singh

Bhai Vir Singh

Arcana
2020

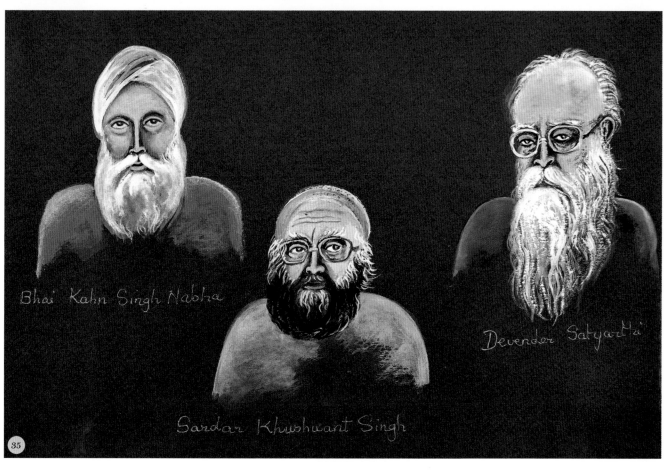

Bhai Kahn Singh Nabha

Sardar Khushwant Singh

Devender Satyarthi

AMAL BAHAUDDIN PESHAWARI

Items 36–45 are from a series of approximately sixty watercolor paintings of royalty and people from Punjab, compiled in an album in the 1860s.

36. Maharaja Ranjit Singh

Amal Bahauddin Peshawari |
c. 1860s | 5.5 x 7.5 in | Watercolor

37. Maharaja Kharak Singh

Amal Bahauddin Peshawari |
c. 1860s | 5.5 x 7.5 in | Watercolor

38. Maharaja Duleep Singh

Amal Bahauddin Peshawari |
c. 1860s | 5.5 x 7.5 in | Watercolor

39. Raja Chattar Singh Attariwala

Amal Bahauddin Peshawari |
c. 1860s | 5.5 x 7.5 in | Watercolor

40. Life at farm

Amal Bahauddin Peshawari |
c. 1860s | 5.5 x 7.5 in | Watercolor

41. A farmer with a bullock

Amal Bahauddin Peshawari |
c. 1860s | 5.5 x 7.5 in | Watercolor

42. A street vendor showing monkey tricks

Amal Bahauddin Peshawari |
c. 1860s | 5.5 x 7.5 in | Watercolor

43. Barber

Amal Bahauddin Peshawari |
c. 1860s | 5.5 x 7.5 in | Watercolor

44. Cloth dyer

Amal Bahauddin Peshawari |
c. 1860s | 5.5 x 7.5 in | Watercolor

45. A couple working on a spinning wheel and a weaving loom

Amal Bahauddin Peshawari |
c. 1860s | 5.5 x 7.5 in | Watercolor

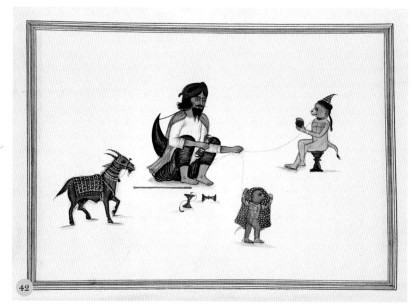

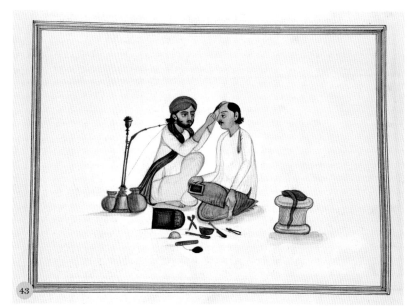

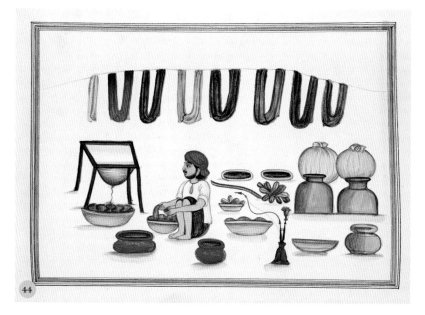

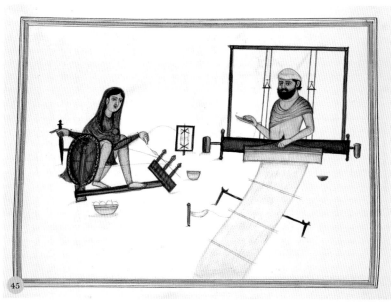

KAPUR SINGH

Commonly referred to as "Kapur Singh of Amritsar," he is considered to be one of the most famous Sikh artists of the nineteenth century. Singh worked almost entirely in watercolors, concentrating on Company style of painting depicting general life in Punjab.

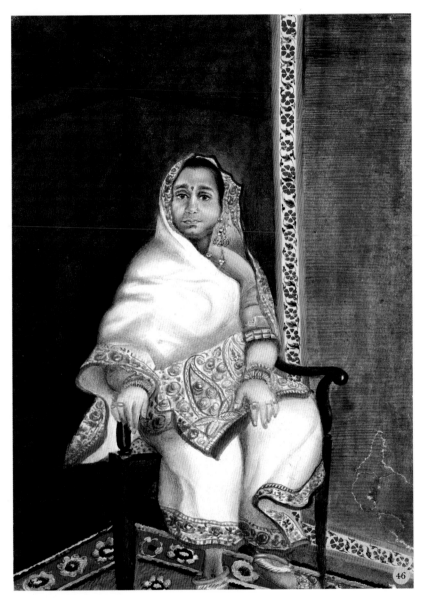

46. A lady, most probably Pahari

Kapur Singh | *c.* 1866 | 8 x 6 in |
Watercolor

47. A boy

Kapur Singh | *c.* 1866 | 6 x 3.5 in |
Watercolor from an album
commissioned by
August W. Honner, Punjab

KEHAR SINGH

Kehar Singh worked in the court of Maharaja Ranjit Singh and moved to Kapurthala after the death of his patron. Coming from an illustrious family of *mussavars* and *naqqashas*, he also made lightly-colored sketches of ordinary people, traders, ascetics, craftsmen, and figures from different castes and tribes.

48

48. A sketch of two noblemen seated in discussion

Kehar Singh | *c.* 1875 | 8.5 x 6.25 in | Pen and ink and watercolor on paper

This painting appears to be part of a well-documented series on trades and occupations.

BISHAN SINGH

Nephew of Kehar Singh, Bishan Singh was well-known for his realistic art in the cities of Lahore and Amritsar. The paintings presented here (49–53) are attributed to him.

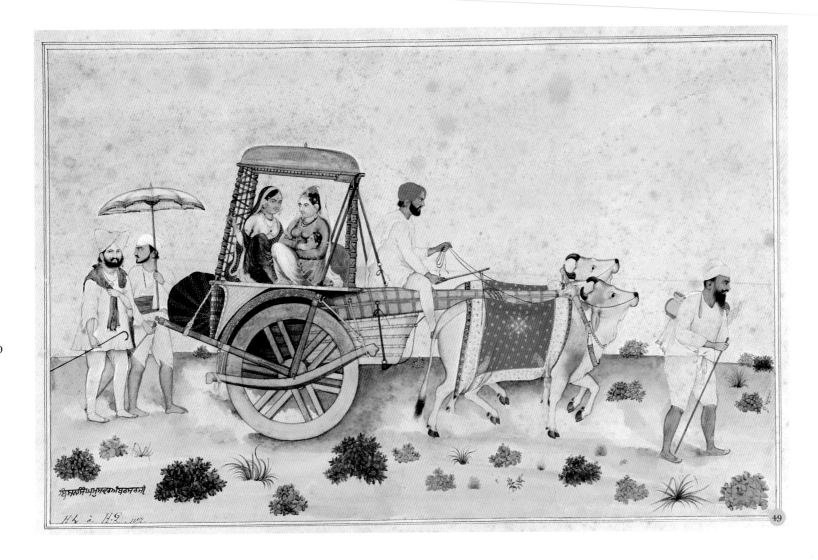

49. Women in bullock cart

Bishan Singh | *c.* 1872 | 5.6 x 4.7 in | Gouache and gold on paper

50. Tradesman, bookbinder

Bishan Singh | *c.* 1860–80 | 5.8 x 4.9 in | Gouache and gold on paper

51. Tradesman, mirror maker

Bishan Singh | *c.* 1860–80 | 5.7 x 4.8 in | Gouache and gold on paper

52. Tradesman, wool merchant

Bishan Singh | *c.* 1860–80 | 5.6 x 4.7 in | Gouache and gold on paper

53. Tradesman, metalsmith

Bishan Singh | *c.* 1860–80 | 7 x 5 in | Gouache and gold on paper

50

51

52

53

RAM SINGH

Bhai Ram Singh (1858–1916), was one of pre-partition Punjab's foremost architects, dominating the scene for nearly two decades. In 1882–83, he designed a new building for the Mayo School of Art. His other prominent works include the Lahore Museum, Aitchison College, and Punjab University, all in Lahore. He also designed the Governor's House in Simla, Khalsa College in Amritsar, and worked with John Lockwood Kipling to design the Durbar Room in Osborne House, England for Queen Victoria.

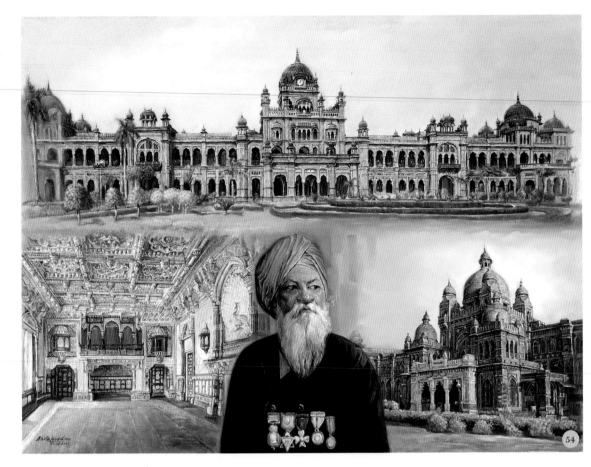

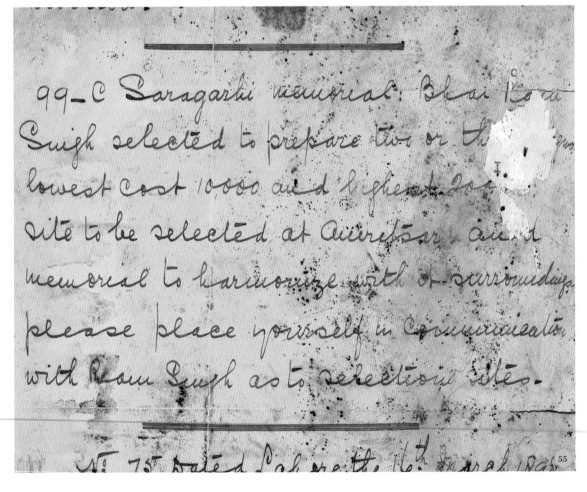

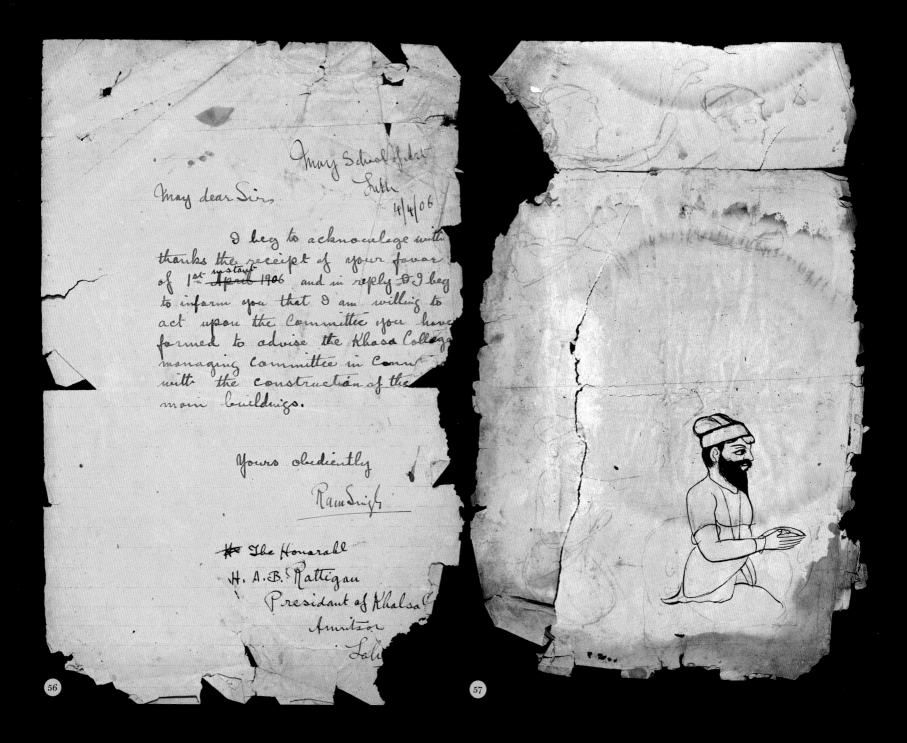

May School of Art
Lahore
4/4/06

May dear Sirs,

I beg to acknowlege with thanks the receipt of your favor of 1st instant April 1906 and in reply I beg to inform you that I am willing to act upon the Committee you have formed to advise the Khasa College managing Committee in Conn with the construction of the main buildings.

Yours obediently
Ram Singh

The Honorable
H. A. B. Rattigan
President of Khalsa
Amritsar
Lah

56

57

54. Bhai Ram Singh
Bholla Javed | 2020 | 27 x 36 in | Oil on canvas

55. Ram Singh's letter, Sargarhi Memorial
Early 1900s | 11 x 8 in

56. Ram Singh's correspondence with Khalsa College, Amritsar
April 1906 | 10 x 8 in

57. Sketch
Bhai Ram Singh | Early 1900s | 15 x 10 in | Ink on paper

August 20/92

Buckingham Palace.

Colonel Egerton is desired by H. R. H. The Duke of Connaught to ask Mr. Ram Singh - if he could make it convenient to meet this Royal Highness on Thursday

58

59

58. Ram Singh's correspondence with Buckingham Palace

1892 | 7 x 4.5 in

59. Sketch

Bhai Ram Singh | Early 1900s |
6.5 x 4 in | Ink on paper

60. Sketch

Bhai Ram Singh | Early 1900s |
12 x 20 in | Ink on paper

**64. Krishna and Radha
in a palace pavilion**

Artist unknown (Kangra) |
c. 1810-20 | 8 x 6 in |
Gouache and gold dust

65. Todi Ragini

Artist unknown (Guler) |
c. 1840-60 | 10 x 8 in |
Gouache and gold dust

A woman in a bright yellow dress plays
a *veena*, followed by a grey buck. In
the background stands a blossoming
tree and a banana tree.

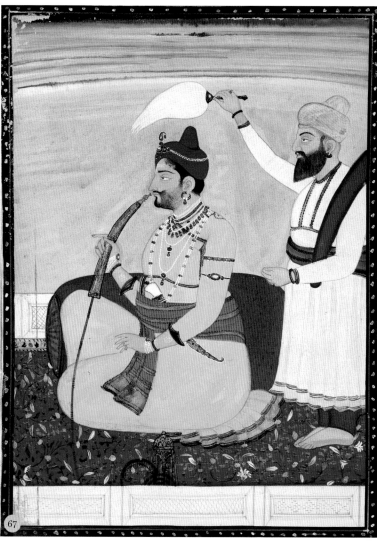

399

66. Young Sikh prince with an
attendant seated on a balcony
receiving a priest

Artist unknown (Guler) | *c.* 1820 |
11 x 9 in | Gouache on paper

67. Maharaja Sansar Chand of
Kangra on a terrace smoking a
hookah with an attendant waving
a fly whisk

Purkhu (Kangra) | *c.* 1800–05 |
11.75 x 8.25 in | Gouache on paper

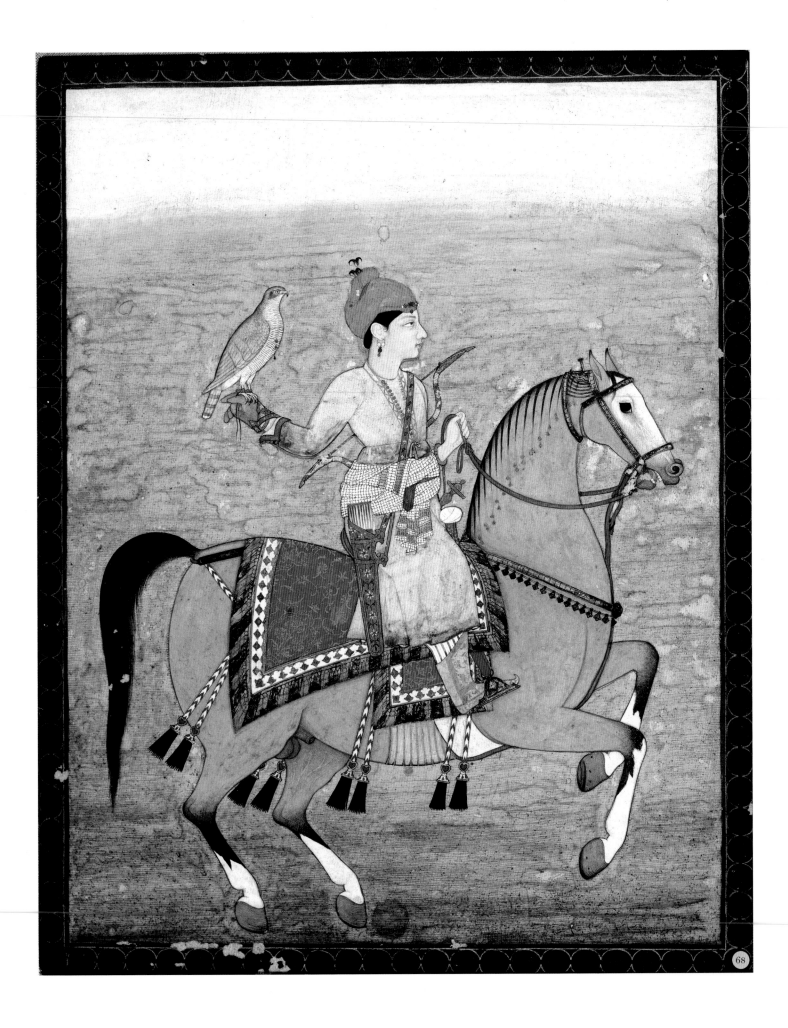

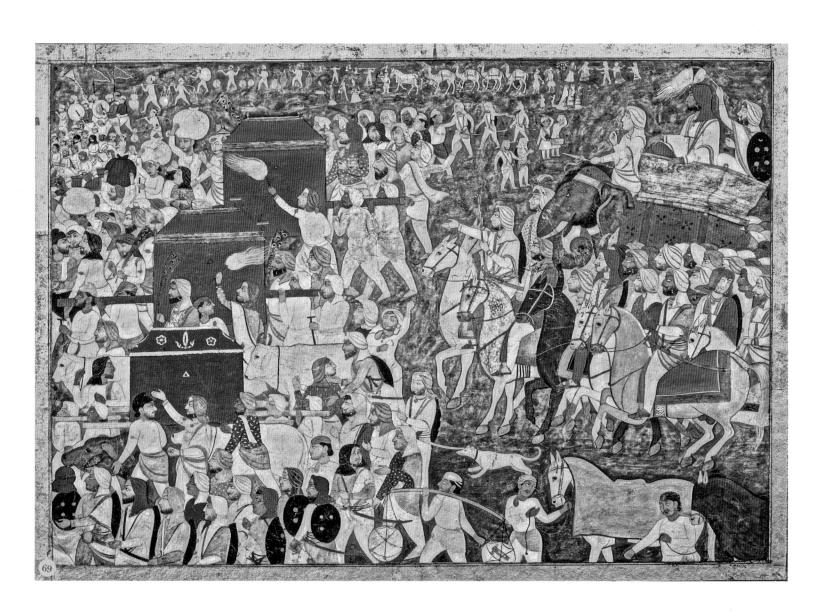

68. A Sikh prince on horseback with a falcon resting on his hand

Manaku-Nainsukh family | *c.* 1800 |
8.75 x 7 in | Gouache on paper

69. A processional scene of Maharaja Jai Singh of Guler, Punjab Hills

Artist unknown (Guler) | *c.* 1840–50 |
12.6 x 17.7 in |
Gouache and gold on paper

MANUSCRIPTS

Folios from an illustrated manuscript (70–75) on the history of Kashmir from the early nineteenth century.

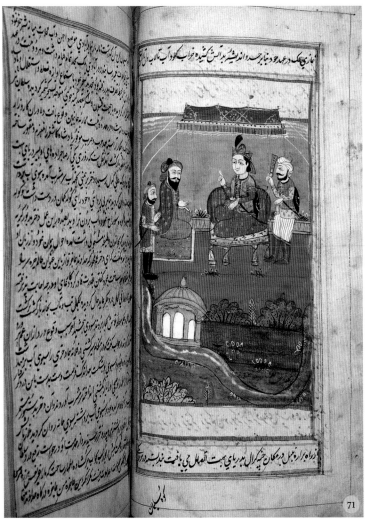

70. Probably Maharaja Ranjit Singh top right, Gulab Singh on the carpet below

Artist unknown | *c.* Early 19th century | 10 x 6 in | Watercolor

71. Prince sitting under a red canopy

Artist unknown | *c.* Early 19th century | 10.5 x 5 in | Watercolor

72. A king seated in fort appears to illustrate the moment of the invasion of the Durranis

Artist unknown | *c.* Early 19th century | 10 x 5 in | Watercolor

73. A learned man teaching

Artist unknown | *c.* Early 19th century | 9 x 5 in | Watercolor

74. Older gentleman and a lady against the backdrop of a mountain

Artist unknown | *c.* Early 19th century | 10 x 5 in | Watercolor

75. A warrior mounted on a blue horse

Artist unknown | *c.* Early 19th century | 10.75 x 5 in | Watercolor

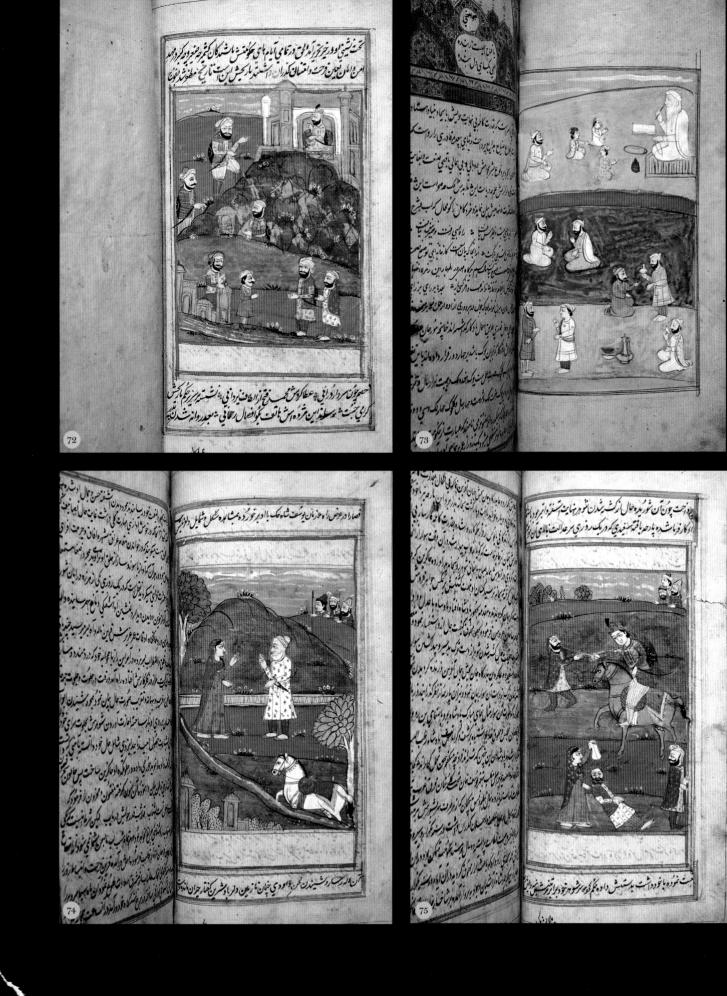

76

Milan 27 April 1857

My dear Sir James

I had the pleasure to receive your note
of the 22 Yesterday that of the 13 which you had addressed
to Geneva having been also forwarded here. We reached
this on the 24 and have been detained here both on account
of the Maharajah and Mr Melville —

His Highness is I am thankful today
getting on very well and will be quite strong enough to travel
in a few days and to undergo any ordinary fatigue — but his
Companion Mr Melville will I fear be unable to leave this
for a fortnight and even then will require to travel very slowly
It is likely, therefore that Lady Logan and I will leave here in
charge of his father and mother whom we expect to join him
in a few days and that we shall proceed with the Maharajah
to Geneva, probably by the Simmel Cenis route — The Maharajah
after his recent illness will be very glad to find himself
safely back again at Castle Menzies as soon as possible —
I shall deny myself the pleasure of writing to you again as soon
as we are fairly started on our journey —

His Highness desires me to offer his best thanks
to you for your kind wishes —

Yours faithfully
Sir James C. Melville Kte. [Ly] J. S. Logan
India House —

Turin 3 May 1857

Dear Sir

As I expect to pass through Paris about the 12
with H. H. the Maharajah on our way to England, it may here
I moreover give me an opportunity of meeting you there or at
any other place on our route to arrange matters, if possible, for a lease
of Castle Menzies after the expiry of our present agreement, I shall

77

Lady Logan

78

1857

Dec 17th 1856.

Embarked at Folkestone, delightful passage. was
greatly amused watching different groupes on board
one middle-aged couple sat poring over guide books and
maps already, with spectacles on, looking so serious
they were evidently setting out on a tour of great
importance! Ronald feeling chilly had coolly put
on a plaid belonging to a fellow-passenger, in
the belief that it was mine, the owner was in
despair at having lost it, when he caught
sight of it on R's shoulders, who declared it
belonged to me & would not give it up un-
til I had disowned it. slept at Boulogne after
having had our first experience of foreign custom
houses. R— went out to visit a friend. & found
out, after having asked a woman his way in
bad French & been replied to in equally bad,
that she was English as well as himself!
18th Left Hotel de Bains for Paris. passed through
an uninteresting country generally, though we
passed the site of the battle of Cressy, and
took up our abode at Hotel Brighton, Rue
de Rivoli.
19th Spent the day at the Louvre
20th Today we were greatly interested at the Ghobelins
manufactory of Tapestry, also at the Luxembourg

79

Manuscripts closely related to the last maharaja of Punjab, Duleep Singh, who was deposed as a child and was under the guardianship of Sir John Login and Lady Lena Login.

80

81

A VICTIM OF THE ENTENTE CORDIALE

BY

E. DALHOUSIE LOGIN

after placing the amulet on his arm, and admiring the diamond "replaced it in its box, which, with the topaz, he made over to Belee Ram, to be placed in the Toshkhana, under the charge of Misr Bustee Ram Toshkhana. After a little while it was taken by the Maharajah to Amritsar, under charge of Belee Ram" (the narrator's elder brother), "along with other articles of the Toshkhana, and carried with the Maharajah, wherever he went, under a strong guard.

"It was always carried in a large camel trunk, placed on the leading camel (but this was known only to the people of the Toshkhana), the whole string of camels, which generally consisted of about one hundred, being well guarded by troops. In camp, this box was placed between two others alike, close to the pole of the tent, Misr Belee Ram's bed being very close to it, and none but his relations and confidential servants having access to the place.

"For four or five years it was worn as an amulet, then fitted up as a sirpêsh for the turban, with a diamond drop of a tolah weight attached to it. It was worn in this manner for about a year, on three or four occasions, when it was again made up as an amulet, with a diamond on each side, as at present. It has now been used as an amulet for upwards of twenty years."

Shortly before the death of Runjeet Singh, when the old Lion of the Punjab lay speechless, the Wazeer, Rajah Dhyan Singh, tried to induce the Treasurer, Belee Ram to give up the Koh-i-noor, on the pretext that the Maharajah had willed it to the

76–77. Copies of letters from and to Dr. John Login, written in the course of and relating to his guardianship of Maharaja Duleep Singh, variously London, Scotland, Venice, and Geneva

1857-58 | 13.25 x 9 in (21 leaves)

78–79. Lady Lena Login's handwritten travel diary, recounting part of the four-month tour accompanying Duleep Singh through France and Italy

c. 1856-57 | 9 x 6.5 in (each)

80–81. A typewritten memoir, The Koh-i-Noor in the *toshakhana* of the "Great Maharajah" by E. Dalhousie Login, daughter of Dr. John Login, guardian of Maharaja Duleep Singh

c. 1914-18 | 10.5 x 8.5 in (each)

82–83. *The Maharajah Duleep Singh and the Government: A Narrative*

9 x 6.5 in | 1884

FOR PRIVATE CIRCULATION.

Dorothy Loreen
for PW July 1884

THE

MAHARAJAH DULEEP SINGH

AND

THE GOVERNMENT.

A NARRATIVE.

82

CHAPTER XI.

INTERPRETATION OF THE TREATY OF 1849.

Chap. XI. It seems comparatively unimportant whether the document signed at Lahore on the 29th March 1849, and ratified by the Governor-General of India on the 5th April of the same year, be called a Treaty or "Terms." In either case the fact remains that if it was drawn and dictated by the British power, and neither altered nor discussed by those who signed it on behalf of the Maharajah, it ought by every rule to be construed most strictly against its framers, who should not seek an advantage over the other party from any ambiguity of its language.

Having regard, moreover, to the circumstance that the transaction recorded by the treaty was forced by the British Government upon the Maharajah, in disregard of their duties towards him as his guardians, it behoves our own honour and credit to show if possible that the terms so dictated were reasonably fair, or at least as fair as the nature of the case would allow.

The document itself is given above (page 47), and also appears in the Appendix, therefore we will not repeat it here.

83

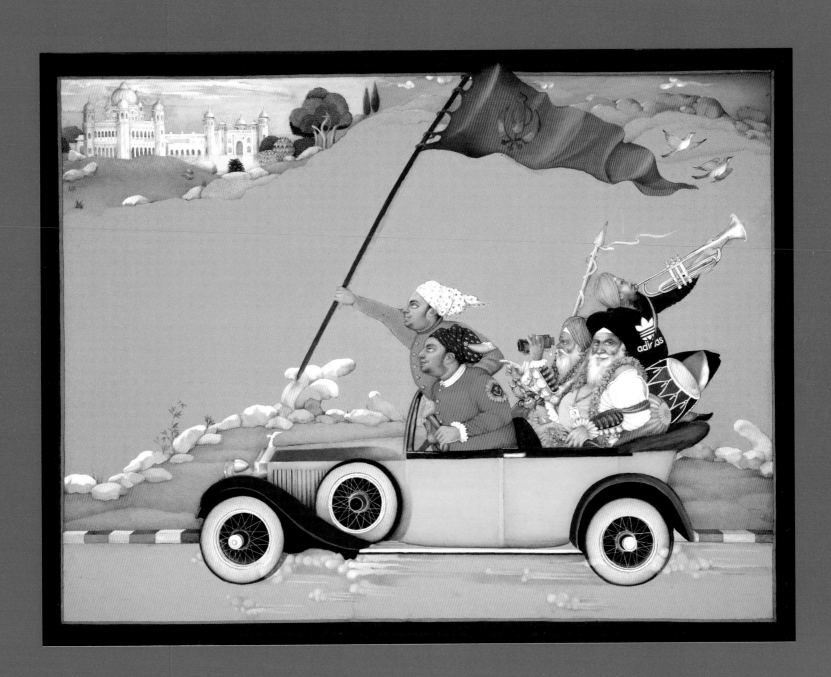

11

THE SPIRIT OF *PUNJABIYAT* AND *CHARDI KALA*

"A FEELING OF FULL-BLOODED LIVING, OF ENCOMPASSING THE WHOLE HUMANITY IN A LOVING AND COMPASSIONATE EMBRACE, OF BROTHERHOOD AND UNABATED COURAGE, OF GIVING UP ONE'S OWN LIFE FOR JUSTICE."[1]

Ajeet Caur on *punjabiyat*

The word *punjabiyat*, which can be translated in English as "Punjabi-ness," has a distinctive connation that evokes hundreds of years of incessant invasions of Punjab and oppression of its people, as well as the Sikh concept of *chardi kala* ("eternal optimism"). The people of Punjab have been made resilient by the hardships they have been historically subjected to, and their spirit reflect the teaching of the gurus. Punjabis epitomize the spirit of oneness, gender equality, hard work (*kirat karo*), sharing (*wand chhako*), democracy, upholding human rights, and spiritual quest. Many of these attributes come alive in the artworks and artifacts belonging to the Khanuja Family Collection that connect with Sikh history and contemporary affairs.

First, we introduce Bhai Kanhaiya, a disciple of the ninth guru, Guru Tegh Bahadur. Bhai Kanhaiya was known for serving water to all the wounded soldiers on the battlefield, regardless of which side they were fighting on, because he saw the image of his Master in every person. This philosophy of selflessness and service continued into the eighteenth century with the Sikh *misl*, which took on the cause of "*degh, tegh* and *fateh*", providing food and protection to the vulnerable and needy. Securing the release of captured women from the Afghan invader Ahmad Shah Abdali (and escorting them safely to their homes) was also in accordance with these principles.

Another notable example of the Sikh ethos is the earlier Namdhari tradition amongst certain Sikhs. They were the first ones to implement the idea of non-cooperation with the British colonizers in late 1800s, thus preceding Mahatma Gandhi by half a century. The Namdharis believed in monotheism and opposed all forms of rituals. In 1872 some of them retaliated against the Muslims for slaughtering cows, which were considered sacred animals by the Hindus. For this reason, they were subsequently punished and "under the order of British..., 49 Namdhari Sikhs were blown from cannons."[2]

During the latter part of the nineteenth century, the Singh Sabha Movement was initiated to awaken the Sikhs and encourage them to follow the tenets of their religion. Its most prominent members included Bhai Vir Singh and Bhai Kahn Singh Nabha, who in his classic tract *Hum Hindu Nahin* (We are not Hindus) made the case for a distinct Sikh identity. Bhai Kahn Singh Nabha's ideas inspired the Sikhs and eventually led to the Gurdwara Reform Movement and Bhai Jaito Movement, which were both aimed at gaining a control of their places of worship and practice Sikh faith freely.

The Akalis also organized themselves in a movement that fought oppression through passive resistance and non-cooperation with the colonizers. They marched towards gurdwaras to free them from government appointed priests (*mahants*) who were degrading these places. For instance, on February 20th, 1921, a *jatha* (band) of Akalis led by Lachman Singh went to Nankana Sahib (the birthplace of Guru Nanak) in a peaceful manner. They were attacked by Mahant Narain Das and his men. Writer Khushwant Singh reconjures that scene of terror and grief: "the dead and dying Akalis were dragged to a pile of logs... and burnt... 130 men had been consumed by the flames."[3]

Various leaders expressed remorse on this incident, and on March 3rd, 1921 Mahatma Gandhi visited Nankana Sahib to lend his sympathy to the Akalis.[4] The non-violent *shahidi jathas* (band of

1. On road to Gurdwara Kartarpur Sahib

Saira Wasim | 2020 | 15 x 20 in | Gouache and gold on wasli paper

This contemporary miniature is a tribute to the Sikh community, whose silent prayer seemed to have been answered ahead of the 550th birth anniversary of their religion's founder, Guru Nanak, with the opening of the Kartarpur Corridor in 2019. This is the site where Guru Nanak spent the last eighteen years of his life. The artist, in a spirit of peace and oneness, sees it as a ray of hope amidst the darkness that has enveloped India-Pakistan ties.

martyrs) continued their protest with over 30,000 Akalis joining in. Thousands were arrested and beaten up. More than one hundred were killed. The protests ended in 1925 with the enactment of the Sikh Gurdwara Bill, which brought Sikh places of worship under the control of an elected body of Sikhs. As Kashmir Singh has observed, the bill "represented a model for the democratization of religious institutions, being the first democratically elected managing body of any religious shrine(s) in the world."[5]

Around the same time, the Jallianwala Bagh massacre also took place. On April 13th, 1919, Brigadier-General Reginald Dyer ordered the British Indian army to fire their rifles on a crowd of unarmed Punjabi civilians who were protesting peacefully in Jallianwala Bagh, Amritsar, killing at least 379 people and injuring over 1,200. Sikhs, who were arrested in overwhelming numbers compared to other communities, continued to make sacrifices to protest foreign oppression, thus sowing the seeds of India's independence in 1947.

The national policy of the British in India was founded on the principle of "divide and rule," i.e., separating and pitting communities against each other based on their religion. This approach resulted in the partition of the Indian subcontinent in August 1947 into Pakistan and India. The partition affected Punjab considerably as the province was divided into East Punjab and West Punjab, in the newly independent dominions of India and Pakistan, respectively. Nonetheless, the main actors involved in this decision were the Indian National Congress, the Muslim League, and the British government, whose leaders were mostly non-Punjabis.

In the 1940s, Punjab had a population of twenty-eight million that comprised of approximately 55 per cent Muslims, 30 percent Hindus and the rest primarily Sikhs. Over 65 percent of the Sikhs lived in Punjab and, despite being a minority, they paid more than 40 percent of the land revenue of the state. One immediate result of the partition of Punjab between India and Pakistan was the separation of families and communities who had lived together for generations in their villages. This was a bloody affair tainted by riots and involved killings of monumental proportions. According to Richard Symonds, "at the lowest estimate, half a million people perished and twelve million became homeless."[6] Historian Yasmin Khan has described how "foot columns sometimes 30–40,000 strong, created human caravans 45 miles long in places," thus highlighting one of the biggest displacements and refugee crises the world had faced till then.[7]

It took years for Punjabis on both sides of the border to recover from this traumatic event. However, the indomitable spirit, which is an intrinsic part of the Sikh ethos, became the driving force behind their revival. In the years that followed, political intervention and the demand for rights of minorities led to the Anandpur Sahib Resolution of 1978, which tackled both religious and political issues. The resolution called for recognizing Sikhism as a religion separate from Hinduism. It also demanded that the central government grant more power to local governments and more autonomy to Punjab. What started as a demand for all Punjabis (including Hindus and Sikhs), was in time mislabeled as a purely Sikh and anti-national movement and as an attempt by the Khalistani, a Sikh separatist movement, to create an independent sovereign state.

Even though the movement started off with peaceful protests, in later years there were some killings which were labeled as communal, with the Akali Dal blaming the central government and vice versa. In this context, religious leader Jarnail Singh Bhindrawale came into the spotlight as he was accused of being responsible for the violence. Nonetheless, Bhindrawale's main teachings focused on inspiring the youth to follow the tenets of Sikhism and keeping them away from drugs and alcohol, and, as Cynthia K. Mahmood has noted, he "never took up the cry for Khalistan…"[8]

In June 1984, on one of the holiest days in the Sikh calendar, the Indian government attacked the Golden Temple, which at the time was brimming with pilgrims. They wanted to remove Bhindrawale and his followers, who had been using the sacred site as their headquarters since the previous year. They damaged the Akal Takht and Golden Temple complex, and thousands of people were killed in a ghastly manner, most of whom were pilgrims. Even women and children were not spared by the perpetrators. In addition, thirty-seven other gurdwaras in Punjab were attacked

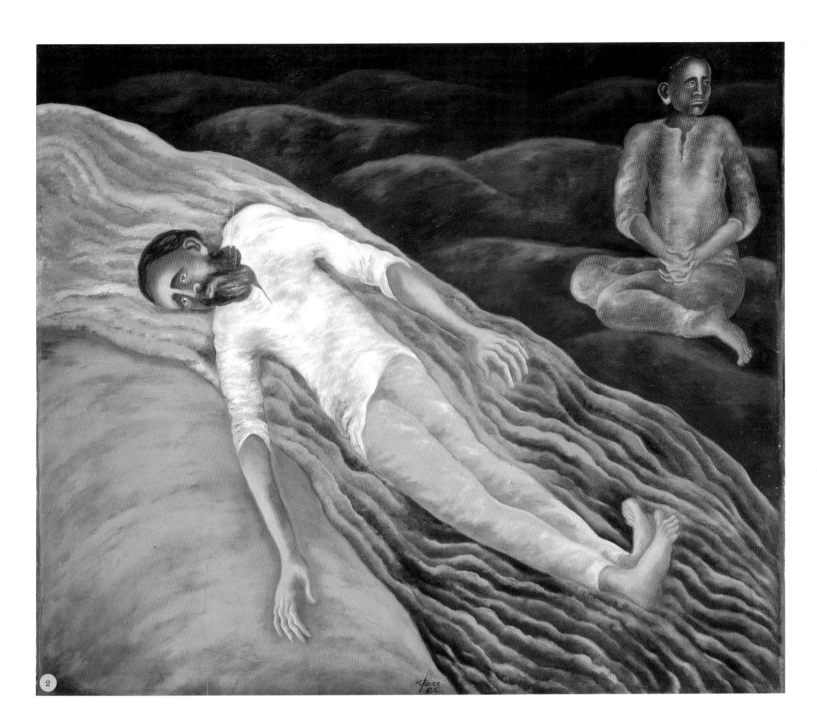

2. Genocide 1984, India

Arpana Caur | 1984 | 60 x 72 in |
Oil on canvas

This painting highlights human
apathy, when one person is
suffering, and the other person
looks away. Caur began using
drowning figures and water as
metaphors for death after the 1984
Sikh Genocide.

without any explanation. All democratic principles were suspended and there was a complete media blackout, which resulted in brutality and abuses of unimaginable proportions.

In October 1984, Mrs. Indira Gandhi, the then prime minister of India, was killed by her Sikh bodyguards in New Delhi. This resulted in further backlash against the Sikh community and in a state-sponsored massacre. Women were raped. Men were pulled, rubber tires were tied around their necks, and they were doused with kerosene for the next three days. Sikh properties were burnt and destroyed to "teach the Sikhs a lesson."[9] More than 8,000 Sikhs were killed all over India with approximately 3,000 in Delhi alone. According to Supreme Court advocate Harvinder S. Phoolka, "Delhi had its tryst with genocide in 1984... despite Rajiv Gandhi's infamous attempt to shrug off responsibility by dismissing the massacre of 3,000 Sikhs in three days as the tremors caused by the fall of a mighty tree."[10] Emphasizing the Indian government's complicity in these crimes, Khushwant Singh wrote, "Congress party cadres commissioned trucks to bring in villagers from the outlying localities, armed them with iron rods and cans of gasoline. They were assured police would not interfere."[11]

As lawyer Mallika Kaur has noted, "the period from the late 1970s to mid-1990s that expanded the rural Punjabi lexicon to include 'police encounters', when anywhere from 25,000 (police estimates) to 250,000 (civil society estimates) were killed. This period includes the deadly 1985–1995 'decade of disappearances'..."[12] These heinous crimes against the Sikh community inspired a growing demand for justice and an effort to document the horrors of history. Jaswant Singh Khalra (1952–95), a Sikh and human rights activist from Punjab, received global attention for his research concerning 25,000 illegal killings and cremations. In September 1995, Khalra was kidnapped from outside his house in Amritsar and killed. Six Punjab police officials were later convicted and sentenced to imprisonment for Khalra's abduction and murder.

The year 1984 and the following decade witnessed a new wave of violence against Sikhs, marking the third ghallughara (genocide) of the community. Ensaaf, a human rights organization based in California, has conducted considerable research to document the kidnapping and disappearances of Sikhs during this period. One of its founders, Jaskaran Kaur, has stated that "until India ends impunity for these genocidal killings, it will continue to be a nation ruled by men, and not the law."[13]

While often the subject of violence and oppression, Sikhs have extended their help to other communities. Social service is in fact an important part of the Sikh way of life. For instance, since 1999, Khalsa Aid, a non-governmental international organization, has been working to provide humanitarian aid in disaster-afflicted areas and civil conflict zones around the world. A number of similar Sikh-based organizations exist around the world serving humanitarian causes. In this chapter we present Pingalwara, an organization based in Amritsar, through a painting belonging to the Khanuja Family Collection. Bhagat Puran Singh who started taking care of orphans, the disabled, and the destitute in 1947, went on to found this organization. Through his selfless service, it has grown to take care of more than 2,000 residents as of today. In addition, the organization runs schools, vocational centers, and medical clinics, all free of cost. The Sikh community has also demonstrated its commitment to the guiding principle of social service during the current COVID-19 pandemic, opening facilities for patients, providing oxygen cylinders and other medical equipment, setting up communal kitchens in various parts of the country, and offering cremation services to victims.

Apart from selflessness, *punjabiyat* is characterized by a genuine love for life and its daily aspects. Traditionally leading a rural lifestyle, Punjabis have a rich tradition of poetry, festivals, and romantic folktales. Four folktales (*kissa*) that are part of this tradition – Heer Ranjha, Mirza Sahiba, Sassi Punnu, and Sohni Mahiwal – immortalize and enshrine worldly love as the spirit of divine love. Their female characters rebel against the conventional norms of society and sacrifice everything for love. Two of these stories, Heer Ranjha and Sohni Mahiwal, are depicted in the paintings from the Khanuja Family Collection we present in the following pages.

Heer Ranjha was created by Waris Shah (1706–98), and it centers on Heer, the gorgeous daughter of a wealthy family in Jhang and her tragic fate. The tale's male hero, Ranjha, arrives at her village, after a land dispute with his brothers. Heer meets Ranjha when he is offered a job as caretaker of her father's cattle, and she is mesmerized when she hears Ranjha play the flute. The two fall in love, but Heer eventually gets engaged to a rich man, Khera. The heartbroken Ranjha becomes a *jogi* (mystic), pierces his ears, and renounces the material world. While on his travels around Punjab, Ranjha eventually reunites with Heer, and her parents finally agree to their marriage. But on the day of her wedding, Heer's jealous uncle poisons her food. Ranjha also takes a bite of the poisoned food, dying by her side.

Sohni Mahiwal is another tragic folktale in which the female protagonist, Sohni, is in love with Mahiwal, but is eventually married off to someone else. Sohni swims across a river to meet Mahiwal, using an earthenware pitcher to keep afloat. Her jealous sister-in-law, however, replaces the pitcher with an unbaked one, which dissolves in the water causing Sohni to drown in the river. When Mahiwal sees this from the other side of the river, he jumps into the water and drowns with his lover.

Although Punjab was divided with the partition of the Indian subcontinent, a feeling of *birha* (longing for reunion) has remained strong on both sides of the region across generations, and to this

day Punjabis still feel a strong urge to visit ancestral homes and religious sites on the other side of the border, especially those connected to the Sikh gurus. The opening of the Kartarpur corridor in 2019 to allow Sikhs to visit Gurdwara Kartarpur, where Guru Nanak spent his last eighteen years, is a step toward Sikhs reclaiming their past. Saira Wasim, a US-based artist originally from Pakistan, has captured the excitement brought by the opening of the corridor and travelers' hope for peace in a beautiful painting we present in this chapter.

The spirit of *chardi kala* and quiet resolve, which has characterized Sikhs for centuries, continues to live today and inspires the people of this land to rise again and look to the future with a sense of confidence. Since December 2020 Indian farmers, led by the Sikhs, have been peacefully protesting new agricultural laws passed by the central government which endanger their survival. Over 250,000 people have come together, standing united in the chilling cold of Delhi. This has arguably been one of the largest farmer protests in the history of the world. Despite being forced to sleep on the streets and being attacked by the police with water cannons, protestors remain in high spirits. Their resilience is an example for the world. Old farmers with wizened skin, along with their sons and daughters, have showed resolute bravery, while creating folklore poetry for the future of humanity.* As the world cries for their justice, the daily Sikh *Ardaas* (supplication to Divine at the end of their prayers) ends with the words *Sarbat Da Bhala* (blessings for all mankind). Guru Tegh Bahadur Sahib, a beacon for human rights who died while trying to defend religious freedom, serves as an inspiration for the farmers' movement. On the 400th anniversary of his birth, we pay tribute to him by portraying a painting of farmers' protest which we commissioned for this chapter.

REFERENCES & NOTES

1. This quote from Ajeet Caur's personal writings has been kindly provided by her daughter Arpana Caur in an e-mail exchange on August 4th, 2020. We express our sincere gratitude to both.

2. J. Singh, "Nāmdhārī" in *Brill's Encyclopedia of Sikhism*, eds. K.A. Jacobsen, G. Singh Mann, K. Myrvold and E. Nesbitt (Boston: Brill, 2017), 362.

3. K. Singh, *A History of the Sikhs (1839-2004)*, vol. 2 (New Delhi: Oxford University Press, 2004), 199.

4. M. Singh, *The Akali Movement* (Patiala: Punjabi University, 2015), 40.

5. K. Singh, "Shiromani Gurdwara Parbandhak Committee: An Overview," in *The Oxford Handbook of Sikh Studies*, eds. P. Singh and L.E. Fenech (New Delhi: Oxford University Press, 2014), 328.

6. R. Symonds, *The Making of Pakistan* (London: Faber and Faber, 1950), p. 74.

7. Y. Khan, *The Great Partition: The Making of India and Pakistan* (New Haven: Yale University Press, 2000), 160.

8. C.K. Mahmood, "'Khalistan' as Political Critique," in *The Oxford Handbook of Sikh Studies*, eds. P. Singh and L.E. Fenech (Oxford: Oxford University Press, 2014), 578.

9. S. Singh, "Teach the Sikhs a Lesson," All about Sikhs, accessed on August 27, 2021, https://www.allaboutsikhs.com/sikh-history/1984-pogrom/teach-the-sikhs-a-lesson/

10. M. Mitta and H.S. Phoolka, *When a Tree Shook Delhi* (New Delhi: Roli Books, 2007), 211.

11. K. Singh, *A History of the Sikhs*, vol. 2 (New Delhi Oxford University Press, 1999), 383.

12. M. Kaur, *Faith, Gender and Activism in the Punjab Conflict: The Wheat Fields Still Whisper* (New York: Palgrave Macmillan, 2019), 8.

13. J. Kaur, *Twenty Years of Impunity: The November 1984 Pogroms of Sikhs in India* (Portland: Nectar Publishing, 2006), 140.

*In November 2021, after over one year of protests with significant sacrifices and over 700 deaths, the Indian government relented and withdrew the bills affecting the farmers.

प्रथम दिवस आवरण FIRST DAY COVER

भाई कन्हैयाजी BHAI KANHAIYAJI

3

INCIDENT DU
KOMAGATA MARU
INCIDENT

DAY OF ISSUE JOUR D'ÉMISSION
CANADA POST POSTES CANAD 4

प्रथम दिवस आवरण First Day Cover

गदर आन्दोलन शताब्दी
GHADAR MOVEMENT CENTENARY

5

3. Commemorative first-day cover celebrating Bhai Kanhaiya and Guru Gobind Singh

1998 | 4.25 x 8 in

Both the stamp and the first-day cover celebrate the selfless service of Bhai Kanhaiya. Without any discrimination between Sikhs and the Mughal soldiers, he took upon himself the task of quenching the thirst of the wounded men and women in the battle of Anandpur Sahib in 1704.

4. Commemorative envelope marking 100th anniversary of Komagata Maru incident

2014 | 4.5 x 7.5 in

In April 1914 a group of people from British India attempted to immigrate to Canada aboard the Komagata Maru, a Japanese steamship. Most were denied entry and forced to return to Calcutta, where the Indian Imperial Police attempted to arrest the group leaders.

5. Commemorative envelope celebrating the 100th anniversary of the Ghadar Movement

2013 | 4.5 x 8.6 in

The Ghadar Movement was an international political movement founded at the start of the twentieth century by expatriate Indians to overthrow British rule in India. Early members included mostly Punjabi Indians who lived and worked on the west coast of the United States and Canada.

6. Commemorative first-day cover and stamp celebrating the 25th anniversary of Azad Hind Government, 1943–68

1968 | 3.5 × 6 in

The Indian National Army (Azad Hind Fauj) was an armed force formed by Indian collaborationists and Imperial Japan in 1942 in Southeast Asia during the Second World War. Its aim was to secure Indian independence from the British rule.

7. Commemorative first-day cover and stamp celebrating the bravery and martydom of Bhagat Singh (1907–31)

1968 | 3.5 × 6 in

Executed with his two comrades at the age of twenty-three, Bhagat Singh was a revolutionary student leader who killed John Saunders, a British police officer to avenge the death of Lala Lajpat Rai, a prominent leader of the freedom movement.

8. Commemorative stamps celebrating Udham Singh (1899–1940)

1992

An Indian revolutionary belonging to the Ghadar Party, Sardar Udham Singh was deeply influenced by political events, such as the Komagata Maru incident and the Jallianwala Bagh massacre. As a mark of revenge for the killings, he shot Michael O'Dwyer, Punjab's Lieutenant Governor at the time of the massacre, at a meeting in London in March 1940.

414

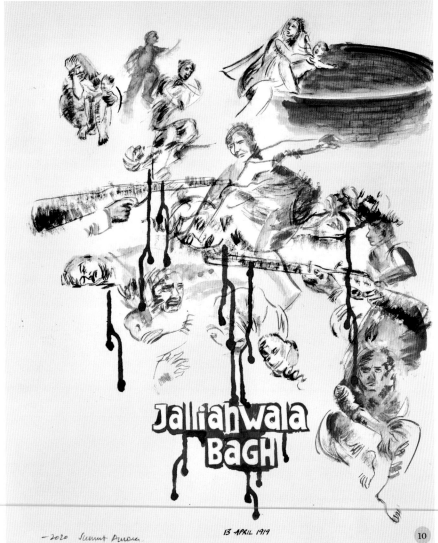

9. Kuka Movement

Bholla Javed | 2020 | 40 x 51 in |
Oil on canvas

This movement was the first major reaction of the people in Punjab to the new political order initiated by the British after the Second Anglo-Sikh War in 1849. The Namdhari Movement, of which the Kuka Movement was the most important part, aimed at overthrowing the British rule. The government had many of the Kuka ring-leaders blown away from the cannon mounts.

10. Jallianwala Bagh

Sumeet Aurora | 2020 |
17.5 x 13.5 in | Watercolor

The Jallianwala Bagh massacre, also known as the Amritsar massacre, took place on April 13th, 1919, when Acting Brigadier-General Reginald Dyer ordered troops of the British Indian army to fire their rifles on a crowd of unarmed Indian civilians at Jallianwala Bagh killing at least 379 people and injuring over 1,200 others. In this painting, besides the wounded and dead, there is a lady trying to hide her child in a well.

11. Sixth *shahidi jatha* of 500 Akalis, led by Sant Prem Singh Ji Kokari, Jaito Morcha

Photographer unknown | *c.* 1924 |
12 x 10 in | Albumen print

Jaito is the name of the place near the location where this event took place, while *morcha* means "demonstration" or "agitation". This was an Akali agitation that took place in February 1924 for the restoration to the throne of Maharaja Ripudaman Singh of Nabha, a Sikh princely state in Punjab. The maharaja had strong pro-Akali sympathies and had overtly supported the Guru-ka-Bagh Morcha and donned a black turban as a mark of protest against the massacre of the reformists at Nankana Sahib. His contacts with the Indian nationalist leaders and involvement in popular causes had irked the British government. The *morchas* would start at Akal Takht Sahib and were non-violent.

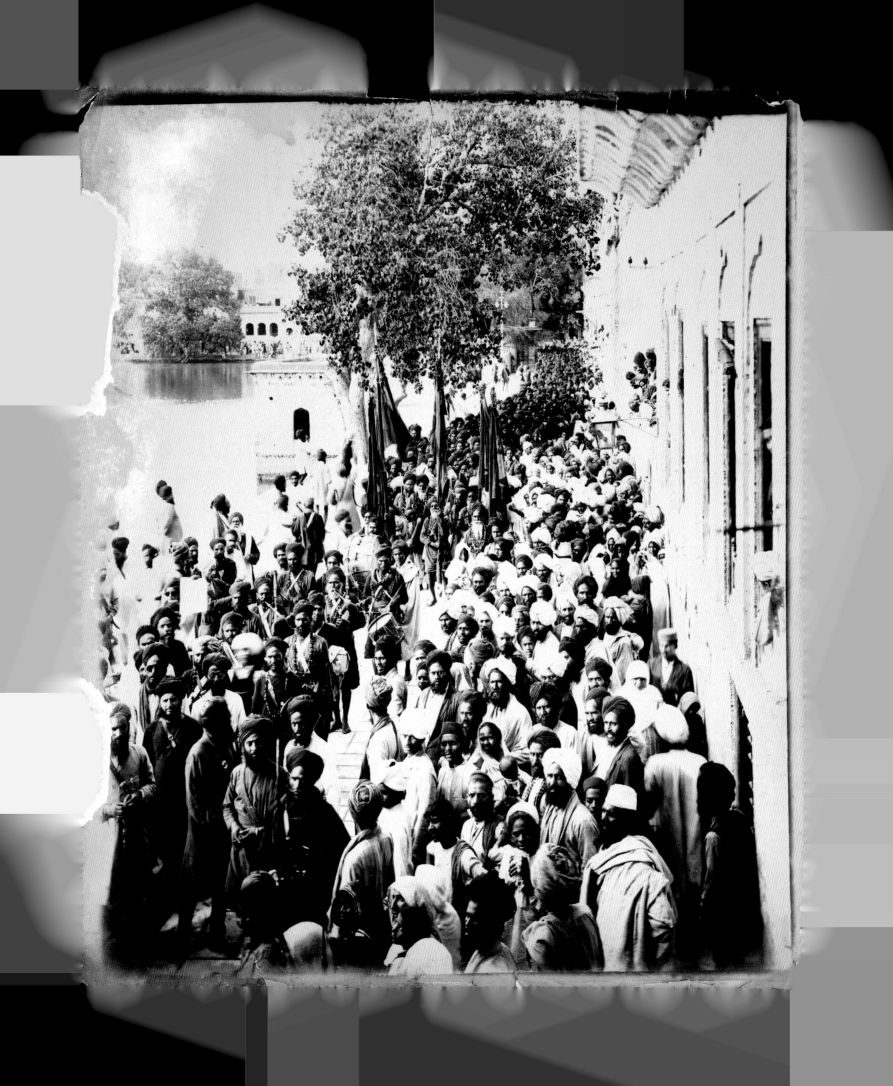

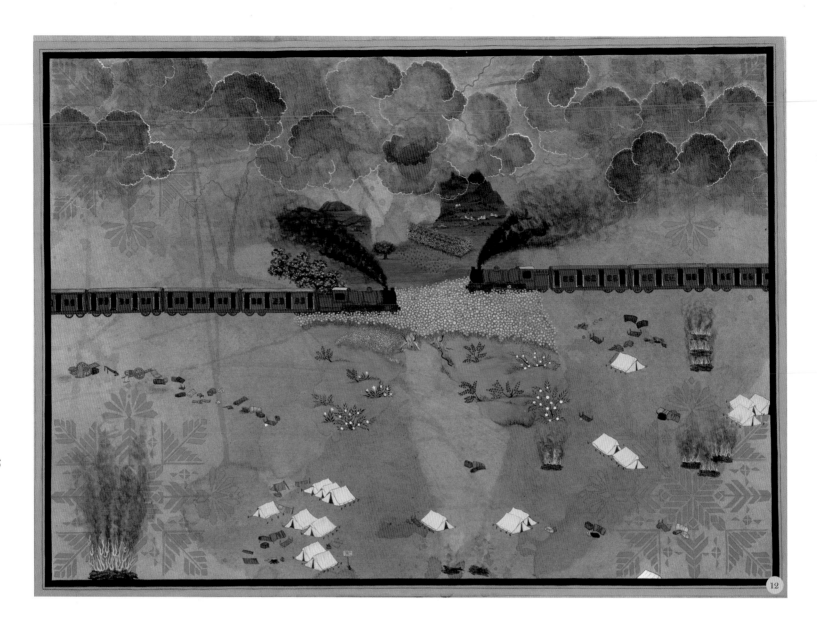

416

12. The ghost trains of 1947

© Rupy C. Tut | 2019 | 25 x 34.5 in |
Natural stone pigments and tea stain
on hand-made hemp paper

This is a work devoid of any human
presence representing the absence
of humanity in moments of carnage,
riots, and genocide. In the painting,
the emptiness of the trains, the void
space in the landscape, and the
deafening silence of the vacant camps
all point to the violent absence of
humans and humanity witnessed and
existent during and after the Partition.

THE PARTITION OF INDIA, 1947

The unfortunate story of the partition of India with the bifurcation of Punjab and the displacement of people is considered the largest mass migration in human history. This was also a somber story of riots, rapes, senseless killings, and a bloody legacy involving millions of people who became migrants in their own country.

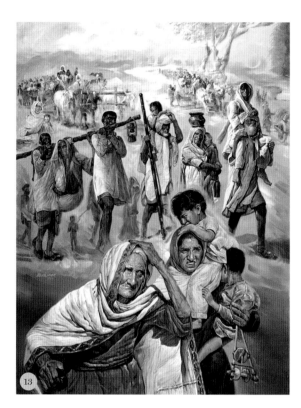

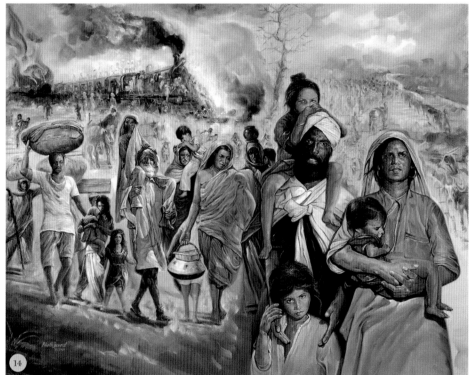

13. Partition, 1947

Bholla Javed | 2021 | 51 x 38 in |
Oil on canvas

14. Partition, 1947

Bholla Javed | 2021 | 40 x 51 in |
Oil on canvas

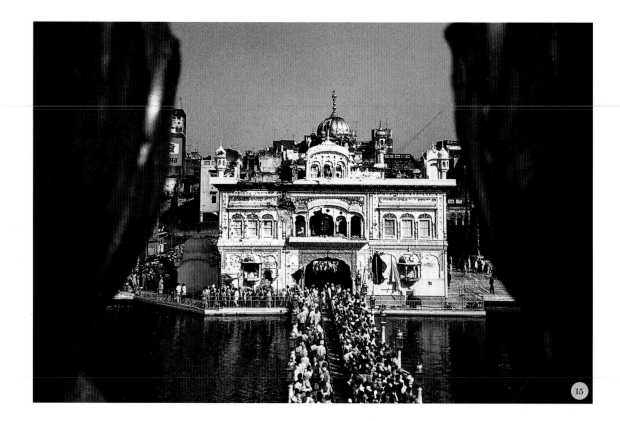

15

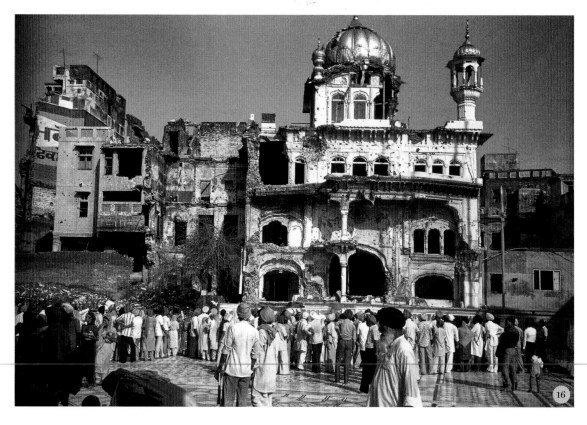

16

15. Damage of Harmandir Sahib, 1984

Satpal Danish | 1984 |
11.5 x 8.25 in | Photograph

16. Damage of Akal Takht Sahib, 1984

Satpal Danish | 1984 |
11.5 x 8.25 in | Photograph

17. Jaswant Singh Khalra

Gurpreet Singh | 2020 | 54 x 41 in |
Oil on canvas

A human rights activist, Jaswant Singh Khalra was kidnapped by the police forces from his home in 1995. The painting also depicts a distraught family: the grandparents and the grandchildren are grieving over the disappearance of their children and parents, respectively. Also seen in the painting is the Akal Takht Sahib which was damaged by the Indian forces when they attacked the Golden Temple complex in 1984.

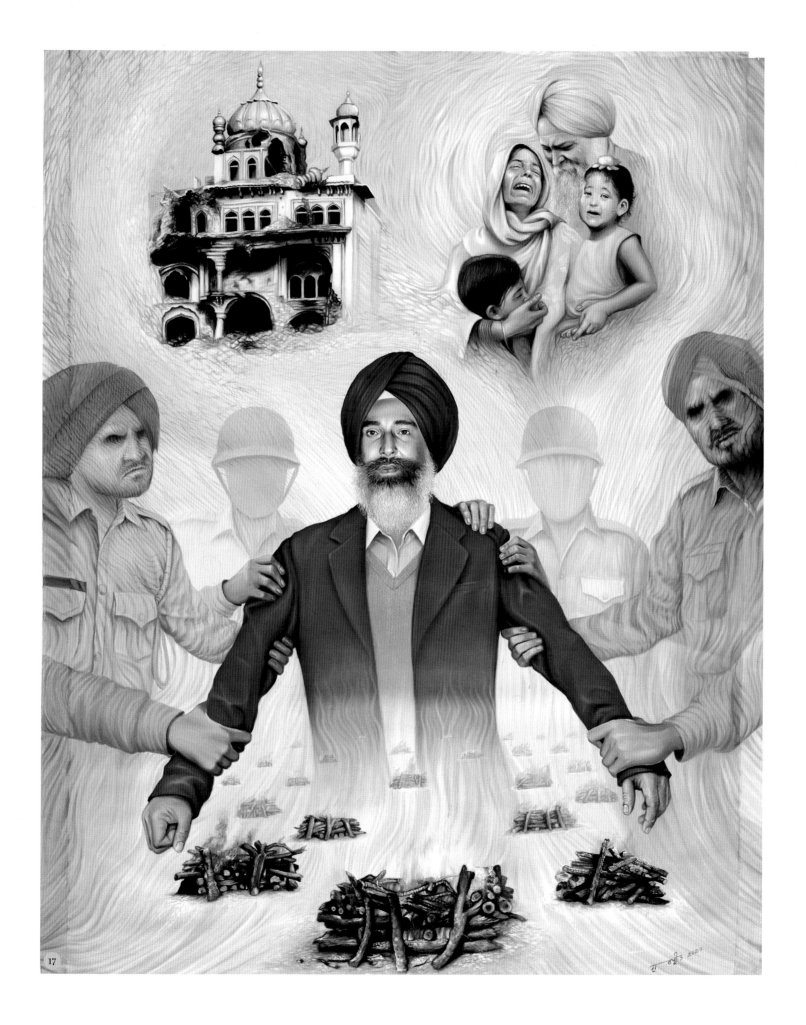

17

420

18. Sohni Mahiwal

Arpana Caur | 2017 | 54 x 30 in |
Oil on canvas

Sohni Mahiwal or Suhni Mehar is one of the four popular tragic romances of Punjab. Sohni Mahiwal is a tragic love story. The heroine Sohni, unhappily married to a man she dislikes, swims every night across the river using an earthenware pot to keep afloat in the water, to where her beloved Mahiwal herds buffaloes. One night her sister-in-law replaces the earthenware pot with a vessel of unbaked clay, which dissolves in water causing Sohni to die in the whirling waves of the river.

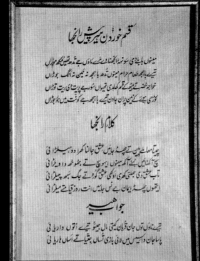

19. Heer and Ranjha

Fyza Aamir Fayyaz | Calligraphy by Ahmed Alia Bhutta in Lahori Nastaliq script | 2021 | 10 x 14 in | Black ink, gouache, natural indigo pigment, gold-leaf and tea-wash on hand-made Rajasthani paper

The scene depicts the first meeting of Heer and Ranjha, during which the two youngsters fall in love on a boat in the river Chenab.

20. Heer and Ranjha

Fyza Aamir Fayyaz | Calligraphy by Ahmed Alia Bhutta in Lahori Nastaliq script | 2021 | 10 x 14 in | Black ink, gouache, natural indigo pigment, gold-leaf and tea-wash on hand-made Rajasthani paper

The Panj Pir (Five Holy Saints) visit Heer and Ranjha.

21. Heer and Ranjha

Fyza Aamir Fayyaz | Calligraphy by Ahmed Alia Bhutta in Lahori Nastaliq script | 2021 | 10 x 14 in | Black ink, gouache, natural indigo pigment, gold-leaf and tea-wash on hand-made Rajasthani paper

Ranjha, having become an ascetic, arrives at Rangpur, the town where Heer now lives with her husband.

SUKHPREET SINGH

A well-known contemporary Sikh artist, Sukhpreet Singh was born in Ludhiana and has exhibited his works in India, the United States, Canada, England, Italy, Australia, and Russia. His subjects include portraits and scenes of rural Punjab (22–36).

22. Posting a letter to husband

Sukhpreet Singh | 2021 |
20 x 16 in | Acrylic on canvas

A lady with tears in her eyes posting a letter from her village in Punjab to her husband working, most probably, in a foreign land.

23. Village activities

Sukhpreet Singh | 2021 |
20 x 16 in | Acrylic on canvas

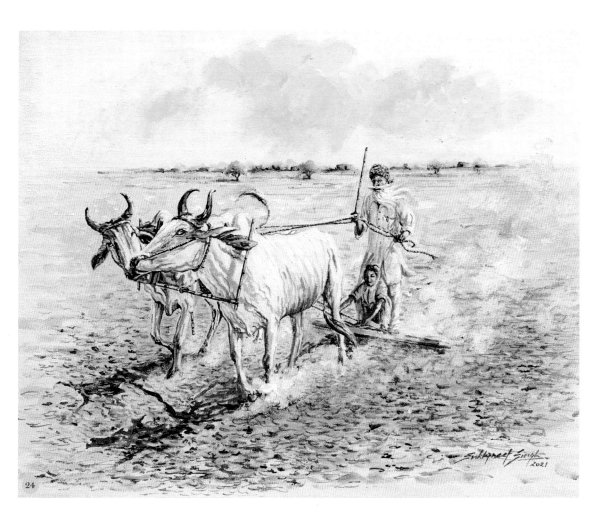

24

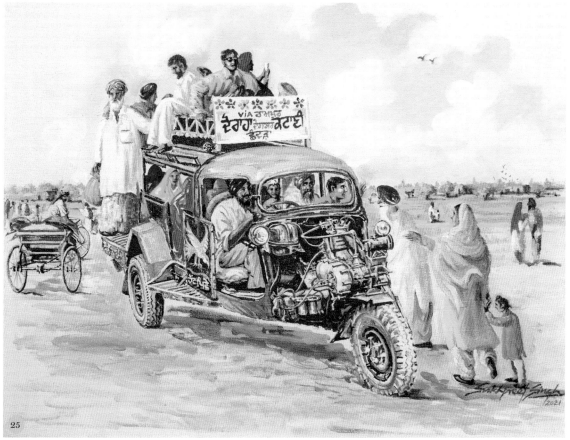

25

24. Farming, *suhaga* ride

Sukhpreet Singh | 2021 |
20 x 16 in | Acrylic on canvas

25. Travel
(modified tempo/three-wheeler)

Sukhpreet Singh | 2021 |
20 x 16 in | Acrylic on canvas

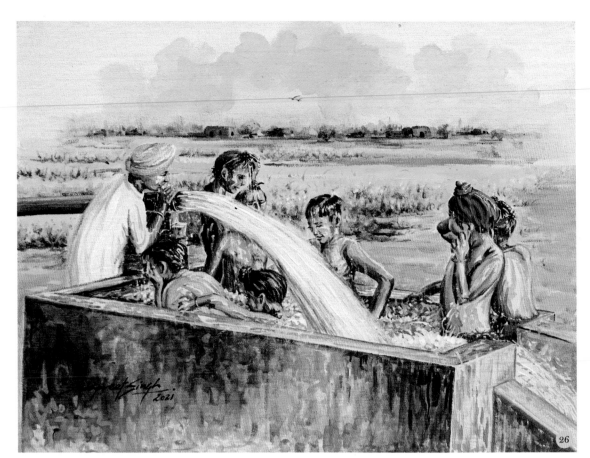

26. Children bathing in a tubewell

Sukhpreet Singh | 2021 |
20 x 16 in | Acrylic on canvas

27. Young boys playing *kabaddi*

Sukhpreet Singh | 2021 |
20 x 16 in | Acrylic on canvas

28. Boys playing *bandar-killa*

Sukhpreet Singh | 2021 |
20 x 16 in | Acrylic on canvas

29. Children playing *anna-zhotta*, a game similar to blind man's buff

Sukhpreet Singh | 2021 |
20 x 16 in | Acrylic on canvas

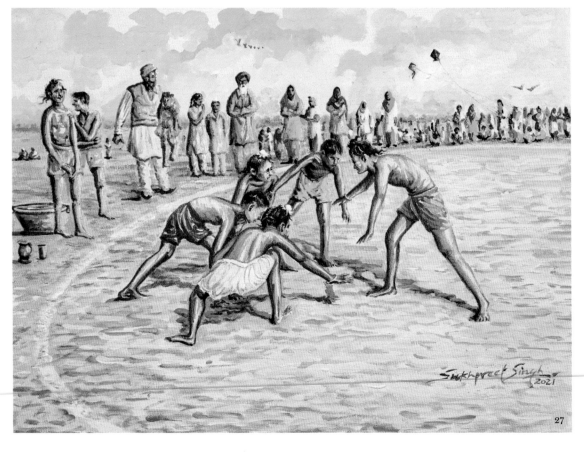

30. Girls playing *kokla-chappaki*

Sukhpreet Singh | 2021 |
20 x 16 in | Acrylic on canvas

31. Children preparing kites for flying

Sukhpreet Singh | 2021 |
20 x 16 in | Acrylic on canvas

32. Boys playing *gulli-danda*

Sukhpreet Singh | 2021 |
20 x 16 in | Acrylic on canvas

33. Children playing *kanche* (marbles)

Sukhpreet Singh | 2021 |
20 x 16 in | Acrylic on canvas

28

29

30

31

32

33

34. Bhagat Puran Singh

Sukhpreet Singh | 2020 |
32 x 48 in | Oil on canvas

One of the most prominent Sikh heroes
of last century, Bhagat ji devoted most
of his adult life to selfless service to
terminal and mentally ill patients, who
in most cases had been abandoned
by their families and society at large.
Whenever and wherever he saw a
deserted dead body (human or animal),
he would immediately prepare by his
own hands a grave and give the corpse a
deserving burial or cremation as a
sign of respect for the dead. He is
recorded to have said, "I believe in
dignity. Dignity in death is a birth right
of each living thing."

35. *Seva* during Covid

Sukhpreet Singh | 2021 |
48 x 72 in | Acrylic on canvas

From arranging oxygen *langars*
to ambulance services, and from
looking after medical needs to helping
people cremate their loved ones, Sikh
organizations and people associated
with them from all over India and
abroad helped those in need during
the Covid-19 pandemic. This painting
embodies the Sikh's faith in selfless
service and love for humanity.

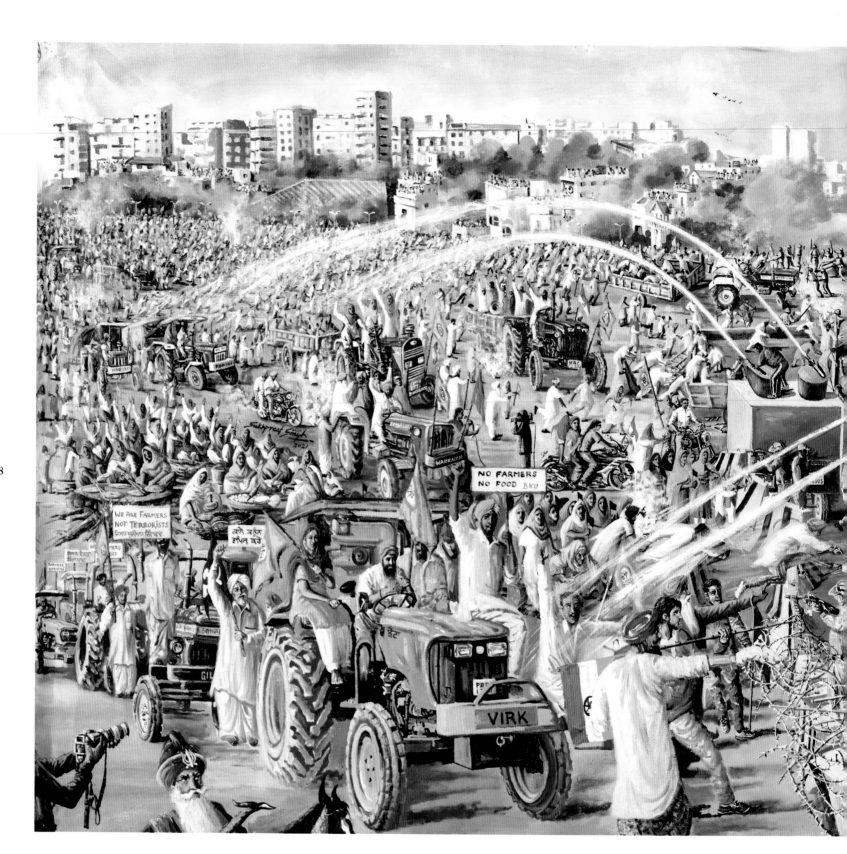

36. Farmers protest

Sukhpreet Singh | 2021 |
43 x 84 in | Oil on canvas

A landmark painting on human rights abuse at the farmers' protests that started in 2020, during which more than 250,000 farmers and their families held prolonged peaceful protests against new laws endangering their livelihood and future survival. The artist portrays multiple scenes, including human right abuses, peaceful demonstration, *langar* being served even to policemen, and removal of illegal barricades on streets by the protestors. It also depicts water cannons being used in extremely cold weather. This painting is a tribute to Guru Tegh Bahadur, the ninth guru who was a champion of human rights and is referred to as *Srishti-di-Chadar* (Protector of Humanity), on his 400th birth anniversary.

429

BIBLIOGRAPHY

Ames, Frank, *Woven Masterpieces of Sikh Heritage: The Stylistic Development of the Kashmir Shawl under Maharaja Ranjit Singh 1780-1839*. London: Antique Collector's Club, 2010.

Atwal, Priya. *Royals and Rebels. The Rise and Fall of the Sikh Empire*. Oxford: Oxford University Press, 2020.

Aulakh, Satnam. *Sikh Warriors in World Wars*. Amritsar: Printwell, 2016.

Baker, Janet. "Guru Nanak: 550th birth anniversary of Sikhism's founder." *Sikh Formations* 15, nos. 3-4 (2019): 495-515.

Bance, Peter. *Sovereign, Squire and Rebel: Maharajah Duleep Singh*. London: Coronet House, 2009.

Bell, Evans. *The Annexation of the Punjaub and the Maharajah Duleep Singh*. London: Trubner & Co., 1882.

Brar, Rupinder S. *The Japji of Guru Nanak: A New Translation with Commentary*. Washington, D.C.: Asian Cultural History Program, Smithsonian Institution. 2019. [Later First Indian Edition published by Roli Books.]

Burton, R. G. *The First and Second Sikh Wars*. Simla, Govt. Central Branch Press, 1911. Reprint, Yardley, Westholme, 2008.

Cole, W. Owen. "Sikh Interactions with Other Religions." In *The Oxford Handbook of Sikh Studies*, edited by Pashaura Singh and Louis. E. Fenech, 250-61. Oxford: Oxford University Press, 2014.

Cunningham, Joseph D. *History of the Sikhs*. London: John Murray, 1849.

Curzon, George. *Speeches by Lord Curzon of Kedleston, 1898-1901*. Calcutta: Thacker, Spink & Co. 1901.

Dhawan, Purnima. "Early Sikh Darbars." In *Brill's Encyclopedia of Sikhism*, edited by Knut A. Jacobsen, and Gurinder S. Mann, Kristina Myrvold, Eleanor M. Nesbitt, 57-69. Boston: Brill, 2017.

Dhillon, Balwant S. "From Guru Har Gobind to Guru Gobind Singh." In *Brill's Encyclopedia of Sikhism*, edited by Knut A. Jacobsen, and Gurinder S. Mann, Kristina Myrvold, Eleanor M. Nesbitt, 32-44. Boston: Brill, 2017.

Fenech, Louis E. *Martyrdom in the Sikh Tradition*. New Delhi: Oxford University Press, 2000.

Forster, George. *A Journey from Bengal to England*. Vol.1. London: R. Fauldner, New Bond Street, 1798.

Fraser, John F. *Round the World on a Wheel*. London: Methuen & Co., 1899.

Gillow, John, and Nicholas Barnard. *Indian Textiles*. London: Thames & Hudson, 2008.

Goswamy, Brijinder N. *Piety and Splendour: Sikh Heritage in Art*. New Delhi: National Museum, 2000.

Goswamy, Brijinder N., and Caron Smith. *I See No Stranger: Early Sikh Art and Devotion*. Ocean Township, NJ: Rubin Museum of Art, 2006.

Grewal, Jaswant S. *Four Centuries of Sikh Tradition*. New Delhi: Oxford University Press, 2011.

Grewal, Jaswant, and Indu Banga. *A Political Biography of Maharaja Ripudaman Singh of Nabha*. New Delhi: Oxford University Press, 2018.

Griffin, Lepel H. *The Rajas of the Punjab*. New Delhi: 1870. Reprint, Lahore: Sang-e Meel Publications, 2006.

Gujral, Gurprit S. "The Mystery of the Moran (Mora) Rupees Solved." *Journal of the Oriental Numismatic Society* 219 (Spring 2014): 26-28.

Gupta, Anu H., and Shalina Mehta. *Phulkari from Punjab: Embroidery in Transition*. New Delhi: Niyogi Books, 2019.

Gupta, Hari Ram. *History of the Sikhs*. 5 vols. New Delhi: Munshiram Manoharlal Publishers Pvt. Ltd., 2008.

Gurdas, Bhai. "Bhai Gurdas Vaaran – Vaar Index." Search Gurbani. Accessed on August 11, 2021. https://www.searchgurbani.com/bhai-gurdas-vaaran/index/vaar

Hawley, Michael. "Sikh Institutions." In *The Oxford Handbook of Sikh Studies*, edited by Pashaura Singh and Louis. E. Fenech, 317-27. Oxford: Oxford University Press, 2014.

Herrli, Hans. *The Coins of the Sikhs*. New Delhi: Munshiram Manoharlal Publishers, 2004 [orig.: 1993].

Hitkari, Satnam S. *Phulkari: The Folk Art of Punjab*. New Delhi: Punjab Press, 1980.

Holland, Bhupinder S. *Sikhs in World War I*. Ludhiana Punjab: A Wisdom Collection: GS Distrib., 2013.

Honigberger, John M. *Thirty-Five Years in the East*. London: L.H. Baillière, 1852.

Hugel, Karl Alexander. *Travels in Kashmir and the Panjab, containing a particular account of the government and character of the Sikhs*. London: J. Petheram, 1845.

Irwin, John. *The Kashmir Shawl*. London: Her Majesty's Stationery Office, 1973.

Iqbal, Muhammad. *Tulip in the Desert. A Selection of the Poetry of Muhammad Iqbal*. Translated by Mustansir Mir. Kuala Lumpur: Islamic Book Trust, 2011.

Johar, Surinder. *The Heritage of Amritsar*. New Delhi: National Book Shop, 2008.

Kaur, Jaskaran. *Twenty Years of Impunity: The November 1984 Pogroms of Sikhs in India*. Portland: Nectar Publishing, 2006.

Kaur, Madanjit. *The Golden Temple*. 3rd ed. Amritsar: Guru Nanak Dev University, 2013.

Kaur, Mallika. *Faith, Gender, and Activism in the Punjab Conflict: The Wheat Fields Still Whisper*. New York: Palgrave Macmillan, 2019.

Khan, Yasmin. *The Great Partition: The Making of India and Pakistan*. New Haven: Yale University Press, 2000.

Khera, Paramdip. *Catalogue of Sikh Coins in the British Museum*. London: The British Museum, 2011.

Lawrence, George. *Reminiscences of Forty-Three Years in India*. Lahore: Sang-e-meel Publications, 1974 [orig.: 1874].

Leitner, Gottleib W. *History of Indigenous Education in the Punjab*. Calcutta, 1882. Reprint, Lahore: Sang-e Meel Publications, 2002.

Macauliffe, Max A. *The Sikh Religion: Its Gurus, Sacred Writings and Authors*. Oxford: Clarendon Press, 1909 (6 vols. in 3).

Mahmood, Cynthia K. "'Khalistan' as Political Critique." In *The Oxford Handbook of Sikh Studies*, edited by Pashaura Singh and Louis. E. Fenech, 571-80. Oxford: Oxford University Press, 2014.

Mann, Gurinder S. "Guru Granth: The Scripture of the Sikhs." In *Brill's Encyclopedia of Sikhism*, edited by Knut A. Jacobsen, Gurinder S. Mann, Kristina Myrvold, and Eleanor M. Nesbitt, 129-37. Boston: Brill, 2017.

McLeod, William H. *Sikhism*. New Delhi: Penguin Books, 1997.

McLeod, William H. *Sikhs and Sikhism*. Oxford: Oxford University Press, 1999.

M'Gregor, William L. *The History of the Sikhs: The Lives of the Gooroos; the History of the Independent Sirdars, or Missuls and the Life of the Great Founder of the Sikh Monarchy, Maharajah Runjeet Singh*, 1846.

Mitta, Manoj, and Harvinder S. Phoolka. *When a Tree Shook Delhi*. New Delhi: Roli Books, 2007.

Nalwa, Vanit. *Hari Singh Nalwa, "Champion of the Khalsa ji."* New Delhi: Manohar, 2009.

Osborne, William G. *Court and Camp of Ranjeet Singh*. London: Henry Colburn, 1840.

430

Prinsep, Henry. *Origin of the Sikh Power in the Punjab and Political Life of Muha-Raja Runjeet Singh, with an Account of the Present Condition ... of the Sikhs.* G. Huttmann: Calcutta, 1834.

Reddy, Ravinder. *Arms & Armour of India, Nepal & Sri Lanka.* London: Hali Publications, 2018.

Sethi, Cristin M. *Phulkari: The Embroidered Textiles of Punjab.* Philadelphia: Philadelphia Museum of Art, 2016.

Sikh Missionary Center. *Sikh Religion.* Ann Arbor: Braun-Brumfield, 1990.

Sikh Missionary Society UK. "The Saint-Soldier (Guru Gobind Singh): Extracts from Guru Gobind Singh's Writings." Sikh Missionary Society. Accessed on August 12, 2021. https://www.sikhmissionarysociety.org/sms/smspublications/thesaintsoldier/chapter16/

Singh, Amarpal. *The First Anglo-Sikh War.* Gloucestershire: Amberley Publishing, 2014.

Singh, Bhagat. *A History of the Sikh Misls.* Patiala: Punjabi University, 2019.

Singh, Bhai S. *Gurbilas Patshahi 10*, edited by Gursharan Kaur Jaggi. Patiala: Bhasha Vibhag, 1989.

Singh, Fauja. *The City of Amritsar.* Patiala: Punjabi University Press, 1977.

Singh, Ganda. *Early European Accounts of the Sikhs.* Calcutta: R.K. Maitra, 1962.

Singh, Ganda. *Life of Banda Singh Bahadur.* 4th ed. Patiala: Punjabi University, 2016.

Singh, Gurprit. *Coins of the Sikhs (Sri Amritsar Jiyo): A Catalogue of Silver Rupees of the Amritsar Mint.* Chandigarh: The Nanakshahi Trust 2015.

Singh, Joginder. "Nāmdhārī." In *Brill's Encyclopedia of Sikhism*, edited by Knut A. Jacobsen, and Gurinder S. Mann, Kristina Myrvold, Eleanor M. Nesbitt. Boston: Brill, 2017.

Singh, Kashmir. "Shiromani Gurdwara Parbandhak Committee: An Overview." In *The Oxford Handbook of Sikh Studies*, edited by Pashaura Singh and Louis. E. Fenech, 328-38. Oxford: Oxford University Press, 2014.

Singh, Khushwant. *A History of the Sikhs.* 2 vols. Vol. 1: *A History of the Sikhs: 1469-1839.* New Delhi: Oxford India Paperbacks, 2014.

Singh, Mohinder. *The Akali Movement.* Patiala: Punjabi University, 2015.

Singh, Nikky G. K. *The Birth of the Khalsa: a Feminist Re-memory of Sikh Identity.* New York: State University Of New York Press, 2005.

Singh, Nikky G.K. "Sikh Art." In *The Oxford Handbook of Sikh Studies*, edited by Pashaura Singh and Louis. E. Fenech, 419-29. Oxford: Oxford University Press, 2014.

Singh, Nikky G. K. *The First Sikh: The Life and Legacy of Guru Nanak.* New Delhi: Penguin Random House, 2019.

Singh, Pashaura. "Gurmat: The Teachings of the Gurus." In *The Oxford Handbook of Sikh Studies*, edited by Pashaura Singh and Louis. E. Fenech, 225-39. Oxford: Oxford University Press, 2014.

Singh, Patwant, and Jyoti M. Rai. *Empire of the Sikhs: The Life and Times of Maharaja Ranjit Singh.* New Delhi: Hay House India, 2008.

Singh, Runjeet. *The goddess: arms & armour of the Rajputs.* Coventry, England: Runjeet Singh, 2018.

Singh, Runjeet. *Arms, Armour & Works of Art.* Coventry, England: Runjeet Singh, 2019.

Singh, Runjeet. *Treasures from Asian armories.* Coventry, England: Runjeet Singh, 2019.

Singh, Sikander, and Roopinder Singh. *Sikh Heritage: Ethos and Relics.* New Delhi: Rupa, 2012.

Singh, Sukhjit H.H., and Cynthia M. Frederick. *Prince Patron and Patriarch: Maharaja Jagatjit Singh of Kapurthala.* New Delhi: Roli Books, 2019.

Singh, Surinder. *Sikh Coinage, Symbol of Sikh Sovereignty*, 2nd ed. New Delhi: Manohar Publishers, 2004.

Singh, Surinder. "Teach the Sikhs a Lesson." All about Sikhs. Accessed on August 27, 2021. https://www.allaboutsikhs.com/sikh-history/1984-pogrom/teach-the-sikhs-a-lesson/

Smyth, George. *A History of the Reigning Family of Lahore.* Calcutta, W. Thacker and Co. 1847. Reprint, Lahore: Sang-e-meel Publications, 1996.

"Sri Dasam Granth Sahib." Search Gurbani. Accessed on August 23, 2021. https://www.searchgurbani.com/dasam-granth/page-by-page

Steinbach, Henry. *The Punjaub: A Brief Account of the Country of the Sikhs.* London: Smith, Elder & Co., 1845.

Stronge, Susan. *The Arts of the Sikh Kingdoms.* New York: Weatherhill, 1999.

Symonds, Richard. *The Making of Pakistan.* London: Faber and Faber, 1950.

Taylor, Paul M. "Sikh Heritage at the Smithsonian." *Journal of Punjab Studies* 11, no.2 (2004):221-36.

Taylor, Paul M. "Introduction: Perspectives on the Punjab's Most Meaningful Heirlooms." In *Sikh Heritage: Ethos and Relics*, Sikandar Singh and Roopinder Singh, viii-ix. New Delhi: Rupa, 2012.

Taylor, Paul M. "Sikh Material Heritage and Sikh Social Practice in a Museum-Community Partnership: The Smithsonian's Sikh Heritage Project." *Sikh Research Journal* 1, no. 1 (Spring/Summer 2016). http://sikhresearchjournal.org/sikh-materialheritage-and-sikh-social-practice-in-a-museum-community-partnership-bypaul-michael-taylor/

Taylor, Paul M. "Exhibiting the Kapany Collection: Observations on the Transformation of Sikh Art and Material Culture in Museums." In *Sikh Art from the Kapany Collection*, edited by Paul Michael Taylor and Sonia Dhami, 286-309. Palo Alto, Calif.: The Sikh Foundation, in association with the Asian Cultural History Program, Smithsonian Institution, 2017.

Taylor, Paul M. "Sikh Art and Devotion in the Collection of Parvinder S. Khanuja," *Arts of Asia* 49, no.1 (January-February 2019):107-116.

Taylor, Paul M. "Introduction." In *The Japji of Guru Nanak: A New Translation with Commentary* (by) Rupinder S. Brar, 7-13. Washington, D.C.: Asian Cultural History Program, Smithsonian Institution. [First Indian ed. co-published with Roli Books, New Delhi, 2020.]

Taylor, Paul M., and Sonia Dhami, *in press.* "Collecting the Arts of the Punjab: Arts and Identity for the Sikh Diaspora in Singapore and Beyond." In *Sikhs in Singapore – A Story Untold*, Tan Tai Yong, ed.

Taylor, Paul M., and Sonia Dhami, eds. *Sikh Art from the Kapany Collection.* Palo Alto, Calif.: The Sikh Foundation, in association with the Asian Cultural History Program, Smithsonian Institution, 2017.

Taylor, Paul M., and Robert Pontsioen. *Sikhs: Legacy of the Punjab.* Washington, D.C.: Asian Cultural History Program, Smithsonian Institution; in association with: Sikh Heritage Foundation, Fresno Art Museum, and The Sikh Foundation. 2014.

Toor, Davinder. *In Pursuit of Empire: Treasures from the Toor Collection of Sikh Art.* London: KashiHouse. 2018.

Virdi, Kuldeep S. *Amritsar and Guru Nanak Dev University. The Contours of Inheritance.* Amritsar: Guru Nanak Dev University, 2019.

Waheeduddin, Fakir S. *The Real Ranjit Singh.* Amritsar: Punjabi University, 2001.

PARVINDERJIT SINGH KHANUJA, a medical oncologist, was born in Muzaffarnagar (India) and received his education and medical training in India and in the United States. He is a Fellow of the American College of Physicians and he has lived for the last thirty years in Phoenix, Arizona, where he founded the Ironwood Cancer Centers in 1993. Besides practicing medicine, he is involved with multiple nonprofit organizations and is a member of the Board of Trustees of the Phoenix Art Museum, where he contributed to the creation of a permanent Sikh art gallery. He believes that, although life is a transitory and ever-changing process, history needs to be preserved. He has been collecting Punjab-related art for nearly fifteen years with the goal of preserving it for the future generations.

PAUL MICHAEL TAYLOR, a research anthropologist at the Smithsonian Institution since 1981, is Curator for Asia, Europe, and the Middle East in the Smithsonian's Anthropology Department, and he serves as Director of the Smithsonian's Asian Cultural History Program. He received a B.A. *summa cum laude* from UCLA and Ph.D. from Yale University, both in Anthropology; and is an author or editor of numerous books and scholarly articles on the ethnography, ethnobiology, languages, and art (or material culture) of Asia. These include *Beyond the Java Sea: Art of Indonesia's Outer Islands, Fragile Traditions: Indonesian Art in Jeopardy, Sikh Art from the Kapany Collection*, and *Artists of Modern Kazakhstan*. Many of his publications are available at: https://si.academia.edu/PaulMichaelTaylor. He also served as curator of many museum exhibitions.